Berczy

Berczy

MARY MACAULAY ALLODI
PETER N. MOOGK
BEATE STOCK

Under the general editorship of
ROSEMARIE L. TOVELL

With a technical essay by
ANNE RUGGLES

NATIONAL GALLERY OF CANADA

1991

Published in conjunction with the exhibition *Berczy*, organized by the National Gallery of Canada.

National Gallery of Canada, Ottawa
8 November 1991–5 January 1992

Musée du Québec, Quebec City
17 March–17 May 1992

Glenbow Museum, Calgary
13 June–9 August 1992

This catalogue was produced by the Publications Division of the National Gallery of Canada, Ottawa.

Serge Thériault, *Chief*
Lynda Muir and Jacques Pichette, *Editors*
Colleen Evans, *Picture Editor*
Jean-Guy Bergeron, *Production Manager*

Designed and typeset in Bembo by Eiko Emori Inc., Ottawa
Printed on Warren's Patina by Beauregard Printers, Ottawa
Film by Chromascan, Ottawa

Available through your local bookseller or from:

The Bookstore
National Gallery of Canada
380 Sussex Drive, Box 427, Station A
Ottawa K1N 9N4

Cover: William Berczy, *Self-portrait,* 1783 (cat. 27). Collection: Royal Ontario Museum, Toronto.

Canadian Cataloguing in Publication Data
Allodi, Mary Macaulay, 1929–
Berczy.
ISBN 0-88884-615-0

Exhibition catalogue.
Issued also in French under same title.
1. Berczy, William, 1744–1813. 2. Painters–Canada–Biography.
I. Moogk, Peter N., 1943– II. Stock, Beate.
III. National Gallery of Canada. IV. Title.

ND249 B47 A85 1991 759.11 CIP 91-099151-0

1991
1806.1e

CONTENTS

FOREWORD

ILLIAM Berczy is a relatively unknown artist in the annals of Canadian art history. Only with the National Gallery of Canada's acquisition of his *Joseph Brant* in 1951, and the gift by Major Edgar C. Woolsey of *The Woolsey Family* in 1952, did Berczy begin to receive any real recognition as one of Canada's most important pre-Confederation artists. Yet, the rapid acknowledgement of these two paintings as masterpieces of early Canadian art added little to our knowledge of the man and artist. John Andre's research and subsequent publication in the 1960s somewhat remedied this problem, but no institution undertook a major exhibition to reveal and celebrate the entire artistic oeuvre of this Canadian pioneer.

The problems in mounting such an exhibition are many. Documents would have to be examined and analyzed to locate works of art in private, public, and ecclesiastical collections in Europe and Canada. Works suffering from two hundred years of neglect would have to be examined by fine art conservators to determine their conservation needs for the exhibition. Complex international loans would have to be negotiated and their transportation arranged by the registrar. Objects as diverse as altar paintings and tiny miniatures on ivory, would require specialized handling and display techniques to be devised by the design department and technical services. To do justice to the exhibition, a major scholarly catalogue would have to draw upon the multilingual and publishing talents of editors and the publications division. The co-ordination of all of these activities would draw upon the organizational and management skills of the curatorial and exhibitions departments. With its past experience in mounting the Joseph Légaré, Degas, and Vatican exhibitions, the National Gallery of Canada was uniquely placed to undertake such a project, for it could draw upon the wealth of experience and expertise among its professional staff in all sectors of the institution.

It would be possible to cite many such instances of expertise among the Gallery's staff, whose members made invaluable contributions to this exhibition and catalogue. However, to serve as an example, I would like to single out the conservators, who worked closely with the exhibition organizer, Rosemarie Tovell, and the guest curators, Mary Allodi and Beate Stock, from the research stages to the final presentation of the exhibition.

Because it was recognized at the outset that this exhibition would present innumerable conservation problems, at the earliest planning stages prints and drawings conservator Geoffrey Morrow and paintings conservator Anne Ruggles were assigned to the project. They undertook the examination of works in all the private and ecclesiastical collections and many of the public collections. Their task was to

anticipate any difficulties that would arise with the loan of these works, and to recommend and undertake some treatments.

Aside from the all-important treatments, which were essential to the preservation and presentation of Berczy's art, an added bonus for the curators was the conservators' growing knowledge and understanding of Berczy's technique. This became an invaluable tool in deciding the attributions of many works of art. As well, particularly with the paintings, the understanding of Berczy's complex technique allowed for their safe restoration. We decided that this resident expertise should be made known. Therefore, included in the catalogue is an essay by Anne Ruggles on Berczy's painting techniques, using the National Gallery's painting *The Woolsey Family* as the model. It is an essay that will be useful to conservator and art historian alike. But most of all, it offers us a fascinating insight into the meticulous craftsmanship of William Berczy.

The success of this exhibition and catalogue rests with the efforts of the National Gallery of Canada's staff, but I would like to make special mention of the voluntary contribution of a much admired colleague and of a sister institution. The plan to undertake the Berczy exhibition began with the recognized need to involve Mary Allodi, curator at the Royal Ontario Museum and one of Canada's senior art historians. To Mary Allodi, who toiled many a weekend towards the exhibition, and to the Royal Ontario Museum, who allowed the Gallery to appropriate her talents, my profound gratitude.

Dr Shirley L. Thomson
Director, National Gallery of Canada

PREFACE

HEN William Berczy crossed the Niagara River into Upper Canada in the spring of 1794 for a meeting with Lieutenant-Governor John Graves Simcoe and his councillors, he must have appeared as an exotic bird of paradise to the British colonial administrators. Here was a former painter at the Hapsburg and Bourbon courts, a former art dealer in Florence and London, seeking a home for a group of German settlers he was leading out of the wilderness of western New York State. Under these circumstances, their puzzlement and difficulty in understanding the character of William Berczy, which would eventually lead to grave consequences, can be understood, and its effect continues even today.

Berczy was not a bird of paradise so much as a chameleon, changing his occupation, his political and social interests, possibly his religious affiliation, and certainly his name to suit the day-to-day circumstances in which he found himself. He was a man of robust good health, supreme self-confidence, and unbridled energy and imagination. He was a devoted father and husband, yet he ceased all contact with his mother and siblings left behind in Vienna. He was multilingual, university educated, and well-versed in the most advanced social and political ideas of the Enlightenment. As a student of the Enlightenment he was a believer of the then revolutionary concept of the individual as the author of his own destiny. And he was certain of his destiny. He carefully copied his personal correspondence and recorded his fascinating life in documents which have come down to us today.

Raised in the circles attached to the court of Vienna, Berczy had learned the polish of courtly manners and the politics of opportunism. He was therefore repeatedly able, with remarkable alacrity, to ingratiate himself with those in power. While he was a dreamer, he was also a man who was constantly looking for the realistic means to financial success. Unfortunately, his naïvete and impracticality constantly led him to business failure and at times outright disaster. Not one to be introspective or self-critical, Berczy never seemed to learn from his mistakes. But despite many setbacks, he accomplished much. He is now considered one of the founders of Toronto and, during his brief years of artistic activity in Canada, he was unsurpassed.

While Berczy may have been a jack-of-all-trades, he is not remembered for his road building but rather for his painting. The style of his art, which he had learnt over numerous years of training and practice in Vienna, Bern, and Florence, could be characterized as a nascent form of Neo-Classicism peculiar to late eighteenth-century Central Europe. Essentially, Berczy's style can be described as the blending of the clarity of light and simplicity of composition typical of the new Classicism with the gentleness and lyricism of the Rococo. He avoided the often harsh allegorical undertones of Neo-Classicism, but he also avoided the overt sentimentality and sensual-

ity of the Rococo. Since his specialty in Europe was the portrait miniature, it is not surprising to find a high degree of realism in his art – but a realism that overlays actuality with charm. As well, his years as a miniaturist affected his technique for all his work: uniformly we can find deliberate modelling of the forms by means of a careful application of paint layers in smooth, barely distinguishable brush strokes applied to the smallest miniatures and the largest canvases, such as the monumental altar painting of *The Archangel St. Michael.*

William Berczy was a practising artist in Switzerland, Italy, and Great Britain from 1780 to 1801. He was successful in painting the portraits of members of the leading royal houses – the Hapsburgs, the Bourbons, and the Hanovers – as well as the leaders of Bernese society. The quality of the miniatures he produced, as exemplified by his astonishing self-portrait on ivory of 1783, places Berczy within the best of Europe's miniaturist tradition. His more ambitious group portraits and works in oil demonstrate that while Berczy did not join the upper ranks in these categories, he certainly would have rested comfortably among the middle-ranked painters. Yet Berczy remains unknown in Europe. The reasons for this obscurity lie in the brevity of his career – he can claim only eleven short years of European artistic activity; in addition, his work was rarely signed and has been scattered in private collections and large royal collections prone to dispersal.

In Canada, Berczy's artistic predecessors and contemporaries could not and did not bring the gloss of European court painting to their clients. Only William Berczy could make the Grand Duke Peter Leopold of Tuscany, future ruler of the Holy Roman Empire, remove his powdered wig, satin and brocade garments, sashes and bejewelled medals to don plain woollen garments and become John Woolsey, Quebec merchant. Only William Berczy, with his experience, training, and active participation at the centre of European cultural activities,

could bring an authentic knowledge and understanding of the full panoply of European taste to the emerging cultural aspirations of the rough-hewn colonial heart of British North America.

It is only recently that William Berczy's place in Canadian history and his standing as one of our finest pre-confederation artists has been confirmed. Much is owed to an intrepid few "believers," for Berczy's reputation had been tarnished by his difficult dealings with the Tory gentry. This group comprised the colonial councillors and professionals of Upper Canada, whom Berczy met in 1794. After his death in 1813, the artist's son, William Bent Berczy, became the primary custodian of his father's name and papers. He aided Jacques Viger, the great amateur antiquarian of Montreal's history and personal friend of William Berczy, to copy documents which were added to Viger's own correspondence with Berczy. Viger's collection eventually made its way to archives in Montreal and Quebec City. The bulk of the Berczy papers entered the collection of the Montreal antiquarian and executor of William Bent Berczy's estate, L.-F.-G. Baby. Baby finally deposited these papers with archives in Montreal and Ottawa. Over the first half of this century only a handful of publications based on these papers, mostly by Quebec archivists, historians, and art historians, such as Antoine Roy, Arthur Maheux, and Gérard Morisset, appeared. These publications along with a few isolated works of art constituted our entire knowledge of William Berczy.

In English-speaking Canada no article or mention of any significance in historical surveys of Canadian art was published until the research of the indefatigable Toronto historian John Andre became known. Andre took it upon himself to restore Berczy to his rightful place in Canadian history. In 1967 he published the first full scholarly biography of William Berczy, and through his success at locating Berczy's descendants, Andre uncovered a wealth of new works, most of which – through his efforts –

have found their way into public collections. Not only did John Andre succeed in having Berczy officially recognized as a founder of Toronto, he has given future historians and art historians a solid base from which to launch their own research.

One immediate outcome of Andre's research was the retrospective exhibition of William Berczy's work organized by Mary Allodi at the Royal Ontario Museum in Toronto in 1968. This was the first real attempt to organize and attribute the art of William Berczy. Unfortunately, no catalogue accompanied the exhibition. Nevertheless, the research that went into producing this 1968 retrospective only marked the beginning of Mary Allodi's interest in the artist. Since that time, attributions have changed and many new works have been identified. Particular mention should be made of her re-attribution to Gerrit Schipper of the fifty-odd pastel portraits in profile that had commonly been given to William Berczy. This important finding was revealed in a lecture at the Royal Ontario Museum in 1988 and has been presented in shortened form in Appendix B, The Pastel Profiles.

John Andre and his predecessors began their writings with Berczy's North Americancolonizing activity, and no one had undertaken any explorations of the artist's life and work prior to 1791. In 1977 an important group of letters, written from Florence by William Berczy to his Bernese business partner and friend Marguerite Gruner, was deposited in the *Kunsthistorisches Institut,* in Florence. These letters formed the basis for an article by Dr Beate Stock, a German art historian living in Canada, which was published in 1983. Her subsequent research in the archives, museums, libraries, and collections of Europe has unearthed much new information and many new works.

Given the advanced state of Mary Allodi's and Beate Stock's research, the time seemed right to invite these two scholars to undertake a major review of William Berczy. Not only is this the first inten-

sive scholarly, art-historical examination of William Berczy, it is also the first time that his European and Canadian artistic careers will be joined as the subject of an exhibition and publication.

It would be impossible to explain the artist's career in Canada without providing an historical background to his efforts as a colonizer in Markham Township, Upper Canada. His life in Canada revolved around his attempts to provide for his German settlers, to ensure their land titles (and his own), and to extricate himself from the debts and legal tangles in which he found himself. This is the episode in the saga in which we see William Berczy at his worst; but to be fair to him, he was evidently not justly treated by the British clique in control of the judicial and political administration of Upper Canada. To provide this important element in Berczy's story, Dr Peter N. Moogk, a social historian specializing in French North America and Upper Canada, has found additional documents on William Berczy and offered an interpretation of Berczy's biography set in the context of his land-colonizing activities.

The authors of this catalogue realize that their efforts at locating all of William Berczy's paintings, watercolours, miniatures, prints, drawings, and architectural studies could not be completed at this time. Nevertheless, it was important to treat this publication not just as a catalogue of the works in the exhibition but rather as a record of all his known work. To help future scholars, a catalogue of lost works has also been compiled. The information for this listing has been extracted from the many Berczy documents and the rare published references.

A further problem relating to the identification of William Berczy's art has been the artistic activity of his wife Charlotte, his son William Bent, and daughter-in-law Amélie Panet Berczy. Since the Berczys rarely signed their work, we felt it was important to isolate their art in order to define their styles. Unfortunately, we were not successful in locating any work by Charlotte Berczy.

There is a vivid quality about William Berczy which strikes those who are familiar with his biography and his work. He also succeeded in capturing the individuality of his portrait subjects; many of whom were the leading figures of his day. These factors combine to produce an historical account that is peopled with colourful characters, making a bygone era come to life. We believe that the readers of this catalogue and the visitors to the exhibition will enjoy their encounter with this truly intriguing man, who played a significant role in the cultural and political history of our nation.

Rosemarie L. Tovell
General Editor

ACKNOWLEDGEMENTS

I would like to express my sincere thanks to the many private European and Canadian lenders, many of whom are descendants of Berczy's portrait subjects. They have generously parted with their treasures for the benefit of all the visitors to the exhibition.

Many public and ecclesiastical institutions generously lent their works to the exhibition and assisted with the recording of works of art by Berczy family members for the catalogue raisonné. To these people who gave so generously of their time and attention I am most grateful: Michael Bell and Dorothy Farr at the Agnes Etherington Art Centre, Kingston, Ont.; Dennis Reid, Christine Boyanoski, and Catherine Spence at the Art Gallery of Ontario, Toronto; Artur Bablok, Austrian Embassy, Ottawa; Daniel Olivier, Marie Baboyant, and Daniel Bélair at the Bibliothèque municipale de Montréal, Salle Gagnon; James H. Nottage at the Gene Autry Western Heritage Museum, Los Angeles; Fern Bayer at the Government of Ontario Art Collection, Toronto; A. Rolph Huband at the Hudson's Bay Company, Toronto; Conrad E.W. Graham at the McCord Museum of Canadian History, Montreal; Bruce Whiteman at McGill University, Department of Rare Books, Montreal; Nicole Cloutier, Micheline Moisan, and Suzelle Baudoin at the Montreal Museum of Fine Arts; Pierre Brouillard and Linda Lapointe at the Musée du Château Ramezay, Montreal; Mario Béland, Paul Bourassa, and Michel Cheff at the Musée du Québec; Jim Burant, Mari-elle Campeau, Lydia Foy, Gilbert Gignac, Patricia Kennedy, and Elizabeth Krug at the National Archives of Canada, Ottawa; Corinne Collins, Cheryl Evans, Harry McCarthy, Barbara Perry, and John Thompson at the National Library of Australia, Canberra; M. le Chanoine Denis Clément, Église de Notre-Dame-de-la-Visitation, Champlain, Que.; Dott. Ettore Spalletti at the Galleria d'arte moderne, Palazzo Pitti, Florence; Karen Smith, Cara McEachern, Diane McKay, and Isabelle Hambleton at the Royal Ontario Museum, Toronto; Claude Pilon at the Fabrique de Saint-Michel de Vaudreuil; André Juneau, l'Abbé Laurent Tailleur, and Sonia Mimeault at the Musée et Archives du Séminaire de Québec, also Joanne Chagnon and Didier Prioul, formerly of the Musée du Séminaire de Québec; Denys Chouinard, Denis Plante, and Denise Pelissier of the Service des archives de l'Université de Montréal; Bob Starr, House of York Antiques, Toronto; Révérende Mère Gabrielle Dagnault, o.s.u., Vieux Monastère des Ursulines de Québec.

A special expression of appreciation goes to the following private individuals, who were most helpful and constructive in our efforts towards the realization of the exhibition: David Alexander, York, U.K.; Willie Amtmann, Ottawa; John Andre, Downsview, Ont.; Wendy Baker, Ottawa; Henri de Lotbinière Harwood, Vaudreuil, Que.; Patrick Legris, Carp, Ont.; and A.J.H. Richardson, Ottawa.

While the mounting of large-scale exhibitions and the publishing of extensive catalogues is part of

all our jobs at the National Gallery of Canada, I would, nevertheless, like to thank the following people for their special efforts in assisting me with the organization of the exhibition and the general editing of the catalogue: photographers Charles Hupé and particularly Clive Cretney; Laurier Marion, whose organizational skills and experience allowed us to borrow the altar paintings; the designer of the exhibition installation, Alan Todd; Serge Thériault and his staff in the Publications Division; Jacques Naud, Alison Cherniuk, and Naomi Panchyson in the exhibitions department; loans co-ordinators Kate Laing and Diana Payne; and Suzanne Lacasse, of Education Services, who organized the Berczy symposium and educational program accompanying the exhibition in Ottawa.

I would also like to express my gratitude to René Villeneuve, assistant curator of early Canadian art, for his ongoing enthusiasm and support for the project, but particularly for his help in negotiating the loans of paintings from the churches in Vaudreuil and Champlain.

A special mention should be made of a small band of colleagues who worked most closely with me on the exhibition: conservators Geoffrey Morrow and Anne Ruggles for their assistance and enthusiasm, beyond the call of duty, throughout the four years it took to realize the exhibition; and Julie Hodgson, my assistant on the exhibition, who kept me organized and on track at all times.

Lastly, I would like to thank my collaborators, Mary Allodi, Peter Moogk, and Beate Stock, without whom the exhibition and catalogue would not be.

Rosemarie L. Tovell
Associate Curator
Canadian Prints and Drawings
National Gallery of Canada
and exhibition organizer

I wish to express my gratitude to John Andre, who generously shared with me the information he had gathered during many years of Berczy studies; and to Rosemarie Tovell, initiator of this exhibition, for her support during all phases of the project. My co-authors Peter Moogk and Beate Stock were also unfailingly helpful.

Although their names are mentioned in the catalogue entries, I also wish to thank the lenders to this exhibition for their generosity in providing access to paintings and drawings by William Berczy and family.

A special acknowledgement is due to Patrick Legris, Diane McKay, Geoffrey Morrow, and Anne Ruggles, who helped me to understand the structure of Berczy's paintings and drawings during many visits to their conservation laboratories. Although I did not trouble them as often, my thanks also to Wendy Baker, Joan Rathbone, and Roger Roche.

Among the many colleagues and individuals who went out of their way to help me during the last three years, I would like to thank Conrad E.W. Graham, Stephen A. Otto, and John L. Russell for early and continued support. Other friends and associates were consulted in special areas, and thanks are due to: Georgia Barnhill, Mario Béland, Paul Bourassa, Mimi Cazort, René Chartrand, Nicole Cloutier, Robert Derome, Lucie Dorais, Michel Doyon, Henri de Lotbinière Harwood, Mary Holford, Julie Hodgson, Laurier Lacroix, Roxane Léonard, Eva Major-Marothy, Denis Martin, Henri McKenzie Masson, Micheline Moisan, Luc Noppen, Michael Pantazzi, John Porter, Didier Prioul, l'abbé Laurent Tailleur, Karen Taylor, Claude Thibault, Maija Vilcins, René Villeneuve, l'abbé Claude Turmel, the Trustees of the Samuel E. Weir Collection, and C. Gordon Winder.

I received help from many departments of the Royal Ontario Museum, and especially from my colleagues at Canadiana: Carol Baum, Honor de

Pencier, Isabelle Hambleton, Janet Holmes, Deborah Maw, Karen Smith, Donald Webster, and Catherine Wyss. For specific information from Dr Trudy Nicks, Kenneth Lister, and Arni Brownstone of the Ethnology department, Mary Holford of the Textile department, and Peter Kaellgren from European. And certainly not least, thanks to Brian Boyle, Allan McColl, and Deirdre Shimwell from the Photography department.

My son James Seymour Allodi has been a constant and cheerful ally during the long march.

Mary Macaulay Allodi
Curator, Canadian Art
Royal Ontario Museum
and guest curator for the exhibition

The writing of my essay was assisted by the critical comments of Dr F. Murray Greenwood and Dr Beate Stock. Mr Franz-Albrecht ("Frank") Elfert of Vancouver gave me invaluable assistance in reading and translating difficult passages from documents written in old German *Schrift* or cursive handwriting. I would like to express my gratitude for all their help.

Peter N. Moogk
Associate Professor
Department of History
University of British Columbia

Many years ago the idea of a William Berczy exhibition was suggested by Dr Elke Schmitz, then Counsellor at the German Embassy in Ottawa. Thanks to her assistance, I received a travel grant from the German Academic Exchange Service (DAAD).

In pursuing research on William Berczy in various European countries and in resolving numerous questions on specific problems, I profited greatly from the generous help and assistance of the following persons: David Alexander, Esq., York, England; Barbara Benoit, Ottawa; Prof. Rosemarie Bergmann, Ottawa; Dr Hans Haeberli, Burgerbibliothek Bern; Prof. Werner Hager, Oberhausen/ Bavaria; Herr Ulrich C. Haldi, Stuker Galerie Bern; Dr Georg Kugler, Kunsthistorisches Museum, Vienna; Dr Silvia Meloni Trkulja, Soprintendenza regionale ai beni artistici e storici, Florence; the late Dr Ferdinand von Praun, Oberhausen/North Rhine-Westphalia; Dr Steffi Röttgen, Kunsthistorisches Institut in Florenz, Florence; Dr Elisabeth Springer, Haus-, Hof- und Staatsarchiv, Vienna; Prof. Franz Szabo, Carleton University, Ottawa; Dr Paola Venturelli, Monza, Italy; Dr Volker von Volckamer, Fürstl. Oettingen-Wallerstein'sche Sammlungen, Harburg, Bavaria; Herr Harald Wäber, Burgerbibliothek Bern.

I also should like to express my gratitude to our capable editors Lynda Muir and Jacques Pichette.

Beate Stock
Guest curator for the exhibition

NOTE TO THE READER

This volume is intended to serve as a catalogue raisonné of the known and lost works of three members of the Berczy family: William Berczy, William Bent Berczy, and Amélie Panet Berczy.

ORGANIZATION

References to the works have been organized according to the following scheme:

Cat. 1–98 The works of William Berczy

LW 1–106 The lost works of William Berczy

WBB 1–38 The works of William Bent Berczy

LW-WBB 1–8 The lost works of William Bent Berczy

APB 1–4 The works of Amélie Panet Berczy

LW-APB 1–5 The lost works of Amélie Panet Berczy

Not all of the works catalogued here will be shown in the Ottawa exhibition or in the other venues.

DATES, DIMENSIONS, INSCRIPTIONS

Standard conventions in the recording of dates and dimensions have been used in the catalogue entries. All inscriptions were transcribed from the front and back of the works, and their position is specified according to this grid:

u.l.	u.c.	u.r.	*upper* left, centre, and right
c.l.	c.	c.r.	*centre* left, centre, and right
l.l.	l.c.	l.r.	*lower* left, centre, and right

QUOTATIONS, TRANSLATION

All quotations from the correspondence and other writings of William Berczy respect his original grammar and spelling. This attempt to cite Berczy as much as possible in his own words has been done to convey to the reader something of the essence of this multilingual and widely travelled man. The use of [*sic*] has been restricted to other contexts. All extracts taken from correspondence between Berczy and Marguerite Gruner, and between Berczy and Charlotte, his wife, were translated from French. Extracts translated from German have been identified as such.

REFERENCES

In the references section of each catalogue entry, archival sources are listed first. References to published works follow in order of date of publication.

ABBREVIATIONS

Some frequently cited institutions have been abbreviated in this catalogue:

AGF Archivio delle Gallerie di Firenze, Florence

AGO	Art Gallery of Ontario, Toronto		NA	National Archives of Canada, Ottawa
AO	Archives of Ontario, Toronto		NFG/GSA	Nationale Forschungs- und Gedenkstätten, Goethe- und Schiller- Archiv, Weimar
ANQ	Archives nationales du Québec, Montréal		NGC	National Gallery of Canada, Ottawa
ASQ	Archives du Séminaire de Québec		RHS	Rochester Historical Society, Rochester, New York
BMM	Bibliothèque municipale de Montréal, Salle Gagnon		ROM	Royal Ontario Museum, Toronto
FÖWAH	Fürstlich Oettingen-Wallerstein'sches Archiv, Harburg		SAUM	Service des archives de l'Université de Montréal
HHSTA	Haus-, Hof- und Staatsarchiv, Vienna		VAG	Vancouver Art Gallery
KIF	Kunsthistorisches Institut in Florenz, Florence			
MMFA	Montreal Museum of Fine Arts			
MSQ	Musée du Séminaire de Québec			
MTL	Metropolitan Toronto Library, Baldwin Room			

For an explanation of the shortened forms of exhibition titles, e.g., 1965 NGC, see Exhibition History, opposite. Shortened mentions of exhibition catalogues, e.g., NGC 1945, are listed in full in the Selected Bibliography. For abbreviated references to other publications, see Selected Bibliography.

EXHIBITION HISTORY

1790 London. *Twenty-first Annual Exhibition of the Royal Academy,* London, Somerset House, April 1790. Exh. cat. *The Exhibition of the Royal Academy M.DCC.XC* (London: T. Cadell, 1790).

1852 Toronto. *Paintings, Water-Colours and Engravings, exhibited in ... aid of the Bazaar for the Liquidation of the debt due on St. George's Church,* Toronto, Assembly Chamber, Parliament Buildings, September 1852. Exh. cat. Toronto 1852.

1860 Montreal. *Lower Canada Provincial Exhibition: Fine Arts Department,* organized by the Art Association of Montreal, August 1860. Exh. prize list, *Montreal Gazette,* 5 October 1860.

1887 Montreal. *Loan Exhibition of Canadian Historical Portraits and Other Objects relating to Canadian Archaeology: held in the Natural History Society's Building,* Numismatic and Antiquarian Society of Montreal, 15–31 December 1887. Exh. cat. Montreal 1887.

1892 Montreal. *Canadian Historical Portraits and Antiquities ... in Commemoration of the 250th Year of the Foundation of Montreal,* Numismatic and Antiquarian Society of Montreal, opened 15 September 1892. Exh. cat. Montreal 1892.

1899 Toronto. *Loan Portrait Exhibition,* Toronto, Women's Art Association of Canada, 3–15 April 1899. Exh. cat. Toronto 1899.

1909 Mannheim. *Jubiläums Ausstellung,* Mannheim, Altertumsverein, 1909. Exh. cat. *Katalog der Jubiläums Ausstellung des Mannheimer Altertumsverein* (Mannheim: Verlag des Mannheimer Altertumsvereins, 1909).

1910 Munich. *Sammlung H. Leonhard, Mannheim,* Munich, Galerie Helbing, opened 14 November 1910. Exh. cat. *Sammlung H. Leonhard, Mannheim: II Teil, Kunstgewerbe* (Munich: Galerie Helbing, 1910).

1942 Quebec City. *Le Vieux Québec,* Quebec City, Musée de la province de Québec, 10 December 1942–31 January 1943. Exh. cat. Percy F. Godenrath, *Le Vieux Québec* (Montreal: Canada Steamship Lines Limited [?], 1942).

1950 Washington, D.C. *Canadian Painting: An exhibition arranged by the National Gallery of Canada,* Washington, D.C., National Gallery of Art, 29 October–10 December 1950; and tour to San Francisco, San Diego, Seattle, and Vancouver. Exh. cat. Hubbard 1950.

1952 Quebec City. *The Arts in French Canada,* Quebec City, Musée de la province de Québec, 1952. Exh. cat. Quebec City 1952.

1953 NGC. *Exhibition of Canadian painting to celebrate the Coronation of Her Majesty Queen Elizabeth II,* Ottawa, National Gallery of Canada, 2 June–

13 September 1953. Exh. cat. *Exhibition of Canadian painting to celebrate the Coronation of Her Majesty Queen Elizabeth II* (Ottawa: NGC, 1953).

1959 Vancouver. *The Arts of French Canada, 1613–1870,* organized by the Musée de la province de Québec and held at the Vancouver Art Gallery, 15 May–11 June 1959; and tour to Winnipeg Art Gallery. Exh. cat. Morisset 1959.

1965 NGC. *Treasures from Quebec,* Ottawa, National Gallery of Canada, 5 February–7 March 1965; and tour to Quebec City. Exh. cat. Harper and Hubbard 1965.

1966 Vancouver. *Images for a Canadian Heritage,* Vancouver Art Gallery, 20 September–30 October 1966. Exh. cat. Doris Shadbolt, *Images for a Canadian Heritage* (Vancouver: VAG, 1966).

1967 London, Ont. *Remembrance of Things Past: The Artist in Early Canada, 1750–1867,* London Public Library and Art Museum, 3 January–18 February 1967; and tour to Hamilton and Sarnia.

1967 NGC. *Three Hundred Years of Canadian Art,* Ottawa, National Gallery of Canada, 12 May–17 September 1967; and tour to Art Gallery of Ontario. Exh. cat. Hubbard and Ostiguy 1967.

1967 MMFA. *The Painter and the New World,* Montreal Museum of Fine Arts, 9 June–30 July 1967. Exh. cat. MMFA 1967.

1968 ROM. *William Berczy,* Toronto, Royal Ontario Museum, 15 March–15 May 1968.

1969 NGC. *Early Canadian Portraits,* Ottawa, National Gallery of Canada, Extension Services Exhibition, on tour 5 September 1969–31 May 1970 to St. John's, Sherbrooke, Hamilton, Kitchener, Kingston, Edmonton, and Saskatoon. Exh. cat. Wayne J. Ready, *Early Canadian Portraits* (Ottawa: NGC, 1969).

1973 Kingston. *Early Canadian Portraits,* Kingston, Agnes Etherington Arts Centre, 4 February–4 March 1973.

1975 Cleveland. *The European Vision of America,* organized by the Cleveland Museum of Art; opened Washington, National Gallery of Art, 7 December 1975–15 February 1976; returned to Cleveland; on tour to Paris, Grand Palais. Exh. cat. Hugh Honour, *The European Vision of America* (Cleveland: Cleveland Museum of Art, 1975); and *L'Amérique vue par l'Europe* (Paris: Secrétariat d'État à la Culture, Éditions des musées nationaux, 1976).

1976 Omaha. *Artists of the Western Frontier,* Omaha, Nebraska, Joslyn Art Museum, 3 July–17 October 1976. Exh. cat. Mildred Goosman, *Artists of the Western Frontier* (Omaha: Joslyn Art Museum, 1976).

1977 NGC. *Berczy and Girodet: Exploring the Collections, No. 17,* Ottawa: National Gallery of Canada, 1 February–3 April 1977.

1978 ROM. *Canadian Faces,* Toronto, Royal Ontario Museum, 7 April–10 September 1978.

1979 Pitti. *Curiosità di una reggia. Viande della Guardaroba di Palazzo Pitti,* Florence, Pitti Palace, January–September 1979. Exh. cat. Pitti 1979.

1980 Market Gallery. *An Exhibition of Paintings, Drawings and Watercolours by William Berczy (1744–1813),* Toronto, City of Toronto Archives, Market Gallery, 6 September–2 November 1980. Exh. cat. Market Gallery 1980.

1981 McCord. *The Portrait of James McGill by Louis Dulongpré,* Montreal, McCord Museum of Canadian History, 15 July 1981–3 January 1982. Typescript exh. cat. Robert Derome (Montreal: McCord Museum, 1981).

1982 AGO. *Sight and Insight,* Toronto, Art Gallery of Ontario. Exh. cat. AGO 1982.

1984 AGO. *From the Four Quarters: Native and European Art in Ontario, 5000 BC to 1867 AD,* Toronto, Art Gallery of Ontario, 30 March–20 May 1984. Exh. cat. Reid and Vastokas 1984.

1984 ROM. *Georgian Canada: Conflict and Culture, 1745–1820,* Toronto, Royal Ontario Museum, 7 June–21 October 1984. Exh. cat. Donald Blake Webster, *Georgian Canada: Conflict and Culture 1745–1820* (Toronto: ROM, 1984).

1986 ANQ. *Le notaire et la vie quotidienne des origines à nos jours,* Montreal, Archives nationales du Québec, 1986. Exh. cat. Lafortune 1986.

1987 McCord. *Face to Face with History: Portraits from Early Canada,* Montreal, McCord Museum of Canadian History, 11 February–21 June 1987.

1987 AGO. *Recent Acquisitions: Canadian Historical Works on Paper,* opened 20 November 1987.

1988 Château Ramezay. *Montréal en couleurs: aquarelles du 19ᵉ siècle,* Montreal, Musée du Château Ramezay, 7 July–28 August 1988.

1989 AGO. *Staffage to Centre Stage: The Figure in Canadian Art.* Exh. cat. Boyanoski 1989.

1989 Château Ramezay. *Témoignages: 125 ans d'histoire et d'acquisitions,* Montreal, Musée du Château Ramezay, 18 September–29 November 1989. Exh. cat. Château Ramezay 1989.

1990 NA. *A Place in History: Twenty Years of Acquiring Paintings, Drawings and Prints at the National Archives of Canada,* Ottawa, National Archives of Canada, 31 October 1990–2 April 1991. Exh. cat. Burant 1991.

1991 Quebec City. *Nouveaux Regards, Nouvelles Perspectives: la Peinture au Québec, 1820–1850,* Quebec: Musée du Québec, 11 October 1991–5 January 1992; tour to Ottawa, Vancouver, Halifax, and Montreal. Exh. cat. Quebec City 1991.

CHRONOLOGY
WILLIAM BERCZY

by Rosemarie L. Tovell

1744 10 December: Baptized Johann Albrecht Ulrich Moll in Wallerstein, County of Oettingen-Wallerstein (now part of Bavaria).

1745 Moll family moves to Vienna, where Berczy's father takes up his appointment to the Imperial Aulic Council.

1762 15 May: Enrols at the *Hof-Academie,* Vienna, receiving his only formal art training.

c. 1763 Late 1763 or early 1764: Departs for Poland, possibly on minor diplomatic mission.

c. 1765–66 Returns to Vienna following reputed adventures in Turkey and Hungary.

1766 9 October: Enrols at the University of Jena in Saxony.

1771–72 In Poland at the outbreak of hostilities which led to the first partition of Poland.

1772 14 June: Father dies; after August, Berczy returns and helps support his mother and younger brothers and sisters.

c. 1772–79 In the Hapsburg domains of Hungary and Croatia working in land settlement, road building, and probably trade.

c. 1779 Changes his name to Albrecht Wilhelm Berczy (or uses French and Italian equivalents); after 1790 modifies and anglicizes his name to William Berczy.

1780 Moves to Bern, Switzerland, taking up the profession of miniature portrait artist; becomes friend and business partner of Marguerite Gruner. Late summer: At Fischer estate in Oberried. 1 October: At Frisching estate in St. Blaise, on Lake of Neuchâtel. 18 December: Arrives in Florence to study the old masters.

1781 April: Receives commission for group portrait of the family of the Grand Duke Peter Leopold of Tuscany. 7 September: Becomes member of the *Accademia del Disegno.*

1782 August: Completes all portrait commissions for the Grand Duke of Tuscany. Late August: Leaves for Bern, arriving mid-September. Receives commission from Bernard Louis de Muralt for portraits of several family members. Becomes engaged to Jeanne-Charlotte Allamand.

1783 Around June: Departs for Florence. Completes self-portrait miniature and group painting of the de Muralt children.

1784 Departs Florence. By late February to mid-March: In Rome, en route to Naples. 20 March: Arrives Naples. By July: Has received commissions for portraits of the Queen of Naples and her two oldest daughters. October to December: At Caserta with the Neapolitan Court.

1785 24 March: Issued passport and departs Naples for Switzerland. Mid-June: In Bern. By September: Working in Geneva on a portrait of Princess Sophia Mathilda of Gloucester. 1 November: Marries Charlotte Allamand and settles in Geneva.

1786 March: Returns to live in Bern; lack of work creates financial difficulties.

1787 January: In Florence, active primarily as an art dealer.

1790 In London, acting as agent for Florentine art dealers. April: Exhibits at Royal Academy, giving his address as 28 Pall Mall.

1791 6 January: Son William Bent Berczy born. 7 September: Signs contract with the Pulteney Associates to recruit German settlers for colonization in the Genesee district of western New York State. October: In northern Germany signing up settlers.

1792 2 May: Sails on the *Frau Catharina* from Altona near Hamburg for the United States. 25 July: Berczys arrive in Philadelphia; they travel through Pennsylvania, with colonists clearing roads en route. 21 December: They reach Williamsburg at Genesee Tract.

1793 January: Survey of site; house building begins. March: Problems arise between Berczy and Pulteney Associates' resident Genesee agent Charles Williamson.

30 August: In New York City to present settlers' complaints to the German Society. November: Legal action initiated by Williamson against Berczy for debt. 30 November (to 7 April 1794): Berczy travels between New York City, Philadelphia, Albany, and Schenectady, investigating settlement in Upper Canada.

1794 19 April: Arrives at Queenston Ferry for talks with Governor Simcoe regarding land grant in Upper Canada. 17 May: Meets with Simcoe and councillors. June: Returns to Genesee to arrange transfer of German settlers. July: Visits proposed Markham site. 26 August: Son Charles Albert Berczy born at Niagara. August: Negotiates possible land purchase with Joseph Brant but transaction not carried out. 8 October: Berczy family sails to York to establish settlement at Markham Township. Autumn: Construction of Yonge Street to Markham settlement begins.

1795 Start of settlement at Markham Township; winter famine in settlement.

1796 January: Berczy provisions settlement from Military Commissariat by giving his bond. 23 May: Sails for Kingston to buy further provisions for settlement. October: Berczy informed that as non-British born aliens, he and his settlers are only entitled to land grants after seven years residency.

1797 Land title and debt problems with local officials increase.

1798 February and March: Petitions Executive Council of Upper Canada and the King. April: Leaves York for Montreal and Quebec City, having decided to plead his

own cause. June: Arrives Quebec. Mid-July to late November: Travels to York to escort his family to Montreal; short trip to New York City. Further negotiations with Executive Council fail and Berczy returns to Quebec in early December.

1799 19 February: Departs Quebec and travels overland to Halifax. 20 May: Sails to England. 28 June: Arrives Gravesend, and proceeds directly to London. 17 October: Imprisoned at King's Bench prison for debts owed to former art dealing associates.

1800 4 February: Berczy's case presented to British Cabinet. 4 June: Discharged on bail from debtors' prison and returns to art dealing business with old Florentine associates.

1801 1 April: Elected corresponding member, Royal Society. 10 September: Sails for Canada. 14 November: Ship grounded at Paspébiac, Baie des Chaleurs.

1802 16 February: Sets out on foot across Gaspé peninsula, reaching Quebec City by 9 March. 22 March: Arrives in Montreal. 22 May: Departs with son William for York, arriving on 3 June, and stays with Willcocks family. November: Begins legal action against German settlers for restitution of expenditures (to 20 September 1803).

1802–03 At York, undertakes various commissions for design and building of bridges and houses, as well as portrait painting.

1804 Around late September: Leaves York for Montreal; resides there from October and resumes his profession as artist.

1804–08 Paints miniatures and portraits in oil, and takes up architectural commissions, such as Christ Church in Montreal.

1808 22 July: Arrives in Quebec with son William and soon begins work on *The Woolsey Family*.

1809 Receives final word from Upper Canada that his land claims will not be recognized; *The Woolsey Family* completed. 28 July: Leaves Quebec for Montreal. 31 July: At Trois-Rivières; and in Montreal during August. Begins work on altar painting for Saint-Michel de Vaudreuil, and continues with portrait commissions.

1810 March: Completes *The Archangel St. Michael* and continues with several other church commissions.

1811 Autumn: Resumes work on his manuscript on history of Canada.

1812 1 February: Puts his house in Montreal up for rent. Sets out for New York City to pursue business with German Company and arrange for publication of his manuscripts, visiting friends en route. 19 May: In Chambly. 24 May: In Burlington, Vt. 27 May: In Middlebury, Vt., where he falls ill. 16 July: In evident poor health, departs for Albany. 10 October: Meets with associates of German Company in New York City.

1813 5 February: Dies and is buried at Old Trinity Church, New York City.

Europe 1763

Great
Britain

London

The Netherlands

Altona
Hamburg

Berlin

Holy Roman Empire

Kingdom
of Poland

Poznan

Rhine

Paris

Jena

France

Wallerstein

Danube

Munich

Vienna

Pressburg

Lake of Neuchâtel

Bern
Belp

Lausanne

Switzerland

Varazdin

Kingdom
of Hungary

Geneva

Karlovac
Fiume (Rijeka)

Spain

Florence

Grand Duchy
of Tuscany

Rome

Kingdom
of Naples

Naples

WILLIAM BERCZY
THE EUROPEAN YEARS, 1744–1791

by Beate Stock

THE man we know as William Berczy was baptized Johann Albrecht Ulrich Moll on 10 December 1744 in the Roman Catholic Church of St. Alban, in the little town of Wallerstein (fig. 1) near Nördlingen, in the County of Oettingen-Wallerstein, now part of Bavaria, Germany.[1] (How Albrecht Moll evolved into William Berczy will be discussed later; however, for the sake of consistency we shall refer to him only as William Berczy in this volume.) The Moll family was first recorded in the region in 1575, when one Johann Moll was noted as the owner of a prosperous farm.[2] The next four generations of the family were all Lutheran ministers, and the first to break this pattern were Berczy's uncle, Bernhard Paul von Moll, and his father, Albrecht Theodor Moll (see Appendix A, Genealogy), both of whom entered government service. Berczy's father also broke with the Lutheran tradition of the family when in 1742 he married a Catholic, Johanna Hefele. She was the daughter of Johann Anton Hefele, a vice-prefect in the neighbouring town of Oettingen.[3]

At the time of Berczy's birth, his father was in the service of the counts of Oettingen-Wallerstein, first as state secretary, and then as cabinet secretary. In 1741, he was promoted to the position of actual aulic councillor in the Oettingen-Wallerstein court. On 13 December 1745, Moll was accredited by Count Philipp Carl of Oettingen-Wallerstein as his agent to the Imperial Aulic Council of the Holy Roman Empire in Vienna.[4] His family soon joined him there.

Once in Vienna, Moll followed the standard practice of representing a number of clients and soon became the agent of several small territories and Imperial Free Cities.[5] However, the Count of Oettingen-Wallerstein found his own interests neglected, and Moll was dismissed in 1755.[6] Nevertheless, Albrecht Theodor Moll seems to have been able to make a good living, a fact which was also reflected in the family's residences. They lived mostly in fine houses near the Imperial Palace.[7]

Berczy's cosmopolitan nature and cultivated manners, as well as his writings and what we know about his family, all suggest that he grew up in a cultured and intellectually stimulating environment. Berczy's grandfather and father had studied at the Protestant university in Jena, one of the leading German universities of the seventeenth and eighteenth centuries. The Protestant pastors, who figured so prominently among Berczy's ancestors, generally belonged to the most educated groups in the Holy Roman Empire and helped prepare the way for the politically and philosophically liberal theories of the Enlightenment. With such a background, it is therefore not surprising to find Berczy strongly influenced by this movement in his ideals, his goals, and his way of life.[8]

However, Berczy's contact with modern ideas was not confined to the political and philosophical: natural sciences were held in high regard and studied by members of his family. Berczy's uncle, Bernhard Paul von Moll, owned an important collection of maps and charts, which is now in the University Library of Brno, Czechoslovakia, and an extensive private library. Both his uncle and his father had large natural history collections, important enough to be examined by scientists who visited Vienna.[9] While later in life Berczy was to show no interest in his father's natural history collection, one must assume that the minute attention he paid to the physiognomy of his sitters and to the natural settings of his subjects, as well as his written observations on the landscapes through which he travelled, were influenced by an early exposure to his father's intellectual pursuits.

In the Catholic Vienna of Berczy's time there were no Protestant schools, and there is no indication that he and his brothers studied at the Protestant *Lyzeum*, a preparatory school in nearby Pressburg across the Hungarian border (now Bratislava in Czechoslovakia), where their cousin Hieronymus Albrecht Bernhard von Moll had studied.[10] It is most likely that Berczy received his education through private tutoring, following more or less the curriculum of the *Lyzeum* at Pressburg. While there was a strong emphasis on languages, other subjects included philosophy, religion, and sciences, as well as literature and music.[11] The father no doubt envisaged a diplomatic career for his sons. However, in 1762 Berczy, then aged seventeen, and his elder brother Bernhard Albrecht enrolled in art school, the *Kaiserliche Königliche Hof-Academie der Mahler-, Bildhauer- und Baukunst* (now the *Akademie der bildenden Künste*), in Vienna.[12] Berczy probably remained there for about a year, and this seems to have been his only formal training as an artist. It cannot be determined, however, whether his presence at the Hof-Academie was in serious pursuit of an artistic

career or simply to acquire the polish of a cultured gentleman.

During his adolescence, Berczy had led an orderly, uncomplicated, and normal life. But with the years 1763 to 1779, a period of youthful adventure ensued. While there is little source material for this time and much remains hypothetical, the few sources we have – largely Berczy's own writings – can be accepted as fairly reliable, since some details are verifiable. For his earliest adventure, however, we must depend on a rather muddled family oral tradition. It was probably in late 1763 or early 1764 that young Berczy was sent on a diplomatic mission to Poland. The unsettled state of affairs is said to have prevented his return to Austria and he went into hiding for three years, in various disguises including that of a woman in a Turkish harem! While making his way home across a range of mountains he was captured by Hungarian brigands, who held him for ransom. After some months a friendship with the leader developed and Berczy was released.[13]

Once home, Berczy settled into the student's life. In October 1766, Berczy and his brother Bernhard Albrecht enrolled at the University of Jena. There, since he was preparing for a career in the diplomatic service, Berczy would almost certainly have studied law.[14] We do not know how long he stayed at the university; apparently he remained a student for several years, occasionally returning home to Vienna and making short trips in the area. Despite his previous misadventure and the country's critical political situation, Poland did not lose its attraction for Berczy. In 1769 he planned a trip from Frankfurt an der Oder to Schwerin, but it is not known if he actually made it. In 1771, a year before the first partition of Poland, he was preparing to travel across Poland from Memel to Hungary.[15] Hostilities had already begun between the French and the Confederates of Bar on the one side, and the Prussians and Russians on the other. Brushing aside warnings of the dangers the trip would involve, Berczy left for

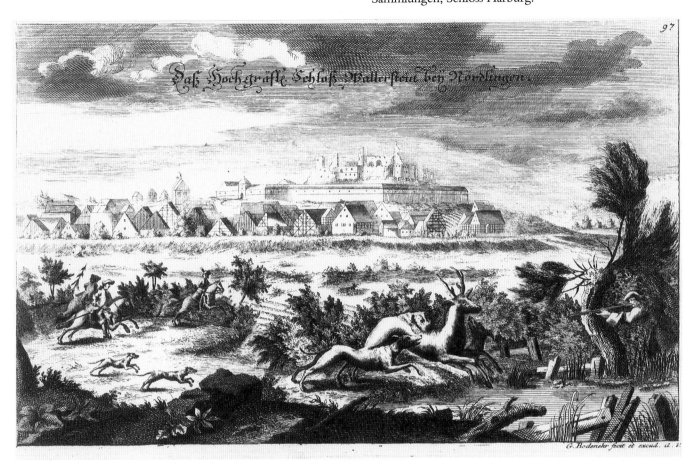

I.

The Castle of Wallerstein near Nördlingen, c. 1720, by G. Bodenehr.
Collection: Fürstlich Oettingen-Wallerstein'sche
Sammlungen, Schloss Harburg.

Poland, where he soon found himself in trouble. Confronted by a troop of French soldiers, he was at first able to pass himself off as a Frenchman; but the situation was very perilous and he decided to take refuge in the castle of an acquaintance, the Countess Walewska.[16] The countess brought him secretly to Poznan, where, because of the continuing war, he remained hidden for over a month in the attic of a German merchant.[17]

When Poznan was finally captured by the Russians, Berczy was presented to the Russian commander, a Baron de Virgin, who had taken quarters in the house where Berczy was hidden. It so happened that the baron had not only studied in Jena but was also a close friend of Berczy's father. Surprised and happy to see the son of his old friend, he temporar-

ily adopted Berczy. Thus, as Berczy recounts, he was given an officer's uniform and served for a time as a volunteer with the Russian army, but declined the offer of a commission.[18]

Presumably, Berczy was still in Poland when his father died on 14 June 1772 at the age of fifty-nine.[19] Since Albrecht Theodor Moll left behind little of value except his library and natural history collection, his death plunged his family into serious financial difficulties. Although he had represented a good number of Imperial cities and small territories as agent to the Imperial Aulic Council for many years, most of his employers were very slow in paying their fees, a situation not at all unusual in that era. In fact, most of them never paid at all for Moll's services.[20] At the time of his death, his wife was in

poor health and of his seven surviving children, four were still minors.[21] There were well-to-do Protestant relatives in Vienna, but they distanced themselves and gave no help to the Catholic widow and her children. As a result, the burden of responsibility for the family fell upon the two eldest sons, Bernhard Albrecht and William.

In August 1772, Russia, Prussia, and Austria signed treaties agreeing on the first partition of Poland, and it is likely that Berczy was able to make his way home only after that date. Upon his return to Vienna, he naturally accepted his responsibilities towards the family. While details of his efforts at supporting the family are unclear, it is apparent that from late 1772 to the beginning of 1779, Berczy spent most of his time in Hungary and Croatia, where his work involved colonization and trade.[22] It is also apparent that Berczy was attempting to make his fortune. For the first time, the pattern emerges of seeing his hopes and schemes come to naught. He wrote to his mother of his anguish in knowing that their prosperous relatives were willing to offer pity but no help:

> This fired me on to seek riches. I had the most promising hopes and the intention of sharing all my gains with you … [but] a series of unexpected complications in which I was involved brought my high hope to nothing. Last year, shortly after my return to Croatia, I saw all my hopes sink. You know my tempestuous nature; you can judge what I have felt, and you can imagine how I could summon the courage to tell you such bad news.[23]

William Berczy was eventually relieved of his obligations in October 1777, when the Empress Maria Theresa generously bestowed a yearly pension of 200 gulden on his mother and three sisters, in recognition of their great poverty and their loyalty to the Catholic Church. "On account of the difference in religion," the empress wrote, "they have been completely deserted by their neighbouring, prosperous Protestant relatives."[24]

Berczy now felt free. He turned his back on his series of disappointments and the problems of his family; in fact, he turned his back on his family forever. There was to be no more contact. He would in future no longer be known as Johann Albrecht Ulrich Moll. For a while he would cling to Albrecht or Albert, but for the most part he wanted to be known, according to his fancy and the predominant language, simply as Wilhelm, Guillaume, Guglielmo, or finally William Berczy.

How Albrecht Moll arrived at the surname Berczy is a matter of some speculation. It may have held romantic associations for him, as the name *Bérczy* in Hungarian is a poetic (somewhat aristocratic) way of saying "from the mountains" (*bérc* is literally "crag" or "peak"). Was the name chosen as a reminder of his adventures among the Hungarians? Or did it perhaps derive from his youthful nickname "Bertie," altered to "Berczy" by his Hungarian acquaintances? Why he took another name, according to Berczy, was in order to relinquish any further claim on his patrimony, and thus to safeguard it for his mother's use.[25]

SWITZERLAND AND ITALY, 1780–82

> I have embarked on a fresh Career, and my past life must be erased from my memory as much as can be; at most, I should retain so many memories to guide my steps in future, and to avoid the mistakes that were perilous pitfalls for me in the past.[26]

William Berczy had changed not only in name. In his youth he had been a handsome, charming, cultured, well-mannered man of the world, much given to the pleasures of good society; he was almost, in his own words, "frivolous, conceited, fortune's favourite."[27] But now, in his mid-thirties, he was resolved to devote his considerable energy to a career as a professional artist.

Up to this time, the only apparent training Berczy had as a painter was his months – a year at the most – at the Hof-Academie in Vienna, in which he enrolled in May of 1762. The curriculum in this era followed closely that of the *Académie Royale de Peinture et de Sculpture* in Paris. There were no restrictions or prerequisites for registration, and the students were divided into two groups: beginners and advanced.[28]

The instruction consisted largely of drawing: making copies of prints and drawings, drawing from the cast, and drawing from the nude (only male models were allowed).[29] Anatomy was taught, since it was considered absolutely necessary for the students to understand the musculature of the human body. Whoever studied architecture, and Berczy claimed to have done so, received a thorough grounding in geometry, perspective, and ornamen-

tation, as well as more theoretical considerations of an aesthetic nature.[30] Lectures were given on the theory of painting, in which the various aspects of painting were discussed, such as invention, proportion, colour, expression, composition, and design. The actual technical side of painting was not, however, taught at the Hof-Academie, but had to be learned privately in the studio of a painter. Where Berczy received this practical training is not known. Martin van Meytens (1695–1770), the famous portrait and miniature painter, was director of the Hof-Academie when Berczy studied there, but it is not known if Berczy actually studied in Meytens' studio. From the time he left the Hof-Academie until his arrival in Switzerland, there is little record of his activities as an artist, but it seems that he regularly sketched or painted for his own pleasure and with a view to social advancement.[31]

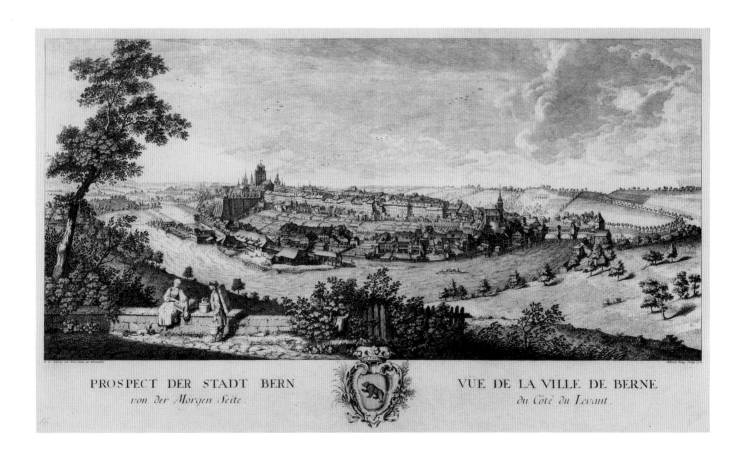

PROSPECT DER STADT BERN
von der Morgen Seite.

VUE DE LA VILLE DE BERNE
du Côté du Levant.

William Berczy arrived in Bern (see fig. 2), probably during the first half of the year 1780, for reasons unknown to us. His letters and his life bear witness to the fact that Berczy was an idealist born of the Age of Enlightenment; these sentiments may have prompted his move to the relatively egalitarian society of Bern. What he wanted was to lead a life in tranquility. To achieve this goal he was willing to renounce all worldly pretentions, stating, "I no longer desire to be anything in this world but a good and virtuous man."[32] But Berczy the idealist also had a realistic and pragmatic side and, undeniably, the prosperity of the Swiss city was as much an attraction as his desire to lead a good and virtuous life. It is also a matter of historical record that the arts, especially portrait painting, were flourishing in Bern on a scale previously unknown.[33]

It seems that Berczy soon made the acquaintance of Mlle Marguerite Gruner, who owned a millinery shop. Mlle Gruner came from an old Bernese family, a family actually not unlike Berczy's own. Like the Molls, the Gruners had produced a number of clergymen, and both families shared a lively interest in natural history. Another similarity was artistic: Mlle Gruner's father, Johann Emanuel, had been a painter.[34] This communality of background certainly helped lay the foundation for the developing friendship between the two, which later on included business ties as well. Berczy's amicable and detailed letters to Mlle Gruner are typical of the literary style of the period and constitute the major source of information on the artist's life in the years 1780 to 1787.

It appears that Berczy quickly established himself as a portrait painter, especially with some of the leading patrician families. With his elegant manners, self-assurance, and good breeding, he was easily able to establish contact among the upper classes, a talent that served him well throughout his lifetime. In the late summer of 1780, Berczy, who had already resolved to spend some time in Italy to improve his art, found himself on the estate of Gottlieb Fischer in Oberried near Belp. Fischer, known as a great art lover, belonged to one of the most important Bernese families.[35] Berczy seems to have been at Oberried not only for pleasure, but also for painting: he wrote to Mlle Gruner to send him a specially shaped sheet of crystal to glaze a miniature.[36] However, it is uncertain how many miniatures he painted there or of what subjects. The appreciation of a distinguished connoisseur – for Fischer remained one of the artist's good customers – indicates that Berczy had already achieved a certain success and ability in his newly-chosen profession.

In mid-October, much later than he had intended, Berczy started off for Italy, but again interrupted his journey to spend some time at the estate of another Bernese patrician, this time Samuel Rudolf Frisching von Rümlingen, in St. Blaise (on the Lake of Neuchâtel). Once again the visit was extended, as he was asked to paint a portrait of Frisching (LW 3).

Berczy finally arrived in Florence on 18 December 1780.[37] It is unclear what his reason was for choosing Florence rather than a centre such as Paris or Rome, both of which were much more prominent in new developments in the arts and in art dealing. There were, however, sufficient reasons to make his stay profitable. The city afforded the artist many potential patrons, extending well beyond the local aristocracy. This was the time of the Grand Tour, when the young gentlemen from the aristocratic and wealthy classes of Northern Europe and Great Britain in particular, finished their education by examining at first hand historic and contemporary Italian culture. These "Tourists" inevitably spent some time in Florence, the cradle of the Renaissance, en route to Rome and Naples. As well, a wealthy English colony resided in Florence, whose best-known members were George Nassau Clavering, 3rd Earl Cowper, and Sir Horace Mann, the

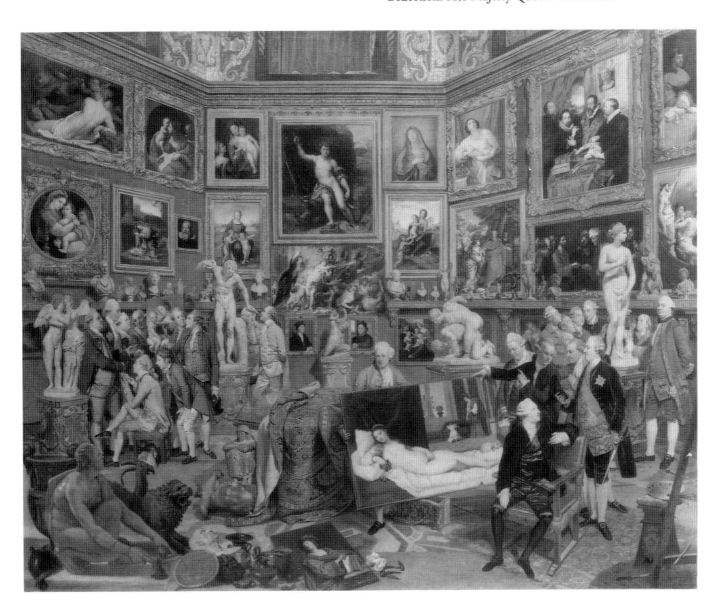

British Envoy Extraordinary from 1740 to 1786, both of whom attracted the society of their visiting compatriots.[38]

For the aspiring student of art, Florence's greatest attraction was its magnificent art collections. The most important, incorporating the enormous Medici heritage, belonged to Grand Duke Peter Leopold, son of Maria Theresa, and brother of Emperor Joseph II. In 1769, four years after he became Grand Duke of Tuscany, Peter Leopold began the full reorganization of all his collections. It was a mammoth undertaking in which vast numbers of objects, which had hitherto been jumbled together, were now logically grouped by subject. He then gave these collections, most of them housed in the Uffizi (officially called "La Real Galleria"), to the state. Permission was freely given to artists wishing to copy the paintings in the Uffizi (see fig. 3). One such visitor, John Flaxman, described the collection with enthusiasm:

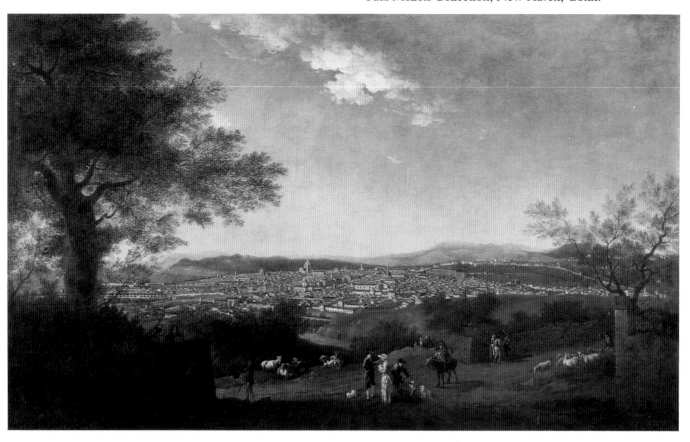

It would be ingrateful not [to] acknowledge the generous behaviour of the Prince towards the professors & Lovers of fine Arts, he has placed attendants in his Gallery who show all persons the wonders of the place with utmost politess & patience, & never receive anything from the Company, & to enable them to do this the Duke has lately increased their salaries & made them very handsome, every person who is inclined to draw in the gallery by only applying to the keeper not only obtains immediate permission but he may have paper, chalk & every convenience in the same manner as in the Academy, & from the same Royal Munificence, as an artist I am grateful for & remember this instance of his liberality.[39]

The Uffizi must indeed have been a very busy place, filled not only with travellers wishing to view the pictures but also with artists, some of whom stayed for years, copying the most famous pieces. A special part of the collection would have been of particular interest to the aspiring portrait painter William Berczy. This was the important collection of artists' self-portraits begun under the Medici and still being extended by Peter Leopold. When Berczy arrived in Florence in December 1780, over three hundred were on display and more were in storage. Although engravings of a good number of self-portraits were available, the demand for copies was so great that some artists created careers for themselves by making copies in various techniques and sizes.[40]

All the initiatives, political as well as cultural, of the grand duke were in accord with the contemporary ideal of the enlightened monarch, a view that Berczy shared. Berczy repeatedly wrote of his satisfaction with the grand duke and his entire family. Perhaps he was already beginning to form the hope of coming into contact with the court. The only immediate and concrete goal he expressed for

the future, however, was to make enough money to return in a few years to Switzerland, his "gem of liberty," and settle there for the rest of his life.[41] Thus he set to work with great energy to improve his abilities in "an art in which I have still wrought so little," as he frankly admitted.[42]

Berczy took quarters in Florence at the Piazza Santa Felice, just opposite the western corner of the grand-ducal residence, the Palazzo Pitti. He wasted no time, and only five days after his arrival he requested permission to copy Adriaen van der Werff's putti in miniature (see LW 4).[43] Three weeks later he was able to write Mlle Gruner that the first copy done at the gallery was ready. On 13 February 1781 he successfully sought permission to copy seventeen pictures, and proceeded to copy them all. Thirteen of these were self-portraits of artists and the other four included a sleeping woman by Frans van Mieris, *Hélène Fourment* by her husband Peter Paul Rubens, *Judith* by Cristofano Allori, and the *Magdalene* by Francesco Furini (see LW 5–19).[44] Berczy also applied for permission to copy drawings. According to the records, he was interested in Andrea del Sarto, Raphael, Pietro da Cortona, and Santi di Tito. He copied a good number of drawings of Stefano della Bella, but he seems to have been most interested in Jacques Callot, producing a total of thirty-three copies of that artist (see LW 20).[45]

Although Berczy assured Marguerite Gruner that he lived a lonely and retiring life devoted entirely to his work, as was certainly largely the case, he had by chance become acquainted with the court physician, Baron Matthäus von Störck. Finding each other's company most agreeable, they soon became fast friends. The Baroness von Störck (see LW 42) was also attached to the court, serving as a governess to the young archduchesses. It is almost certain that it was through the von Störcks that Berczy was introduced to the grand duke and duchess and received his most important commission (cat. 12). "The Grand Duchess wishes to send her father, the King of Spain, a picture showing the entire family," Berczy wrote to Mlle Gruner on 15 April 1781.

Around the beginning of February he had been asked for a preliminary study in gouache for the portrait. Satisfied with the design, the grand-ducal couple gave their approval and Berczy immediately began to work on the preliminary individual portraits. By the middle of May the heads of the four oldest archdukes were ready, and Berczy proclaimed them to be better than the best gouache he had done in Bern. Already his intense studies seem to have been paying off. In the middle of June the grand-ducal family moved to their summer residence, the Villa Poggio Imperiale, a few kilometres outside Florence. Walking there almost every day, Berczy continued the preparatory work for the family portrait until the beginning of August.

Berczy had decided to do the setting for the family portrait entirely by himself and not to farm this out to an artist specializing in settings, as was common practice. To do this, however, he had to return to the study of architecture, which he had but begun at the Hof-Academie in Vienna. He undertook an intensive study of the works of Palladio, Vitruvius, Vignola, and others, which eventually proved useful for his landscape painting as well.[46] In general, he seems to have been ceaselessly active, even to the point of threatening his health by overwork. For the sake of his health, therefore, he began to take a two-hour walk each day to provide fresh air and exercise. Even so, he used these walks to study the sculptures and the paintings in the many churches and monasteries throughout the city (see fig. 4). He sketched what interested him and supplemented the drawings with quick notes. Back at his lodgings, he would rework his observations in greater detail and add his own reflections. He enjoyed sketching and found that it, too, was good practice for landscape painting.[47]

Although Berczy spent considerable time on the picture of the grand-ducal family and painted addi-

tional individual portraits of the grand duke (cat. 11 and LW 35), his sons Francis (LW 36) and Joseph (LW 40), and his daughter Maria Therese (cat. 13 and LW 41), he by no means neglected other pursuits. He wanted, for example, to publish an engraving after his own painting of the grand-ducal family. While working on the painting he was simultaneously trying to make arrangements for prints to be engraved after it. He first approached the established London engraver Francesco Bartolozzi (c. 1725–1815);[48] shortly after, he thought of involving Anton Balthasar Dunker (1746–1807) in Bern. Never having seen one of Dunker's engravings, Berczy wished to have one sent so that he could judge its quality. Once satisfied with Dunker's ability, Berczy intended to have the grand-ducal family portrait engraved full-size and with the utmost precision. He also wanted to know approximately how much the preparation of a print of the young Archduke Francis, "en buste" but without hands, would cost. A third print after the portrait of the grand duchess was to be engraved – this time in Italy – as soon as it was ready.[49] Unfortunately, as no trace of these engravings has been found, it must be assumed that they were never published.

Just a few weeks after receiving the commission from the grand duke, Berczy expressed an interest, on 27 May, in the coloured prints of Swiss costumes being produced by the Bernese painter Johann Ludwig Aberli (1723–1786). Behind this unexpected interest was a plan for a series of similar prints of figures wearing costumes of the countryside around Florence. He intended to publish this series of prints in partnership with a local engraver (see LW 23). Orders had already come in from Rome, Naples, and Bologna, and the future of the enterprise seemed assured. Berczy wrote to Marguerite Gruner on 4 June 1781 that the first engraved plate would be ready in eight days and that he would send her a sample to stimulate sales in Bern. Again, none of these prints has been found, and the only trace of

this particular project can be found in the unfinished watercolours of costume studies (cat. 2, 3).

Berczy's last known Florentine print-publishing project was an attempt to make an engraving after a gouache self-portrait which he had planned to give to the *Accademia del Disegno,* after having been made a member of that society in September 1781 (see fig. 5). Later in that same year, he submitted the portrait to a local engraver. Finding his client displeased with the first attempt, the unhappy engraver managed to ruin the plate completely while trying to improve it. But Berczy did not give up: by the early summer of 1782, an unfinished proof impression of his engraved self-portrait was sent to Mlle Gruner. In the letter that accompanied it, he mentions that other proofs had been pulled, but it is unclear whether he is referring to the same plate or to new versions. Unfortunately, the fate of this project, like all the other Florentine printmaking ventures, remains a mystery.

On 15 April 1781, Berczy noted the approval for the commission of the grand-ducal family portrait and his start in learning to paint in oils. Typically, once he had decided to paint in oils, he threw himself into the new métier. After a month he was able to announce the completion of two heads from life, and boasted that they were so good that his fellow painters would not believe that he was a novice in the medium. He intended to keep as a memento the first of the two heads he had done in oil, and to give the other, a self-portrait, to the Accademia, which had asked for it (see cat. 27 and LW 28, 29, 32). As Berczy's interest in oil painting grew, he realized that it would improve his technique in miniature painting. He became so convinced that this was the right path to achieve his goal that he temporarily gave up all exercises except two: oil painting and the sketching of over-sized heads. Larger-than-life drawings were considered a valuable exercise in perfecting an artist's technique, and Berczy shared this opinion. As he explained to Mlle Gruner, "Nothing

joiced in the great improvement in his painting and wished to move into genres other than miniature and portrait painting. To this was added financial ambition – an independent artist with no fixed position or regular salary had, of course, to take advantage of opportunities as they presented themselves.

Such an opportunity arose when Grand Duke Paul, heir to the Russian throne, came to Florence with his wife and his sister-in-law, the young Princess Elisabeth von Württemberg-Mömpelgard. The visit had been arranged so that the princess might meet her future husband, Grand Duke Peter Leopold's eldest son, the Archduke Francis, heir to his uncle Emperor Joseph II. "You will agree with me," Berczy wrote to Mlle Gruner, "that it would be altogether unpardonable if I wished to leave in such Circumstances."[53] He therefore delayed his return to Bern. On 11 March 1782 Berczy wrote that, in addition to the family portrait, he had finished individual portraits of the grand duke, his sons Francis and Joseph, and his daughter Maria Therese. Two weeks later, on 25 March, he wrote again excusing his tardiness. He had been asked to paint two additional portraits of Archduke Francis (LW 37 and LW 38) for the visiting princesses, and, as the royal guests would leave on 9 April, he had to work under great pressure to complete the commission before their departure.

Although Berczy was already receiving daily visitors in March 1782 to admire his grand-ducal family portrait, there were still minor corrections to be made and further unexpected delays. Not until August 1782 was his "grand ouvrage" finally completed and William Berczy able to leave Florence.[54] He left well satisfied with his stay. He had learned much, accomplished much, and achieved a measure of success. He felt himself now fully competent as a painter and recognized as such. Certainly the next few years would increase his facility, but he had found the style which was to remain fairly constant during his remaining years in continental Europe.

THE ARTIST'S STYLISTIC DEVELOPMENT

Since so little is known about Berczy's early artistic development, some attempt must be made to find the roots of his art, the influences to which he was exposed, and the traces of these influences in his work. On the whole, the cultural variety of the Holy Roman Empire and the vast Hapsburg lands to the east was also reflected in the arts. There was also, not to be forgotten, a considerable difference between the Catholic and Protestant parts of the Empire. As Berczy moved through its far-flung territories he was exposed to many and varied influences.

Another difficulty is that most of Berczy's European work is lost or not identified. Since he was never well known and only rarely signed his paintings, his name has disappeared from the annals of art history. The best chance for the survival of unidentified portraits lies in their retention in family collections.

When one considers the works of Berczy's European period, it is clear that he is a typical example of an artist of this time of transition: on the one hand, still attached, to a certain extent, to the traditions of the Rococo; on the other, attracted to the developing style of Neo-Classicism – with its ideals of clarity and simplicity.[55] He also was oriented towards the emerging values of self-reliance and the primacy of the individual. These values are reflected in his portraits, where he limits the use of stylization and idealization.

His earliest influence was clearly the Vienna in which he grew up, the Vienna of Maria Theresa, a city still dominated by the powerful Baroque tradition. Vienna was far more than its paintings, its sculptures, and the handsome façades of its buildings. It was unique among the capitals of Europe as the centre of the Holy Roman Empire and the Hapsburg lands, reflecting its mosaic of races and

6.
The Family of the Empress Maria Theresa, c. 1754–55,
by Martin van Meytens.
Collection: Kunsthistorisches Museum, Vienna.

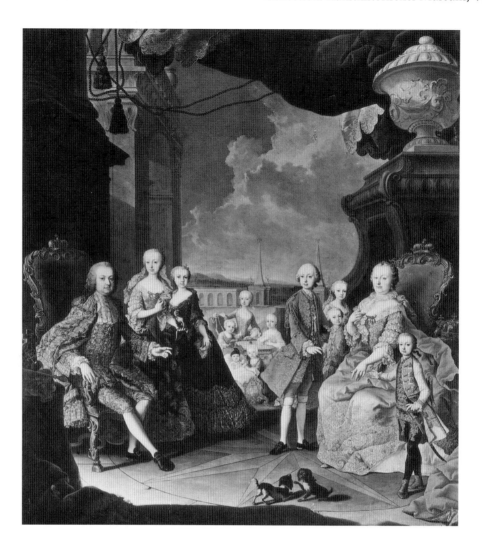

languages – a city of great cultural diversity and richness.

The empress, like most of her ancestors, showed considerable interest in the arts. She was especially drawn to portrait painting, and her collection ranged from miniatures to huge group portraits, usually of the Imperial family in all its many branches (fig. 6). The style favoured in these paintings was realistic in its precision of detail, and was largely intended for close examination, in contrast to a freer and more impulsive rendering that is intended to achieve great effect when viewed from a distance.

Thus, it is not surprising that Martin van Meytens (1695–1770) and Jean-Étienne Liotard (1702–1789) were highly regarded by the Imperial Court.[56] Both painted in an exemplary manner according to the prevailing aesthetic criteria. Both were first trained as miniature and enamel painters, and this background shows itself very clearly in the importance they gave to precision and fine detail. There were traces, too, in their work of the seventeenth-century Dutch and Flemish tradition, which enjoyed continuing popularity. But the similarities ended there. Meytens favoured the representative dramatic French portrait style, while Liotard rejected theatrical elements almost completely and attempted to stress the individuality of the sitter without losing the sense of grace and charm (see fig. 7).

Since Meytens was director of the Hof-Academie when Berczy studied there in 1762, the younger painter would certainly be well acquainted with his theory and practice. But Meytens' influence was not exclusive, and Berczy undoubtedly knew other painters in Vienna who rejected the pathos of the Baroque and the lightness of the Rococo styles, painters such as Georg Weikert (1745–1799) and Joseph Hickel (1736–1807) – the latter had studied at the Hof-Academie in 1756.

Finally, we must remember that Berczy's family background would have exposed him to many modern ideas and trends. The new-found interest in and excitement about the antique world prompted the publication of many books on the subject.[57] Some of these must surely have found their way into the libraries of the circles in which Berczy moved, where they would have been carefully studied and discussed. Certainly, similar interests and ideas were current at the University of Jena where he studied, and definitely in the nearby city of Leipzig where, in 1764, two years before Berczy came to Saxony, an art academy was founded. Its director, Adam Friedrich Oeser (1717–1799), had considerable in-

fluence on the spread of neo-classical theory, especially through his exchange of ideas with Johann Joachim Winckelmann.

How much Berczy was attracted to the new ideas is shown by his great admiration for Anton Raphael Mengs (1728–1779). Mengs was seen as a pioneer of the Neo-Classical style and was highly esteemed by his contemporaries. Berczy was equally enthusiastic, "I consider him the foremost painter of our Century."[58] Furthermore, he thought Mengs was a "scholar and man of letters" of the highest order and, as is clear from the number and diversity of themes to be found in his subsequent writings, this was exactly what Berczy himself wished to be. It was indicative of the extent of Berczy's esteem that he copied Mengs' portrait in Florence (LW 12) and kept it for himself. He thought this was one of the greatest works Mengs had painted and wished never to part with it.

Berczy would certainly also have come into contact with his compatriot Johann Zoffany's work in Florence. The latter was sent there in 1772 by Queen Charlotte, consort of George III, to paint his famous picture of *The Tribuna of the Uffizi* (fig. 3). He was also commissioned by Joseph II to portray the grand-ducal family for his mother, Empress Maria Theresa. Berczy would not have seen this huge family picture, which Zoffany had personally brought to Vienna in 1776; he would, however, undoubtedly have seen either Zoffany's self-portrait, given to the renowned grand-ducal collection of artists' self-portraits in 1778, his portraits of other members of the ruling family, or portraits he painted for the English colony living in Florence. Although his years in England had given Zoffany the ease and informality of English portrait painting, his style did not deny his German background and showed, therefore, many of the qualities the Hapsburgs appreciated: close attention to detail, exact rendering of material, and brilliant handling of surface.

There is practically nothing in Berczy's surviving writings that would give us his own artistic views and principles in detail.[59] We find, however, much written evidence that his main objective in portrait painting was to make the portrait true to life. He also tried to show sharpness and boldness ("hardiesse" and "franchise" in Berczy's words). One can, indeed, find these characteristics of Berczy's style in his very best portraits. The sitters display great confidence, awareness, and self-assurance. Their personalities engage the viewer. (The one signed self-portrait miniature of 1783 (cat. 27) done in Florence and the later full-length portrait of Joseph Brant (cat. 77) from his Canadian period show these qualities most strikingly.) On the whole, his surviving European works exemplify the characteristics of the transitional period from the Rococo to the Neo-Classical.

Most of the small-scale, single portraits he painted in Europe, and especially the miniatures, show the sitter before a plain, almost monochrome, and rather dark background in three-quarter view – a standard convention at the time. Nowhere in his work does one find drama in gesture or in the use of light, lively brushwork; form is not diffused nor contour blurred. On the other hand, one cannot say that in Berczy's European period contour and line dominate to the same degree as with painters of the purest neo-classical manner. Rarely exploiting the luminosity of the ivory or vellum support, he built up layers of paint, creating a smooth, rather compact and opaque appearance. The paint is applied with great delicacy and variation in the use of colour, especially in the flesh tones. In his self-portrait the flesh tones range through many shades of red to wonderfully luminous colours: shadings of green, turquoise, and light blue. The sketchy, suggestive, fluid brushwork of a Gainsborough, a Cosway, or a Füger – all roughly contemporary with our artist – is entirely foreign to Berczy.

His group compositions are also very quiet, mostly without action. Individuals are placed next to each other rather than built into a cohesive group. A unifying chiaroscuro for people and objects is lacking. Berczy, like many artists, made individual studies of his subjects and settings, fitting them together later like a puzzle. Yet a certain lack of cohesiveness in his compositions, the felt effort in the arrangement of his figures, as well as a slight awkwardness in the handling of anatomy, are not just due to the painter's artistic conviction, but definitely show a lack of proper training. In the picture, the figures and other compositional elements are arranged in fixed receding lines, parallel to the picture's lower edge. He does not offer that often-used neo-classical device, the closed-off, box-like space. Instead, although it cannot be compared with the urgent Baroque striving for depth, he almost always, in his more complex compositions, provides a view into the distance. His figures also lack the strong anatomical definition favoured by many classical painters. They do not stand firmly on the ground but seem to be dancing the steps of a minuet, their feet hardly touching the floor. And although the gestures and movements of the sitters are free from Baroque theatricality and seem to be comparatively at ease, they still convey the grace that one associates with the Ancien Régime.

Berczy knew Latin well and was acquainted with classical literature, but except for one obscure allegorical sketch (cat. 16), there is no evidence of works that would indicate an interest in the iconography of Neo-Classicism with its emphasis on Greco-Roman mythology and history. Nor can we find – apart from his admiration for Mengs – any indication in his œuvre that Berczy took a particularly active interest in the aesthetic theories of Neo-Classicism. But he adopted elements of this style, so that his work shows increasingly classical overtones – a development that can be observed in the work of many of Berczy's German contemporaries. He also made copies of a number of masters and of various schools, and certainly accepted the widespread appreciation of the styles of various epochs that was

8.
Charlotte Allamand Berczy, c. 1782–83,
by William Berczy (cat. 18).
Collection: Art Gallery of Ontario, Toronto.
Gift of John Andre, 1982.

then current, but he did not aspire, as other artists did, to imitate those he copied. Berczy cannot be called an eclectic. To copy the masters was for him no more than to learn from them and to please his patrons.

The artist's tendency to exact reproduction was likely kindled by his family's interest in natural history. Such objects as petrified plants or shells when described or drawn, of necessity had to be observed as precisely as possible. Both his brother, Bernhard Albrecht, and his cousin, Carl von Moll, painted natural history subjects with the utmost exactitude and accuracy.[60] Berczy shows a similar penchant for precision and objectivity, not only in his paintings but also in his writings, as seen in his detailed observations on Canada, which he intended for publication in his "Statistical Account" (see Appendix E).

At the Hof-Academie in Vienna, Berczy's tendency to emphasize detail, i.e., to paint in a manner which is intended to be looked at closely, would have been reinforced by the style of its director, Martin van Meytens. All these influences were further strengthened by the various copies he made in Florence of the Dutch and Flemish painters (see LW 4–7, 16, 17, 45). The process of copying the old masters enriched and extended his palette, and sharpened his eye and appreciation for the exact rendering of the objects he was painting.

Even if Berczy felt himself called to a higher artistic genre, as he wrote on 19 January 1782, and even if when irritated by a dissatisfied client he threatened to give up portrait painting altogether, his surviving works show that his real strength lay in portraiture. However, he rejected the fashionable tricks and flattering stylization characteristic of many painters of the period. Berczy strove in his portraits to catch the sitter's individuality. But, like Liotard, he never forgot that to portray all with charm was the painter's first commandment (see fig. 7).

SWITZERLAND AND ITALY, 1783–90

In August 1782, Berczy travelled north by way of Milan and Lago Maggiore, crossed the St. Gotthard Pass on horseback, and arrived in Bern to a friendly reception. Success and good fortune seemed to have followed him from Florence: commissions came in good numbers.[61] Among the commissions were several portraits for Bernard Louis de Muralt (of his wife and three children), and for other family members (cat. 20–26).

Berczy's success was not limited to his career as a painter but extended to his private life. During his first stay in Bern, he had met Charlotte Allamand (see fig. 8 and cat. 17) who lived with Mlle Mar-

guerite Gruner and was treated almost as her daughter. From the very beginning Berczy was attracted by the charm of the then twenty-year-old woman and soon fell in love with her. The difficulty was that Charlotte was practically engaged to her benefactress' nephew, Beat Samuel Gruner, who was, in Berczy's opinion, a boorish good-for-nothing and quite contemptible. Under these circumstances, Berczy felt he could not abuse Mlle Gruner's hospitality by declaring himself and pressing his suit. He left for Florence resolved to remain silent, regarding his cause as hopeless.

Mlle Gruner, however, suspecting that Berczy's feelings toward Charlotte went further than friendship, wrote asking him to express his true feelings. Berczy replied with the honest admission that he loved Charlotte.[62] By the time he returned to Bern in mid-September 1782, she was free, having broken off with Beat Samuel Gruner. Berczy then proposed marriage and was accepted.

Berczy was not yet ready to settle permanently in Bern. He wanted to continue his training. More importantly, he wanted to make his name known and establish business connections, which he could later direct from Switzerland. Therefore, after hardly nine months, he returned to Italy. Having made side-trips to Milan and Parma, he was back in Florence by the beginning of July 1783.

Marguerite Gruner found it difficult to accept Charlotte's engagement to Berczy. It is hard to say whether she herself had had hopes of marrying him. She fell into a deep depression and wrote increasingly neurotic letters over her fears of being neglected and losing his friendship. This put Berczy in a difficult position, and in his letters he made more and more attempts to soothe and reassure the poor woman, finally going so far as to suggest that he and Charlotte could continue to live with Mlle Gruner after their marriage.

Berczy's engagement creates problems for his biographer. Many of the reports on his painting and other artistic activities, formerly sent to Mlle Gruner, were now, during his second stay in Italy from July 1783 to May 1785, directed to his fiancée. Unfortunately, whereas the letters to Mlle Gruner have been in large part preserved, those to Charlotte for this important period have disappeared.

During Berczy's nine-month sojourn in Bern, he had begun to give Charlotte drawing lessons, which continued through correspondence while he was in Italy. As models for her to copy, Berczy sent his own sketches and probably engravings by other artists. She also received lessons from Berczy's friend and fellow artist Friedrich Rehfeld (c. 1749–1825). Even though Charlotte applied herself to Berczy's instructions, she was unsure of her own abilities. Nevertheless, Berczy was delighted by her progress in sketching. "She is making giant strides," he insisted, and predicted that she would also begin to paint and in a few years would reach a "distinguished perfection."[63] The energy and enthusiasm that Charlotte brought to her lessons made her even more adorable in Berczy's eyes.

Once back in Florence at the beginning of July, and with the added incentive of soon being able to marry Charlotte, Berczy resumed work with his usual energy. As early as August he managed to finish five of the portraits he had begun in Bern and send them off to Mlle Gruner; further paintings followed. He also resumed his efforts in oil painting; mastery of this technique, he declared, would be the best guarantee for living the life that he envisaged.[64]

Another stimulus for his work was the *genius loci* of Florence. Only about six weeks after his return he felt that he had once again made considerable progress. This was due, according to Berczy's own analysis, to three factors: above all, the great number of master works with which he was surrounded; the fact that he was less occupied and pressed with commissions and had, therefore, more time to study; and lastly, contact with other good artists and the ensuing lively exchange of ideas.[65]

9.
Maria Carolina, Queen of Naples, with Her Children, n.d.,
by an unknown artist.
Collection: Kunsthistorisches Museum, Vienna.

Berczy had clients and acquaintances in Naples and for a long time had hoped to visit that city. Feeling that this might be his last opportunity to travel south, given his plans and projects for the future, he resolved to make the Naples trip as soon as possible. He announced his intention on 13 July 1783 to visit Naples but, typically, was delayed and did not leave Florence until late February 1784. He stopped in Rome for several weeks and finally arrived in Naples on 20 March.[66]

Foreign travellers in Italy were drawn to Naples and wished to view the many antique remains and natural attractions of the surrounding countryside.

At first Berczy also spent his days sightseeing; he visited Herculaneum, Portici, Pozzuoli, Pompeii, and Mount Vesuvius. In the evenings he was busy cultivating social contacts and widening his circle of acquaintances, to learn, as he said, "the genius of the nation."[67]

Naples pleased Berczy greatly; he was happy there and felt that he was held in higher esteem than in Florence. Since he did not intend to remain in Naples for long, at the outset he showed no interest in establishing contact with the royal court. However, his usual desire to show off his ability and to capitalize on opportunities was too strong to resist,

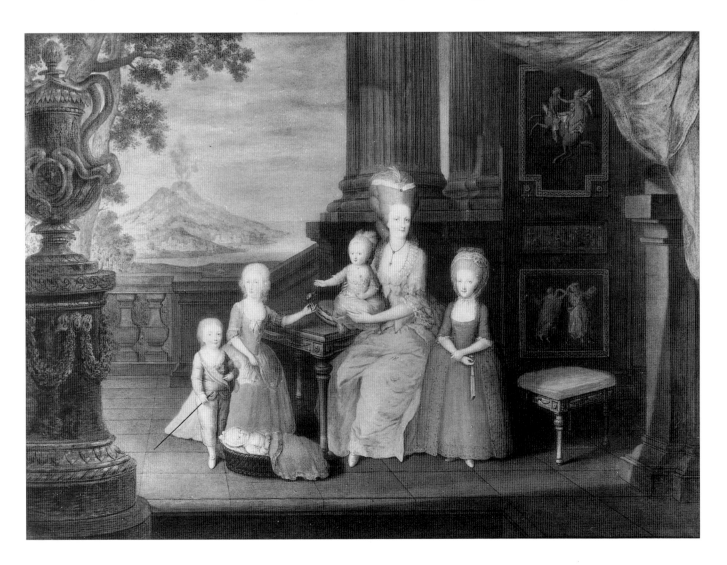

and the situation was indeed favourable. The Bourbon king, Ferdinand IV, was the brother of the Grand Duchess of Tuscany, and his Hapsburg wife, Queen Maria Carolina (fig. 9), was yet another child of the Empress Maria Theresa and therefore the sister of Peter Leopold. The queen, understandably, was well disposed to visitors from her native land, and Berczy, as we have seen, was adept at gaining access to the best society. He had, as he admitted, "experience of high society" and "flexibility of character."[68]

By mid-June 1784 the contacts were made, and three weeks later Berczy was able to announce the completion of his first portrait. He had been successful "more than I could desire for the sake of my honour and to satisfy the Queen," and the work was praised by both the king and the queen.[69] This portrait was of their eldest daughter, the Infanta Maria Theresa (LW 49). It was followed by a portrait of their second daughter, Maria Louisa (LW 50). A second portrait of the Infanta Maria Theresa came soon after (LW 51). Berczy was also commissioned to paint the queen, whose difficult pregnancy occasioned many delays in the sittings. The artist had to accompany the court to the palace at Caserta, where he was obliged to remain until the end of 1784 in order to finish his work; this was much longer than he had planned.

William Berczy found life at court hard to bear, a veritable whirlwind of activity and intrigue, which could ruin one's character. Even though he longed for a quiet, simple life, he could not avoid letting it be known in his letters to Bern that his position in the Neapolitan Court was a most enviable one. Finally, in December 1784, Berczy received his great reward. He was invited to show his newly completed portrait to the assembled court, in the presence of the king and queen: "I had great satisfaction this morning, having presented the monarchs and the entire Court with a portrait."[70] Although it is unclear who was portrayed, the presentation of

the picture before the assembled court suggests a member of the royal family, and it was probably the long-postponed portrait of the queen (LW 52). The praise bestowed on his work was most gratifying to the artist, and he noted to Mlle Gruner on 14 December 1784 that even his enemies had to admit its merits.

Now, at last, Berczy could return to marry his beloved Charlotte. With a passport issued on 24 March 1785, he left Naples and arrived in Switzerland by early summer.[71] To his great dismay, he learned that because he had travelled so extensively and could not easily furnish proof that he was a bachelor, he needed special dispensation for his marriage. This dispensation was given on 24 October, and on 1 November 1785, at Chavanne-le-Veyron north-west of Lausanne, near the home of Charlotte's relatives, "Albert Guillaume Berczy, peintre en miniature," married Charlotte Allamand.[72]

Berczy had long planned travelling to the various courts of Europe, to take advantage of the connections he had made in Naples and Florence. For reasons that are not entirely clear, he postponed these plans indefinitely and settled with his wife in Geneva. He had been working there in September, on a portrait commission he had managed to obtain from the visiting Prince William Henry, Duke of Gloucester and brother of George III. The portrait was of the duke's twelve-year-old daughter Princess Sophia Mathilda (LW 53). The favourable reception of the work garnered him further commissions in Geneva, and this may well have encouraged him to stay on. Inexplicably, the Berczys left the city abruptly after a stay of only four months, returning to Bern in March 1786. Why he abandoned such a promising situation so soon is not clear, but it was to prove a mistake.

In Bern he received very few commissions and earned so little money that he and Charlotte had to give up their modest quarters in the centre of town and seek cheaper lodgings on the outskirts.[73] Some

of their previous friends began to distance themselves, and Berczy became very depressed and uncharacteristically withdrawn. Charlotte had to help him in preparing his paints, a task he had mostly left to others in more prosperous days. It is hard to say why Berczy's fortunes turned so quickly. Charlotte wrote that some new painters had come to Bern and there was more competition for the work available: "The Presence in this City of a number of Painters who, though inferior to Mr Berczy, do not let him do much of anything."[74] The painters referred to may have been Anton Graff (1736–1813) and Anton Hickel (1736–1807), both very able portraitists, who were briefly in Bern during the second half of 1786, and who undertook a few commissions. Other newcomers cannot be identified. Charlotte asserts that they were all inferior to her husband, but loyalty may have coloured her judgment. A disastrous fire in 1784, which destroyed Mlle Gruner's house, added to Berczy's problems. He had left all his possessions there, including his savings, pictures, painting equipment and supplies. Everything that he had saved and collected with so much effort over a period of four years was destroyed, and he had no reserves to fall back on.[75] In these unhappy circumstances, there was little alternative but to leave Bern and seek work elsewhere. On 16 October 1786, Charlotte wrote to Mlle Gruner that they had not yet decided where to go, but the beginning of 1787 saw them on their way to Florence, where they would spend the rest of the decade.

In Florence, Berczy's depression lifted and he was once again at work with his former energy. More progress was made in mastering painting in oil. Nevertheless, we know nothing of his painting activities or any commission he may have received as an artist. On this, his third stay in the Tuscan capital, there seems to have been a greater emphasis on selling art than during his previous sojourns. Florence was then a leading source of supply for art dealers, who were able to buy both original paintings and

copies at reasonable prices and sell them at a handsome profit in Paris and London. From 1769 to the end of the century, several hundred sculptures and more than three thousand original paintings were exported from Florence. Copies of the old masters, which were extraordinarily popular, would certainly have accounted for several thousand more paintings.[76] The *Dutch Courtesan* by Frans van Mieris, which Berczy had copied for Monsieur de Muralt (LW 16), was a much-loved painting. Over a twenty-year period, thirty-four requests to copy it had been granted.[77] Dutch and Flemish masters were generally much in demand, and one can safely assume that Berczy found the copying of paintings useful, not only in perfecting his own skills but also as a much-needed source of income.

The records show that in this last period in Florence, Berczy applied only once to make a copy in the Uffizi, but a number of times for permission to export paintings.[78] He seems, in fact, to have been so busy with his work as an art dealer that he had no time to copy the one painting for which he had asked and obtained permission: the *Venere che pettina amore* ("Venus Combing the Hair of Cupid") by Giovanni da San Giovanni.[79] But he put his knowledge of Bernese art collections to good advantage by helping the director, Giuseppe Bencivenni Pelli, to acquire Joachim Sandrart's important self-portrait for the Uffizi.[80]

In May 1788, Berczy and Charlotte had a most memorable encounter. They were honoured to make the acquaintance of and receive at their home the great German writer and philosopher, Johann Wolfgang von Goethe (fig. 10). Goethe, returning to Germany from a sojourn in Rome, stopped for a few days in Florence. Berczy assisted Goethe by hiring a coachman and forwarding a few things on to Germany.[81]

In Geneva, Berczy had made good contacts with Englishmen – as the commission for the young English princess showed – some of whom suggested

LONDON, 1790–91

Berczy arrived in London early in 1790; the fragmentary documentation that survives only allows us to speculate on his activities there. Presumably, he was busy establishing his business as an artist and dealer while ingratiating himself into London society, where he hoped to find customers. He recorded his address as 28 Pall Mall, the fashionable street that boasted the residence of Gainsborough and Cosway, and where the print publisher and art dealer Colnaghi was located.[84] Nothing of Berczy's business as an art dealer has been documented.

In order to establish themselves as artists, both William and Charlotte Berczy submitted works to the annual exhibition of the Royal Academy. The exhibition, which opened on 28 April 1790, included a portrait of an unidentified artist by William (LW 54) and two interiors of a Tuscan country kitchen by Charlotte.[85]

How prolific Berczy was as a painter in London is not known. To the few works attributed to the London period (cat. 34, 35, 38, 39), we may now add the recently discovered pair of pendant watercolour portraits of the Italian composer Vincenzo Federici and his wife (cat. 36, 37). It cannot, however, be determined with certainty whether the pair belongs to Berczy's first (1790–91) or second (1799–1801) stay in the English capital. The scarcity of works we actually have for the extended period from about 1784 to 1803 makes the Federicis key works in Berczy's œuvre, quite apart from the quality of these two portraits.

The Federici portraits are attractive examples of the convincing and lively way in which Berczy could capture his sitter's personality. In particular Signor Federici's portrait, done with thinner layering of pigments and in vivid colours, almost succeeds in conveying the impression of spontaneity. The Signora's portrait, on the other hand, is carefully built up in multi-layered applications of colours

that he should go to London. London, they said, was the portrait capital of the world, and a promising place to work, both for artists and art dealers.[82] Berczy did not follow this advice right away, but before long he began to make concrete plans.

The British aristocrats on the Grand Tour, as well as those in Britain, were major customers of the Florentine art dealers. As the demand for works of art was growing steadily, it made good business sense to some Florentine entrepreneurs to set up their own agent in London. The chief financial backers of this undertaking seem to have been Antonio D'Angliana and the family of art dealers headed by Vincenzo Gotti.[83] It is not difficult to understand why they singled out William Berczy to represent them: he spoke many languages, moved easily among the upper classes, was quick to make and use contacts, and most importantly, he was hardworking.

and brought to a high degree of finish – a method one associates with the artist's earlier portraits.

The only other known work produced for certain by Berczy during his stay in London was an engraving of King George III (cat. 38), published on 1 November 1791 by Moltens Colnaghi. The print was after Berczy's head-and-shoulders copy of Gainsborough's full-length portrait at Windsor Castle. A variant of this engraving (cat. 39) was published a short time later that same year or possibly during his second stay in London.

In Berczy's personal life a major event occurred on 6 January 1791: William and Charlotte's first son, William Bent, was born. Long before Berczy married, he had dreamt of having children, and his letters reveal his sentiments: "There is no happier state than that of a paterfamilias."[86] In his idealism, he espoused the view that in addition to the responsibility of educating one's own children, caring for other human beings and teaching them by example to become good citizens was a happy task.[87]

Amidst all the London activities, however, Berczy's career as an artist and dealer came to a sudden halt. In July 1791 he began a new venture, one that would change his life forever. The project was land colonizing, which for Berczy meant realizing his long-held ideal of helping his fellow man to a better life, fulfilling his ambition to be an organizer on a grand scale, and achieving his goal of financial success. The land colonizing scheme originated with the Genesee Association, headed by Sir William Pulteney and Patrick Colquhoun. Berczy's task was to recruit German settlers and bring them to a tract of approximately one million acres of wilderness along the Genesee River in western New York State. Berczy was so convinced of the validity and profitability of the venture that he invested not only his own money but also, without their knowledge, a considerable amount of the funds of his Italian business partners! This action was to later prove a disaster for the artist-turned-entrepreneur and for the Italians. Nevertheless, these troubles were in the unforeseeable future when William Berczy departed for Hamburg in the autumn of 1791 to find potential German settlers. Nor could he have predicted that he had embarked on an adventure that would eventually lead him to a new homeland in Canada.

NOTES

The collection of Berczy letters in the *Kunsthistorisches Institut in Florenz* (T 719 ai, Rariora) was donated by Professor Werner Hager in 1977. (For the provenance of the manuscripts, see RACAR, x:2, 1983, p. 124.) It consists of 712 densely written pages bound together. Pages 1 to 158 present a mixture of letters to Marguerite Gruner from Charlotte Allamand and William Berczy, for the years 1785 to 1787. Letters that Berczy wrote during his stay in Italy (1780 to 1785) begin on page 159. Miscellaneous letters and extracts, not bound with this volume, include the letter that Charlotte wrote to Marguerite Gruner from Montreal in 1815, and two letters to Mlle Gruner from William Bent Berczy (in 1817 and 1820). In these notes, letters cited are always from William Berczy to Marguerite Gruner, unless indicated otherwise. The excerpts from Berczy's letters have been translated from the original French. The notes have been abridged. See p. 16 for abbreviations.

1. Catholic Parish of St. Alban, Wallerstein, Register of Baptisms for 10 Dec. 1744. In most of the documents that have come down to us, Berczy declared that he came from Saxony. The County of Oettingen-Wallerstein, which became a principality in 1774, was never a part of Saxony. Berczy's father, who was dismissed from the service of Oettingen-Wallerstein in 1755, then worked as imperial agent ("Reichshofratsagent") for Sachsen-Coburg-Saalfeld [Staatsarchiv Coburg, LA B no. 1908], and could have become a subject of the Wettin family. This is the most convincing hypothesis for Berczy's repeated declarations that he was a Saxon (suggested by Dr Rainer Hambrecht, Staatsarchiv Coburg).

2. FÖWAH, SLB 891. fol. 65r.

3. Catholic Parish of St. Alban, Wallerstein, Register for 8 Jan. 1742.

4. FÖWAH, Dienerakten (service contracts) Albrecht Theodor Moll.

5. *Repertorium...*, vol. II, pp. 99, 234, 236, 237; vol. III, pp. 106, 107, 208, 225, 247, 254, 347, 401, 447, 462, 474.

6. FÖWAH, Ältere Kabinetts-Registratur (older cabinet register), II.A.10.2. no. 540: letter from Count Philipp Carl to the legation councillor ("Legationsrat") Bernhard Paul von Moll, dated 9 Sept. 1755.

7. *Kaiserlicher und Königlicher Staats- und Standes Calender, Wien in Österreich,* 1756, 1758, 1763, 1765, 1769. One of the houses the Moll family lived in was the house of Count Cavriani at 8 Bräunerstrasse (now 5 Habsburgergasse). The house, considered one of the best in Vienna at the time, is very large and impressive with a richly decorated portal bearing a statue of the Virgin. [Paul Harrer, typescript, *Wien, seine Häuser, Menschen und Kultur* (Wiener Stadt- und Landesarchiv, Vienna: 1952), vol. 6, part II, p. 329.]

8. In Vienna, Empress Maria Theresa was able to censor the spread of the Enlightenment among the general public. However, she was not able to prevent some privileged groups from obtaining prohibited writings. [Hans Wagner, "Die Zensur in der Habsburger Monarchie (1750–1810)," in exh. cat. *Joseph Haydn in seiner Zeit,* ed., Gerda Mraz (Eisenstadt: Office of Cultural Affairs for Burgenland, Austria, 1982), p. 211.] Therefore, Berczy was able to read the works of the leading philosophers and political thinkers of his day, among them Abbé Raynal. Berczy mentioned Abbé Raynal's works in his "Letters from Poland," and the influence of Raynal may also be seen in Berczy's observations and manner of writing in his notebooks. [SAUM, S/19, boîte 11442: "Lettres sur la Pologne," sixth letter, p. 131; and boîte 11446: "Notes and Diaries," p. 422.]

9. Re: Bernard Paul von Moll's map collection, see *Mapová sbírka B.P. Molla v Universitní knihovně v Brně* (The Moll Collection in the University Library, Brno, Czechoslovakia), comps., Karel Kuchař and Anna Dvořáčková (Prague: State Pedagogical Publishers, 1959). Re: B.P. von Moll's natural history collection and library, see Rögl, *Annalen* 1982, p. 71.

Re: Albrecht Theodor Moll's natural history collection, as well as the 1762 visit to Moll's collection by Jean Étienne Guettard of the Académie Royale, see Rögl, *Annalen* 1982, p. 71. Other mentions may be found in Georg Adam Michel, *Der Oettingischen Bibliothek…* (Oettingen: Johann Heinrich Lohse, 1762), pp. 154–55; as well as F. Rögl and H.J. Hansen, "Foraminifera described by Fichtel & Moll in 1798. A revision of Testacea microscopia," in *Neue Denk-Schriften des Naturhistorischen Museum in Wien* (Wien-Horn: Ferdinand Berger, 1984), vol. 3, p. 19.

Ignaz Edler von Born, a respected geologist and mineralogist, inspected the collection in 1770 and wrote: "I go zealously to our friend Herr Reichsagent von Moll. I have spent three days examining his well-chosen collection of minerals, which is especially rich in petrified objects. The informative remarks that he makes regarding each object serve me as well as a formal lecture and please me greatly." [Ignaz von Born, *Briefe über Mineralogische Gegenstände…* (Frankfurt and Leipzig: Johann Jacob Ferber, 1774), p. 227.]

10. *Mapová sbírka,* p. 89.

11. Concerning the curriculum from the year 1714, see Ján Kocka, "Belova pedagogika vo svetle bratislavského učebného plánu…," in *Pedagog Matej Bel* (Bratislava, 1985), St. 153.180. Information about the curriculum was kindly provided by Dr František Kyselica, director of the Central Library of the Slovak Academy of Science, Bratislava.

12. "Aufnahms-Protocoll für die academischen Schüler vom Jänner 1738 bis Juli 1785," Akademie der bildenden Künste, Vienna, Archives, entry for 15 May 1762.

13. Andre 1967, p. 48. The death of August III of Poland in October 1763 set off a diplomatic crisis, and Berczy may, in fact, have been given a small secret mission, which led to the events described.

14. Friedrich-Schiller-Universität, Jena, Register for 1766, entry for 9 Oct. 1766; and SAUM, S/11, boîte 11441, registre 76a, p. 41: Berczy to Patrick Colquhoun, Hanover, 13 Feb. 1792.

15. SAUM, S/19, boîte 11442: "Lettres sur la Pologne," for 1769 journey, see second letter, unnumbered page after p. 4; for 1771 journey, see first letter, ff. (no page number).

16. He had met the countess in Berlin and attracted her attention with some of his landscape drawings. [SAUM, S/19, boîte 11442: "Lettres sur la Pologne," second letter, pp. 8f.]

17. SAUM, S/19, boîte 11442: "Lettres sur la Pologne," second letter, pp. 49–95.

18. SAUM, S/19, boîte 11442: "Lettres sur la Pologne," pp. 99ff. Although the "Letters from Poland" are addressed to a fictitious friend, the material in them seems largely based on Berczy's personal experiences. For example, the military and political situation in Poland corresponds to Berczy's description; Count Walewski was indeed a marshal of the Confederates of Bar. [*Geschichte des gegenwärtigen Krieges zwischen Russland, Polen und der ottomanischen Pforte* (Frankfurt and Leipzig, 1772), part 19, p. 40.] The records of the University of Jena in 1729 and 1730 show that a "Jo. Daniel Virgini" of Konitz and Albertus Theodorus Moll (Berczy's father) were fellow students. [Otto Köhler, *Die Matrikel der Universität Jena,* vol. III, 1723 to 1764, part I (1723–31) (Halle/Saale: Max Niemeyer Verlag, 1969), pp. 127, 153.]

19. Wiener Stadt- und Landesarchiv, Vienna, Totenbeschauprotokoll (coroner's records) 1772.

20. When Frau Moll died in 1792, the debt still owed to her late husband's estate was the large sum of 11,361 gulden and 24 kreutzer. [HHSTA, Verlassenschaftsakten (estate papers) Albrecht Theodor Moll, Faszikel 132, Konvolut 1793–95, fols. 3v, 4r, 19r.]

21. HHSTA, Verlassenschaftsakten, Konvolut 1772–78, fols. 33v, 35. According to her doctor's certificate of Feb. 1773, Frau Moll was in such poor health that she was unable to leave the house when required to attend a legal proceeding.

22. There are two Berczy letters, dated 31 [*sic*] June 1777 and 9 Jan. 1779, written from Karlstadt in Croatia (now Karlovac, Yugoslavia). The letter of 1777 shows that Berczy had previously been in Croatia in 1776, that he had connections in Varazdin, and that he had visited Fiume (now

49

Rijeka, Yugoslavia). [HHSTA, Verlassenschafts-akten, Konvolut 1793–95, fols. 9r–10v; fol. 72.]

Further explanation of Berczy's activities in this region can be obtained from manuscript fragments in Canada that describe the organization and problems of trade in Hungary and mention the difficulties involved in colonizing and building a small section of the "Karoliner" road, between Karlstadt, Fiume, and Trieste, to further trade. [SAUM, série S, boîte 11447: manuscript fragment in German about Hungarian trade with the title "Erster Brief."] In a 1792 letter, written at the time that Berczy was involved in North American colonizing efforts, he refers back to similar activities in Croatia: "I am not entirely a Stranger with unsettled and wild countries, I was for several years in the savage high Woods of Croatia where by Ravnagora Verwosko Fusina etc. & near the confines of Turkey new Settlement by German Colonies were made." [SAUM, S/11, boîte 11441, registre 76a, p. 13: Berczy to Patrick Colquhoun, Hamburg, 30 Dec. 1791 and 4 Jan. 1792.]

Modern research confirms the historical accuracy of Berczy's description and his detailed knowledge of Hungarian trade under Austrian commercial regulations. [Hermann Widerhofer, *Die Impopulation und wirtschaftliche Bedeutung der Karolinerstrasse im 18. Jahrhundert* (doctoral dissertation, Universität Wien, 1938), pp. 57–80.] The following were very helpful in resolving the complicated matter of the military border: Dr Karl Kaser of Graz University; Prof. Igor Karaman, Zagreb; and Prof. Franz Szabo of Carleton University, Ottawa.

23. HHSTA, Verlassenschaftsakten, Konvolut 1793–95, fols. 9r–10v: letter from Berczy to his mother, dated Karlstadt, 31 [sic] June 1777.

24. HHSTA, Oberhofmeisteramt, Sonderreihe 82, Pensionsbewilligung (grant of pension) from 8 Oct. 1777. The empress also agreed to send the youngest Moll son, Johann Ludwig Bernhard, to the Imperial Engineering Academy (see Appendix A, Genealogy).

All the daughters of Albrecht Theodor Moll and Johanna Hefele Moll were baptized as Roman Catholics, whereas most of their sons were baptized as Lutherans; this practice was customary in mixed-faith marriages of the times.

25. Berczy's renunciation of his inheritance is dated, "Karlovac in the Kingdom of Croatia, 9 Jan. 1779."

[HHSTA, Verlassenschaftsakten, Konvolut 1793–95, fol. 72.]

In a letter to Patrick Colquhoun, dated Hanover, 13 Feb. 1792, Berczy wrote: "Family relations and economical vewes have engaged me to take an other name." He did so, he explained, "In order to spare my patrimony which as long as my mother lieves is in her possession for uso fructo." [SAUM, S/11, boîte 11441, registre 76a, p. 41.] In a report to the Justice Commission, it is mentioned that the last letter to his family from Italy was dated 8 Oct. 1780. [HHSTA, Verlassenschaftsakten, Konvolut 1793–95, fol. 1v, 2r.] Prof. Kálmán Benda of Budapest kindly suggested the Hungarian translation of "Berczy".

26. KIF, Oberried, 3 Sept. 1780, p. 159.

27. KIF, Florence, 3 Sept. 1781, p. 332.

28. Re: curriculum, see Lützow, pp. 11ff.; re: registration, see Akademie der bildenden Künste, Vienna, Archives, Verwaltungsakt (administrative papers), 62/1760, fol. 171, Artikel 2; and Lützow, pp. 31f.

29. Pevsner, pp. 92, 173.

30. KIF, Florence, 10 June 1781, p. 289; Lützow, p. 32.

31. See LW 1. In Berlin he came to the attention of Countess Walewska, an amateur artist herself, through his drawings of Berlin landscapes (see LW 2). When he stayed at her residence in Poland a few years later, she asked if he wished to do some drawings of Polish landscapes or costumes. [SAUM, S/19, boîte 11442: "Lettres sur la Pologne," second letter, pp. 8ff.]

32. KIF, Florence, 10 June 1781, p. 292.

33. It was common for various levels of the social classes of Bern, from patricians to merchants and innkeepers, to have portraits painted of themselves. [Hans Haeberli, "Ein bernischer Porträtkatalog," in *Stettler,* p. 247, note 3.

See also Wolfgang Friedrich von Mülinen, "Von älteren bernischen Porträts und Porträtisten," in *Neues Berner Taschenbuch für das Jahr 1916* (Bern, 1915), vol. XXI, pp. 48ff.; and Edward von Rodt, *Bern im achtzehnten Jahrhundert* (Bern: Verlag Schmid & Franke, 1901), p. 108.

34. For the Gruners, see *Historisch Biographisches Lexikon der Schweiz* (Neuenburg, Switzerland, 1926), vol. III, pp. 781f.; and Rudolf Wolf, "Gottlieb Sigmund Gruner von Bern," in *Biographien zur Kulturgeschichte der Schweiz* (Zürich: von Orell, Füssli & Comp., 1862), pp. 61, 171, note 20.

Johann Emanuel Gruner (1711–1770) found little demand for his paintings, and the family's chief income came from the millinery shop run by his wife. [Burgerbibliothek Bern, MSS. Hist. Helv., VIII, 35, "Geschlechts Stammbuch der Herren Gruner," 1745, pp. 234ff.] Following the death of her parents, Mlle Gruner took over the family business.

35. KIF, "undated note," Oberried, c. Aug.–Sept. 1780, p. 157; also letter, Oberried, 3 Sept. 1780, pp. 159–60. Fischer was the director of the Bernese postal service, which had been founded by one of his ancestors. He had a splendid estate in Oberried complete with formal gardens and fountains. He also had a mansion in Bern and vineyards in Wingreis near Twann, where in 1774 the painter and engraver Balthasar Anton Dunker (1746–1807) was his houseguest. [Hermann von Fischer, "Anna Charlotte Fischer née Fischer d'Oberried," in Stettler, pp. 230ff.]

36. KIF, "undated note," p. 157.

37. KIF, Florence, 19 Dec. 1780, p. 197.

38. Re: English colony in Florence, see exh. cat. Firenze e l'Inghilterra...; Moloney, Florence and England; Brian Moloney, "The third Earl Cowper: an English patron of science in eighteenth century Florence and his correspondence with Alessandro Volta," in Italian Studies, XV–XVII, 1960–62; and Walpole.

39. Quoted in Moloney, Florence and England, p. 101. Re: the reorganization of the collections, see Lanzi, La Real Galleria; Prinz, Geschichte der Sammlung, pp. 49–55; Meloni, "Dalla reggenza...," pp. 9ff.; Borroni, "A passo a passo...".

40. Re: the Uffizi, see Borroni, "Artisti e viaggiatori..."; Borroni, "A passo a passo...,"; and Borroni, "Memoralisti...". Re: the collection of artist's self-portraits, see Lanzi, pp. 90ff.; Prinz, "La collezione degli autoritratti di artisti," in Uffizi 1979, pp. 765–72; Prinz, Geschichte der Sammlung, p. 51; Borroni, "Carlo Lasinio," pp. 109–32; Borroni, "Riprodurre...," vol. I, p. 54, vol. II, p. 102; and John Fleming, "Giuseppe Macpherson: A Florentine Miniaturist," in The Connoisseur, CXLIV:581 (Dec. 1959), pp. 166–67.

41. KIF, Florence, 25 Feb. 1781, p. 228; and 24 July 1781, pp. 314f.

42. KIF, Florence, 16 Jan. 1781, p. 207.

43. AGF, f. XV (1780) n. 154/57. The Archivio delle Gallerie di Firenze contains the registers of applications for copying works of art. The putti were most likely a detail of Adriaen van der Werff's (1659–1722) Adoration of the Shepherds.

44. AGF, f. XIV (1781) a 96.

45. AGF, f. XIV (1781) a 96.

46. KIF, Florence, 10 June 1781, p. 289.

47. KIF, Florence, 25 Mar. 1782, pp. 241f.

48. KIF, Florence, 4 June 1781, p. 287; Bartolozzi's offer was refused because of the high price and the long waiting period. [KIF, Florence, 25 Nov. 1781, p. 385.]

49. KIF, Florence, 10 June 1781, p. 293.

50. KIF, Florence, 26 July 1781, p. 318.

51. KIF, Florence, 17 Dec. 1781, pp. 394f.

52. KIF, Florence, 16 Sept. 1781, p. 347; Archivio Di Stato, Florence: Accademia del Disegno, n. 14, c. 34rv; and Pinto, "La promozione delle arti," p. 848. Berczy's certificate from the Accademia (fig. 5) is in SAUM, QI/54, boîte 11650, with parchemin 3.

53. KIF, Florence, 13 Aug. 1781, p. 324.

54. KIF, Florence, 13 Aug. 1782, p. 459.

55. Re: painting in Germany in Berczy's time, see Biermann; Börsch-Supan; Einem; Feulner; and Lemberger. Re: painting in Austria: Günther Heinz, "Bemerkungen zur Geschichte der Malerei zur Zeit Maria Theresias," in Koschatzky, pp. 277–93; Günther Heinz, "Die Figürlichen Künste in Österreich zur Zeit Josefs II," in Österreich..., pp. 181–99; and Leisching.

56. Liotard was an itinerant Swiss painter who visited Vienna in 1743–44, 1762, 1777–78.

57. Robert Rosenblum, The International Style of 1800, A Study in Linear Abstraction (New York and London: Garland Publishing Inc., 1976), pp. 50ff.

58. KIF, Florence, 10 June 1781, pp. 290f.

59. He was apparently preparing a treatise on composition in painting for the Accademia in Cortona, which had offered him a membership [KIF, Florence, 13 Aug. 1782, p. 462]. The treatise has not been found [communication of 29 Jan. and 20 Mar. 1985 from Prof. Eduardo Miri at the Accademia Etrusca in Cortona].

60. Bernhard Albrecht Moll (see Appendix A, Genealogy) painted natural history subjects for the Imperial

Natural History Cabinet ("Kaiserliches Königliches Hof-Naturalien Cabinet"), and his cousin Carl von Moll illustrated scientific texts, see Rögl, *Annalen* 1982.

61. KIF, Florence, 8 Nov. 1783, p. 569. While there is no record of the precise number of commissions, we know that when he returned to Florence nine months later, Berczy brought with him a number of unfinished portraits.

62. KIF, Florence, 23 Dec. 1780, p. 203.

63. KIF, Florence, 4 Aug. 1783, p. 495; and Naples, 21 Mar. 1784, p. 627.

64. KIF, Florence, 29 Jan. 1784, p. 608. Berczy had also contemplated publishing hand-coloured line engravings in the manner of the Bernese artist Johann Ludwig Aberli. [KIF, Florence, 27 Nov. 1783, pp. 576f.] These "illuminations," as they were called, were most popular and lucrative for Aberli and his Bernese imitators.

65. KIF, Florence, 26 Aug. 1783, pp. 524ff.

66. KIF, Florence, 19 Feb. 1784, p. 620; and Rome, 6 Mar.1784, p. 623; and Naples, 21 Mar. 1784, p. 625.

67. KIF, Naples, 30 Apr. 1784, p. 639ff.

68. KIF, Naples, 30 May 1784, pp. 647f.

69. KIF, Naples, 4 July 1784, p. 655.

70. Berczy dates the event to 14 Dec., but he must have been mistaken. In her diary the queen noted that on the morning of Tuesday, 14 Dec. 1784, she gave birth to her eleventh child. [Archivio di Stato di Napoli, Naples, Archivio Borbone, vol. 96, "Journal 1781–1785," p. 223r.] My research at the Archivio di Stato in Naples was generously assisted by Dr Maria Antonietta Arpago and Dr Maria Louisa Storchi.

71. SAUM, Q1/58, parchemin 3: "Berczy's passport."

72. KIF, Geneva, 3 Oct. 1785, p. 70; "Brevet de dispense" (entry dated 24 Oct. 1785), Archives de l'État de Berne, BIII 725, S.573; and KIF, unbound papers, "Extrait des registres de marriage … de la paroisse de Cuarnens," dated 1 Nov. 1785. For the dispensation, Berczy registered himself as "Albrecht Wilhelm Berczy" and in the church records he is listed as "Albert Guillaume Berczy."

73. Stadtarchiv, Bern, Hintersässen Rödel (a kind of registration list of inhabitants) 1786, A 285 (148), no. 40; KIF, letters from Charlotte Berczy to Mlle Gruner, Bern, 10 Mar. 1786, p. 86; and 13 Oct. 1786, p. 133.

74. KIF, undated letter from Charlotte Berczy to Mlle Gruner (possibly spring 1786), p. 96.

75. KIF, Caserta, 20 Oct. 1784, p. 681; and 5 Dec. 1784, p. 689; and Bern, 2 Aug. 1785, p. 45; and 16 Apr. 1786, p. 99.

76. Borroni, "Artisti e viaggiatori…," vol. 1, pp. 6f. Re: demand for copies, see Louise Lippincott, *Selling Art in Georgian London. The Rise of Arthur Pond* (Paul Mellon Centre for Studies in British Art, New Haven and London: Yale University Press, 1983), p. 63.; Borroni, "L'esportazione di opere d'arte nella Firenze della seconda metà del '700," in *Amici dei Musei,* no. 31 (Dec. 1984), p. 8.

77. Borroni, "Artisti e viaggiatori…," vol. V, p. 42.

78. "Permissions for export," AGF, f. XX (1787) n. 43/26; f. XXI (1788) n. 49/17; f. XXIII (1790) n. 30/4/16/21/26. Interestingly enough, the official approving the export of works of art was none other than Berczy's friend and colleague, Gesualdo Ferri.

79. AGF, f. XXI (1788) n. 50/20. Berczy had also received special permission to have the picture taken down to be copied at eye level. Eventually he asked a colleague, André Dutertre (1753–1842), to copy the painting for him, and Giuseppe Pelli, the director of the Gallery, who knew Berczy well, raised no objection. [Borroni, "Artisti e viaggiatori…," vol. VI, pp. 72, 77.]

80. Prinz, *Geschichte der Sammlung,* p. 215. The Sandrart belonged to the artist Johann Ludwig Aberli, who died while negotiating its sale. The picture was then acquired by Monsieur de Mülinen, one of Berczy's long-standing clients. [KIF, Florence, 8 Aug. 1783, p. 514; 20 Sept. 1783, p. 543; and 9 Dec. 1783, p. 582.] Berczy was thus able to step in and arrange the sale. Berczy also attempted to sell the Uffizi a painting of a head by Balthasar Denner (1685–1749). [AGF, f. XXI (1788) n. 24; 23 August; Borroni, "Artisti e viaggiatori…," vol. VI, p. 72.]

81. NFG/GSA, 28/1041: letter from Berczy to Goethe, Florence, 20 July 1788; NFG/GSA, 29/88: copy of Goethe's letter to Berczy, Weimar, 30 June 1788; *Goethes Werke* (Sophien Ausgabe), IV:30 (Weimar: Hermann Böhlaus Nachfolger, 1905), p. 43; and Otto Harnack, ed. *Zur Nachgeschichte der italienischen Reise. Goethes Briefwechsel mit Freunden und Kunstgenossen in Italien 1788–1790* (Weimar: Goethe Gesellschaft, 1890) pp. 14, 223, 227. Prof. Paul Raabe, director of the Herzog August Bibliothek,

Wolfenbüttel, pointed out Goethe's contact with Berczy.

82. KIF, letter from Charlotte Berczy to Mlle Gruner, Cuarnens, 1 Oct. 1785, p. 67; and Marcia Pointon, "Portrait-painting as a business enterprise in London in the 1780s," *Art History,* 7:2 (June 1984), p. 187.

83. Although no documentation can be found, it may be assumed that Berczy was sent to London as an agent for those Florentine entrepreneurs. [SAUM, U/1366: Anq [*sic*] D'Agliana to Berczy, Florence, 4 Sept. 1792, and U/1367: 17 Jan. 1795.] Andrew Tendi, an Italian painter living in London and former protégé of Vincenzo Gotti [AGF, f. XIV (1781) a 96], and Salomon D'Angelo Finzi, a merchant in London, were probably two other partners in Berczy's art dealing business.

Re: Vincenzo Gotti, see Borroni, "Il coinvolgimento dell'Accademia...," p. 32; Borroni, "L'esportazione...," p. 10; and Borroni, "Artisti e viaggiatori...," vol. V, p. 60.

84. Graves, vol. I, p. 184.

85. Graves, vol. I, p. 184.

86. KIF, Florence, 25 Feb. 1781, p. 227; and 25 Mar. 1782, p. 242.

87. SAUM, S/11, boîte 11441, registre 76a, p. 47: Berczy to Patrick Colquhoun, Darmstadt, 24 Feb. 1792.

William Berczy,
Self-portrait, c. 1798–99 (cat. 47).

WILLIAM BERCZY
THE CANADIAN YEARS, 1794–1813

by Mary Macaulay Allodi

HEN William Berczy immigrated to North America, he abandoned his profession as a painter in favour of a career as a colonizer and land speculator. Berczy arrived in Philadelphia on 28 July 1792, leading a large group of German immigrants with the purpose of establishing them in western New York State. When his expectations were not met on the assigned lands in the Genesee Tract, he obtained permission from John Graves Simcoe, lieutenant-governor of Upper Canada, to settle his immigrants in this newly surveyed British colony. In June of 1794, Berczy, his family, and his immigrants crossed the Canadian frontier at Niagara (also known as Newark, now Niagara-on-the-Lake), the first capital of the province. His second son, Charles, was born there on 26 August 1794.[1]

YORK, 1794–98

In early October 1794 the Berczy family moved to York (Toronto), a site which had been chosen as the new capital of the province, and which was then a virtual wilderness. The German immigrants were given the task of clearing a road called Yonge Street, from York towards their promised lands in Markham Township, twenty kilometres to the northwest.

Because he was fully occupied with a problem-ridden settlement project, he probably had little op-

portunity to paint or sketch. His own writings about those first years in the New World, from 1792 to 1797, make no reference to art. Nevertheless, the unsettled condition of the area presented Berczy with the opportunity of using his talents as an architect and builder. He supervised the construction of housing for the Markham settlement, and at York built himself a house and storehouse. His abilities were in demand, and in 1797 he supplied designs and oversaw the building of "Russell Abbey" for Peter Russell, the administrator of the provincial government after the departure of General Simcoe.[2] Unfortunately, neither Berczy's structures nor his drawings have survived as evidence of his first Canadian building projects; however, the single-storey Russell house can be seen in the distance in an 1803 watercolour by Edward Walsh (fig. 11).

Although he was no longer active as an artist, a man of Berczy's training and intellectual curiosity could hardly have resisted making some graphic note of his new surroundings. Datable to this period are pen-and-ink sketches, two of which illustrate his notebook descriptions of Upper Canada: they are small and tidy drawings, one of a saddle (cat. 42), and another a diagram of his proposed plan for a farming settlement with maple-tree orchards (cat. 43). A third drawing (cat. 40), one of his rare landscapes, shows a lumberyard and buildings in the town of Newark. He must have kept sketchbooks

11.

York the intended Capital of Upper Canada, as it appeared in the Autumn of 1803, by Edward Walsh.
Collection: William L. Clements Library,
University of Michigan, Ann Arbor.

for use as he travelled, but they have not been found. One of his small diaries does record his interest in the physical aspect of the countryside on his arrival in Upper Canada:

> *At 8th o'clock this morning I set out on horseback for Navy Hall for the purpose of visiting Chief Justice Osgoode and to present him Mr. Hammonds Letter of introduction. Navy Hall being only distant about 7 miles from here [Queenston] I rode on purpose very slowly in order to enjoy better the view of the country through which the road leaded me almost constantly along the left shore of the River Niagara, and presented me an uninterrupted variety of charming views. The river which is already more than half a mile broad at Queenstown, widens by degrees until it grows to above a mile in breadth at Niagara where it empties in Lake*

> *Ontario. The shores on both sides of this river are very high and this procured me constantly an extensive prospect as well towards the opposite side or downwards; and the country through which the road goes being all along completely settled presented me to my left an equaly pleasant variety of aspects, which forms an agreable contrast with the American country on the other side, which not being settled at all between Queenstown and Niagara is covered with high woods....*[3]

Robert Irvine's watercolour (fig. 12) confirms Berczy's verbal description.

In addition to landscapes, Berczy must also have made some portrait sketches in Upper Canada. His most famous portrait, an oil painting of the Mohawk leader Joseph Brant of about 1807 (cat. 77), is based on a drawing or painting made from the life

during his earliest years in this country. Berczy had met the Mohawk leader in 1794 and had reached an agreement to buy some land from him – an arrangement that was vetoed by the government in 1795.[4] He remained friendly with Brant, whom he would have seen as a fellow-sufferer at the hands of the administration, and in 1794 and 1799 wrote essays describing him in terms of admiration (see cat. 75 and Appendix D).

Berczy was the first professional artist to settle in this western outpost, and it is improbable that anyone on the frontier influenced his already well-established painting style. However, it is interesting to note the artists he could have met in Upper Canada between 1794 and 1798; they were amateur painters in watercolour, usually army officers and surveyors who were mapping the area.

In 1794 the most socially prominent amateur was Elizabeth Posthuma Simcoe (1762–1850), wife of Lieutenant-Governor John Graves Simcoe. She painted small watercolour landscapes in the picturesque style, which are graceful but tentative.[5] She also drew some Indian figure studies, which she etched herself on copper, sending the plates to Eng-

land for printing. Two of her etchings that have survived are half-length portraits of *Paccane, a Miamis Chief* and *Canise, or Great Sail: Chippewa Chief,* in the collection of the Archives of Ontario. The faces are drawn in profile, and the studies illustrate elements of costume that are of documentary interest. Berczy could have seen these etchings, and/or the drawings for them, during his first years in Upper Canada. The subjects may have inspired him to portray Joseph Brant, and to make studies of various tribes and their costumes, which he contemplated eventually reproducing as prints. However, as he had already undertaken genre and costume studies in Europe, this was not his first encounter with the idea of making prints of such subjects. Elizabeth Simcoe's diaries and letters only mention Berczy in connection with the work of the German settlers in opening Yonge Street,[6] and Berczy never refers to her artistic endeavours.

Another amateur artist was Captain Robert Pilkington (1765–1834), a Royal Engineer on Simcoe's staff, who knew Berczy and who seems to have been friendly with him. In his official capacity he drew maps and designed and supervised architectural

projects; he also painted landscapes, but these water-colours have not survived. Mrs Simcoe copied a number of his sketches, and some of the best wash drawings known as her work may actually be by Pilkington.[7] Pilkington also drew at least one historic group portrait, illustrating the meeting of the Great Indian Council at Buffalo Creek in 1793.[8] At some unknown date, Berczy's friend Lewis Foy of Quebec (act. 1778 – d. 1825) copied this work by Pilkington (MMFA, 967.1575). These few surviving drawings and prints show that amateur artists were recording Indian subjects in Upper Canada before 1800. It was a theme that also interested Berczy and which he hoped to write about and illustrate for publication.

Another draughtsman and surveyor whom Berczy met in Upper Canada at the end of the eighteenth century was young Joseph Bouchette (1774–1841), who was surveying York harbour. Berczy was interested in obtaining maps, both for the information they contained and for later use in proposed publications; in this connection he was to have many contacts with Bouchette. For one reason or another they never managed to collaborate.[9]

The most accomplished topographer working in Upper Canada had left the province in 1789, well before Berczy's arrival. He was James Peachey (act. 1773 – d. 1797), surveyor and Royal Engineer, who painted some remarkable landscapes during his postings, as well as illustrating Joseph Brant's Mohawk-language gospel and drawing a portrait of Mrs Brant, the latter work now unlocated.[10] In Quebec City, Peachey had been on intimate terms with the Samuel Holland family, and Berczy may have seen some Peachey drawings or etchings during his visits to the Hollands in 1798. The Peachey landscape prints, which are etched outlines finished in watercolour, are similar in technique to the European etchings that Berczy said he would emulate for his publication illustrations. There were other talented topographers whom Berczy probably met when he travelled to Quebec, or on his second stay in Upper Canada in 1802–04. Unfortunately, no Canadian landscape paintings by Berczy have survived, which makes it impossible to make comparisons or judge influences.

Berczy's preoccupation with his infant colony would have allowed little time for painting. He had been financing the Markham settlement by borrowing money. When the government of Upper Canada rescinded all grants of townships and refused to consider his petitions, he determined to travel to London to seek redress. In December 1797 his principal creditors in Upper Canada signed a document giving him eight months' respite for repayment, taking into account in their decision Berczy's "Great losses and Misfortunes."[11] This amounted to a travel permit, and Berczy left York in early April of 1798.

Berczy's family remained in York for a few months longer, and it is thanks to his letters to his wife that we can follow him on his voyage to Quebec. These writings reveal that despite the pressing worries and difficulties that had caused him to leave Upper Canada, he took pleasure in the voyage and continued making plans for future speculative enterprises. Obviously a man of immense physical stamina, he travelled by any means available – preferably by the water route, often ending the day by walking several miles through a storm to find shelter for the night. At informal "inns" he slept, sometimes in a bed, but at others on the floor or seated by the fireside. At Kingston, despite having caught a heavy cold, he attended a ball and played a few rubbers of whist after dining with a local merchant. While at Gananoque he noted that shingles for roofing were only half the price asked in York, and wished that he had the means to turn a quick profit. The month of May 1798 was spent in Montreal and at nearby Chambly, where Berczy made new friends who gave him introductions for Quebec City.[12]

William advised Charlotte to save his letters, from which details could be used to supplement his usual

travel journals: these he intended to put to good use in the future. This is an early hint at his intentions to publish a description of Canada.[13] The log of his journey from the Montreal area to Quebec in June of 1798 suggests that he was also drawing views of the countryside. As he progressed along the Richelieu River towards Sorel, he noted that the pretty churches on its shores were all built with good taste; and estimated that he would need at least eight days (sometime in the future) to sketch the most remarkable sights shown to him in and around Sorel. He continuously praised the scenery along the St. Lawrence River, and avowed that if he ever succeeded in having enough time for himself, he would make a six-month "Picturesque Voyage" through the same country by calèche, with the proper sketching equipment, to make a collection of views. Typically, he added that he believed this would be a "good Speculation" and a project which could be put to use advantageously. His first sight of the Quebec City gate and the high bastion of the Citadel impressed him as a superb example of the Picturesque.[14] Regrettably, he never seems to have made his promised sketching trip, and any views he might have drawn in 1798 are now unknown, or unrecognized.

QUEBEC CITY, 1798–99

Berczy arrived in Quebec City, the administrative capital of British North America, during the first week of June 1798, equipped with introductions and recommendations. His principal intention was to gain political information about the granting of lands, as well as to seek allies who would help his cause in London. His broad, cultured background and attractive personality eased his way, and he was soon enjoying the company of the city's social, political, and commercial leaders.

Some of Berczy's activities in Quebec are suggested in a detailed memorandum sent to him by John Robertson of Chambly.[15] Robertson listed the buildings and institutions that Berczy must visit, some of which were noted as attractive subjects for drawing: "Take a View of Chief Justice Monk's House, being the best & handsomest, in Quebec...; House & Falls of Montmorency ... You may take views there to great advantage;" and "visit the Convent of the General Hospital – a fine view."[16] No drawings of Quebec houses are now known, but a 1799 pen-and-ink sketch of the Jesuit Chapel in Montreal (cat. 44) has survived as a rough sample of Berczy's documentary drawings of buildings for his notebooks on Canada. Other drawings of Montreal buildings are referred to, but have not been found.[17]

Sometime between mid-July and late November of 1798, Berczy returned briefly to York in order to escort his family to Montreal.[18] He resumed correspondence from Quebec again in late December of 1798, and in the following two months recorded that he had drawn or painted twenty-four portraits (LW 55–78). Nineteen of the portraits were sketches in "craion," or quick studies in India ink, taken during social gatherings. The remaining five portraits were based on more formal sittings and were painted in watercolour and gouache; one of these he repeated in oil.[19]

Berczy described his portrait painting as being politically motivated, rather than a return to the artistic profession. His choice of subjects for the five studio portraits makes this evident. He portrayed General Sir Robert Prescott, Governor-in-Chief of the Canadas; his secretary Samuel Gale; Dr John Mervin Nooth, a man of science and friend of the prestigious and influential Sir Joseph Banks of London; Dr Nooth's eight-year-old daughter Mary; and William Vondenvelden, assistant surveyor-general of Lower Canada, whose map Berczy wished to publish. He planned to take the portraits of Prescott, Gale, and Nooth to London, to open doors into the right circles.[20] He wished to make use of the "enchanting art" of portraiture without appearing

13.
Robert Prescott, 1798–99,
by William Berczy (cat. 49).
Collection: Musée du Séminaire de Québec.

on the scene as an artist who must support himself by painting. In other words, he wanted to be perceived as a Gentleman Amateur. In this way, he told his wife, he hoped to gain truly lucrative advantages, that is, the contacts and influence necessary to achieve a favourable solution to his land-grant problems.

In the midst of his burst of artistic activity in Quebec, Berczy claimed that he was able to achieve not only a perfect likeness of each of his sitters, but also a resemblance so flattering that his models preferred his portraits to their reflections in a mirror; and that neither enemies nor those jealous of the models could dispute a perfect resemblance.[21] A small portrait of Prescott (fig. 13 and cat. 49) retained by Berczy because the paper tore before he completed it, remains our only documented evidence of his work in Quebec in 1799. The face and background are painted in watercolour, in miniature style with short parallel hatching; graphic touches in light red outline the eyes, chin, and jawline, and emphasize features. The costume is painted in broader style, with gouache highlights for the details of epaulettes and reflected light in the brass buttons. The general looks younger than his seventy-four years, no doubt an intended effect on Berczy's part.

The watercolour portrait of surveyor Louis Charland (cat. 51) could also have been painted at this early period, when Berczy was negotiating for the right to publish the Vondenvelden-Charland map. It is a livelier personification, as the subject is turned almost to a side view, and glances at the spectator from the corner of his eyes. The pencil underdrawing can still be seen, showing how Berczy carefully planned the proportions of the face and placement of features. Another small work, the gouache and watercolour portrait of a young man with a late-eighteenth-century hairstyle (cat. 48), may also be a 1798–99 portrait. The face is mapped out in hatched strokes that follow its contours; it is a rather mechan-

ical portrayal, and the subject lacks the individuality of expression seen in the portrait of Charland.

On one of his visits to Montreal in late 1798 or in February 1799, Berczy painted portraits of his two sons (cat. 45, 46) as a parting gift for Charlotte before sailing for England. William Junior is drawn

in miniature style, in watercolour on paper, in Berczy's graphic and subtle manner. Charles is painted in oil on copper, and despite the small size of the work, it is more broadly rendered in the technique of an oil painting. A late self-portrait (cat. 47) was also probably painted at this time; now almost fifty-five and white-haired, Berczy is still the robust and compelling individual depicted fifteen years earlier.

A jewel-like oil on copper portraying Montreal resident Louis Genevay in an interior setting (cat. 52) is dated 1803; this date, however, was in-

scribed after the painting was varnished, indicating that it must have been added later to commemorate Genevay's death. The tightness of the rendering and the scale of the figure in relation to the space around it differ from the documented 1803 portraits; it has links, rather, with Berczy's works of 1798–99, as seen in the mezzotint after his portrait of Prescott (cat. 50).

Berczy left Quebec on 19 February 1799, and travelled via Nicolet and Sorel to Pointe Olivier, where he was reunited with his family for a few days. He then continued alone to the Vermont border and travelled on to Halifax by way of Portsmouth, New Hampshire. On this journey, he was carrying portraits in his luggage, and some of these, depicting members of the Gale family (LW 67–69), were lost en route through the United States.[22] In Chambly he showed John Robertson a portrait of the young Quebec lawyer George Pyke, which Vondenvelden had copied from Berczy's drawing.[23] Berczy intended to visit Pyke's parents in Halifax, and may have given them the portrait (LW 76). He sailed from Halifax for England on 20 May 1799.[24]

LONDON, 1799–1801

Berczy arrived in England at the end of June. He immediately presented his portrait of Dr Nooth to Sir Joseph Banks, as planned, and enlisted Banks' help and that of Alexander Davison in submitting his land-grant petition.[25] He intended to give his portrait of Samuel Gale to Gale's friend, a Mrs Barrow, but first wanted to make a copy of it for himself. General Prescott's portrait was shown to friends, and presumably would have been delivered to an engraver, although there is no mention of this in extant letters from London.[26]

In his letters to Charlotte, Berczy told of pleasant visits with some of their old friends from the artistic community.[27] He had evidently forgotten that he owed money to several former associates in an art-

dealing business and on 3 September 1799, Andrew Tendi and Solomon D'Angelo Finzi had him sign an affidavit acknowledging his debt to them of £420.[28] Two other creditors, Antonio D'Agliana and John Schnadhorst, were not as patient and had him taken under sheriff's custody and committed to King's Bench debtors' prison on 17 October 1799.[29] There he remained for over eight months, carrying on business as best he could, writing letters and documents and receiving visitors until his release on 4 June 1800.[30] He had convinced his creditors that if given his freedom, he could successfully pursue his property business and thus gain enough funds to satisfy his entire debt of £1,200.[31] In fact, he even continued dealing in art with the same associates, acting as middleman between collectors and auctioneers.[32]

Berczy also had several printing ventures in mind for his London visit. He was writing a historic description of the two Canadas, and had brought his 400-page manuscript with him, which he intended to have published in England.[33] He had also entered into a formal agreement with William Vondenvelden and Louis Charland to have their large topographical map of Lower Canada (and an accompanying book describing the location of the seigneuries) published in London. His hopeful estimate was that this venture would bring a financial return of £400 to £600.[34] And, finally, he intended to publish, by subscription, an engraving after his portrait of Robert Prescott (cat. 50). As often happened with Berczy, his plans were more optimistic than his circumstances allowed. For example, his book was not published, possibly because it was not finished; and although he had preliminary proofs of the map printed by William Faden, he did not see this project through to completion.[35] The portrait of Prescott was published in mezzotint (cat. 50), with Berczy named as the artist but not as its publisher. It seems that, despite his efforts, he probably did not profit from any of these initiatives. However, his multiple

interests and studies did not go unnoticed, and on 1 April 1801 he was named a corresponding member of The Royal Society for the Encouragement of Arts, Manufactures and Commerce.[36]

Berczy left England for Canada late in the sailing season, in September 1801, and had a slow passage; on 14 November the ship was grounded on the shores of the Baie des Chaleurs at Paspébiac. Two months were spent waiting for help, and finally Berczy and his guides walked across the Gaspé peninsula to Quebec City, which he reached on 9 March 1802.[37] His journal gives an account of the hardships of travel in mid-winter on snowshoes, an adventure which interested Berczy the author, but which delayed the progress of Berczy the businessman. At Quebec he was told by Captain Robert Pilkington that the Executive Council of Upper Canada had given away part of his lands.[38] Berczy remained in the city only a week, during which time he turned over the unfinished map publication project to Vondenvelden by notarial agreement.[39] On 22 March 1802 he arrived in Montreal for a reunion with his family. He allowed himself a two-month rest before leaving for York, Upper Canada, accompanied by his twelve-year-old son William.

YORK, 1802-04

Berczy's second term of residence in York was to last from early June 1802 until late September 1804, and most of this time was spent wrestling with land-grant problems and debts. To pacify his creditors, he finally had to exact repayment of loans that he had made over the years to his German settlers – a painful business. The precarious balancing of accounts fills most of his correspondence from this time.

Because their own house had become uninhabitable, the Berczys stayed with the Willcocks family in York. William reported finding their "Genesee luggage" with many clothes stolen, but most of the colours and brushes still intact – evidently the painting

supplies he had brought with him in 1794.[40] From the time he left Montreal in May 1802, however, he did not take up painting again for almost a year. He explained to his wife that part of the difficulty was that he could not paint while living somewhere other than in his own house; and so in April he started to repair his dilapidated dwelling, and to work there during the day, although he and his son still boarded at the Willcocks' and took their meals with friends.[41]

The time lapse does not seem to have dulled his abilities, and he soon produced four sensitive and skilled portraits in watercolour, which capture the varied temperaments of his subjects. He portrayed an alert and wary Alexander McDonell (fig. 14 and cat. 58), politician, stylishly dressed in blue coat and red vest and with a sideward glance that suggests motion despite the static pose. In contrast, Attorney-General Grey (cat. 57) is rendered in almost monochrome colouring and has a soft, gentle expression. Peter Russell (cat. 59), then the administrator of the government of Upper Canada, is perceived as a shrewd senior official, who gazes thoughtfully and non-committally into the distance. Phoebe Willcocks (cat. 60), daughter of Berczy's friend and host, is given an interior setting and shown as a self-assured and sensible young woman. Berczy had business dealings with these subjects or their families, so that the painting of their portraits was not without political motivations. The portraits painted in York in 1803 are informal in expression, and show an increased naturalism, which Berczy may have observed and emulated during his recent stay in England. Certainly, the York portraits (cat. 57–60) bear a close stylistic relationship to his London portraits of the Federicis (cat. 36, 37).

Berczy may well have had other portrait commissions, even though he later stated that it would not be possible to earn a living through his art in Upper Canada.[42] A watercolour portrait that falls into this period in style and format depicts a handsome man

14.
Alexander McDonell, 1803,
by William Berczy (cat. 58).
Collection: Royal Ontario Museum, Toronto.

sitting in his library (cat. 53). The subject, once mis-identified as being Berczy himself, is unknown, but bears an interesting resemblance to Dr William Warren Baldwin, who married Phoebe Willcocks (cat. 60). He may also have painted a portrait of or for Major James Givins (LW 79). And a few weeks before leaving York, in September 1804, Berczy collected $80 from Peter Russell for "two drawings."[43] Was Russell paying for his portrait and that of his cousin Phoebe Willcocks? The surviving Russell and Willcocks portraits are three-quarter-length, and would have been priced higher than bust-lengths. However, the price seems high, and it may well be for an architectural design or some other building service rendered.

There is some evidence that Berczy was involved as the architect and building contractor for several projects.[44] On 26 November 1802 he delivered a plan for a house to Chief Justice Henry Allcock, and

two days later he visited the chief justice's farm property and fixed on a site where the house would be built.[45] On 21 December 1802 a Committee of Council recommended that Berczy be paid £3 provincial currency for his plan for a bridge over the Don River (see fig. 26, p. 105) and for his advice on the contracting submissions for this work.[46] In January 1803 his opinion in the matter of construction materials and costs was sought by the committee planning the building of the town's first Anglican church.[47] And he was probably connected with the large house that Attorney General Thomas Scott began building on his town lot in the autumn of 1803.[48] The rough sketch of a floor plan in Berczy's address notebook may represent his first thoughts for the design of Scott's house (see cat. 56). Again, as with his earlier architectural work in York, the buildings have disappeared and his house plans have not been found.

In spite of these activities and his debt collecting, Berczy was not managing to make ends meet. In reply to Berczy's description of his Upper Canadian business affairs, Charlotte wrote from Montreal to say that in her opinion York was an abyss where one would perish if one did not have revenues separate from land-ownership, especially if one did not cultivate the land personally. She noted that the excessive price of labour and the shortage of workmen absorbed much of any profit, and concluded that in York only government officials, merchants, and skilled craftsmen could subsist.[49] She advised her husband that he would do better to abandon his uncertain prospects and return to Lower Canada to earn money by means of his valuable talent (painting), a task in which she hoped she might assist.[50] At the time, Charlotte's Montreal landlord was threatening to seize all her belongings in lieu of unpaid rent. During her husband's frequent absences, Charlotte had managed to provide for herself and the children by giving drawing and language lessons, as well as taking in some boarders for a young ladies'

15.
North West View of Montreal, c. 1800,
by Richard Dillon.
Collection: McCord Museum of Canadian History,
Montreal.

finishing school. Unfortunately, none of her own art work has been identified. Meanwhile, Berczy, who was doing his best to collect cash from his debtors, was being paid in land and promissory notes – anything but money. Once he had collected as many debts as possible and repaid the most pressing of his creditors, William Berczy and his son left York, towards the end of September 1804.

MONTREAL, 1805–08

During more than half of his residence in Canada, Berczy regarded himself as a land developer and painted only sporadically, as a Gentleman Amateur, for pleasure or to gain political advantages. In 1805 he looked back on his colonizing and land-development years and summarized the outcome: "After having thus partly payed what I owed in Canada,

I remain litterally with nothing, have lost almost Eleven Years which I passed for myself under very toilsom work...."[51] His return to Montreal in October 1804 marks his return to the career of professional painter. In comparison to York, then a village of about 420 inhabitants, Montreal (see fig. 15) had a population of over 6,000. Berczy sought out clients among the port city's wealthy merchants and fur traders, churchmen, and civic officials. In retrospect, he explained the move in this way: "I retired to Lower Canada confiding for all resources only in the talents with which providence has blessed me, which however would have been of no assistance in Upper Canada but could afford me a tollerable subsistance at Montreal or Quebec...."[52] From the time of his return to Montreal he began to paint portraits of a larger size, in oil on canvas, and to un-

dertake more complex compositions with landscape backgrounds for some works. His bust-length subjects are depicted in the same classical style as his smaller watercolour portraits, presented simply against a neutral background, in subtle tones; however, the difference in scale, in brushwork, in density of colour, creates images that seem heavier and more earthbound than the delicate miniature or cabinet-sized works that were his specialty until this time.

There were a number of professional artists working in this older settled part of Canada. In Montreal, and later in Quebec City, Berczy was friendly with the best painters of his day: Louis Dulongpré, François Baillairgé, and George Heriot. Other artists were either at the beginning of a career, such as Jean-Baptiste Roy-Audy, who was still a carriage and sign painter at this period; or were passing visitors to the province, such as miniaturists John Ramage and Anson Dickinson.[53] One itinerant artist, Gerrit Schipper, drew pastel profiles which were later thought to be by Berczy because they were of his period of activity (see Appendix B). Still other artists painted so indifferently that they were soon forgotten. During his visit to Montreal in 1820, the American painter William Dunlap commented: "De Lampre [Dulongpré] & Berzy [Berczy] are the painters who have preceded me here, the first has been to see me ... the other who had some little merit as a painter is dead. There are two others here beneath notice...."[54]

The most prominent portrait painter of Berczy's period was Louis Dulongpré (1759–1843). The Berczy and Dulongpré families were evidently quite friendly, and Charlotte Berczy even contemplated renting space in one of Dulongpré's Montreal houses in 1808.[55] Born in France, and Berczy's junior by fifteen years, Dulongpré spent his first years in Canada as a dancing and music teacher and painter of theatre scenery. Evidently inspired by the success of François Malepart de Beaucourt (1740–1794) as a

portraitist, Dulongpré completed art training in the United States in 1793–94, before returning to Montreal to advertise as a portrait painter in miniature and pastel. Thus, he had only been in the portrait-painting business for about four years at the time of Berczy's first visit to Lower Canada. Dulongpré was very productive, so that by 1808 he and Berczy were receiving similar commissions for portraits and religious subjects. Unlike Berczy's precisely and densely painted surfaces, Dulongpré lays in broad planes, adding rather coarse graphic strokes to the surface of the work to define the image; this is more noticeable in his pastels, although it is true of some oil paintings as well. Like Berczy, Dulongpré's subjects are presented in a restrained and classic manner, in half- or three-quarter-length and on the first plane of the picture. But these subjects do not have the crispness of outline seen in Berczy's works; at the same time their gaze is more lively and direct, in contrast to Berczy's frequent use of a soft and sensuous expression. Technically, Dulongpré was not as accomplished a painter and it is unlikely that he would have influenced Berczy's style or his approach to his subjects.

François Baillairgé (1759–1830), a native of Quebec City who had studied in France, was a congenial visitor to Berczy's studio in Quebec in 1808–09. He was principally a sculptor and architect, and Berczy was critical of his painting: "I again promised to retouch and correct the portrait of an old lady of his family which is a fair likeness but very poorly painted, being by Bayarge's hand...."[56] Existing studies on Baillairgé as a portraitist assign a variety of styles to his name, so that it is difficult to determine what his talents were.

George Heriot (1759–1839) also visited Berczy's Quebec studio, and was the most accomplished of the British painters in watercolour in Canada at that date. His subject was landscape, with figures being subordinate to picturesque views rendered in simplified masses defined in light and shade. In England

16.
Christ Church, Montreal, 1827,
by John Poad Drake.
Collection: Archives du Séminaire de Québec,
Album Verreau.

and before he met Heriot, Berczy had been exposed to the aesthetic theories on the Picturesque and the Sublime – terms which he used when writing about Canadian landscape.[57] Whether Berczy painted watercolour landscapes in this manner in Canada is unknown. What surely would have impressed him was Heriot's publication in 1807 of a description of the country, *Travels Through the Canadas*, which was richly illustrated with aquatints after his watercolours.

Berczy's inaugural commission in Montreal was architectural. In January 1805 his plan was chosen, from among several submitted, for the building of the Anglican cathedral (see fig. 16 and cat. 62).[58] His neo-classical façade was the first of its type in Montreal; it has evident connections with the published designs of James Gibbs, as well as with Berczy's own studies of architecture in Italy. He also supplied plans for the interior of this church (see fig. 17). A recently discovered drawing raises the possibility that Berczy was the designer of the Palladian façade applied to the front of the old parish church of Notre-Dame in 1811 (cat. 89). He may have contributed to other Montreal building projects, as suggested by his plan for a guardhouse (cat. 63). To date, little attention has been paid to Berczy's architectural work because there was almost no evidence of his activity in this field. As archival collections become better known, further examples of his designs may come to light.

There is some evidence that Berczy also drew plans for commemorative monuments. He may have designed the monument for fur trader Simon McTavish, who died on 6 July 1804. This column was in place by 1806 when Edward Walsh painted a view of Montreal showing the monument in the foreground.[59] Although there is no record of Berczy's contract or drawing, he and his son later painted views of the monument for friends of McTavish, which suggests an association with the column (see LW 94 and WBB 17). It would be sur-

prising if he did not submit a design for Nelson's monument (cat. 73), and his painting of Mrs Henderson's tomb (LW 98) may mean that he was also its designer.

The McTavish monument was commissioned by Simon McTavish's nephew, William McGillivray, who was executor of his uncle's will and successor in his fur-trading partnerships. It was also at the request of McGillivray that Berczy embarked on his earliest surviving large-scale oil portrait. It is a conversation-piece depicting William and Magdalen McGillivray with their infant daughter, born in May 1805 (cat. 64). Adapting an English genre print for the composition, Berczy made it his own. He painted a charming family group seated in their garden with their dogs, and added a fallen tree trunk with foliage – a foreground device that he had used in Florence (see cat. 2) and would repeat again in his full-length portrait of Joseph Brant (cat. 77). Unfor-

tunately, it is difficult to judge the work as conceived and painted by Berczy, because of the extensive overpainting it suffered in 1820 when McGillivray had his figure altered and his costume updated.

Another commission, probably from William McGillivray for the North West Company of fur traders, was the painting of two twelve-foot canvases depicting Admiral Horatio Nelson (cat. 73) and the Battle of Trafalgar (cat. 74). The large canvases are summarily and broadly painted, and are based on engravings after English paintings. Nonetheless, they are effective icons and show Berczy's ability to adapt his style to a monumental size. The subjects also represent a transition for Berczy towards "history painting," a branch of art considered superior to portraiture by eighteenth-century artists.

In general, however, it can be assumed that Berczy was spending the major part of his time taking sittings for portraits, in order to support his family. Unavoidable debts were paid with work in kind, deeds to property, and what little cash he earned.[60] Portraits commissioned in Montreal between 1805

and 1808 are half- or three-quarter-length oils, in which a sharply outlined figure fills the space, set against a neutral ground – compositions comparable to the watercolour portraits painted in York in 1803. Pierre de Rastel de Rocheblave (cat. 71) is shown as a fashionable young romantic; his still and sensuous features remind us of the portraits of Gray (cat. 57) and McDonell (cat. 58). The feminine equivalent in expression is Maria Sutherland Hallowell (cat. 70). Her portrait in three-quarter-length includes hands that are well drawn and painted, in contrast to the boneless hands of the 1803 watercolour of Phoebe Willcocks (cat. 60). Both the Rocheblave and Hallowell portraits have suffered a loss of the surface paint layer, so that we only get glimpses of Berczy's finishing glazes. A third portrait painted in early 1808 is that of William Logan (LW 82). Logan appears more austere than the previous sitters, with facial structure defined in areas of light and shade. Berczy's attention to costume detail is evident in the painting of his dark purple-red coat with yellow vest; the background is painted in a uniform tone of

grey. This portrait is only known through a colour slide (fig. 35), as it was destroyed in a fire in 1962.

The most striking portrait of Berczy's career is his full-length image of Joseph Brant (cat. 77) standing in an open landscape. The Mohawk leader died in Upper Canada on 24 November 1807; this event may have led Berczy to paint a ceremonial and romantic portrait, based on sketches taken in the 1790s in York (see cat. 75). Berczy recognized Brant as a subject of historic significance, and one who had already been portrayed by leading artists in England and America. Admiration for Brant, interest in his role as a leader of his people, and a desire to compete in the international art world may well have inspired Berczy to create a dramatic image, one that is unique in early Canadian painting. He has returned to a smaller format (although the composition makes the figure look monumental, the canvas is in fact only 60.9 cm in height), in a picture that combines history painting, ethnological study, and straightforward portraiture. Brant stands robed in red, blue, and white, against a green background. The paint is dense and smooth, with glistening touches of impasto highlights. Every detail of costume is described, but it is the impact of form and colour that dominates the whole.

It may be at this same time that Berczy painted another portrait of Brant (cat. 76), bust-length and wearing European dress. Although presented in simple classical format within an oval *trompe-l'œil* frame, this image achieves a dramatic quality through a combination of minor-key colours (apple-green coat against a grey-blue background) in a strange and striking contrast. The silhouetted figure has become an abstract symbol enclosed in an airless space.

These tour-de-force portraits of Brant were evidently painted for Berczy's own satisfaction rather than on commission. They were showpieces, and remained in his family's possession.[61] Watercolour versions of Brant's head were repeated by Berczy

and his son William (see WBB 7, 8), and an oil on paper (cat. 75) may be the earliest of this series of images. It is also probable that Berczy intended to publish a print of Brant's portrait, as suggested by his son's inscription on the reverse of the full-length oil (see cat. 77).

After his return from London in 1801, the pressures of debt and discouragement had caused Berczy to stop working on his history of the Canadas. His interest in publishing was revived in Montreal by the requests he received for drawings describing Upper and Lower Canada, as well as for statistical information. In the autumn of 1806 he made a tour of Montreal Island to sketch some of the most interesting views for an unnamed client, possibly a publisher.[62] In the spring of 1808 he was supplying drawings to Edward Augustus Kendall (1776?–1842), an English travel writer.[63] The *New York Literary Herald* issued a brochure advertising Kendall's forthcoming book on "Travels in Lower and Upper Canada" from the press of Isaac Riley, and declared that the publication would be accompanied by a splendid series of coloured plates, including a portrait of Joseph Brant drawn from the life.[64] In September 1808, Berczy was busy finishing still more drawings for Kendall, but he never described their content.[65] However, Kendall's book on the Canadas failed to appear, and none of the Berczy drawings is now known.[66]

Berczy's outline for his own long-planned publication on Canada had become more elaborate over the years. In 1808 he told prospective publishers that his "Statistical Account of Upper and Lower Canada" comprised three volumes, each consisting of at least 350 pages. Two volumes contained his topographical survey, including several maps. The third volume, titled "A Picturesque Journey through Upper and Lower Canada," was to be accompanied by a suite of coloured copper-plate prints representing the most striking views of the country, as well as costume studies of white inhabitants, Métis and Indians of the tribes of the Hurons, Abenaki, Mon-

tagnais, Iroquois, Mississagua, and Chipawa (see Appendix E).[67]

When he was in Quebec City in 1809, Berczy talked of issuing a series of engravings as a business venture that would be useful for his sons in the future; accordingly, he set William and Charles to sketching principal churches and squares of the city. He also asked his wife to order from New York seven-by-twelve-inch copper plates prepared for engraving; he intended to publish views and costumes of Canada in the style of Freudenberger, that is, with a delicate etched outline and hand-coloured.[68] From many references to his travel drawings, it is evident that Berczy was sketching and/or painting landscapes and city views, as well as costume and genre studies. He took these drawings on his last voyage to the United States, where he intended to have them published as engravings; after his death in New York, many of his papers were missing, including the drawings.[69] They may have been left with some unnamed publisher. The only related sketch surviving among his correspondence in 1809 is a pen-and-ink profile of the Île d'Orléans.[70] It is probable that the enchanting genre scenes that William Bent Berczy painted many years later at Amherstburg (WBB 4–6) echo ideas that came from his father. They combine the elements that Berczy described in his writings: picturesque landscape, buildings, and costume studies of Indians and white inhabitants.

QUEBEC CITY, 1808–09

The year that Berczy spent in Quebec City, from July 1808 through July 1809, is the best documented portion of his artistic life in Canada. Quebec (see fig. 18) was then larger in size than Montreal, and prospective clients could be found among its resident government administrators, politicians, professionals, and merchants. Berczy's letters show that during the year he painted at least eight miniatures,

one watercolour portrait, and four subjects in oil on canvas. He also restored oil paintings for the Ursulines and for the Anglican bishop of Quebec.

Berczy had brought his son William to Quebec, for company and as his studio assistant. In the city they met old friends and made new ones; Berczy felt so cheered by his reception that he quoted *Candide,* "All goes well in this best of all possible worlds."[71] Their lodgings must have been respectable, as their old friend, Solicitor-General Sir James Stuart, was also rooming there. However, they soon moved because Berczy needed more space; by late August they were settled into new quarters, with both studio and bedroom in the same house. The situation suited him well because one room received sun in the morning and the other in the afternoon, which meant that he could work during every precious daylight hour.[72]

It may have been the prospect of painting a group portrait of eight members of the Woolsey family (cat. 84) that brought Berczy to Quebec. Although they had not met before, he sought out John William Woolsey as soon as he arrived in the city, and an agreement was reached for the commission, for which he was to be paid £10 per figure. For the composition he chose a conversation-piece format, which in many ways echoes his 1782 group portrait of the grand-ducal family of Tuscany (cat. 12), particularly in the setting and the disposition of the major figures. Also similar is the staged effect of the scene, which is the result of Berczy's method of drawing each figure separately and then placing them one by one against the architectural background. Despite this posed look and the awkwardness of some of the drawing, Berczy's meticulous attention to both the interior setting and his subjects has resulted in a portrait that captures the essence of the bourgeois family at home in Quebec. His letters mention his progress with the work almost every month for the next year. The painting proceeded slowly through its preparatory phases, and

there were delays whenever the artist took up other commissions.

While in the preliminary drawing stage for the Woolsey canvas, Berczy completed more routine jobs: he was still working on drawings for Kendall, which he finished in early September. He painted a small watercolour portrait of his son William (fig. 19 and cat. 78), which was sent off to Charlotte in Montreal; and he made short work of a miniature of Dr George Longmore (LW 83). For a lawyer friend, George Pyke, he began a miniature portrait of a young lady from Halifax, Eliza Tremain, without her knowing that she was being portrayed. Berczy called this portrait (LW 85) his "Chess Player,"

because he observed his subject while her attention was on this game.

After only six weeks in town, Berczy was well satisfied with the progress of his art business. He had good commissions under way and had raised his prices: he was now asking six guineas for a bust-length portrait in oil or in "any other manner," which he noted was two louis more than he could get at Montreal.[73] In this connection, Berczy said that he could finish large oils quickly; this explains why he charged the same price for an oil portrait as for a miniature on ivory or a small watercolour on paper, on which he lavished much time.

Throughout his Quebec stay, Berczy was busy buying ivory and oval frames for miniatures, and cutting down the ivory to fit the locket frames. On more than one occasion he reported that William Junior painted the backgrounds and drapery details to finish his miniature portraits. Well-documented Berczy miniatures are the portraits of Judge and Madame De Bonne of 1808 (cat. 81, 80A) and of Roderick Mackenzie of 1811 (cat. 95). A miniature portrait of Amélie Panet (cat. 66) is perhaps an example of the collaboration of father and son. Three other miniatures (cat. 67–69) are attributed to Berczy's hand for stylistic reasons, and at least eight more are mentioned by him between 1807 and 1809 (LW 81, 83–86, 88–90).

Berczy's Canadian miniatures are equal to the best work in that genre anywhere. Watercolour plays a greater role in these late works than it did in his European miniatures, with gouache confined to costume and details. The influence of the English school can be seen in his use of transparent colours on ivory, which lends a soft sheen to the flesh tones. Features are sensitively modelled, and most subjects are given a poetic expression – a dreamy and slightly remote gaze. Berczy's hatched brushwork, although visible, remains subservient to expression and physical description.

Berczy had arranged for a congenial studio life in Quebec. His friends, Captains Edward Dewar and Lewis Foy, wished to take art lessons, and would each pay three guineas a month for the privilege of working at his studio for an hour or two on weekdays. Berczy remarked that this would be no trouble, as they already drew quite well. He was so pleased with these arrangements that he could not resist telling Charlotte how far off the mark was "Mr. Harriot" (no doubt the artist George Heriot), who had told him that he would not find encouragement in Quebec, a town with little taste and fewer means. However, Berczy did not want his success publicized, especially since there were hungry creditors awaiting him in Montreal.[74]

Berczy's work on the Woolsey family portrait was interrupted by another commission, from Judge Pierre-Amable De Bonne (1758–1816), wealthy seigneur, lawyer, and politician. The artist spent a week at the judge's country residence at Beauport, painting oil portraits of De Bonne and his young wife (cat. 79, 80). The size of the canvases was dictated by the wall-space they were to adorn, which was large enough to accommodate half figures with two hands; for this larger format and extra content Berczy charged twelve guineas per portrait. In addition, he painted miniature replicas of the portraits, and was asked to restore an oil painting of Mrs De Bonne's mother, which Berczy said had been poorly painted by François Baillairgé. In all, he expected to earn thirty-nine guineas, or £45.10. In composition these oil portraits repeat the seated pose that Berczy had used in his 1803 watercolours of Peter

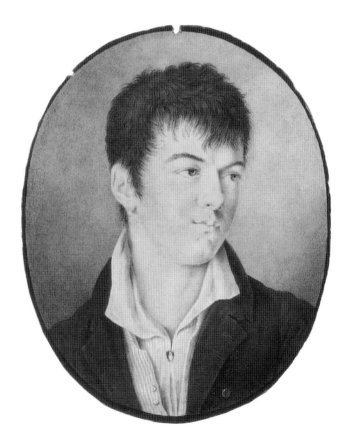

71

Russell and Phoebe Willcocks (cat. 59, 60), and in the oil of Maria Hallowell (cat. 70). In technique and expression they belong to his last period, during which he painted larger canvases and more direct, factual likenesses. Still, he allowed himself the whimsical gesture of placing a small bird on Madame De Bonne's hand.

The last month of 1808 brought a new commission, this time from Anglican Bishop Jacob Mountain, who wanted Berczy to paint a miniature of his recently deceased sister (LW 88), after an original oil painting.[75] About this time Berczy recorded that he was "repainting" the heads in the Woolsey portrait, which may mean that he was adding individualized portrait features to the figures.

During the festive season there were many visitors to his studio, to look at his paintings. It is interesting to note that he had brought his 1799 watercolour portrait of Robert Prescott to Quebec; Captain Edward Dewar asked permission to show it to Governor-General Sir James Craig, an old friend of Prescott.[76] Was Berczy still using this portrait for political purposes? Whatever the case, he was again petitioning the governing council of Upper Canada for a settlement of his land claims, and spent time during December 1808 and January 1809 writing out petitions and accounts of his settlement claims.[77] He told his wife that this would be his final request for a definite (and affirmative) answer. While waiting for a response from Upper Canada, Berczy busied himself with several restoration projects, most of them for the Ursulines. The most extensive work was on the main altarpiece in their chapel, which he mounted on a new stretcher, cleaned, and retouched.[78]

By May 1809, Berczy evidently received the worst possible news from Upper Canada – that his land claims would not be recognized. He told Charlotte that her children had been robbed, and that the persons to whom he appealed did not deign to answer him. He arranged to have his manuscript account of his Upper Canadian dealings bound in two volumes, to keep as evidence of his unjust treatment.[79] From this time, he started to wind down his activities in Quebec and prepared to return to Montreal.

The last portrait painted in Quebec was a bust-length oil of Michel-Eustache-Gaspard-Alain Chartier de Lotbinière (LW 93). Berczy described it as one of his better works. Although two oil portraits of Lotbinière are known, neither is stylistically attributable to Berczy.[80] He also hastened to finish the Woolsey portrait. In early May only four of the eight figures were finished; on the 28th of June he had a last sitting for the likenesses in the portrait.[81] His other commissions were either quickly terminated or deferred until after his return to Montreal.

MONTREAL, 1809–12

On arrival in Montreal in August 1809, Berczy set to work on six large oil paintings commissioned by parishes and religious orders of the Catholic church of Lower Canada. Having visited numerous churches during his year in Quebec City, and having restored the altar painting for the Ursulines, he could see that this was a field of activity with possibilities. The older religious canvases that had survived from the French régime were in poor condition, and many new churches built since 1759 needed altar paintings. Moreover, in his opinion, many of the church paintings he saw were mere "barbouillages."[82]

One must remember that during the French régime religious art was usually imported from France, and these paintings were often mediocre copies of famous works. After 1760 the colony was cut off from this supply and had to develop its own school of painters, who copied the models available in Lower Canada;[83] their works lacked the technical and artistic expertise that Berczy had admired in the Florentine churches. As to Berczy's own contemporaries in this field, Baillairgé and Dulongpré, their

20.
Christ on the Cross, 1809,
by William Berczy (cat. 86).
Collection: Vieux Monastère des Ursulines de Québec.

works are now in such poor condition that it is difficult to judge them as originally executed.

The idea of painting large canvases on moral themes appealed to Berczy: "I find it much more to my taste to do historical pictures than portraits, even though I do not earn quite as much with the former as with the latter...."[84] As with his large secular canvases of Nelson and Trafalgar, his religious paintings were copied after engravings of earlier compositions by European artists. It was usual at this time for the church to commission familiar images, and it was not considered demeaning for an artist to copy other paintings or prints. Berczy had already worked as a copyist in Europe, a flourishing trade in the eighteenth century. He had also assisted with some large religious canvases in Florence, and had looked at many master works in this field. When using prints as a source for his compositions, he did not hesitate to make practical changes and adjustments. The four religious paintings by Berczy that survive show him to have been competent in this genre.

He began with the painting of *Christ on the Cross* (fig. 20 and cat. 86), the earliest and smallest of his church canvases. The classic theme is densely painted and dramatically presented in contrasting areas of colour, light, and shade. This canvas was finished in October 1809, and he then set to work on the subject of St. Michael. *The Archangel St. Michael* (cat. 88), was to be an eleven-foot-tall canvas for the church at Vaudreuil. He had already calculated that with rollers and scaffolding the subject could be painted in his attic-studio, which had a nine-foot ceiling. The figure of the warrior archangel is sharply defined and set against a background dominated by clouds and a chalk-blue sky. In the scene, Lucifer is quite vanquished, lying prone on the rocks at the entrance to the flames and smoke of hell.

The commission was evidently an important one to Berczy. Instead of repeating the rather summary treatment he had given to the large subjects of

Nelson and Trafalgar, he painted St. Michael with attention to anatomical description, to tonal subtlety, and to detail. The work, restored for this exhibition, is one of the best religious paintings of its period in Canada.

The St. Michael probably occupied the artist's time for most of the winter of 1810. In March of that year the wardens of the church of Notre-Dame voted the funds for a large circular canvas of the *Triumph of the Virgin* (cat. 91), which was to create the illusion of a cupola. The preliminary study for this work (cat. 90) shows Berczy's method of organizing his composition by first drafting in the setting and then placing the figures in the space. With this copy after Charles Le Brun's famous painting, he has replaced a semi-circle of attendant saints with the architectural device of a balustrade; and when space was lacking in the central composition, he replaced adult angels with putti.

During the same year, Berczy was working on *The Death of St. Joseph* (cat. 94) for the parish of Notre-Dame de la Visitation in Champlain, and a *St. John*

the Baptist (LW 99) for the church at Rouville. The parish of Saint-Michel de la Durantaye also wanted a twelve-foot oil of *St. Michael* (LW 100), and the painting was in place by August 1811. A letter written about this time, and evidently concerning this last commission, gives an idea of the activity in the artist's studio:

All I could do without absolutely damaging my interests would be to content myself with the price of 40 Louis for the picture of St. M. that you ask for, and which according to your last letter should be 12 French feet approximately. Everything is so dear at present that in spite of my working with uncommon assiduousness I can barely meet my expenses while at the same time satisfying as far as possible some honest folk to whom I still owe considerable sums as a result of my unfortunate business in Upper Canada. Even doing this picture for you at the price indicated, I beg you to say that it is costing L50 and that you or some other benefactor are giving the rest — which you can do without injury to the truth, since it is positively out of consideration and to oblige you that I am coming down the 10 Louis, having for some time steadily refused all pictures of equal value at less than 50 Louis. If I could persuade myself to work with more negligence, the difference of ten or even twenty Louis would not be a concern to me — but I know myself too well, I would have formed this resolve in vain, I would only be fooling myself — I love art too much, my inclination would always lead me not to stop and to do all I can — especially for a picture that I am undertaking on your recommendation.

Next week I am changing houses, having taken one where I can embark on 3 or 4 of these big pictures at the same time, and if you are satisfied with my latest resolution the St. Michael will be put in the works straight away. But will you believe that I have to pay 100 Louis for the yearly rent on this house?

Yesterday I finished the sketch for the cupola of the parish church of Montreal and my St. John the Baptist and the death of St. Joseph are considerably advanced....[85]

Berczy's earnings are difficult to decipher because he quotes them in the many rates of exchange of his day, that is, in pounds sterling, in louis (worth about one pound sterling); in "livres courant" (worth one twenty-fourth of a pound sterling); in New York dollars, and in Halifax dollars. Taking all this into account, it would seems that between the autumn of 1809 and the summer of 1811, he earned about £280 for his religious paintings.[86] It must have been the prospect of generating these earnings in a short period that led to the rental of a large and expensive house in Montreal, where Charlotte's school would also be accommodated. Berczy had other commissions as well, such as the portraits of the Hertel de Rouvilles (cat. 92, 93) and the Mackenzies (cat. 95, 96).

Berczy's portraits painted on paper or ivory have survived in fair condition, apart from a fading of colours from light exposure, so that the careful brushwork is generally visible. His Canadian works in oil on canvas, on the other hand, had almost all been cleaned at early dates and have, as a result, lost the surface layer of paint that contains the artist's final highlights, and the unifying layer of transparent glazes. This is true of all of Berczy's larger oils, with the exception of the full-length portrait of Joseph Brant, the St. Michael, and the 1811 portrait of John Mackenzie — each of which shows a brilliancy of finish, a subtlety of tonal nuances, and a freedom of surface brushwork that is lacking in the overcleaned oils. From these few examples it would seem that he was moving towards a more expressive and painterly style at the end of his life.

By the autumn of 1811, with the church paintings completed, Berczy turned once again to his history of Canada and sent questionnaires to well-placed friends, asking them to document local statistics.[87] He had visited some of the seigneuries in October[88] and had sent a sample of his manuscript to printers in London.[89] He evidently did not reach an agreement with Joseph Bouchette for permission to use the Bouchette map of the Canadas,[90] but

included some maps of his own drafting. With the history well under way, and possibly with fewer painting commissions coming in, he decided to quit the country, once again in search of a profitable enterprise: the publication of his various manuscripts.

THE FINAL YEAR, 1812–13

The "fine and large house" near the courthouse, which the family occupied, was put up for rent on 1 February 1812.[91] Berczy was still in Montreal in early April, settling a few business accounts and borrowing money.[92] Shortly afterwards he left Montreal for the last time and travelled through Longueuil and Rouville, visiting his old friends, Colonel de Salaberry and the seigneur of Rouville, and collecting some last-minute information for his "Statistical Account." As he journeyed to the United States on the eve of the War of 1812, he still believed that war might be averted; however, he observed the mobilization of militia, notably the Voltigeurs canadiens under Colonel de Salaberry and Captain Perrault.[93]

After Berczy's departure, there was some speculation as to the motive and purpose of his visit to the United States at a time of open conflict with Great Britain.[94] Surviving documents show our artist in pursuit of his usual interests, that is, to make a further and, he hoped, final settlement of his land grant – Berczy was not a man to give up! – and to arrange the publication of several manuscripts and portfolios of etchings after his drawings.

Berczy's last letters to his family were from Vermont. He wrote from Burlington, describing the architecture and remarking that a drawing should be made of the town from the top of the hill, showing the most handsome houses, and with the lake and mountains as a backdrop. He also visited the owner of a local printing company and showed him his "Letters from Poland," to get an idea of publishing costs. As he only remained in town for two days, no arrangements were reached.[95]

The next stopping place was Middlebury, Vermont, where Berczy stayed with an old friend, David Page Jr., and his family.[96] He fell ill and remained with them from 26 May until 15 July 1812. To thank his hosts for nursing him, he portrayed both David Page and his wife in profile (LW 102, 103), portraits that were carefully finished in India ink and probably coloured. He described this work as occupying him, on and off, for nine days, and pronounced them polished in style and good likenesses. From references in his letters, it seems that one of the Page daughters, Eliza, had been a pupil at Mrs Berczy's school, and that he had previously made a profile of her (LW 104) in Montreal.

During his stay in Middlebury he avoided most social engagements because of poor health, but enjoyed meeting professors from Middlebury College and a leading local citizen, Judge Gamaliel Painter, as well as Samuel Swift, editor of the *Vermont Mirror,* who he hoped might publish his statistical history of the Canadas.[97] Swift read two volumes of his manuscript, but no business arrangement was struck, and Berczy left Middlebury for Albany on 16 July 1812, where he intended to talk to a bookseller and an engraver about his publication.[98] He also was prepared to contact publishers in New York, Philadelphia, Boston, Baltimore, Charleston, Savannah, and Richmond – if necessary.[99]

The first stop after Albany was to be New York, and our last record of Berczy comes from that city. On 10 October 1812 he met with the associates of the German Company and proposed that they advance him a sum of money against his shares, so that he could pursue, in England, his quest for redress of his claims regarding the Upper Canada land grant.[100] But time had run out for our determined artist-entrepreneur; he fell ill once more, was looked after by old friends,[101] and died in New York on 5 February 1813.[102] It is interesting to note that New York obituaries describe him as a writer rather than an artist:

Died. Lately, of a lingering illness, WILLIAM BERCZY ESQ., aged 68 years, a distinguished inhabitant of the Province of Upper Canada, and highly respected for his literary acquirements. In the decease of this gentleman society must sustain an irreparable loss, and the Republic of Letters will have cause to mourn the death of a man eminent for genius and talent.[103]

William Berczy was fifty years old when he first crossed the border from New York State to Upper Canada. His personality, attitudes towards life, and talents had already been formed in Europe, and onto these was overlaid the pattern of his career in Canada. The enterprises that he undertook in this country echoed his previous activities, both in business and in art.

In painting, it is doubtful that Berczy was influenced by anyone he met in Canada; and apart from his family, William Bent Berczy and Amélie Panet Berczy, he formed no school of followers. In Florence he had found stimulation through association with fellow artists, through the presence of many artists of superior experience, and also of con-noisseurs. In addition, he derived inspiration from the works of art that abounded in that city. By comparison, in Canada he was isolated from the best artists and also from masterpieces of art. Nevertheless, his style evolved during his brief years in this country, beginning with the delicate, controlled rendering of watercolour on paper, and progressing over time towards the breadth and volume of the late oil portraits and, at the end, towards a greater freedom in his brushwork. His subjects became more direct and realistic, more bourgeois, and less idealized than they had been in Europe.

William Berczy was the most accomplished painter of his period in Canada. To this country he brought European traditions in technique, current developments in style, and fresh contributions in iconography. He painted the first conversation-piece portraits, and his full-length portrait of Joseph Brant remains unique in Canadian imagery. He imbued each sitter with a sensuousness and a spiritual presence that to this day distinguishes his portraits from all others.

NOTES

The largest holdings of Berczy documents in Canada may be found in the Service des archives de l'Université de Montréal, Collection Louis-François-Georges Baby (P 58), Papiers de William Berczy. Montreal antiquarian and executor of William Bent Berczy's estate, Judge Baby (1832–1906) bequeathed most of his collection of Berczy papers to the Université Laval in Montreal. The fact that the Berczy papers in the SAUM collection are not yet fully catalogued presents researchers with certain difficulties in citing references with consistency. In these notes, letters cited are always from William Berczy to Charlotte Berczy, unless indicated otherwise. See p. 16 for abbreviations.

1. SAUM, boîte 11447, p. 7: diary, "1794 From March upwards."
2. MTL, Peter Russell Papers, A 38: Russell to McGill, West Niagara, 15 Mar. 1797; Firth, *Town of York, 1793–1815,* pp. 39–40; Arthur and Otto 1986, pp. 24, 241.
3. SAUM, S/21–22, boîte 11443, pp. 29–30: diary, "Volume Second / of / America. / 1st Part."
4. NA, MG23, H II 6, vol. 3, pp. 529–31: William Berczy draft letter, Upper Canada, 1794; SAUM, U/7663: E.B. Littlehales to Berczy, Johnstown, 4 Feb. 1795.
5. Watercolours by Elizabeth Simcoe have been reproduced in numerous publications. For the catalogue of one collection, see Bruce Wilson, *Archives Canada Microfiches,* Microfiche 9, "Elizabeth Simcoe" (Ottawa: NA, 1977).
6. Fryer 1989, pp. 106, 147.
7. Wilson 1977, p. 16, cat. no. D5.
8. For a lithograph after Pilkington's lost drawing, see "General Lincoln's Journal," *Massachusetts Historical Society Collections,* vol. 5, series 3, 1836, p. 176 and facing repr.
9. In 1798, Bouchette hesitated to give Berczy some Upper Canada surveys without official sanction. [AO, Simcoe Papers, envelope 51: Bouchette to Simcoe, Montreal, 26 Nov. 1798.] In 1811, Berczy wanted to use a Bouchette map in his proposed publication of a Statistical History of Upper and Lower Canada; Bouchette evidently proposed a fuller collaboration. [SAUM, U/1516: Berczy to Bouchette, Montreal, 20 Nov. 1811; and Berczy to McKenzie, Montreal, 21 Nov. 1811.] Berczy's manuscript disappeared after his death, and some biographers suggested that Bouchette plagiarized Berczy's work in his 1815 *Description topographique de la Province du Bas-Canada.* [Gagnon 1895, pp. 68–69, no. 523.] This accusation is unproved and unlikely.
10. Harper 1970, p. 146; Cooke 1983, pp. 158–61; Bruce Wilson, *Archives Canada Microfiches,* Microfiche 2, "James Peachey" (Ottawa: NA, 1975/76).
11. SAUM, Q1/91. The document, dated 7 Dec. 1797, was signed by James Macaulay, William Willcocks, Samuel Heron, Thomas Barry, John McDougal, Elijah Phelps, Joseph Forsyth, Archibald Cameron, Abner Miles, Isaac Jones, and Job Loder.
12. SAUM, U/1428: Quebec, 7 June 1798.
13. SAUM, U/1424: Bay of Quinte, 17 and 18 Apr. 1798; U/1425: Kingston, 19 Apr. 1798; U/1426: Gananoque, 25 Apr. 1798; and U/1427: Johnstown, 27 and 28 Apr. 1798.
14. SAUM, U/1428: Quebec, 7 June 1798.
15. SAUM, boîte 11445. A group of manuscript notes by John Robertson are kept in this box. They are on various sizes of paper, and not all of the same date. Two sheets of recommendations referred to here must have been written in June of 1798, as they introduce Berczy to people whom he met very shortly thereafter. John Robertson (act. 1782–1807), at

that date a Captain in the 60th Regt., was the son of Daniel Robertson, officer and landowner.

16. SAUM, boîte 11445. Monk had rebuilt his house on St. Louis Street in 1797 (it burned in 1796); its vaults and ground-floor walls remain as a part of the building at 57–59 St. Louis Street. See *Bulletin of the Association for Preservation Technology,* 11:3–4 (Ottawa, 1970), p. 30.

17. William Bent Berczy owned an elevation drawing of the Château Vaudreuil, a building destroyed by fire in 1803; the drawing was probably by his father, and William Junior made a copy of it for Jacques Viger. See SAUM, U/12374: Jacques Viger to WBB, Montreal, 28 Sept. 1827. See also WBB 37.

18. Charlotte Berczy had not yet arrived in Montreal on 12 July 1798. [SAUM, U/10455: Robertson to Berczy, Montreal, 12 July 1798.] By 26 Nov. 1798 the Berczy family was in Montreal. [SAUM, U/10456: Robertson to Berczy, Chambly, 26 Nov. 1798.]

19. SAUM, U/10457: Robertson to Berczy, Chambly, 29 Dec. 1798; U/1430: Quebec, 3 and 5 Jan. 1799; U/1433: Quebec, 6 Feb. 1799; U/1434: Quebec, 10 Feb. 1799; U/10463: Robertson to Berczy, Chambly, 14 Feb. 1799.

20. SAUM, U/1433: Quebec, 6 Feb. 1799; and U/1434: Quebec, 10 Feb. 1799.

21. SAUM, U/1433: Quebec, 6 Feb. 1799.

22. SAUM, boîte 11447: Berczy to Mrs Barrow, London, 19 Dec. 1799.

23. SAUM, U/1436: Berczy to Vondenvelden, Pointe Olivier, 25 Feb. 1799.

24. SAUM, U/1437: Gravesend, 28 June 1799.

25. SAUM, U/1437: London, 10 July 1799. Both men were wealthy and politically well connected. Sir Joseph Banks (1743–1820), a naturalist who had brought a scientific expedition to Newfoundland and Labrador in 1766, was president of the Royal Society from 1778. The London merchant Alexander Davison (1750–1829) had business interests in Canada; he was also supply agent to the British forces in North America.

26. SAUM, boîte 11447: Berczy to Mrs Barrow and Samuel Gale, London, 29 Dec. 1799–7 Jan. 1800.

27. SAUM, U/1437: London, 10 July 1799.

28. SAUM, J2/185. A deposition to the court by the plaintiffs, London, c. Feb. 1800, refers to Berczy's affidavit of 3 Sept. 1799.

29. Chancery Lane, London, PRO PRIS 4/16, p. 248v. On 17 Oct. 1799, Berczy was taken into custody for a debt of £480 to Antonio D'Agliana; and a second debt of £40 to John Schnadhorst. He was discharged on bail on 4 June 1800.

30. At this period King's Bench Prison was almost exclusively for debtors, and more freedom was allowed than in an ordinary prison; some debtors were permitted to live outside the actual prison, within a certain radius. See Joanna Innis, "The Kingsbench Prison in the Late 18th Century," in *An Ungovernable People: The English and their Law in the Seventeenth and Eighteenth Centuries,* eds. John Breuer and John Styles (New Brunswick, New Jersey: Rutgers University Press, 1980), pp. 250–98. For this reference and information, I am indebted to Prof. Bruce Dunlop, Faculty of Law, University of Toronto.

31. SAUM, U/1420: Berczy to Andrew Tendi, London, 19 Apr. 1800. The suggested method of payment extended over a seven-year period.

32. SAUM, Q1/98: agreement between William Berczy and Andrew Tendi, regarding the sale of four pictures owned by Thomas Sheppard of London, 16 Oct. 1800.

33. SAUM, U/1434: Quebec, 10 Feb. 1799.

34. SAUM, U/1430: Quebec, 3 Jan. 1799; and boîte 11445: undated draft "Prospectus For publishing by Subscription … A Topographical Survey of the province of Lower Canada with a Map.…"

35. The engraving was completed and the map published on 1 Jan. 1803, titled *A New Topographical Map of the Province of LOWER CANADA, Compiled from all the former as well as the Latest Surveys taken by Order of the Provincial Government by & under the direction of SAMUEL HOLLAND, ESQR. DECEASED, late Surveyor General of the said Province, Is most respectfully inscribed. TO HIS EXCELLENCY, ROBERT PRESCOTT, ESQ. Captain General & Commander in Chief of the PROVINCES OF UPPER & LOWER CANADA &c. &c. by his most obedient & most humble Servants, William Vondenvelden, lately Assistant Surveyor General and Louis Charland Land Surveyor LONDON, Published by Willm. Vondenvelden No. 20 Cannon Street, Jany. 1st. 1803.*

36. Minutes of the Royal Society 1800–1801, pp. 141–42.

37. SAUM, S/22, boîte 11442: journal, 2 Feb.–17 Mar. 1802.

38. SAUM, boîte 11445: manuscript sheet from unbound diary numbered "page 13" and dated "Tuesday 9th March" 1802.

39. Archives judiciaires de Québec, Minutier de Maître Joseph Planté, no. 2984: Procuration, 15 Mar. 1802. [IBC, pp. 9085–90.]

40. SAUM, U/1447: York, 7 June 1802.

41. SAUM, U/1454: York, 26 Apr. 1803.

42. NA, MG23, H II 6, vol. 3, p. 729: Berczy to [?], Montreal, c. 1808.

43. MTL, L 18, Peter Russell Papers, Box 3 (1799–1805), file 3/6: William Berczy's receipted invoice to Peter Russell, York, 3 Sept. 1804.

44. Andre 1967, pp. 82–85; Arthur and Otto 1986, pp. 75, 241.

45. NA, MG24, C I, p. 120: "Diary and Letter-Book of Joseph Willcocks 1800–1803."

46. NA, RGI, E 3, vol. 68, pp. 178–80: "Report of a Committee of Council," York, 21 Dec. 1802.

47. *Upper Canada Gazette,* York, 22 Jan. 1803.

48. MTL, D.W. Smith Papers, A/10, p. 299: William Allan to D.W. Smith, York, 29 Aug. 1804. AO, "Peter Russell's Account Book," p. 30, 8 Jan. 1805. Payment by Scott of £11.10 to Berczy.

49. SAUM, U/1410: Charlotte to Berczy, Montreal, 29 Nov. 1802.

50. SAUM, U/1415: Charlotte to Berczy, Montreal, 26 Feb. 1803.

51. SAUM, U/1457: Berczy to William Fawkner, Montreal, 4 Jan. 1805.

52. NA, MG23, H II 6, vol. 4, p. 729: Berczy to [?], c. 1808.

53. Ramage (c. 1748–1802) lived in Montreal at the end of his life, from 1784 to 1802, but no Canadian subjects have been documented in his œuvre. Dickinson (1779–1852) visited Montreal in the autumn of 1811.

54. Dunlap 1930, p. 558.

55. SAUM, U/1465: Quebec, 18 Aug. 1808.

56. SAUM, U/1470: Quebec, 3 Sept. 1808 (trans. from French).

57. SAUM, U/1427: Gananoque, 25 Apr. 1798; U/1466: Quebec, 22 Aug. 1808.

58. Adams 1941, p. 56; McCord Museum Archives, Anglican church collection, Folder I.

59. *A View of the City of MONTREAL. from McTavish's Monument on the-top of the Mountain,* watercolour, signed l.r., *E. Walsh 49th. Regt. fecit / 1806* (ROM, 952.217).

60. SAUM, boîte 11445: "Account with Samuel Gale, 26 Apr. 1807." To repay a debt of £50.12.7,1/2 to Samuel Gale, Berczy paid £5 in cash, £6 by painting a miniature of Gale's son, and £26.13.6 by assigning 200 acres of land in Markham Township. The remaining amount of the debt was pledged with further shares of Markham Township property as security.

61. A visitor to the Berczy-Panet house at D'Aillebout in 1859 reported the living room adorned with paintings of Indian chiefs done by both Berczy and William Bent Berczy; see De Rainville 1892, nos. 9 and 10, p. 134. In 1860, William Bent Berczy exhibited an oil portrait of Brant; see *Montreal Gazette,* 5 Oct. 1860. In Montreal exhibitions of 1887 and 1892, Berczy-Panet descendants were the lenders of Brant portraits by Berczy; see Montreal 1887, no. 265; and Montreal 1892, no. 228.

62. NA, MG23, H II 6, vol. 4, pp. 710–13: Berczy to [?], Montreal, Nov. 1806.

63. NA, MG23, H II 6, vol. 4, pp. 720–23: Berczy to Fitch Hall, Montreal, 22 and 29 May 1808.

64. ASQ, Fonds Viger-Verreau, Saberdache bleue, vol. I, pp. 25–30: Jacques Viger to Berczy, Montreal, 24 July 1808.

65. SAUM, U/1472: Quebec, 4 Sept. 1808; NA, MG23, H II 6, vol. 4, p. 743: Berczy to Boudinot, Quebec, 23 Nov. 1808.

66. Edward Augustus Kendall did in fact publish one travel book in New York: *Travels through the Northern Parts of the United States in the Years 1807 and 1808,* 3 vols. (New York: printed and published by I. Riley, 1809). This work does not describe Upper or Lower Canada, although reference is made to the Indian trade in Canada. Moreover, it is not illustrated.

67. SAUM, boîte 11445: several draft descriptions of Berczy's manuscript; NA, MG23, H II 6, vol. 4, pp. 719–20: Berczy to Boudinot, Montreal, 21 May 1808; and pp. 720–23: Berczy to Hall, Montreal, 22 and 29 May 1808.

68. SAUM, U/1507: Quebec, 24 June 1809. Sigmund Freudenberger (1745–1801), Swiss artist and

engraver, specialized in genre scenes describing the costumes and customs of France and Switzerland.

69. SAUM, A2/55: four-page manuscript draft by William Bent Berczy titled "Sketch of my father[']s life": "Nor did I find, among the papers I recovered, after the declaration of peace between England & the United States, his work on the Canadas, which possibly may have been appropriated by some one to me unknown...."

70. SAUM, U/1505: Berczy to Jacques Viger, Île d'Orléans, 10 June 1809; ASQ, Fonds Viger-Verreau, Saberdache bleue, vol. 1, pp. 215–19: Viger's transcription of the same letter and drawing.

71. SAUM, U/1462: Quebec, 22 July 1808 (trans. from French).

72. SAUM, U/1466: Quebec, 22 Aug. 1808.

73. SAUM, U/1468: Quebec, 31 Aug. 1808.

74. SAUM, U/1468: Quebec, 31 Aug. 1808.

75. SAUM, U/1476: Quebec, Dec. 1808; and U/1487: Quebec, 1 Feb. 1809. Berczy also later restored the original oil painting of Miss Mountain. [NA, MG23, H II 6, vol. 4, p. 808: Berczy to Bishop Mountain, Quebec, 8 June 1809.] A portrait of Sarah Mountain (1748–1808), oil on copper, by John Downman, 1778, is in the collection of NA, Ottawa, 1982-92-2.

76. SAUM, U/1478: Quebec, 7 Dec. 1808.

77. SAUM, U/1480: Berczy to Francis Gore, Lieutenant-Governor of Upper Canada, Quebec, 2 Jan. 1809.

78. The altar painting was a Nativity, attributed to Charles Le Brun. See SAUM, U/1487: Quebec, 1 Feb. 1809. Berczy also restored portraits of Mère Marie de l'Incarnation and Madame de Lapeltrie. See Thibault 1973, pp. 87, 89.

79. SAUM, U/1499: Quebec, 12 May 1809. If the papers were bound, they have since disappeared.

80. One of the Lotbinière portraits (private collection) is a three-quarter-length composition, painted in the style of Louis Dulongpré (1754–1843). The other, in the ROM collection, is in bust length, and is a more graphic rendering, reminiscent of some portraits painted by Levi Stevens (act. 1810–d. 1832).

81. SAUM, U/1497: Quebec, May 1809; and U/1508: Quebec, 28 June 1809.

82. SAUM, U/1505: Berczy to Jacques Viger, Île d'Orléans, 10 June 1809.

83. See Porter 1983, pp. 55–72.

84. SAUM, boîte 11445: loose sheet detached from a Berczy letterbook, Berczy to [?], c. Oct. 1809 (trans. from French).

85. NA, MG23, H II 6, vol. 4, pp. 831–32: Berczy to unidentified client in Quebec City area, Montreal, n.d., c. 1810 (trans. from French).

86. See individual catalogue entries. In date order of probable payment, they are: *Christ on the Cross*, £12.10; *Archangel St. Michael* (Vaudreuil), £50; *Death of St. Joseph*, £7.10; *Triumph of the Virgin*, £120; *St. John the Baptist* (Rouville), £50; *St. Michael* (Durantaye), £40.

87. SAUM, U/1515: Berczy to Pyke, Montreal, 5 Nov. 1811; U/1516: Berczy to McKenzie, Montreal, 21 Nov. 1811.

88. ASQ, Fonds Viger-Verreau, Saberdache bleue, vol. 2, p. 65: Berczy to Jacques Viger, Montreal, 28 Oct. 1811.

89. Royal Society of Arts, London, F1/123: Berczy to Taylor, Montreal, 28 Oct. 1811.

90. SAUM, U/1516: Berczy to Joseph Bouchette, Montreal, 20 Nov. 1811; and U/1516: Berczy to McKenzie, Montreal, 21 Nov. 1811.

91. *The Gazette* (Montreal), 10 Feb. 1812, p. 1.

92. SAUM, U/1520: Berczy to Judge Panet, Montreal, 6 Apr. 1812.

93. SAUM, U/1521: Berczy to WBB, Chambly, 19 May 1812.

94. SAUM, U/1527: Quebec, WBB to Charlotte Berczy, 7 Jan. 1813.

95. SAUM, U/1518: Berczy to WBB, Burlington, Vt., 24 May 1812. The printer mentioned was probably Samuel Mills, printer of the *Northern Centinel* [*sic*] newspaper at this date. Information courtesy of Mr Merlin L. Acomb, Shelburne, Vt.

96. SAUM, U/1522: Middlebury, Vt., June 1812. David Page Jr. was superintendent of a cotton mill in Middlebury. Information courtesy of The Sheldon Museum, Middlebury, Vt.

97. SAUM, U/1522: June 1812.

98. SAUM, U/1525, Berczy to WBB, Middlebury, 15 July 1812. The bookseller, Mr Backus, is listed in Berczy's address book. [SAUM, boîte 11447.] The engraver was most probably William H. Whiting, who was active in Albany in 1812. See Joel Munsell, "Chronological Record of Printing, 1803–23," p. 148, column 1 (manuscript in collection of

the American Antiquarian Society, Worcester, Mass.)

99. Names of booksellers and publishers in these cities are listed in Berczy's address book. [SAUM, boîte 11447.] Heading the list is the name of a Boston bookseller noted as recommended by Prof. Hall of Middlebury, which suggests an 1812 date for this listing.

100. SAUM, U/1526: Berczy to the German Company, New York, 10 Oct. 1812.

101. SAUM, A2/55: four-page manuscript draft by William Bent Berczy titled "Sketch of my father[']s life."

102. Register of Burials in the Parish of Trinity Church, New York City, vol. 1, p. 378; and Municipal Archives and Records Center, New York City, Register of deaths for years 1813–14. See Andre 1967, footnotes 165 and 264.

103. *New York Spectator,* 13 Feb. 1813, p. 3, column 5; and *New-York Evening Post,* 11 Feb. 1813, p. 3. A shorter notice appeared in the *Weekly Museum,* New York, 13 Feb. 1813. Information courtesy of Joyce Ann Tracy, Curator of Newspapers and Periodicals, American Antiquarian Society, Worcester, Mass. The obituary was said to have appeared in a Boston newspaper on 15 Feb. 1813; it was copied by the *Quebec Gazette* on 11 Mar. 1813. The reference to Berczy as a resident of "Upper Canada" suggests that the original obituary was written by a member of New York's German Company who knew Berczy chiefly in the context of land speculation in that area of Canada.

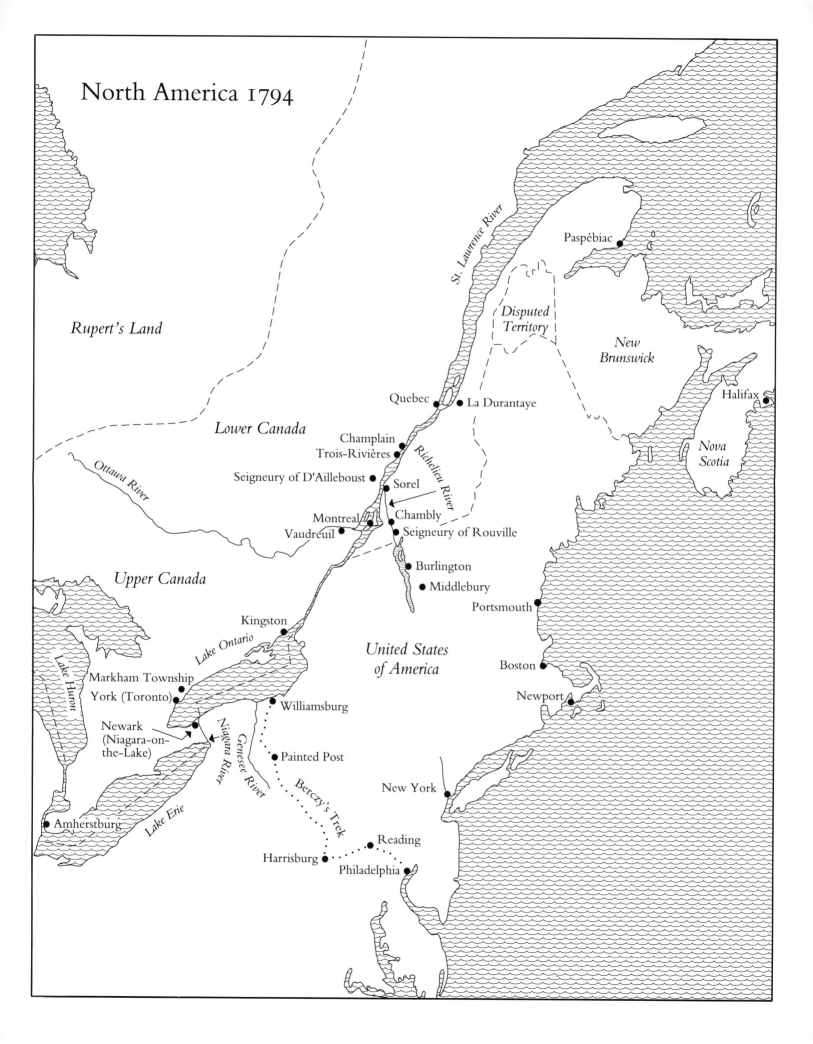

North America 1794

Rupert's Land

Lower Canada

Upper Canada

St. Lawrence River

Paspébiac

Disputed Territory

New Brunswick

Halifax

Quebec ● ● La Durantaye

Champlain ●
Trois-Rivières ●

Nova Scotia

Seigneury of D'Ailleboust ●
● Sorel

Richelieu River

Montreal ●
Vaudreuil ● ● Chambly
● Seigneury of Rouville

Ottawa River

● Burlington
● Middlebury

Portsmouth ●

United States of America

Kingston ●

Lake Ontario

Boston ●

Newport ●

Markham Township ●
York (Toronto) ●

Lake Huron

Williamsburg ●

Newark
(Niagara-on-
the-Lake)

Niagara River

Genesee River

● Painted Post

New York ●

Amherstburg ●

Lake Erie

Berczy's Trek

● Reading

Harrisburg ●
● Philadelphia

WILLIAM BERCZY
COLONIZATION PROMOTER
1791–1813

by Peter N. Moogk

AD William Berczy succeeded as a land speculator and promoter in North America, he would have left a less extensive artistic legacy. Berczy thought of himself as a gentleman with an avocation for painting and drawing. In Upper Canada he sought to obtain landed estates to maintain his family in gentlemanly fashion and to attain the financial security he had not achieved in Europe. The debts incurred to justify and obtain land grants forced him into an energetic application of his artistic talents, both to earn money and to ingratiate himself with influential members of colonial society. In Europe he sought admission to princely courts to practise his art, whereas in the Canadas he used his art to gain access to the colonies' notables. Some clients did use their contacts to assist "Mr. Berczy's case," as his land claims were described. In the end, his case collided with an immovable Upper Canadian administration and his ambitions to join the landed gentry came to little.

RECRUITING IN GERMANY, 1791–92

The story of Berczy's involvement with German colonization in North America reveals much of his character. The traits disclosed are not always endearing ones. He could be headstrong, self-righteous, and devious, while being at the same time a loving husband and devoted father. He was an enthusiastic salesman who even convinced himself. Berczy entered the colonization business by accident. In 1790 this talented, international adventurer was living in England. He and a fellow German, Baron Friedrich von Diemar, became known to Sir William Pulteney and his two associates who had bought the 1,100,000-acre Genesee Tract in western New York State from Robert Morris in March 1791. Settlements and amenities for prospective buyers, such as roads and gristmills, would increase the value of the uncleared lands. The investors intended to bring out Scottish and German emigrants to found the settlements that would attract

land purchasers. The German principalities were considered a potential source of pioneers because German-speakers were reputed to be industrious and efficient farmers. They had been recruited throughout the eighteenth century for the British and French colonies in the Americas, and the associates were willing to pay more for Germans than for Scots. Baron von Diemar and Berczy were engaged to act as emigrant recruiters and land sellers in the German states. The baron had been an officer with the British forces during the American Revolutionary War and Berczy claimed to have experience in the colonization of wild lands, on the strength of "several years" in the new German settlements of northwestern Croatia.

In September 1791, Berczy signed a contract with Patrick Colquhoun, one of the Pulteney Associates, to be their recruiter of German migrants. He was obliged "to hire and engage ... Two hundred German servants of good Moral characters, and such only as have resided constantly in the Country, who are well acquainted with farming, and who have been accustomed to hard labor and Industry." Berczy was empowered to negotiate the emigrants' contracts, make travel arrangements, and ensure their embarkation from Hamburg, Rotterdam or another port. He was cautioned "to prevent any Alarm or embarrassment from the sovereign Princes in Germany from whose countries or Territories the said servants, or settlers are taken;" discretion was necessary because recruitment of emigrant contract workers was illegal. He was entitled to a commission on each person hired as well as for any land he sold and, since he agreed to accompany the recruits to North America, he would be given at least 500 acres in the Genesee Tract (fig. 21).[1] With this mandate, Berczy set off for Hamburg and Bremen, the two principal German ports of embarkation for overseas migrants.

Berczy did not register himself as a recruiter, as Hamburg's laws required, but went ahead seeking emigrants. He later wrote that he had a duty "to listen to no other rules but those of justice and reason."[2] City authorities considered his activity a "nuisance" but did not interfere, possibly to maintain good trading relations with Britain. Berczy vowed "I shall make all Germany fanatic[al] for the Genesee land"[3] and, to this end, he and von Diemar translated and published the Pulteney Associates' pamphlet, which appeared in December 1791 as *Berichte über den Genesee-Distrikt* (Reports on the Genesee District), as well as Benjamin Franklin's *Remarks for the Information of those who wish to become settlers in America*. Berczy's prospectus advertised the terms offered to colonists: six years of service with a salary proportionate to age and skills, from which advances would be deducted, transportation to the United States, and a 25-acre land grant after the sixth year. The Pulteney investors were described as "a group of rich and philanthropic landowners" whose enterprise would contribute to human happiness. Some of the recruiting was by word of mouth and took place in a city churchyard. Berczy employed a number of recruiters, and travelled between Hamburg and Bremen in search of prospective settlers and suitable passenger vessels. He also made trips inland to Hanover, Darmstadt, Frankfurt, and Kassel to contact potential land-buyers and investors. His contacts, he reported, would publicize the Genesee lands.

The Free City of Hamburg could not ignore Berczy's "clandestine recruiting" indefinitely because his unlicensed activity contravened city regulations and the laws of the Holy Roman Empire, to which Hamburg was subject. At the request of the Rhineland princes, who had lost many subjects to emigration, an imperial decree of July 1768 expressly forbade the indenturing of workers for foreign territories, to prevent depopulation and the departure of useful subjects so soon after the Seven Years' War. In 1752, 1759, and 1764, Hamburg's mayor and council imposed penalties on those who under-

21.
The Lower Cataract on the Casconchiagon (Genesee) River,
c. 1768, after Thomas Davies.
Collection: National Gallery of Canada, Ottawa.

took or abetted unauthorized recruiting of emigrants; they claimed that such recruitment caused "disorder and confusion" by enticing servants and apprentices from their masters, children from their parents, and led husbands and fathers to abandon their families.[4] Hamburg's government was not hostile to all emigration, since the traffic provided income for the port's mercantile and shipping houses.

Officials in Germany were more concerned about emigrants bound by service contracts than with free passengers who paid their own passage to America. There were reports about the cruel exploitation of German indentured workers and redemptioners who paid for their passage with three to six years of labour in North America.[5] In 1756, Gottlieb Mittelberger published an account of the sorry fate of bond servants in Pennsylvania, the principal destination of German migrants. Recruiters employed by shipowners were contemptuously known as "traffickers in souls" [Seelenverkäufer] or "thieves of people." Berczy had to combat what he called "ill opinions" that emigrant recruiters were cheats who duped the credulous with honeyed words about the delights of America in order to sell them into hard and lengthy servitude. He assured listeners that the volunteers who signed up with the Pulteney Associates would be settled as a group, and that they would not be transferred individually to American masters.

A surgeon and Lutheran minister/schoolmaster would be provided for them and for their children. Berczy also promised to stay with the settlers until their six years of service were completed to see that they received their land grants. He would act as "their father and an advisor"[6] because, as he explained to Colquhoun, "the vulgar class of people wants always a leader, a chief in their heart; they have chosen me for that purpose."[7]

Berczy preferred to do things in his own way; he represented himself as the associates' "plenipotentiary agent." He complained of Baron von Diemar's indiscretion and ineptitude as well as of his interference with Berczy's arrangements. Berczy did accept the suggestion of Captain Charles Williamson, the investors' man in New York State, to offer the recruits a sharecropping arrangement for the six years instead of keeping them as salaried servants. Most of the people already hired accepted these new terms, although they would be purchasing their farms at 90 percent of estimated value. It was stated that the associates would sell them livestock, farm implements, and other necessities "at a fair and moderate price." As "Deputy Superintendent" to Williamson, Berczy was to keep the accounts, advise the settlers, "use his best endeavour to preserve harmony, and to promote Industry in the Settlement," and do everything to further the association's interests and the colonists' happiness, subject to Williamson's "advice and assistance." For this, Berczy would receive a tenth part of the company's half of the settlers' produce.[8] Berczy signed a supplementary contract with the partners at London on 24 March 1792, accepting these new terms. Some German gentlemen enquired about investing in the Genesee venture, but Berczy sold no farms to individuals, declaring "the whole sum is too great for any family in Germany."[9] When the associates questioned his expenditures and the utility of his travels, while asking if he had settled all his debts in England, Berczy protested these slights to his honour and integrity, displaying a characteristic touchiness.

The recruiting of individual workers went well: "I wish you could see some of my young men from 23 to 32 years; you know I am not a little size of man but I have many of them which are 2 or 3 inches taller than I, and very stout, healthy and well-looking men." Over a third of the men, in fact, were thirty or older.[10] Berczy regretted that he had enrolled "very few women," but assured Colquhoun "some of my young men are now search[ing] for wives."[11] Berczy purchased bedding and bed-linen for the passengers and negotiated with shipowners. Vessels at Bremen were too small or too costly and so he chartered two ships out of Hamburg. A carpenter installed bunks and partitions in the holds for the expected passengers. Berczy supplemented the shipboard rations with "good beer" and sauerkraut, "which is one of the favourite meats [foods] for German people."[12]

Berczy was certain that once the first contingent of recruits had settled in New York State and reports of their good treatment reached Germany, "many thousand good German[s]" would follow. He decided to hire more than the quota of two hundred, but was suddenly forced to abandon his activities. An aggrieved notary, Carl Hassold, felt that he, rather than Johann Vincent Hasse, should have been chosen to draft the emigrants' contracts and denounced the recruiters to the Danish and Prussian royal courts in late April. Hassold exaggerated the number of persons enrolled, but correctly identified Berczy's business partners. The Prussian delegate to Hamburg, Carl von Goechhausen, uncovered more details, including Berczy's ambition to recruit thousands of people. When the Prussian royal council learned of Berczy's grandiose plan, it demanded that the Hamburg administration enforce the 1768 imperial decree, and prevent all ships from departing until the passengers had been examined, so that

Prussian subjects might be returned to their homeland. The support of the Duke of Brunswick-Lüneburg and imperial officials was enlisted for action against Berczy. Under pressure from these other jurisdictions, the Hamburg Senate issued a decree on 7 May 1792, forbidding the hiring of "able-bodied craftsmen and countryfolk to populate distant colonies and for the cultivation of wild lands," even if "untutored people" willingly signed up "in the giddiness of great expectations".[13] Prussian subjects found on vessels at Hamburg were arrested and taken off the ships. Bremen responded with a similar declaration, renewing an interdict on the secret recruiting and gathering of emigrants.

With theatrical exaggeration, Berczy wrote that "by the arbitrary Sentence" of the German princes and Hamburg magistrates, "I have been, as it were, banished from my Country, and been deemed worth hanging."[14] He must have been forewarned because he prudently moved the brig *Frau Catharina,* with one hundred and thirty-one emigrants aboard, from Hamburg to the adjacent port of Altona, under an indulgent Danish administration. He had brought his wife and son from England in March and they were among the passengers. Berczy had long anticipated trouble and had written, "I believe it better not to take on board too great a number of people in one place in order to avoid the attention of the public."[15] The brig sailed for Philadelphia on 2 May. Berczy's partners at Hamburg, Johann Lemmen and Ludwig Lorenz, continued to enrol people as nominally free passengers, and not as redemptioners or indentured servants, to evade the interdict. A second group of eighty-six migrants under Pastor Georg Siegmund Liebich departed Hamburg for the Genesee country on 20 May aboard the *Heinrich und Georg.* A dispatch from the London associates to Berczy telling him to send only one shipload of settlers in 1792 arrived too late to prevent this departure.

The recruiting venture in the north German states revealed Berczy's preference for acting alone as he saw fit, whatever the laws might say. He had absolute confidence in his own judgement and ignored his partner, Baron von Diemar. Berczy enlarged his mandate and exaggerated his credentials. He now viewed himself as a man of great consequence and dreamed of promoting a massive emigration to the United States. The bustling activity of their impulsive, independent agent in Germany made the London associates uneasy. They, after all, were obliged to pay Berczy's bills.[16]

Under his 1791 contract with Patrick Colquhoun, Berczy was simply a land seller, recruiter, and escort for the Germans, who was to be rewarded with land in the Genesee. Berczy saw himself as the leader of his recruits and idealistically hoped to find in the United States of America a more just society than he had known in Europe. Berczy claimed that he had not followed his father, brother, and uncle in the diplomatic and administrative service of the Holy Roman Empire or of its princely houses because of his "principles of independence and republican spirit."[17] His brother Bernhard Albrecht had gone to the United States in the 1780s, and his example may have encouraged William's optimism. William Berczy wrote: "What might I hope for my good German people under the beneficent protection of laws administered by a free and popular government, and under the direction of a generous and enlightened association?"[18] Berczy communicated his rosy vision of the United States to the recruits, who later reproached him with his own words: "Would this be the free state into which you promised to lead us? Would this be the land where, according to your assurances, the laws would be equally strong for the poor and the rich, for the weak and the powerful, where oppression of the weak cannot and may not be allowed?"[19]

TO THE PROMISED LAND, 1792

The ten-week sea voyage brought a harbinger of the supply problems to come when the *Frau Catharina's* stock of drinking water ran out in July, and Berczy diverted the ship to Newport, Rhode Island, to take water and fresh provisions on board. He went ahead to New York by packet with his family to make arrangements for reception of the newcomers at Philadelphia. It was imperative that the migrants be moved inland quickly before they questioned their indentures. Private recruiters were enticing them to desert Berczy. Robert Morris, former owner of the Genesee lands and Berczy's advisor, expressed the opinion that the migrants could legally protest their original contracts. The associates' agent in the country was Captain Charles Williamson, a Scot who had taken out American citizenship in order to manage the company's lands, which were registered in his name. Berczy did not know this at first and treated Williamson as someone only slightly superior to himself in authority but not in ability. He was angry that no arrangements had been made to receive the new arrivals. Morris proposed, with Williamson's written concurrence, to use the Germans to widen a trail from the West Branch of the Susquehannah River in Pennsylvania, over the Allegheny Mountains, some seventy kilometres, to Painted Post in New York State. This would provide a southern route into the Genesee to supplement access by the longer Hudson-Mohawk route, and the Pennsylvania state government would pay the surveying costs. With credit from Morris, Berczy and his men bought clothing, tents, and tools for the migrants and hired wagon-drivers to transport them inland.

The road-builders' caravan reached Lycoming Creek at the trail's southern end in late August. After difficulties in clearing the original route, Berczy decided to make his own survey and deviated from the blazed trail in order to take the road through more level and less wooded terrain. His

Germans were not experienced axemen. Williamson appeared for the first time and employed thirty American woodcutters to aid the newcomers and speed their progress. The road was eight kilometres short of its goal when November rains halted work. Williamson alleged that the Americans had to teach wood-chopping to the recruits. Instead of "the sturdy Saxons" he expected, he accused Berczy of delivering "a heap of vagabonds, of old soldiers, and licenced [i.e., discharged] sailors."[20] A few of the recruits were former soldiers, but most were countryfolk. As for the want of skills, a third of the men were craftsmen and about half of these were woodworkers. Locals mocked the newcomers' awkwardness and their fear of Indian attacks, like those reported in the German press. Such apprehensions were nourished by continuing warfare between the Americans and Amerindians farther west. At Philadelphia and along the road, people also told the migrants that they would surely perish in the wilderness.

Food supplies arranged by Williamson were never adequate, and the migrants balked at such American dainties as corn cakes. They had been promised familiar foodstuffs. Berczy made private arrangements for provisions on the associates' credit and, when he found that most of the food Williamson assured him would be at Painted Post settlement did not exist, he again had to gather supplies from Americans in the area. Johann Heinrich Somerfeldt, a former Hessian sergeant who was now the migrants' baker, also scrounged for provisions. Somerfeldt told Berczy he "could stand it no longer and was so tired out" that he could not go on. He wrote that Berczy "begged me to help him and [said] he would pay me well – if I left them he would have to leave them too."[21] The settlers from the *Frau Catharina* reached Painted Post on 5 December. There Berczy learned that the second group under Liebich had landed at New York and had come to the Genesee via the Hudson-Mohawk route. Fol-

lowing the North American pattern for new arrivals, Williamson hired these people out to established residents at Friends' Settlement (a Quaker community) in return for their winter's keep. Berczy went to the settlement to retrieve these people, whom he regarded as part of his flock, because their contracts were with the association, not with Williamson, and the arrangement violated these accords. He had assured them in Germany that they would be placed on the land and not "sold" to Americans. Twenty-two men followed him back to Williamsburg to help erect cabins for their families. Williamson had pre-empted large blocks of land for his planned town and his own farm, and Berczy had to distribute the Germans between two sites in order to give each head of a household a 20-acre lot. He was obliged to have a bridge built across the creek separating the two settlements. By late January 1793, forty-five shelters were ready for the women and children who were brought in from Painted Post and Friends' Settlement. Some remained behind at Friends' Settlement and Williamson appointed Schott, the surgeon, to be his supervisor over them.

THE AGENTS IN CONFLICT

Berczy had ignored Williamson's request in November to consider "how People may get through the winter at as little expence as possible – consider on whom at last the expenses will fall;" and disregarded his recommendation to "keep them at the Painted Post all winter," where they could be easily provisioned.[22] Williamson was now determined to use his control over funds and rations to bring the refractory agent into submission. He lived at Bath, far from the infant colony, and was irritated by the bills from food suppliers with whom Berczy had contracted. In early January he requested that the recruiter "make no contracts whatever … expecting me on the part of the Association to fulfill them." As for Berczy's request for more cash, he replied

"I know of no need you can have for money excepting to provide provisions, and they are all provided … It is folly to think that your people can be ill off when they can get Indian Corn, Beef and Potatoes" from the company storehouse.[23] Berczy replied in mid-January, "I am here with all that people and find want of everything and I must always provide all in a hurry and in an unseasonable time. I must hear the complaints of the People and … their complaints are just…. You tell me I shall not trouble myself about money – with what shall I procure the necessarie[s] for the people?"[24] Charles Williamson would not pay local suppliers' bills, and it was no longer possible for Berczy to draw on the associates' account. Williamson destroyed Berczy's credit by publishing notices on 2 March that neither he nor the association would honour the German's debts. On his own recognizance, Berczy obtained a $450 loan from Ebenezer Allan and used this money to purchase earthenware, cooking pots, other utensils, and food for his colonists.

Berczy was summoned by Williamson to appear with his account books at Lycoming for a meeting in February, with the threat that "the most disagreeable consequences will attend Your not meeting me."[25] A subsequent letter was equally menacing, stating that should Berczy resist: "The people will soon find that they have been trusting to the Promises of a Man who has not the power of supplying them with one day's Provisions and revert with indignation on him … Your own ruin and the ruin of Your family is inevitable."[26] Schott was to inform the settlers that Williamson could "make them happy, but if they expect Assistance they must look to me for it not Mr. Berczy. I must undoubtedly have the power in my own hands, which he has not – but either from vanity or views very different from their interest, he has assumed a station he has no right to. I know only Mr. Berczy as a man who contracted to place the people in the Genesee and

was to receive a farm for his trouble.... I free You at once of all Contract from Mr. Berczy."[27]

At a tavern in Lycoming, with American employees and a lawyer present, the captain read out a letter to Berczy from the associates, regarding a dispute with the owners of the *Heinrich und Georg,* and interpreted it as proof that Berczy had defrauded the company. Berczy was shocked that Williamson had intercepted and read his correspondence and was shaken to learn that all the Genesee lands were legally registered in Williamson's name. He believed that he could sell Colquhoun's portion of the Genesee lands. The senior agent then upbraided Berczy for extravagance and for entering into unsanctioned agreements during the building of the new road, which Williamson now disowned. Berczy, faced with the possible loss of the benefits of his labour, demanded restitution of the private funds he had laid out for the colonists, and delivery of the lands promised him. Williamson was able to keep Berczy at Lycoming but could not break the bond between the colonists and their leader. He advised Berczy in March that the settlers "request as a favour that I would not prevent Your return to them" and authorized the sub-agent's return to Williamsburg, provided he set the people to work and made amends for his lavish expenditures.[28] Williamson eventually paid one creditor and promised that the settlers would no longer lack essentials. The associates' storekeeper at Williamsburg was unable to meet that promise: farming implements arrived late in May, and the man slaughtered over a dozen work oxen for food without adequate salt to preserve the meat. The result: fewer draught animals and rotten, maggoty flesh that the colonists refused to eat. This was not the first time they were offered inedible food. To provide wheat for the coming winter, Berczy bought 50 acres of unharvested grain. After Williamson defaulted on a promise to provide sickles and scythes for the harvesters, Berczy obtained them himself. When Berczy was ill for several

weeks, the colonists drew supplies from the associates' store on credit without consulting him, and his accounts were now in disorder. Williamson refused to give him land or money until the accounts had been sorted out.

The climax of the discord came in August 1793. On the 6th, fifty-two colonists signed a petition to Berczy drafted by Pastor Liebich, which listed their grievances against the association and its American agent, Charles Williamson. He, they stated, had not provided them with adequate food, tools, livestock, or even thread to repair their clothes. The rest of their clothing was in trunks detained by Williamson. Whatever the associates' store provided was sold at inflated prices. When Berczy tried to remedy deficiencies, Williamson obstructed his efforts. The migrants suspected that Berczy was indeed a "trafficker in souls" who had delivered them into bondage, but urged him to live up to his promises and have their agreement enforced by law: "Now is the moment to have this promise fulfilled."[29]

In January 1792, Berczy had assured Colquhoun: "I pretend not to have the direction of your settlement although it would be for myself the delightfullest occupation."[30] Williamson had foreseen the possible conflict, and his proposals presented to Berczy in March 1792 identified himself as "the Chief Agent of the Association" and designated Berczy "Deputy Superintendent of the Village under the Agent."[31] By May 1793 Berczy was reminding Colquhoun that "I am denominated Superintendent and director of the German settlement under the control of Captain Will[iamson] as Chief Agent," but with a share of the crops equal to that of Williamson.[32] Williamson tried to remove Berczy entirely because, as he told one settler, "Mr. Berczy has no further charge of the people ... I want to get from him the Indentures of the People to make them free as I am myself to sell them their farms.... Mr. Berczy has, I am told, said that the Lands belong to him – but you will all soon find that he has not

one acre in America – nor the means of supporting you for one day without my assistance."[33]

Charles Williamson's version of the conflict with Berczy has prevailed in the United States of America, in part, because of his patriotism. In 1781, Williamson had been captured at sea while en route to the British army in North America, and he spent the last two years of the revolutionary war as a prisoner on parole in the colonies. Here he married and, as his impressions of the country were favourable, decided to return and to stay. Williamson became not only an American citizen but also an enthusiastic defender of the United States' interests in the 1790s. Faced with such laudable sentiments, American scholars lose their critical instincts and readily accept his viewpoint. After the flight of the Germans to Upper Canada in 1794, Williamson shifted entire blame for the turmoil to Berczy. This was unjust since Williamson was responsible for much of what happened.

Through inexperience, lack of personal supervision, and the dishonesty of his suppliers, Williamson's arrangements for settling the recruits were inadequate. Many of his promises and assurances were unfulfilled. What is worse, he would not acknowledge these shortcomings and announced to all who would listen that the Germans were voracious idlers and their leader was a propertyless spendthrift "not worth a farthing." Berczy and the colonists knew of this defamatory campaign and were naturally hostile to the chief agent. Berczy did not conceal his frustration with Williamson and denounced him to Colquhoun for "mismanagement by negligence and by views of private interest."[34] "Captain Williamson," wrote Berczy on another occasion, "constantly promised that all should go well, that nothing should be wanting on his part; but till now, near not half of the most necessary thing[s] are effectuated; though I could have done it with the greatest ease if I had been at liberty to go my own way.... I am able to provide every article which is

sold to the People by C.W. at 60 p[er]C[en]t cheaper."[35] In retrospect, he judged Williamson to be "a man of words but not deeds."[36] The settlers were suspicious of Berczy, but thanks to Williamson's blunders, they had more faith in their countryman than in the Scot.

The colonists' loyalties were tested in a public meeting in August with Williamson at Williamsburg. He offered them food and clothing if they would abandon Berczy and if, after surrendering their original contracts with the association, they would become his dependants. A German-speaker called Mueller had made the same offer to the colonists at Painted Post, without success. Berczy had been offered a sub-agent's position and the young surgeon Schott was now acting as Williamson's deputed spokesman. William Cuyler, who also spoke German, had been installed in the Williamsburg store. Berczy spoke of the recruits as "my people" and he could not have resisted Williamson without their support. It was not a fellowship of equals: the Berczy family enjoyed superior living conditions and the help of two servants. Pastor Liebich was the only one with whom Berczy acknowledged some parity. When Berczy rode on horseback accompanied by his stable-boy, the men followed on foot. Leadership of the German colonists gave him social status in the New World, and the loyalty of his people would allow him to escape Williamson and find a friendly reception in Upper Canada.

Williamson's carefully-prepared *coup d'état* miscarried: his offer was rejected by the Williamsburg colonists. He then told them that as long as they remained attached to Berczy, he would "never give a farthing for their support."[37] That angered them and on the following day, after the surgeon reported that Williamson "would be very glad to be free of them, and ... give up all what they owed to the Association, provided they should leave the Country,"[38] they were furious. The surgeon was struck and they besieged Williamson and his few followers

in a house, demanding confirmation or denial of this rumour. Williamson's allies protected him, he wrote, from "the most savage and daring of the Germans." He likened the assailants to a Parisian revolutionary mob, and "for an hour and a half," he said, he was "expecting to be torn to pieces."[39] Williamson fled the settlement, while Cuyler went off to summon reinforcements.

On 10 August, Berczy initiated a prosecution for trespass against Williamson *and* Colquhoun and Pulteney, claiming damages of £10,000.[40]. He went to New York City, accompanied by four delegates of his colonists, to present their case against Williamson before the German Society there. The society existed to protect German emigrants in the United States, and the New York branch, after a complaint by Liebich, had already advised Berczy of its opinion that the Hamburg contracts were unjust and "not binding on the Emigrants."[41] Berczy would later confess that "for want of sufficient local knowledge, and misled myself by false insinuations, I had entered into contracts with my people, which for servants and farmers in Germany would have been highly advantageous, but which were not adequate to afford to them the means of subsistence in the United States of America."[42] On 30 August the German Society heard the complaints of maltreatment and of unfulfilled contracts and agreed to investigate, while seeking legal advice. One advisor, Benjamin Walker, suggested private arbitration.

In the meantime, Williamson had charged the Germans with a breach of the peace and, aided by a sheriff and sixty militiamen, descended on the settlement early on a September morning to disarm the men and arrest thirty protesters, including Pastor Liebich. Ten protesters were convicted of riot and put out as servants to Americans to work off their fines. If Berczy's testimony can relied upon, Williamson was in a vengeful frenzy: he denied the Germans any provisions, confiscated property including their baggage, and threatened them

all with eviction. He published a decree in October that no one could buy anything from the Germans since all that they had was his property.[43] Berczy, who was being prosecuted for a debt of £800, responded late in October with his own subpoena against Williamson not to trouble the Germans. "I saw the necessity to make preparations for self defence, and to contain Capt: Williamson's Spirit of arbitrary power by the force of the Laws," wrote Berczy, who credited the chief agent with a plan "to enslave the people and to overthrow my Contract."[44]

If Williamson's goal were to starve the mutinous settlers into submission, he was thwarted by their next move. As their dissatisfaction with him mounted, they learned of Lieutenant-Governor John Graves Simcoe's proclamation of 7 February 1792, inviting Americans to settle in Upper Canada on advantageous terms. These terms, they were told by "Various persons," were that "each husbandman could get 200 Acres of Land in free gift and 50 Acres for each of his children on the same conditions."[45] The "various persons" included Thomas Talbot and Edward Baker Littlehales of the Upper Canadian administration. Thanks to his secretary, Littlehales, Simcoe was aware of "the dissatisfaction of the German Settlers" and informed his own superior, Lord Dorchester, "It is more than possible that by degrees these People will emigrate into Upper Canada."[46] Their salvation, it seemed, lay just across the Niagara River.

FLIGHT TO UPPER CANADA, 1794

Berczy spent over four months in the winter of 1793–94 making arrangements for the removal of the settlers to British territory. He came to believe that, by Williamson's actions and dereliction, the chief agent had voided the contracts that Berczy and his colonists had made with the Pulteney Associates. He received no answer from Colquhoun or Pul-

teney to his letters about the dispute. Safely in Upper Canada in July 1794, Berczy penned a furious note to Sir William Pulteney, saying, "I was entitled to expect an immediate answer," and decrying the fate of his colonists "which you induced me to seduce by fair promises out of their native country to settle on your lands." He concluded that he was now "happy to find resources enough in myself to create means not only to save my people but to make them happier as they had never been if they remained engaged by you, if even you had fulfilled in all his extent the contract which you made with me."[47] Pulteney, for his part, blamed Patrick Colquhoun as much as Berczy for the debacle. William Berczy still wished to lead another venture in assisted migration but he would never again consent to be someone else's subordinate. Once more he showed ingenuity and enterprise in escaping his dilemma.

At New York City, Berczy conferred with Diedrich Conrad Brauer, representative of Carl L. Brauer and Son, Bremen merchants, who could transport more emigrants to North America. He also met Andrew Pierce of Southbury, Connecticut, who had a written promise of three townships from the Upper Canadian administration on condition that he settle each one with "Fifty loyal Families" within four years. Berczy saw this 1793 promise as a land title that he might buy from Pierce. The very fact that one could get so much land for the asking whetted his appetite. From George Hammond, British representative to the United States, Berczy obtained a letter of introduction to Governor Simcoe. The March 1794 letter simply described him as "a German, who is anxious to settle in upper Canada."[48] Resettlement of the Hamburg recruits and other Germans required financial help, and for that purpose Berczy drew together seven investors, including Pierce and Diedrich Brauer, to be known as "the German Company." With his settlers as capital, Berczy was given an equal share in the enterprise. The company charter was drawn up on 20 March. They intended to settle the Pierce concession with the Williamsburg settlers and to offer the Upper Canadian government a further 2,000 German migrants in return for one million

East of Newark taken from Valaces Tavern the 9th June 1794.

acres – equal to the Genesee Tract. Their profit would come from the sale of surplus lands after each assisted family had been given a 200-acre lot.

When William Berczy set off from New York City on 26 March, he had recovered his visionary enthusiasm. He met Liebich in Albany and instructed him to forward the supplies for the settlers to Upper Canada. German-speakers met en route were urged to join the move to British territory. Back at Williamsburg on 7 April 1794, he learned how Charlotte had arranged provisions for the colonists over winter, and he called them together to hear the offer of the German Company. Berczy recalled that the proposal was greeted "with loud and universal acclamations,"[49] but nearly twenty-five colonists held back. With the assent of the majority and signed pledges to reimburse him for all expenses, Berczy travelled to Newark (Niagara-on-the-Lake), the provisional capital of Upper Canada (fig. 22 and cat. 40). He had to wait eight days before Simcoe returned from a tour of the western posts. In the meantime, Berczy met Justice William Osgoode and First Secretary William Jarvis, who assured him of his probable success as a supplicant. Jarvis claimed to have a $2,000 interest in the Pierce concession. Berczy also used the time to visit Niagara Falls and to study a nearby water spring that could be set afire, showing that he still retained a Moll's scientific interest in natural phenomena.[50]

As predicted, Governor Simcoe gave William Berczy a friendly reception; Berczy had settlers who would speed the province's development, and Simcoe had a private reason for rejoicing. He disapproved of British capital being used to develop the United States: "It would give me great pleasure to see Mr. Pulteney's labours fruitless and ruinous."[51] Simcoe sped off to visit the site of the future capital, York, before the Executive Council could consider the German Company's land petition, which was in the hands of the talkative clerk, John Small. The request for a million acres astonished everyone, even if the petitioners claimed to be "attached to the British government."

By invitation, on 17 May, Berczy appeared before Simcoe and two councillors to present his case. When told that the first demand was excessive, the petitioner requested 200,000 acres, which could be sold in the German states. He withdrew from the chamber and the three officials discussed the matter. They decided "that a Tract of Land to the extent of sixty four Thousand Acres be granted, and that when they shall be properly settled, the Petitioner may be at liberty to make further Application."[52] When informed of their decision, Berczy assumed that the land would be between Lake Erie and the Thames River, close to the Pierce townships. The conditions of the grant were not clarified in subsequent meetings and dinners with Simcoe, although Berczy was offered use of the barracks and government storehouse at Queenston as temporary shelter for his colonists. The goods forwarded to Burlington Bay by Liebich were also allowed to enter the colony duty-free. Berczy expressed a preference for life under a constitutional monarchy, after his experiences in the great republic, and he provided Simcoe with military intelligence about the United States.

With the aid of Samuel Street the younger, a German Company investor, and Elijah Phelps, Berczy's host, transportation was arranged to bring the German settlers from the mouth of the Genesee River to Upper Canada. Williamson knew they intended to abandon him, and to dissuade them, he spread a story that the British officials would send them back to the United States. He had financial claims against Berczy and the colonists. A militia officer, some volunteers, and sheriff's deputies were paid to patrol the New York shoreline of Lake Ontario since the settlers were more likely to leave by water than traverse the 110 kilometres of forest between Williamsburg and the Niagara River. When Berczy re-crossed into New York State, Joseph Brant persuaded the Senecas to provide him

with a guide and the protection of some warriors. After meeting Brant at Dr Robert Kerr's house in Newark, Berczy became a warm admirer of the Mohawk war chief. He noted Brant's gentlemanly dignity, his "natural genius and penetrative speaking and reasoning about public and political subjects," using "the simple but striking oriental allegorick energy peculiar to all the Indian Nation." As he looked at the well-proportioned head of Brant, Berczy thought he could discern a resemblance to, even a hint of descent from "that great nation," the Chinese.[53]

In New York State, Andrew Pierce was arrested for debt while driving cattle to Upper Canada for the settlers, and Berczy went to Hartford to obtain his release from gaol. In June, not daring to risk arrest at Williamsburg, Berczy sent a message that the settlers who were willing to depart should assemble with their baggage at the mouth of the Genesee River to rendezvous with thirteen boats dispatched from Niagara on the 14th; the colonists had already constructed two barges. The three men in each boat were armed to deal with Williamson's friends. One hundred and eighty-six settlers eventually answered Berczy's call. Twelve vessels were loaded at once and the first passengers, despite a contrary wind, reached Queenston by 21 June. "From this time on," Berczy wrote in his diary, "I had my hands full taking in the livestock arriving from New England … and boat-loads of ploughing and farming implements from New York … as well as completing my land deal with the governor."[54]

DREAMS AND DISAPPOINTMENTS

The "land deal" in question was Simcoe's request that the location of the German settlement be moved to Markham Township, northeast of the future provincial capital, York. The colonists were to be used to extend Yonge Street north to Lake Simcoe and to provide an agricultural hinterland for the infant town. French *émigrés* under Count de Puisaye would be employed for the same purposes at Windham four years later.[55] Berczy claimed that he consented to relocation after Simcoe promised him another two townships. He agreed to open Yonge Street even though he considered the four lots of land offered to be inadequate payment for his expenses; he thought the road would facilitate access to the German settlement and raise the value of his lands to the east. In late July, Berczy, Liebich, a surveyor, and ten colonists went to Markham to examine the land. They were pleased with the quality of the soil and Berczy had already developed his plans: "In the middle of the Settlement I intend to build the Chur[ch] and parsonage house, and my own house with a territory of 400 Acres; and on the opposite side of the road I will establish the Doctor and a schoolhouse. In that manner the most distant of my settlers will have only about four and a half miles walk to the Church, to my self, to the Doctor and the school."[56] He was to be a country squire. To the southwest, on a branch of the Don River, Berczy would build a sawmill and a gristmill for the convenience of his settlers and their neighbours. These facilities became known as "German Mills."

When Berczy reported his observations to Simcoe at Niagara on 5 August, he learned "that the best part of the land promised to me [in York Township for his road-building] prior to my departure had been given to others during my absence."[57] Government officials and their friends had obtained location tickets for lands along the Yonge Street line, now that the road was to be opened and the area settled. Disgusted, Berczy decided to look for more land elsewhere, despite a debilitating recurrence of malaria. He contacted Joseph Brant of the Grand River Iroquois on the 19th, and in three days they reached a preliminary agreement to have 153,000 acres of Indian land sold to the German Company for $9,600. The sale was never concluded; the administration opposed it. In early September, Berczy

23.

Spot of 200 Acres along River Nen destined for the building of a Town..., n.d., by William Berczy.
Collection: Service des archives de l'Université de Montréal (P 58, Q2/28).

was prodding the government surveyor to have the division of Markham Township completed, and dispatching men to the site to begin clearing the trail into it. The deputy surveyor only delivered a draft survey map in late October. This tardiness kept the colonists inactive at Queenston, when they might have been clearing land and planting a crop that autumn.

Illness prevented the Berczy family from sailing from Niagara to York until 8 October. At York, William had arranged for the construction of a house for them and a warehouse for the settlement; he rented another house as a temporary shelter. Later in October, Berczy and the men entered the surveyed lands of Markham Township, drawing lots for settlement. Poor communications between Markham and York disheartened several settlers, who retreated to the town. While seeking a mill site, Berczy happened upon the Nen [Rouge] River flowing south to Lake Ontario. Simcoe had mentioned Philippe-François de Rastel de Rocheblave's proposal of a short portage route to the Upper Great Lakes via a road north from York to Lake Simcoe and thence to Matchedash Bay on Lake Huron. It occurred to Berczy that the Nen might be a waterway into his settlement and a part of the portage route; he found its mouth on the lakeshore and traced it inland. With the river course cleared of snags, and a canal link to the Holland River flowing into Lake Simcoe, he would have a great commercial artery passing through his own lands. At York on 13 November, Berczy shared this dream with Governor Simcoe, who promised Berczy wharf sites at the Nen's mouth (fig. 23). A crude wagon road to Markham had been completed by the 8th and Simcoe was impressed by the work done. The lieutenant-governor offered Berczy commissions as a justice of the peace and a militia captain. The magistrate's office was declined, since it might divert Berczy from his colonizing work, but he agreed to organize and train his settlers to defend the colony.

Berczy was off again to inspect a sawmill site on the Don River and to direct workers building a bridge there, as well as those working on his country and city houses – one styled "Berczy Hall." By December the road north to the present site of Unionville was complete and the German settlers started moving onto their lots along concessions 2 to 7 in Markham Township. The first concession, clos-

est to Yonge Street, was withheld from them. Lateral roads were then constructed. In January 1796 huts were completed and land clearing was under way. The settlers now possessed pioneering experience which sped their work as road builders and land clearers. The Berczy family remained at York where William associated with the administration's inner circle, which was gathering in the new capital. He had no intention of becoming a frontier farmer and expected his new house on Palace (now Front) Street to be his principal residence. When his men would have been better occupied tilling the virgin soil, he employed them in clearing the Nen River's watercourse in the summer of 1795. It was all in vain: the Nen proved to be too shallow for navigation and the portage route continued to follow the Don River. Moreover, Berczy was informed that

the river-mouth location had been pre-empted by another colonist in 1793.

In the best of circumstances, it would have taken a few years to render the settlers self-supporting and prosperous. The harvest of 1795 was modest and the newcomers still depended on food from Berczy. In September the flour ran out. A third of the pioneers retreated to Niagara, Burlington Bay, and York, where skilled tradesmen could find work to carry them over the coming winter. By February 1796 those who remained on the land were in "extreme distress" caused by a "general scarcity of provisions." Simcoe allowed Berczy to draw flour, rice, peas, and pork from the military commissariat against his own credit. The dry summer of 1796 ensured that hunger persisted, with no prospect of a bountiful harvest. The New York associates of the German Company had supported the colonists for over two years, and were uneasy about the delay in granting the land titles that they had expected to receive for their 1794 application. Two, Colonel Fitch Hall and Timothy Green, were dispatched to investigate the progress of the land claims and the veracity of the mounting bills, which exceeded £8,300 in New York currency. Simcoe had repeatedly promised Berczy that the Executive Council would attend to his titles, but nothing had been done when the Simcoes departed from Upper Canada in July 1796. Berczy expected, in conformity with the 1792 proclamation, that patents would be issued within six months of the survey warrants. The departure of Governor Simcoe marked the turning point in Berczy's fortunes, which plummeted thereafter.

A "MISERABLE ALIEN"

Peter Russell (fig. 24 and cat. 59), interim Administrator of Upper Canada, was less generous than his predecessor. Instead of giving Berczy millstones for his gristmill, as Simcoe had promised, Russell released a pair from the King's stores in November 1796, on condition that the German give bond to replace them in nine months' time. He also pressed Berczy to pay for the food from the commissariat with money rather than in kind. The Executive Council took a harder line with the colonizer. In May it decided that the four lots promised to Berczy for extending Yonge Street, "on condition that he laid out Yonge Street in the same Manner as Dundas Street, and Compleated the same in one Year from the 15th of September," were forfeit "from a failure in the Conditions." The council acknowledged that the delay was partly due to "the sickness of the Labourers" and that Berczy had spent money on the project, and they recommended a compensatory land grant elsewhere.[58] Berczy had charged the German Company for the road-building and other improvements, so he did not lose financially.

The foreign origins of Berczy and his colonists provided the next obstruction to their hopes. Back in March 1795, when it had been pointed out to Simcoe that Upper Canadian land titles might be resold to aliens or persons who were not natural-born British subjects, he wrote, "I suppose all American Born antecedent to 1783 to be Citizens unless they have taken the Oaths to the States."[59] This lenient assumption that all persons born in the former thirteen colonies before British recognition of the colonies' independence in 1783 were British subjects by birth permitted land grants to Americans after they had sworn a simple oath of allegiance. Foreign applicants born outside the British dominions could not be given land until they had been naturalized after seven years' residence in His Majesty's possessions. This conformed to the 1740 naturalization statute, and this policy had been communicated to Lord Dorchester and Lieutenant-Governor Simcoe. Berczy never concealed his origins or those of his followers, and yet no one had mentioned the restriction on land grants to foreigners before October 1796, despite his repeated applications for title over the previous two-and-a-half years. In that month, Russell and the council expressed their regret that

24.
Peter Russell, 1803–04,
by William Berczy (cat. 59).
Private collection.

"by an oversight" Berczy had not been informed that, as an alien, he could not receive a land patent. He and his colonists would not be eligible until 1801, and then only after naturalization. Berczy was astounded and dismayed by the government's apparent retreat from the initial agreement. He was already a militia captain, a post reserved for British subjects with 500 acres or more of land. Because the government was accustomed to dealing with British nationals or presumed subjects from the United States, such an oversight was possible. Berczy swore the oath of allegiance and was certified eligible to be "a freeholder of lands" in July 1797. The Berczys received two town lots at York in that month.[60] The administration's delays, which Berczy saw as deliberate procrastination, were probably also caused by the surfeit of claimants.

For the two German Company investigators, who had arrived in Upper Canada in late 1796, the

naturalization issue was the last straw. Tracts of land that could be sold had been the object of their investment; now, it appeared that nothing would come to them for years. One delegate, Timothy Green, gave Berczy full power of attorney to pursue the land claims and, with it, financial responsibility for the Markham settlement. The New York associates' previous reluctance to honour Berczy's drafts against them became an absolute refusal to pay anything more. They had already discontinued his salary as their agent. Berczy still hoped to persuade Diedrich Brauer and Samuel Street to grant him credit. He resorted to building contracts in 1797 to provide an income. Andrew Pierce's entitlement to three townships, which the associates had bought, was also about to evaporate.

In September 1796 the surveyor-general of Upper Canada called upon all claimants to "appropriated Townships" to report on the settlers established with-

in those townships.[61] Colonial administrators were disillusioned by the failure of Simcoe's 1792 proclamation to produce revenue or attract many settlers; they also regretted the large size of his land grants. Offering large tracts to leaders with associated colonists who would settle in the colony, merely encouraged speculators to present padded lists of committed settlers to win proprietorship of a township. Most township claimants never lived up to their obligations. The township concessions were rescinded upon the Executive Council's recommendation of 3 July 1797. Lower Canada's Executive Council had taken the same course a month earlier. There was a strong suspicion, which Berczy shared, that the councillors wanted to free appropriated lands for their own use. This decision affected Markham Township as well as the Pierce claims. Since Berczy had fulfilled part of his promises, unlike most grantees, he petitioned for an exemption from the general cancellation of township concessions, and he annexed lists of the settlers he had established. The councillors, sitting as a land board, gave a curt response on 13 August: "The Board regrets that it cannot consistently with the general rules laid down in its Report on the Townships, make any exception in favor of Mr. Berczy."[62]

The previous October, Peter Russell had suggested a compromise for Berczy, by which every established head of a family would be confirmed as the owner of a 200-acre lot, while Berczy and three of his associates would each be entitled to 1,200 acres, free except for survey charges. He would have up to two years in which to settle people on the unoccupied balance of the 64,000 acres at the ratio of one family head for each 600 acres.[63] The Executive Council rejected this conciliatory proposal, and Berczy did not like it either. He protested that "such terms would not afford a compensation adequate to the difficulties, costs and risks" and argued that "the 64,000 acres had been granted in consideration of the first 60 settlers which I had promised to bring."[64]

In May 1794 the council under Simcoe had ordered that a 64,000-acre tract "be granted" to the German Company associates on the condition that it be "properly settled." To confirm that the tract was "granted," and was not an "appropriated" township, Berczy asked Chief Justice John Elmsley at York if he might examine the minute book himself. Elmsley claimed that he could not find the book and departed in haste for Newark. A subsequent request to see the record of the council's proceedings in 1794 brought the surprising response from the clerk that Elmsley had taken the book with him to Newark. This charade helped convince Berczy that he had a case. Believing that he had lost his copy of the 1794 resolution in a fire, Berczy applied in October 1796 for another official copy, only to find that the clerk had substituted the word "appropriated" for "granted" in the duplicate. The clerk also refused to provide duplicates of his earlier petitions, which had also burned. Furthermore, Berczy and his followers arrived for meetings with the council that were then postponed. Berczy was now certain that justice was not to be expected from the Upper Canadian administration and that he must appeal to a higher authority. In March 1798 he composed two petitions to King George III and his ministers in Britain, which described at length the grant and promises of land made to him, his labours and expenditures to settle loyal subjects in Upper Canada, and his past dealings with the colonial administration. The purpose of his narrative was to show that he was "not under the Description of those Nominees to which Townships were appropriated so as stated in the Address of the [Land] Board to the President [Peter Russell]."[65]

Berczy started out for Britain in April 1798 to present his petitions in person. He had reason to pause in Lower Canada. There the expropriated claimants to townships were organizing a collective petition to the British crown, and their case was favoured by Governor-General Robert Prescott.

The governor-general recommended that each claimant be given a fraction of the original tract proportionate to the expenditures and improvements made to the land. For example, a grantee who had surveyed the land and was willing to take up immediate residence on it should receive one-half of the original concession. Prescott felt that the British crown's good faith was at issue and that Berczy was a perfect example of the victimized claimant whose labours entitled him to full satisfaction. Delays in surveying and the reluctance of the commissioners to receive the special oaths of loyalty demanded of claimants suggested deliberate obstructionism by the colonial administrators. As in Upper Canada, the Executive Council was the centre of resistance. Berczy joined the petitioners and, to embarrass the council, he published a pamphlet called *Extract from the Minutes of Council* (Quebec, 1798). The pamphlet publicized Prescott's recommendation, and disclosed the council's specious objection that leniency would encourage squatters and a seditious spirit. Chief Justice William Osgoode described Berczy as "a wrongheaded meddling Fellow ... made a Tool on the present occasion" by Samuel Gale, the governor's secretary.[66] This embarrassing publication and subsequent conflicts between Prescott and the councillors, some of whom were indeed land speculators, led to the governor-general's recall in April 1799. The Secretary of State for Colonies, the Duke of Portland, shared the council's view that a firm approach should be taken with delinquent grantees, and he had great respect for Osgoode's opinions.

Knowing that Prescott's plan to satisfy the claimants had been forwarded to Upper Canada, Berczy delayed his departure to Britain and returned to the upper colony to press his case in the autumn of 1798. A short visit to New York revealed that even a personal plea would obtain no financial help from this quarter. Two German Company associates refused to pay any more assessments levied on the shareholders, Samuel Street had withdrawn from the

venture, and Diedrich Brauer was dying. Berczy's second appeal to Upper Canada's Executive Council that he be exempted from the cancellation of township appropriations was rebuffed. In October 1798 the councillors expressed their satisfaction with the "Justness of the Principles" in their previous decision.[67] Berczy's personal debts now reached £5,000 yet he managed to obtain a year's guarantee against seizure for debt from the merchants Joseph Forsyth and John Gray, with all of his property as collateral. Gray was also to pay Charlotte Berczy a small pension. William authorized the sale of his farm livestock and implements to raise money. One creditor still obtained a writ for his arrest despite these efforts at partial restitution. Berczy's financial decline was matched by his shrinking credit with the Upper Canadian administration.

Berczy may have wondered at the coldness of the officials whose favour he had courted. He had offered the hospitality of his house to councillors attending the sessions at York (see fig. 25). To oblige Peter Russell's sister, he had surrendered a choice lot on Palace Street in exchange for an inferior location. He had been deferential and had accommodated his plans to Simcoe's wishes. Yet it availed nothing. He did not realize that he was under a cloud of suspicion and disrepute. Charles Williamson's assertions that Berczy had absconded with his property as well as with the German settlers received wide currency in the United States; they were published as fact.[68] Williamson denounced Simcoe to Henry Dundas, Lord Melville, a British cabinet minister, for enticing his debtors to seek refuge in Upper Canada.[69] Travellers, such as the Duc de la Rochefoucauld-Liancourt, who visited Williamson, heard his highly coloured account of Berczy's low character. The duke then published Williamson's story, that he:

> [*Williamson*] *put himself to the heavy expence of transporting eighty families hither from Germany; which*

25.

York on Lake Ontario, Upper Canada in 1804,
by Elizabeth Frances Hale.
Collection: National Archives of Canada, Ottawa
(C-40137).

should have been selected from among the inhabitants of Saxony; but which his agent at Hamburgh chose from among the crouds of foreigners, whom poverty, idleness, and necessities of every kind, induce to resort to that mercantile city, with a view to emigration. These families, which on their arrival here were placed on small farms, have not however cleared the land alloted to them. Being maintained from the first out of Captain Williamson's stores, they did not so much as work on the roads, which they were to finish; and their leader, ... after having rioted for some time in idleness, drunkeness, and debauchery, at length ran away, with the whole set, to Canada; being gained over, if we may believe common fame, by the English.[70]

Sir William Pulteney also attracted sympathy as a British gentleman who had suffered a loss by Berczy's conduct.

More damaging than these tales of Berczy as a scoundrel, or of his colonists as vagrants from Hamburg's docks, was the belief that he was politically dangerous. His participation in the dispute between Prescott and his council identified him, in the eyes of the colonial oligarchy, as a troublemaker. Osgoode denounced this "miserable Alien" to Russell and to correspondents in London, including John King, Under-Secretary of State for Colonies. As Berczy once again prepared to set out for Britain in October 1798, he made common cause with Asa Danforth, another township claimant, whose lawyer issued caveats against the disposal of their lands to other persons. The lawyer employed was William Weekes, a relentless critic of the administration. Berczy was thus identified with the enemy camp and, when he was absent in England, some of them, including Asa Danforth, conspired to overthrow the provincial government. To gossiping tongue-clackers, Simcoe's welcome for the Germans was now perceived as extravagant folly. Upper Canada was to have been populated with loyal landowners, but instead an alien with a tarnished reputation was encouraged to bring in a troop of foreigners with financial support from an American company, whose legal advisor was the radical revolutionary

Aaron Burr. Burr still sympathized with the French republic after the Terror; the Jacobin revolution was the antithesis of all that the conservative colonial oligarchy hoped to establish in Upper Canada. Fear of Berczy was fed by "a confidential communication" relayed to Peter Russell by Robert Liston, the British representative at Philadelphia, in October 1797. Liston wrote:

> It has been suggested to me that there actually is a company in this Country that has formed a project for a large purchase and settlement in Upper Canada, of which the leading though not the ostensible managers are men of high-flying democratick sentiments, who would rejoice to see a Republick established in Canada in the place of the present monarchical Constitution. The men I allude to are Mr. Burr of New York, Mr. Boudinot of New Jersey, and others of the same stamp … Their principal agent is said to be a person of the name of Berzile, who is settled with a number of Germans (from the Genesee Country) on the north side of Lake Ontario, about fifteen miles from Toronto.[71]

The identity of "Berzile" would have been clear to Russell. The colonial administration feared a democratic revolution, especially in Lower Canada, where the *Canadiens* were thought to be most susceptible to French revolutionary propaganda.

Berczy responded to some of the published stories about Simcoe enticing the Germans to desert the estimable Captain Williamson,[72] but he was not aware of all the charges being murmured against him. He could only complain of "the secret motives" and "intrigues" of "designing advisers" on the Executive Council. He went on to damage his own case by altering the facts. He wrote of the "considerable sums" he personally spent while relying on the government's good faith. In reality, he habitually operated with borrowed money or against the credit of others; most of what he earned by his art went to the support of his family. Elaborate computations were used to show the costs incurred.

Skeptics doubted his initial claim that he had lost £15,000, but near the end of his life, he was complaining of a loss of £38,500 sterling.[73] Berczy also demonstrated mathematically that 64,000 acres did not correspond to a township. He was deliberately vague in describing how his Hamburg recruits came to North America, and he wrote that they "had followed me at my expense from their native country."[74] Nor did he mention how intolerable their situation in New York State had become. According to his version of events, the departure was an orderly move after mature reflection on Simcoe's offer and the merits of constitutional monarchy. At some point, Berczy decided that the 64,000 acres promised in 1794 were *in addition to* any land settled by the colonists, and that the grant belonged *to him alone*; the other German Company associates were forgotten. Ever persuasive in conversation, he convinced himself of the truth and justice of his claim. He never fully explained how he came to this conviction, although Green's transfer of financial responsibility for the Markham settlement to Berczy might have justified a greater share of the benefits. Berczy, on the other hand, refused to be answerable for his associates' debts. He was realistic enough to heed advice to let the Pierce claims go, yet his obstinate insistence that he was personally entitled to 64,000 acres harmed his reputation and brought him nothing but grief.

At the same time that Berczy was demanding the entire 64,000 acres for himself, he was using the prospect of the long-delayed grant to sustain the interest of his surviving associates, who expected to share in the land grant. They voted assessments to aid their agent; only the executor of the Brauer estate, Judge Elisha Boudinot, sent Berczy remittances. Berczy continued to play upon the hopes of his hapless business partners to draw money from them.

His autobiographical writings were equally self-serving. Berczy kept small diaries and account books

in German and, later, he supplemented these cursory entries with his memories in journals, usually written in English. After 1798 these were reworked for publication as literary narratives, in the form of personal letters. At each stage history lost ground to invention; dialogues were re-created and the prose became clouded with verbose circumlocutions which he mistook for elegant style. Every writer is the hero of his autobiography, with Berczy this was doubly so – one narrative even calls him "our hero." In the final epistolary narratives, he is the romantic whose sensibilities are constantly touched by nature's grandeur. He presents himself as the wise, fatherly leader of a devoted band of followers. Opponents are identified by initials alone, and Schott, the surgeon, is an anonymous villain. Much of what we know of Berczy's life comes from his own hand and these much-rewritten narratives show the man as he wanted to be seen.

Rather than bringing him back to reality, as is a wife's office, Charlotte endorsed William's belief that he was a self-sacrificing benefactor of mankind deceived and abused by an ungrateful administration. She and the children moved to Montreal from York in 1798. After Berczy's second rebuff by the upper Canadian government, it was too late to sail for Britain. William spent the winter of 1798–99 at Quebec, where he earned money for the trip to England by making portraits. It was a congenial pause, since he was well-received by *Canadien* notables and by the governor-general's circle.

SUPPLICANT TO THE CROWN, 1799–1802

In England, too, Berczy found a sympathetic audience. He used his connections and his art to win the favour of those who might help his case. Copies of portraits made in Canada were shown to the sitter's relations and friends. The paintings were his "very strong letters of recommendation" and he hoped to win other allies with his paintbrush. To Charlotte he wrote, "I will make use of this charming art without being an artist; I will not present myself as an artist who needs something for his subsistence."[75]

Governor Prescott's companion, Dr J. Mervin Nooth, had given Berczy a written introduction to Sir Joseph Banks. Sir Joseph was on the Privy Council of the Board of Trade and Plantations and presented the colonizer's case to cabinet. Samuel Gale and Alexander Davison, former legislative councillor in Lower Canada, advised Berczy on the means to forward his petition for a mandamus compelling the Upper Canadian government to give him a patent for 64,000 acres. Aided by such redoubtable advocates, his cause advanced, although at glacial speed. Berczy had arrived in London in July 1799 but his case was not presented to the British cabinet until February 1800. In October, he had been consigned to King's Bench debtors' prison at the behest of his two Italian partners in art-dealing. Berczy had absconded with £420 of their money when he left England in 1792. After eight months' incarceration he persuaded them to accept his bond to repay them and was released.

Berczy's land petition was referred to the Privy Council for Trade and Plantations whose chairman, Lord Liverpool, appointed a three-man investigative committee. One of the investigators was John King, who had been predisposed against Berczy by Osgoode. King's absenteeism delayed the committee's work until March 1801, when the two others were ordered to proceed without him. They heard Berczy and reported favourably on his claim. In June 1801 the Privy Council advised the Duke of Portland, as minister responsible for colonies, that "the Lords of the Committee are of Opinion that a Grant should be made to Mr. William Berczy, of the said 64,000 Acres of Land; provided that it shall be made [to] appear to the Lieutenant Governor and Council of Upper Canada, that the Circumstances stated by Mr. Berczy are substantially correct."[76]

Berczy had won a moral victory and yet secured nothing, for the council's stipulation gave the colony's executive the power to judge whether his allegations were true or not.

The Executive Council of Upper Canada was no more disposed to entertain Berczy's case in 1801 than in the past. In its response of 31 October it described the system of granting tracts to agents of associated colonists as a means of attracting American Loyalists, which then became an open door to fraud. It denied that 64,000 acres, above what was settled by Berczy's colonists, was to be given away, and asserted that the royal bounty belonged to the German Company associates and not to Berczy alone. That bounty was limited to 1,200 acres each for four leaders. The council argued that the 64,000 acres reserved were a township and that Berczy had admitted as much by allying himself with the expropriated township grantees. It did not consider Markham Township "properly settled" by the introduction of sixty-four families, who actually amounted to only forty-seven after subtracting Americans who joined the migrants at Niagara, those who had died, and incomplete households. While the councillors revealed contradictions and exaggerations in Berczy's claim, their own prejudices seeped out in references to the petitioner as "an unknown and unaccredited Adventurer" and to his followers as "miserable wretches, the refuse of the streets of Hamburgh." Here the corrosive effect of Williamson's stories on Berczy's reputation is evident. The council concluded that "Mr. Berczy's Statement … has no foundation in truth, and … is a mere fabrication, the last desperate effort of an Adventurer endeavouring to retrieve himself from a difficulty into which his own folly, and his own want of prudence and good faith has involved him." He, they added, had caused the financial ruin of his associates and his own distress by his "inconsiderate and extravagant" mismanagement.[77] John Elmsley, Berczy's old nemesis, signed this confidential reply

to the Duke of Portland. William hastened home to press his claim, abandoning a project to have Louis Charland and William Vondenvelden's map of Lower Canada engraved, which he had undertaken to do to help finance his trip. After a stormy voyage, which grounded his ship in the Baie des Chaleurs, Berczy made a winter trek overland to Quebec City. He arrived there in March 1802, only to find that the new Lieutenant-Governor, Peter Hunter, had already forwarded the council's response to England without comment.

FINANCIAL EXPEDIENTS AND BITTER MEMORIES

Berczy's creditors were pressing hard after his two-year absence, and he went from Montreal to York in June 1802 to salvage what he could from the property entrusted to Joseph Forsyth. He was emotionally and materially exhausted. Since the foreign migrants had now completed the seven years of residence required for naturalization and freeholder status, they were entitled to patents for the farms they occupied and cultivated. In 1804, Berczy himself received title to 900 acres in Markham Township in addition to the town lots granted in York. Some of his colonists resisted voluntary repayment of what they owed him; they no longer needed him. When Pastor Liebich encouraged the resisters, Berczy judged him "deranged in his mind."[78] He sacrificed the bond that had once existed with his colonists by legally compelling them to pay their debts in either land or goods in 1802–03. From some he obtained power of attorney to apply for their land grants. He thus acquired title to an additional 4,800 acres and paid his debts with land and goods. It was the only course left to answer his own creditors, who were also impatient. Somerfeldt, who had been repeatedly promised payment by Berczy, felt he had been duped into releasing the leader. According to the former sergeant, Berczy replied: " 'Sommerfeldt, I have settled with all the others except you and I

26.
The Don River Bridge, 1802,
by William Berczy.
Collection: National Archives of Canada, Ottawa
(NMC-5044).

know you owe me nothing. Put your name at the end of this [paper]; in three days I will come out and give it to you back.'" "But," Somerfeldt wrote, "he went away and did not give it back to me."[79] The leader of the German colonists was now simply Berczy the artist. He survived on occasional commissions, such as designing a bridge over the Don River (fig. 26) and preparing an estimate for a new Anglican church at York, and he may have accepted some portrait work.

Colonial officials in Upper Canada masked their feelings to Berczy, but he knew by 1803 that they had destroyed his case in Britain. He interpreted their silence about his petition as an implicit judgement that his allegations were false. Berczy believed that others had come to the conclusion that he was a liar. In the autumn of 1804 he rejoined Charlotte in Montreal, leaving to William Allan the management of his properties and to William Weekes and Attorney-General Thomas Scott, the pursuit of his debtors. His agents only obtained part of his proper-

ties' value because the Anglo-French Wars had depressed the market. German Mills sold for half their estimated worth. Berczy explained his choice of living in Lower Canada as one dictated by potential patronage for his artistic skills: "Literall[y] without anything and [not] being able to support myself any longer in Upper Canada … I retired to Lower Canada confiding for all resources only in the talents with which providence has blessed me, which however would have been of no assistance in Upper Canada but could afford me a tollerable subsistance at Montreal or Quebec."[80] The upper colony was also the scene of his humiliation and home to enemies who, he believed, had reduced him to poverty. Berczy affected the air of one who could rise above adversity, but he was bitter. In 1806 he wrote to a friend in London, "The Privy Council has examined my Claims – has endeavoured to rectify the wrongs which I have suffered and … these measures have been made abortive again by the further trickish contrivances of the Provincial Administration …

in consequence of these continued accumulation of errors and injustice I have been finally ruined." Characteristically, he concluded, "I am resolved not always to suffer tamely."[81] To Boudinot he confided, "I believed it impossible that a Government, even composed of individuals of the worst moral character, should be capable of degrading itself so far as to descend to the lowest and meanest (and most absurd) tricks."[82] Only his love of public order and respect for the British government, he told one correspondent, kept him from denouncing his persecutors publicly. His pose as a gentleman financially ruined by a faithless administration served to explain his present, humble circumstances.

To Jacques Viger in 1811, Berczy avowed that he now scorned the company of "so called great men," and regarded the *Canadiens,* by contrast, as "so honest".[83] In his own mind he was a blameless martyr. An autobiographical maxim he wrote expressed this view: "It is the general and almost inevitable fate of extraordinary merit to excite the relentless persecution of envy."[84] "It remains to me now only the consoling conviction that I uniformly fulfilled my duty as [a] man towards my fellow citizens and as a subject towards the Government."[85] He could have led thousands of Europeans to a happier land and fostered Upper Canada's growth at no cost to the government, were it not for the opposition of small minds that could not rise above their account books and their jealousy of someone greater than themselves.

During the remaining years of his life, the old mirage of wealth and status as a settlement promoter haunted Berczy. In London he vainly sought an interview with Sir William Pulteney to defend his actions and, possibly, to re-establish some business connection. The replacement of Elmsley as chief-justice by Henry Allcock, a friend, in 1805, revived Berczy's optimism. The arrival of each new official gave him hope. He spoke to Francis Gore, Upper Canada's incoming lieutenant-governor, and in

1810 he presented a memorial to Governor-General Craig offering his services as a recruiter of German immigrants in the United States. He recited his case to anyone who would listen, including the Anglican Bishop of Quebec. The bishop's family and those best placed to help his case received preferential treatment in art lessons and as subjects for portraits. In the evenings Berczy and his son William copied out memorials, supporting documents, and accounts of his noble enterprise and the undeserved "wrongs ... suffered" at the hands of the Upper Canadian administration.[86] That government had deprived him, he wrote, of his rightful property and had stained his honour. Berczy also laboured on his three-volume topographical, statistical, and historical description of Upper and Lower Canada, which incorporated his detailed observations as a traveller as well as information copied from other works. The Montreal historian, Camille Bertrand, has observed that "no man ever wrote so much and published so little."[87]

Berczy's last trip was to New York to seek a publisher for his historical and autobiographical manuscripts and to meet those with interests in the dormant German Company. The seller of great dreams attempted once more to draw money from the associates. He held out hope that their investment might yet be repaid. In October 1812 he spoke optimistically of the claim's prospects and of his influential contacts at Quebec. His listeners were asked to finance another trip to England "to take recourse to the supreme authority." Action must be immediate since "harassed & tormented by our remaining Creditors ... my very existence and the welfare of a beloved family urge me not to lose inutily [uselessly] a moment's time." He demanded that they pay one-half of all his estimated expenses as their agent since 1797 and he offered to submit the balance to arbitration – this notwithstanding the fact that he had already pursued the Markham settlers for restitution of his expenditures. The associates protested that

much of what he had done had been undertaken without their approval or authority. Finally, he asked each associate to give him $300 in return for the promise of 1,000 acres from the eventual grant, while relinquishing all further claims.[88] Burr and Green were prepared to advance him the money, but Berczy never made the second trip to England; within four months – in February 1813 – he was dead.

After the War of 1812, Upper Canada's Executive Council made amends for its treatment of the exiled German. In 1818 it ordered a grant of 2,400 acres to his elder son, William Bent Berczy, "as a full and sufficient remuneration" for his father's claim.[89] There was no doubt about the son's loyalty to the crown; he had served as a British officer in the War

of 1812. William the younger achieved his father's ambition to become a gentleman of property. William Berczy's own hope of joining the landed gentry through land speculation and the promotion of colonization had brought him debt and distress. He saw himself as a gentleman whose intellectual attainments qualified him to be a leader of men but, as he wrote in his last letter to Charlotte, "as a result of the most atrocious injustice, I find myself in a situation where I ought not to be."[90] Whether his financial embarrassment was the result of his own impulsive nature or of the machinations of others, we can be sure that hardship forced him to resume his artistic activities in the New World, thus leaving a substantial legacy in art to future generations.



NOTES

1. RHS, *Publication Series,* 20 (1942), pp. 253–60. A condensed version is in the Ontario County (N.Y.) Historical Society, Pulteney Estate Papers, Minute Book, p. 185.

2. SAUM, S/18, boîte 11442, p. 2: "Report of my Transactions from the 17th July 1792...."

3. SAUM, boîte 11441, registre 76a, p. 4: draft letter, Berczy to Colquhoun, Hamburg, 30 Dec. 1791.

4. Staatsarchiv Hamburg, Senat, CL.VII, Lit. Gg, Pl, no. 1, vol. 17, fol. 251, "Erneutes und geschärftes Mandat, wider das heimliche Anwerben," 13 July 1764 (renewed in 1778, 1780, and 1785).

5. Redemptioners were passengers who could not pay for all or part of their passage and, upon arrival in the New World, sought out a colonial sponsor to pay the cost of their transportation in return for so many years of labour. Indentured workers had already made a contract in Europe with a colonial employer or with the shipowner, who could sell the contract, which pre-determined the conditions of service in the Americas. In theory, a redemptioner had greater bargaining power.

6. Staatsarchiv Hamburg, Senat, CL.VII, Lit. Gg, Pl, no. 1, vol. 17, fols. 127–34: Berczy's recruiting pamphlet.

7. SAUM, boîte 11441, registre 76a, p. 15: Berczy to Colquhoun, Hamburg, 30 Dec. 1791–4 Jan. 1792.

8. RHS, *Publication Series,* 20 (1942), pp. 261–65: "Propositions to be made to Mr. William Berezy [sic]".

9. SAUM, boîte 11441, registre 76a, p. 19: Berczy to Colquhoun, Bremen, 10 Jan. 1792.

10. R.B. Strassburger, *Pennsylvania German Pioneers ... Lists of arrivals in ... Philadelphia from 1727 to 1808* (Norristown, 1934), vol. 2, pp. 50–51.

11. SAUM, boîte 11441, registre 76a, p. 3: Berczy to Colquhoun, Hamburg, 30 Dec. 1791.

12. SAUM, boîte 11441, registre 76a, p. 31: Berczy to Colquhoun, Hamburg, 7 Feb. 1792.

13. Zentrales Staatsarchiv Merseburg, Königl. Geh. Staats-Archiv. (Preussen), Acta der Gesandtschaft zu Hamburg, 1792, fol. 59: "Mandat über die Colonisten Werbungen," 7 May 1792.

14. SAUM, boîte 11445: loose pages, draft letter titled "1st Variante." There is a second version six pages long headed "Fragmente mein Privat Unternehmen" in the same box. They are translations of a German letter dated Genesee, 20 Feb. 1793 [SAUM, S/29, boîte 11443]. In it the phrase is "ungeachtet ich kraft des Machtspruchs der deutschen Fürsten und eines hochweisen Magistrats von Hamburg aus meinem Vaterlande sozusagen forascribiert und des Hängens würdig erkannt bin."

15. SAUM, boîte 11441, registre 76a, p. 37: Berczy to Colquhoun, Bremen, 9 Feb. 1792.

16. Two invaluable accounts of Berczy's recruiting venture are Horst Dippel, "German Emigration to the Genesee Country in 1792: An Episode in German-American Migration," in Hans L. Trefousse, ed., *Germany and America: Essays on Problems of International Relations and Immigration* (New York: Brooklyn College Press, 1980), pp. 161–69; and Beate Stock, "William Berczy als 'Seelenverkäufer'," in Karin R. Gürttler and Edward Mornin, eds., *German-Canadian Studies: Interrelations & Interactions,* Annals 6 (1987), pp. 109–27. I am especially indebted to Dr Stock who allowed me to examine her copies of documents from Germany and Denmark.

17. SAUM, boîte 11441, registre 76a, p. 41: Berczy to Colquhoun, Hanover, 13 Feb. 1792.

18. SAUM, boîte 11441, registre 76a, p. 13: Berczy to Colquhoun, Hanover, 30 Dec. 1791–4 Jan. 1792.

19. "Wäre dieses der Freistaat in den Sie uns zu führen versprachen? Wäre dieses das Land, wo Ihren Versicherungen gemäss, blos Gesetze für Arme und Reiche, für Schwache und Mächtige gleich stark wären, wo Unterdrückung gegen Schwache

weder stattfinden kann noch darf?" [NA, MG23, H II 6, vol. 1, pp. 37–51: "Vorstellungen und Forderungen der sämtlichen Deutschen Colonisten an ihren Director, herrn William Berczy …," Genesee, 6 Aug. 1793.]

20. SAUM, boîte 11441, registre 76a, p. 12: Berczy reporting Williamson's remarks, undated note.

21. "Diary of John H. Summerfeldt" [sic] published in translation in the *Markham Economist and Sun*, 5 Oct. 1922, typescript in MTL, Baldwin Room, Non-Toronto Scrapbook, A22. The author signed documents as "J. Heinrich Somerfeldt" [NA, MG23, H II 6, vol. 4, pp. 630, 674] but his descendants use an anglicized version of the surname, "Summerfeldt," which has been given to him retroactively.

22. SAUM, S/20, boîte 11443, Letter G1: Williamson to Berczy, Northumberland, 30 Nov. 1792. These are Berczy's transcriptions of the letters and may be inaccurate.

23. SAUM, S/20, boîte 11443, Letter M: Williamson to Berczy, Northumberland, 9 Jan. 1793.

24. RHS, *Publication Series*, 20 (1942), 234–35; original in NA, MG23, H II 6, vol. 1, pp. 1–2: undated draft letter.

25. SAUM, S/20, boîte 11443, Letter M: Williamson to Berczy, Northumberland, 9 Jan. 1793.

26. SAUM, S/20, boîte 11443, Letter N: Williamson to Berczy, Philadelphia, 19 Jan. 1793.

27. SAUM, S/20, boîte 11443, Letter O: Williamson to Schott, Philadelphia, 19 Jan. 1793.

28. SAUM, S/20, boîte 11443, Letter Q: Williamson to Berczy, Northumberland, 23 Mar. 1793.

29. "Nun ist der Zeitpunkt das dieses Versprechung in Erfüllung zu bringen." [NA, MG23, H II 6, vol. 1, p. 49: "Vorstellungen," 6 Aug. 1793.]

30. SAUM, boîte 11441, registre 76a, p. 15: Berczy to Colquhoun, Hamburg, 4 Jan. 1792.

31. RHS, *Publication Series,* 20 (1942), p. 262.

32. SAUM, boîte 11441, registre 76a, p. 75: Berczy to Colquhoun, Genesee German Settlement, 23 May 1793.

33. SAUM, S/20, boîte 11443: copy of Williamson's letter to Peter Pining, probably in late January 1793; the same sentiments are expressed in a 19 Jan. 1793 letter to Friedrich Tempel, which follows this one.

34. SAUM, boîte 11441, registre 76a, p. 24: supplement to a letter of Aug. 1793 about the colonists' petition.

35. SAUM, S/18, boîte 11442, pp. 55–56: "Journal from 17 July 1792 to 3 October 1793" (a report submitted to Colquhoun).

36. SAUM, S/14, boîte 11441, p. 62: "narrative," in the form of letters, of Berczy's experiences in New York State.

37. SAUM, S/14, boîte 11441, p. 66: "narrative."

38. SAUM, S/14, boîte 11441, p. 67: "narrative."

39. O. Turner, *History of the Pioneer Settlement of Phelps & Gorham's Purchase, and Morris' Reserve* (Rochester: William Alling, 1852), pp. 256–57.

40. SAUM, boîte 11441, registre 76a, p. 64.

41. SAUM, S/20, boîte 11443, Letter H: German Society to Berczy, New York, 17 Oct. 1792.

42. SAUM, S/41, boîte 11443, p. 77: early draft of Berczy's "narrative" in letters intended for publication.

43. NA, MG23, H II 6, vol. 1, pp. 7–10: Berczy's account of his dispute with Williamson, c. December 1793.

44. SAUM, S/18, boîte 11442, p. 70: "Journal."

45. SAUM, S/18, boîte 11442, p. 37: "Journal."

46. Ernest A. Cruikshank, ed., *The Correspondence of Lieut. Governor John Graves Simcoe, with allied documents relating to his administration of the government of Upper Canada* (Toronto: Ontario Historical Society, 1923–31), vol. 2, p. 110: Simcoe to Dorchester, York, 2 Dec. 1793.

47. SAUM, boîte 11441, registre 76a, pp. 93–94: Berczy to Pulteney, Niagara, 6 July 1794.

48. Cruikshank, *Correspondence of … Simcoe*, vol. 5, p. 82.

49. SAUM, S/22, boîte 11442, p. 13: "The Traveler … An expedition in Upper Canada, Vol. II, First Part, Letter Second."

50. SAUM, S/29, boîte 11443: draft letter in German headed "Mein bester Baron," dated Niagara, 22 Apr. 1794, in which Berczy begs the baron to inform scientists of the puzzling and phenomenal spring he found near Niagara Falls, which burst into flame when a burning branch fell into it.

51. Cruikshank, *Correspondence of … Simcoe*, vol. 2, p. 190.

52. NA, RG1, E1, Upper Canada Land and State Book 'A,' p. 127: Council minutes of 17 May 1794. See also Cruikshank, *Correspondence of … Simcoe*, vol. 2, pp. 191–92, 237.

53. SAUM, S/22, boîte 11442, pp. 71–72: "The Traveler, Letter Eleventh." (This is an earlier draft than the section cited in note 49.)

54. "Von dieser Zeit hatte ich zu Thun das Vieh zu übernehmen das von Neu England ankam selbst nach Burlington Bay zu senden und verschiedene botsladung von Acker und farmers Geräthe zu gehen [?] so von Neu York und durch Mohak kamen. So wie auch soll[–]d mein Land geschäfte mit den Gouverneur zu schlichten." [SAUM, boîte 11447, p. 4: diary, "1794 From March upwards."]

55. P.N. Moogk, "Joseph-Geneviève de Puisaye," in DCB, vol. 6, pp. 618–21.

56. SAUM, S/22, boîte 11442, p. 76: "The Traveler, Letter Twelfth."

57. "Das der beste Theil des Landes so mir – vor meiner Abreise versprochen werde wärend meine Abwesenheit war vergeben werden." [SAUM, boîte 11447, p. 7: diary, "1794 From March upwards."]

58. NA, RG1, L3, Upper Canada Land and State, vol. A (1792–1796), p. 374.

59. NA, MG23, H I 10, Osgoode Papers, File 6: Simcoe to William Osgoode, Kingston, 17 Mar. 1795.

60. NA, MG23, H II 6, vol. 2, p. 446: Certificate entitling Berczy to become a freeholder, 19 July 1797; NA, RG1, L3, Upper Canada Land, vol. C, pp. 118, 119: grants of town lots in York, 3 July 1797.

61. NA, MG23, H II 6, vol. 2, p. 399: Berczy's copy of the 1 Sept. 1796 notice.

62. NA, RG1, L3, Upper Canada Land, vol. C, p. 176.

63. Ernest A. Cruikshank and A.F. Hunter, eds. *The Correspondence of the Honourable Peter Russell* (Toronto: Ontario Historical Society, 1932–36), vol. 1, p. 112.

64. SAUM, S/25, boîte 11442, p. 55: "Narrative of the German Settlement," 1809.

65. NA, MG23, H II 6, vol. 1, pp. 52–54. One of these petitions is reprinted in Cruikshank and Hunter, Russell Correspondence, vol. 2, pp. 130–32.

66. Cruikshank and Hunter, *Russell Correspondence*, vol. 2, p. 274.

67. NA, RG1, L3, Upper Canada Land, vol. D (1797–1802), p. 217.

68. Cruikshank, *Simcoe Papers*, vol. 2, p. 341: extract from the *Gazette of the United States*, Philadelphia, 25 July 1794. Berczy referred to one such article in the 17 June issue of the *Western Centinel* [sic] in NA, MG23, H II 6, vol. 1, pp. 135–45: c. 1800 draft of a letter while in England.

69. RHS, Williamson Papers: Williamson to Lord Melville, Genesee, 19 Aug. 1794.

70. Duc de la Rochefoucauld-Liancourt, *Travels Through the United States of North America … and Upper Canada in 1795, 1796, and 1797*, 2nd ed., (London, 1800), vol. 1, pp. 237–38. Berczy was aware of this book; it is discussed in his correspondence. See SAUM, U/10464: John Robertson to Berczy, Montreal, 20 July 1799. Typical of the local histories that repeat Williamson's version of events is the *History of Ontario County, New York* (Philadelphia: Everts, Ensign & Everts, 1876), p. 21, which added, "Berczy was the source of the evil, and by him the difficulties were increased."

71. AO, MS 75, R1, The Russell Papers, Robert Liston to Russell, Philadelphia, 30 Oct. 1797.

72. NA, MG23, H II 6, vol. 1, pp. 135–45.

73. NA, MG23, H II 6, vol. 3, pp. 567–70: c. 1812 monetary claim against the government of Upper Canada.

74. SAUM, S/22, boîte 11442, p. 50: "The Traveler, Letter Sixth".

75. RAPQ 1940–41, p. 23: Berczy to Charlotte, Quebec, 10 Feb. 1799.

76. Public Record Office, Series BT5, 12, pp. 318–19: 29 June 1801. The decision is restated in NA, MG23, H II 6, vol. 3, pp. 561–63: W. Fawkner to John King, Whitehall, London, 29 June 1801.

77. NA, RG1, E1, vol. 47, Upper Canada State Book, vol. C, pp. 156–82.

78. MTL, Baldwin Room, Series S113, Alexander Wood Papers, Berczy to Joseph Forsyth, York, 10 Nov. 1802.

79. MTL, Baldwin Room, Non-Toronto Scrapbook, A22, "Diary of John H. Summerfeldt."

80. NA, MG23, H II 6, vol. 4, p. 729: incomplete narrative of Berczy's travels in 1801–04.

81. SAUM, U/1459: Berczy to Major J. Robertson, Montreal, 11 July 1806.

82. NA, MG23, H II 6, vol. 4, p. 743–46: draft letter, Berczy to Boudinot, Quebec City, 23 Nov. 1808.

83. ASQ Fonds Viger-Verreau, Saberdache bleue, vol. 2, p. 65: Berczy to Jacques Viger, Montreal, 28 Oct. 1811.

84. SAUM, S/20, boîte 11443: single quarto page watermarked 1807.

85. NA, MG23, H II 6, vol. 3, pp. 525–26: draft letter to a patron in England.

86. SAUM, S/25, boîte 11442, p. 84: 1809 "Narrative."

87. MTL, Baldwin Room, S194, Helen Cowan Papers. Dr Cowan uses this quotation in her unpublished manuscript "Venture in Colonization: William Berczy Associate," chap. 6, p. 16, without footnoting it. It does not appear in Bertrand's books or in any Canadian historical journals published in the 1930s or 1940s. Dr Cowan produced two drafts of an account about Berczy's North American career that are well-researched although the footnotes are in an unfinished state. In her account, the historical context overshadows the man. Her earlier laudatory biography of Charles Williamson published by the RHS made her reluctant to criticize him; rather she condemns assisted colonization by groups of foreign migrants as a costly anachronism. Berczy is also tasked with being inexperienced in North American practices. She and John Andre seem to have been working on Berczy in the early 1960s without exchanging information. The work of both writers helped "blaze the trail" for me.

88. SAUM, U/1526: Berczy's address to the president and secretary of the German Company [New York], 10 Oct. 1812.

89. AO, MS 526, folder "William Berczy Papers 1818," Order in council of 27 Oct. 1818.

90. RAPQ 1940–41, p. 93: Berczy to Charlotte, Middlebury, 21 June 1812.

Plate I.
The Family of the Grand Duke Peter Leopold of Tuscany
(cat. 12)

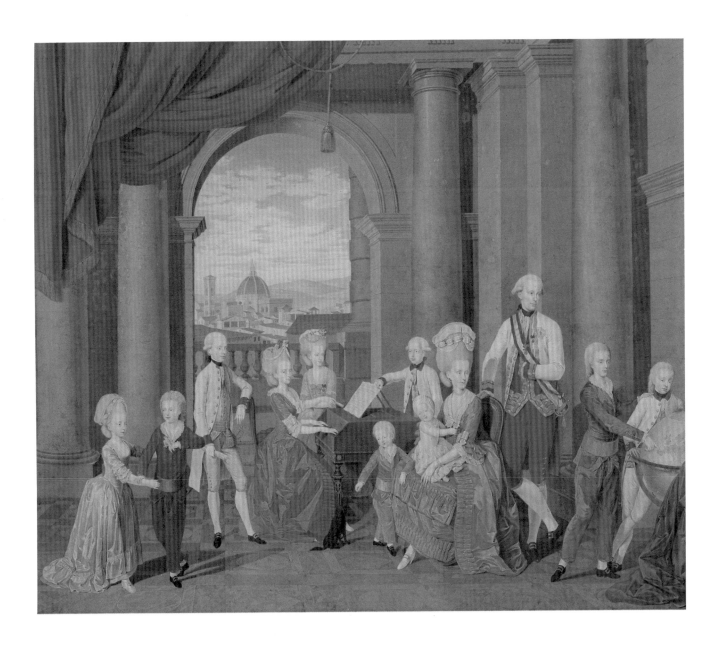

Plate II.
Maria Therese, Archduchess of Tuscany (cat. 13)

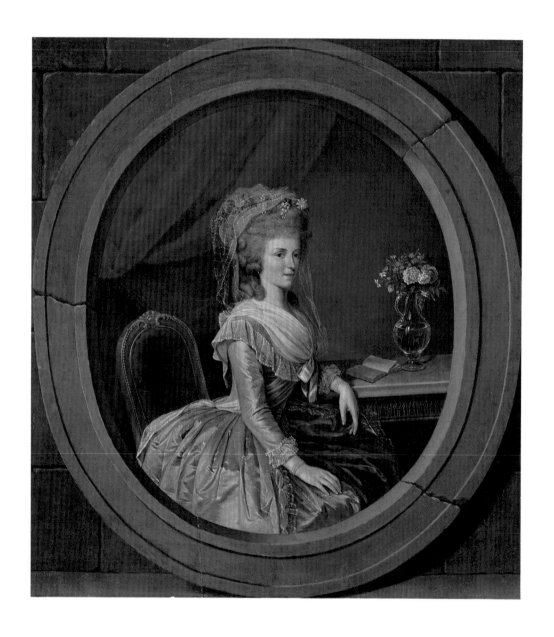

Plate III.
The Three Eldest Children of Bernard Louis de Muralt
(cat. 23)

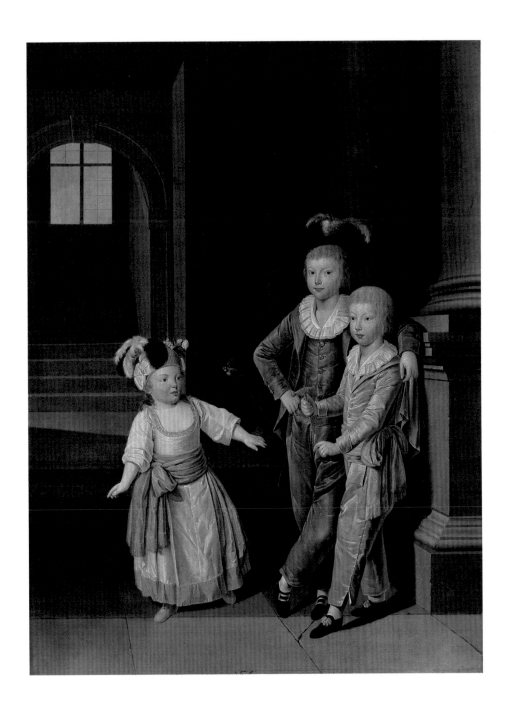

Plate IV.
Self-portrait (cat. 27)

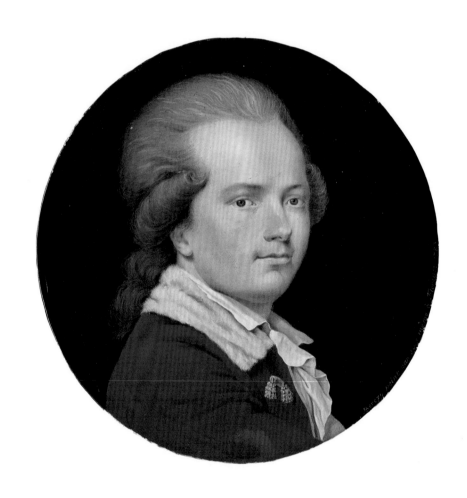

Plate V.
Charlotte Berczy with Hat (cat. 32)

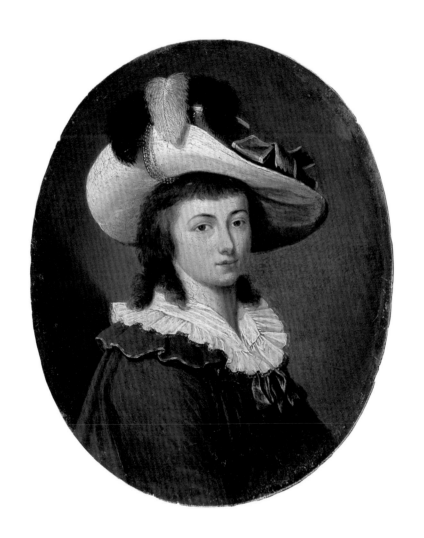

Plate VI.
Vincenzo Federici (cat. 36)

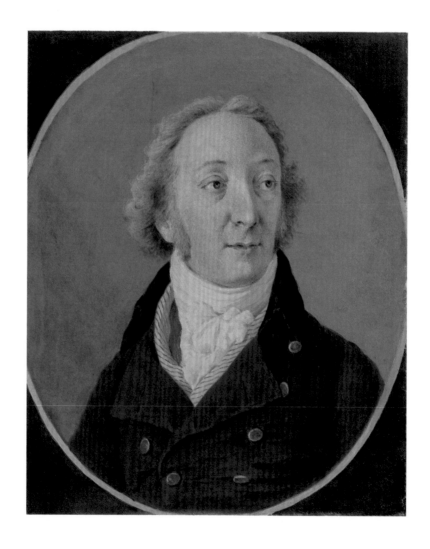

Plate VII.
Signora Federici (cat. 37)

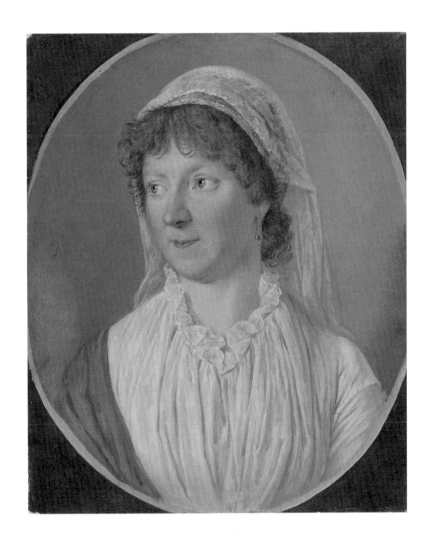

Plate VIII.
Self-portrait (cat. 47)

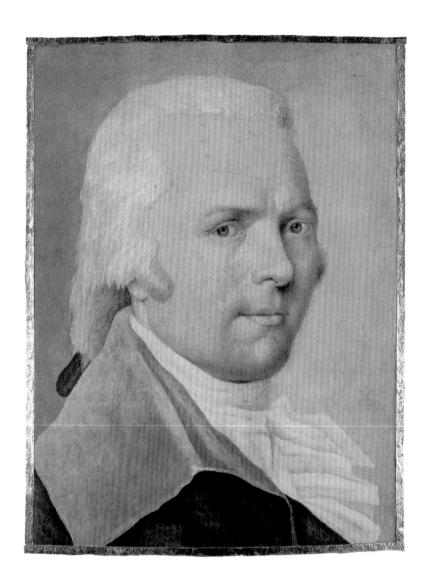

Plate IX.
Louis Genevay (cat. 52)

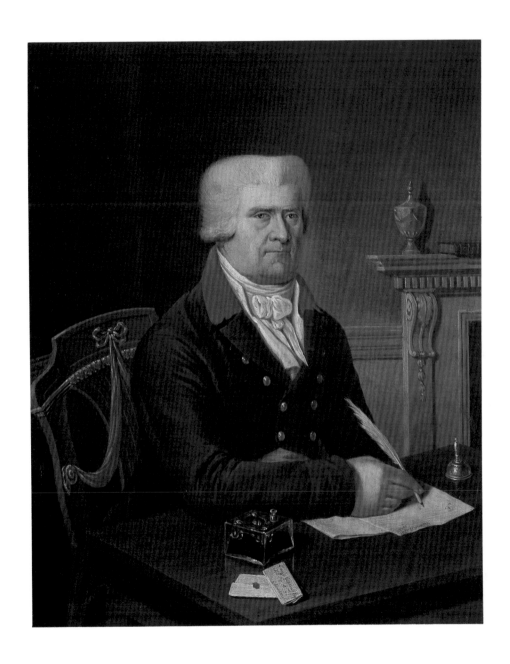

Plate X.
Robert Isaac Dey Gray (cat. 57)

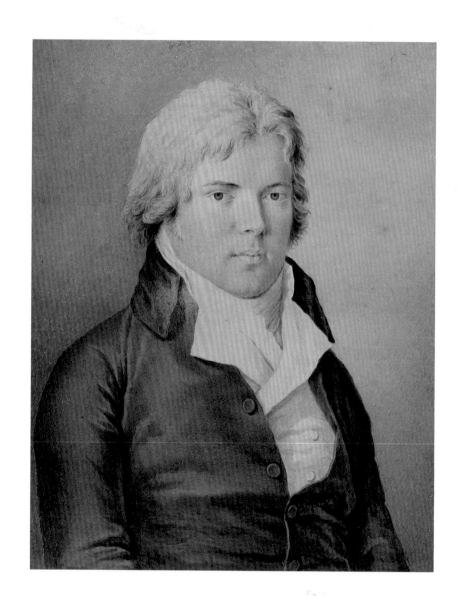

Plate XI.
The Woolsey Family (cat. 84)

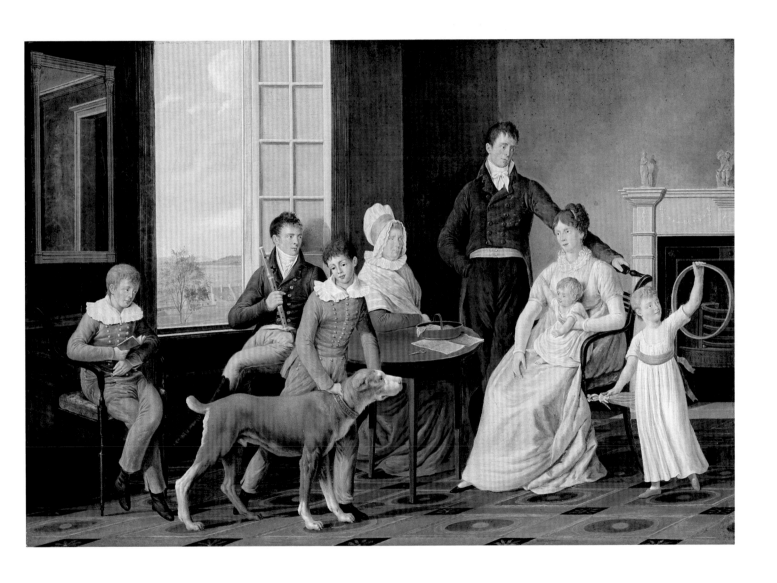

Plate XII.
Joseph Brant (cat. 76)

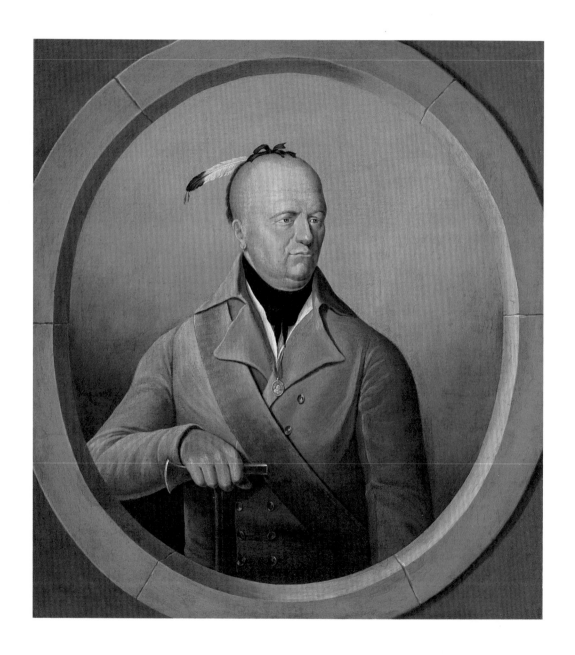

Plate XIII.
Joseph Brant (cat. 77)

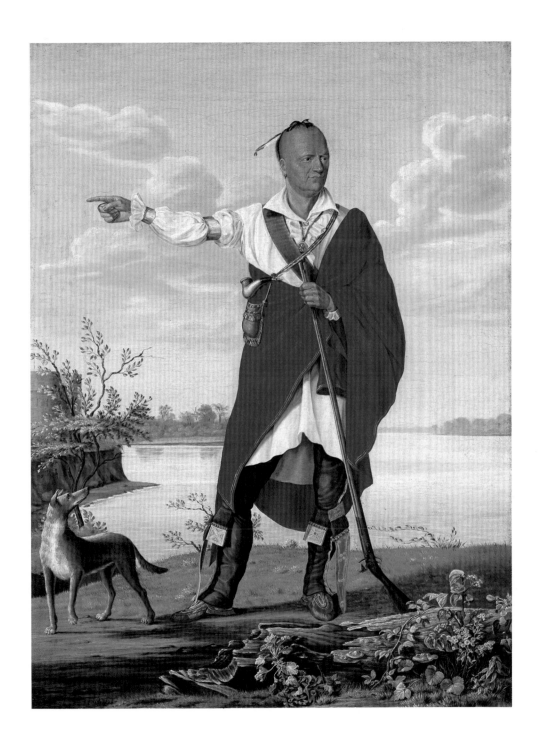

Plate XIV.
The Archangel St. Michael (cat. 88)

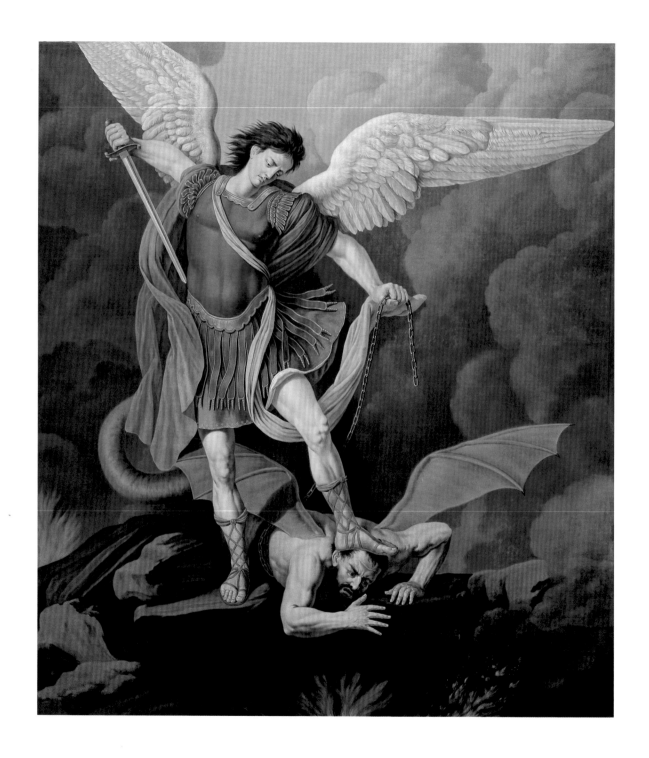

Plate XV.
John Mackenzie (cat. 96)

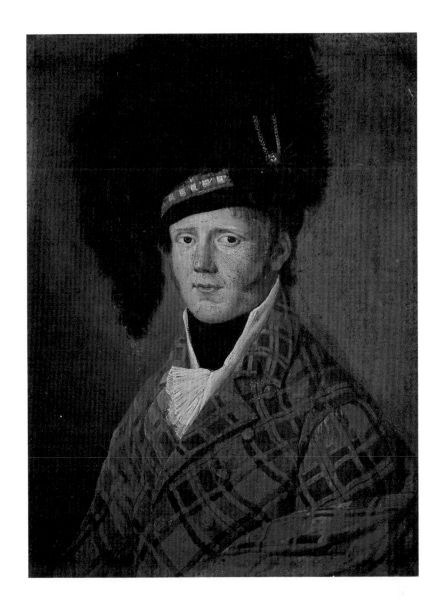

Plate XVI.
William Bent Berczy
Indian Dance at Amherstburg (WBB 5)

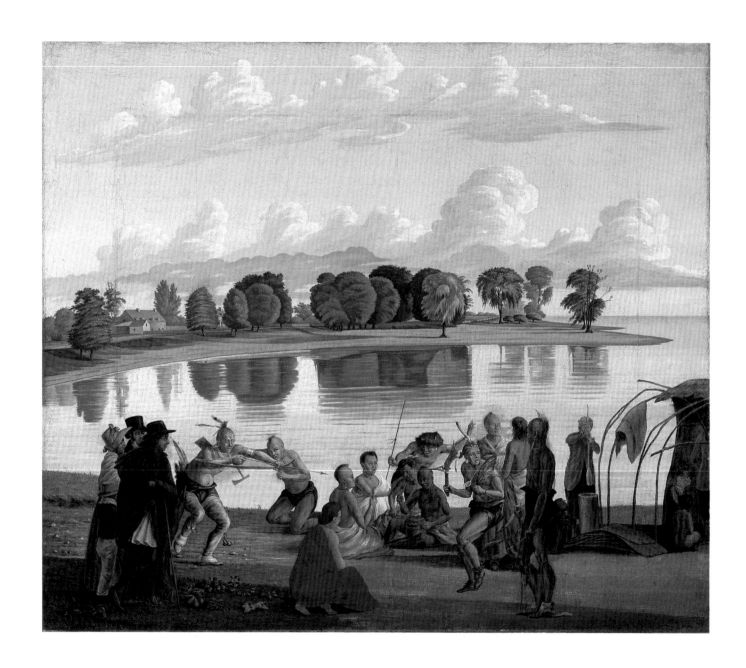

CATALOGUE
WILLIAM
BERCZY

EUROPEAN WORKS
1780–1791

by Beate Stock

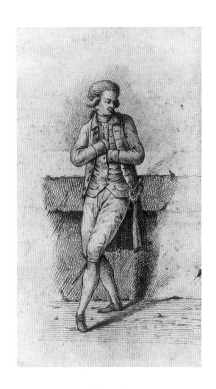

Cat. 1
Young Gentleman Leaning against a Wall
c. 1781–89

Graphite, pen and brown ink on laid paper
18.3 × 10.6 cm
Art Gallery of Ontario, Toronto 82/223
Gift of John Andre, 1982
Not in exhibition

PROVENANCE: by descent in Berczy family; John Andre, 1960s; gift to AGO, 1982.
EXHIBITIONS: 1980 Market Gallery, as "Portrait of a Student".
REFERENCES: Andre 1967, repr. as "A Student".

The purpose of this drawing is unclear. The heavily and solidly applied graphite on the back of the drawing coupled with the presence of incised lines indicate that this drawing was traced for transfer onto another surface. In other words, it was a preparatory study. The style of the man's clothing suggests the Italian/Swiss period (1781–89), but there is no evidence that Berczy was doing either full-length portraits or other group portraits to which this gentleman could have belonged.

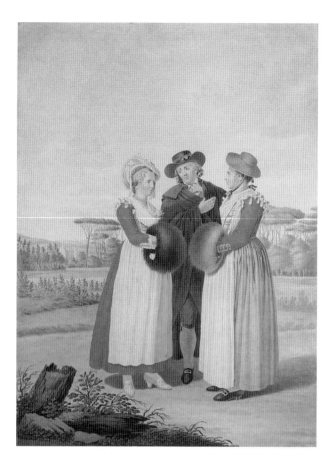

Cat. 2
*Three Standing Figures in a Landscape near
Florence* 1781

Watercolour and gouache on wove paper
42.7 × 31.1 cm
INSCRIPTIONS: Verso: l.c., *L*
National Gallery of Canada 16559

PROVENANCE: by descent in Berczy family; John Andre;
purchased NGC, 1970.
EXHIBITIONS: 1968 ROM.
REFERENCES: Andre 1967, p. 88 and repr. as "A Conver-
sation Scene"; Stock, x:2, 1983, p. 126, repr. p. 127;
NGC 1988, pp. 81–82, repr.

Bernard Louis de Muralt's "jolies paisannes" (LW 22)
was probably similar to this study with three figures,
and to catalogue 3, which has five figures. They
almost certainly give an accurate idea of the series of
costume prints Berczy intended to publish in 1781
(see LW 23). Clearly they bear the mark of the
artist's hand: the floral elements in the foreground
resemble those in the full-length portrait of Joseph

Brant (cat. 77) and in the allegorical drawing (cat.
16). The accurate rendering of the costumes, to the
smallest detail, in an almost documentary manner,
was characteristic of this genre, and also perfectly in
keeping with Berczy's style.

In the Age of Enlightenment, discriminating
minds turned their attention towards many aspects
of life previously considered of no scientific interest.
In the typical way of empirical research, everything
was first documented in word and picture, even the
peasants' tools and costumes. The idealization of
rural life, as described in Jean-Jacques Rousseau's
writings, also led to an appreciation among the
upper classes of peasant costumes, and not just in
theory. Marie Antoinette, for example, had her
own little farm, "Le Petit Hameau," at Versailles,
where she enjoyed playing at rural life. A portrait of
her, painted in 1783 by Élisabeth Vigée-Lebrun
(1755–1842), shows the Queen in a simple muslin
dress and straw hat. In addition, many upper-class
travellers on the Grand Tour studied foreign coun-
tries and customs and collected souvenirs, thus
opening a lucrative market. In Bern, the painter
Johann Ludwig Aberli (1723–1786) made a fortune
with his hand-coloured prints of landscapes and
Swiss costumes. He was probably introduced to such
costume prints by his compatriot Sigmund
Freudenberger (1745–1801), who had spent eight
years in Paris and was well acquainted with the
French publications on costumes.[1]

Having observed his clients' interest and Aberli's success, it is no surprise that Berczy turned his talents to costume studies. He had hardly set foot in Florence when he began with the above-mentioned gouache (LW 22) of Florentine costumes for his Swiss patron Bernard Louis de Muralt. At the end of May 1781, Berczy asked Marguerite Gruner for information on Aberli's prices for his engravings of Swiss costumes and to send him a sample.[2] At that time, Berczy was already involved in a project to publish, with an unnamed local engraver, a series of costume prints representing peasants of the countryside around Florence. At first, the intention was to limit the collaboration to the production of four prints, which would have been exclusively for the profit of the engraver, who was in financial trouble. Yet, having shown the originals to several people, the engraver received commissions from Rome, Naples, and Bologna, and the project was enlarged to be a series of four volumes, each containing four prints depicting two to four figures. Berczy had taken great care with the watercolours, which were to be reproduced as line engravings, hand-coloured to the same detail as the original watercolours. Although the engraver was to receive full credit for the engravings, he had no interest in selling them. Berczy, therefore, handled the sales, giving the engraver a fair profit. By mid-June, Berczy intended to send the first print to Bern, so that his business

partner, Marguerite Gruner, could show it to potential buyers. When orders were taken, the subscribers were not asked for a deposit but only had to pay upon receipt of the final result.[3]

In Italy in the 1780s, the production of costume prints was not yet popular.[4] Berczy, with his keen eye for a business opportunity, thought to present the art market with something which, if not entirely new, was certainly not over-represented. If this project was ever realized, which is doubtful in light of Berczy's other Italian activities in the medium, none of the prints has been found. These surviving costume studies offer the best idea of what the prints would have looked like.

1. Anna Forlani-Tempesti, "Le incisioni e i costumi," pp. 11, 15 (pl. 3), p. 16 (pls. 5 and 6). This source offers a listing on pp. 4 and 5 of some important French publications on costume. For Aberli's costume drawings and prints, see F.C. Lonchamp, *J.-L. Aberli (1723–1786) son temps, sa vie et son œuvre avec un catalogue complet* (Paris and Lausanne: Librairie des Bibliophiles, 1927), pp. 51ff.
2. KIF, Berczy to Gruner, Florence, 27 May 1781, p. 282.
3. KIF, Berczy to Gruner, Florence, 4 June 1781, pp. 285, 286, 288.
4. Forlani-Tempesti, p. 5. Dr Paola Venturelli of Monza, Italy, graciously provided all of the important information on the topic of Florentine costumes.

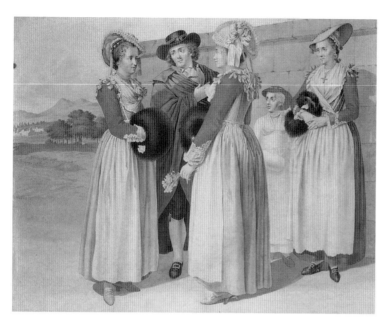

Cat. 3
Five Figures in an Italian Landscape 1781

Watercolour and gouache on laid paper
42.1 × 53.5 cm
WATERMARK: *BLAUW* and crest
National Gallery of Canada 23396

PROVENANCE: by descent in Berczy family to Mabel
 Burkholder; Robert Neff; purchased NGC, 1979.
EXHIBITIONS: 1968 ROM.
REFERENCES: Andre 1967, p. 88 and repr. as "A Family
 Group"; Stock, x:2, 1983, p. 126, repr. p. 127 as "A
 Family Group with Five Figures"; NGC 1988, p. 82,
 repr. as "Family Group with Five Figures".

Re-using the main characters was Berczy's very eco-
nomical way of creating different costume studies.
In this unfinished study with five figures, the young
woman to the left and the man are almost identical
to their counterparts in the three-figured group
in catalogue 2. As to the older woman at the trio's
right, here she is initially replaced by a younger
woman, showing the costume slightly more from

the back and adding some flowers as well as a muff;
however, she appears again at the far right, now
turned more frontally to reveal a little cap under
her hat. Her pearl necklace, worn snugly about the
neck with a suspended cross, is found in contempo-
rary costume studies of the countryside around Flo-
rence.[1] To complete the study, the artist has ad-ded
a young girl, dressed in a simpler style. The group
looks almost monumental. Berczy achieved this by
enlarging his figures to fill most of the available
space, placing them before a wall of large squared
stones, which heightens the solemn concentration
of the composition. Only to the left do we catch a
glimpse of the Tuscan hills.

The five figures, especially the women, are well-
groomed and adorned with straw hats, ruffles,
flowers, ribbons and bows, neckerchieves, necklaces,
and huge muffs. The man – with his broad-brim-
med hat and his rich blue cape – also looks pros-
perous. They do not give the impression of poor,
simple peasants, but must rather be considered as
costumed townsfolk. Or it could be that Berczy
added refinements to the actual peasants costumes in
order to please his customers. One would not expect
the impressive fur muffs in the warm Tuscan cli-
mate, but this accessory was used to "show off."
Muffs were worn by the Italian nobility in the six-
teenth century. In the course of time, this fashion
was adopted by commoners, and by the middle of
the eighteenth century, the first ready-made muffs –
of Canadian fur – appeared on the market. It is also
known that peasants in the districts near Florence
dressed more elegantly and richly than those who
lived further away from the capital.[2] Berczy did not
say precisely to which village his costumes belonged,
but there is no doubt that they are very close to Flor-
ence, as one can see in the distance Brunelleschi's
dome, the landmark of the city.

1. Forlani-Tempesti, pl. 8.
2. Forlani-Tempesti, pp. 11, 15 (pl. 3), p. 16 (pls. 5
 and 6).

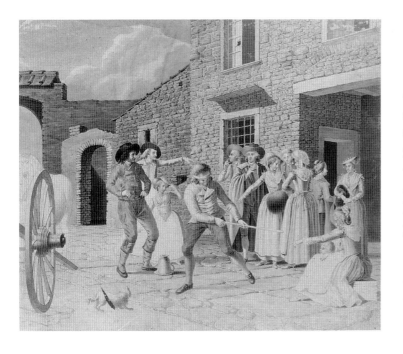

Cat. 4
Pentolaccia c. 1781

Watercolour, brush point and black ink over graphite on
 laid paper
34.8 × 43.1 cm
Art Gallery of Ontario, Toronto 70/148

PROVENANCE: by descent in Berczy family; John Andre;
 purchased AGO, 1971.
EXHIBITIONS: 1968 ROM; 1980 Market Gallery, as
 "Blind Man's Bluff".
REFERENCES: Andre 1967, repr. as "A Family Gather-
 ing"; George Woodcock, *The Canadians* (Don Mills:
 Fitzhenry and Whiteside, 1979), repr. p. 256.

The object of the game of *Pentolaccia* is for the blind-
folded player to find the pot, hit it with the stick, and
retrieve the small prize hidden under it.

Since Berczy only intended to show two to four
figures per print in his publication of costume
engravings, this watercolour would not have be-
longed to the series (see LW 23). But one can redis-

cover in this unfinished work all the figures of the
surviving watercolours (cat. 2, 3). Whereas in the
series the artist's intention was to present exact
reproductions of costumes in a pleasing manner,
without distraction, this composition has a narrative
and even some action, something quite unusual in
Berczy's œuvre. In comparison with such contem-
poraries as Jean-Baptiste Greuze (1725–1805) or
Sigmund Freudenberger (1745–1801), Berczy has
exercised restraint, by not embuing this rustic scene
with a moralizing and sentimental theme, as was the
fashion for this genre of subject.

In addition to the figures borrowed from the
other two compositions, there are several new fig-
ures equally elaborately dressed. In marked contrast,
the two young men smiling at the vain attempt of
their companion to hit the pot, and the older wom-
an in the background on her way into the house, are
dressed more simply, giving the appearance of being
real peasants. This would tend to confirm that
Berczy painted peasants in idealized costumes, or
perhaps townsfolk dressed "à la paysan" as in the
previous watercolours.

The artist has set the scene in the courtyard of
a house in the countryside. For the architecture,
Berczy could well have found inspiration in country
houses around Bagazzano, a villa near Florence
where he spent some weeks in September and
October 1781.[1] He uses the rough stonework of the
walls, with its many delicate shades of grey, blue,
brown, and red, to create a lively yet not imposing
background.

1. KIF, Berczy to Gruner, Florence, 3 Sept. 1781,
 p. 337; and Bagazzano, 23 Sept. 1781, p. 349;
 28 Sept. 1781, p. 359; and 6 Oct. 1781, p. 363.

Cat. 5
*Study for "The Family of the Grand Duke
Peter Leopold of Tuscany", No. 1* 1781

Charcoal, heightened with white chalk on blue laid
 paper
25.8 × 20.2 cm
INSCRIPTIONS: Verso: l.l., *Mary Winter*
Art Gallery of Ontario, Toronto 82/219
Gift of John Andre, 1982

PROVENANCE: by descent in Berczy family; John Andre,
 1960s; gift to AGO, 1982.

For the ambitious and challenging grand-ducal fam-
ily portrait, Berczy made individual sketches of
everything: the setting, the sitters, their costumes,
and their hands (see also cat. 6–10). The few surviv-
ing drawings of the hands are proof of the artist's
careful way of preparing everything, to the smallest
detail.

Anatomy was not Berczy's strong point and hands
were no exception. Here, one does not get the feel-
ing of a real hand with a solid bone structure. He
renders only the surface of a hand, giving it shape by
some hatching and accents of white highlights, and
succeeds in conveying a somewhat flabby delicacy.
This drawing shows the grand duchess' right hand,
with which she is holding her youngest child, little
Amalia.

Cat. 6
*Study for "The Family of the Grand Duke
Peter Leopold of Tuscany", No. 2* 1781

Charcoal, heightened with white chalk on blue laid
 paper
20.6 × 30.2 cm
INSCRIPTIONS: Verso: l.l., *Owner Mary Winter*
Art Gallery of Ontario, Toronto 82/218
Gift of John Andre, 1982

PROVENANCE: by descent in Berczy family; John Andre,
 1960s; gift to AGO, 1982.

Another proof of Berczy's uneasiness with hands is
the fact that it is impossible to determine if this
sketch is for the right hand of Maria Clementina (at
the left) or for that of the baby Amalia. The other
hand on the sheet belongs to Archduke Antony. His
left arm is resting on his mother's knee and the hand
hangs limply down.

Cat. 7
Study for "The Family of the Grand Duke Peter Leopold of Tuscany", No. 3 1781

Charcoal, heightened with white chalk on blue laid
 paper
25.3 × 26.6 cm
Art Gallery of Ontario, Toronto 82/215
Gift of John Andre, 1982

PROVENANCE: by descent in Berczy family; John Andre;
 gift to AGO, 1982.

Three of the four hands are easily recognizable:
Joseph grasping his sister's arm, the grand duke rest-
ing his hand on the chair, Francis pointing to Spain
on the globe. The fourth hand, with a sheet of paper
between the fingers, is not to be found. By altering
it slightly, Berczy could have used it either for
Alexander Leopold holding his sister's music or for
the single portrait of Grand Duke Peter Leopold
(cat. 11).

Cat. 8
Study for "The Family of the Grand Duke Peter Leopold of Tuscany", No. 4 1781

Charcoal, heightened with white chalk on blue laid
 paper
27.1 × 18.4 cm
INSCRIPTIONS: Verso: l.c., *owner Mary Winter*
Art Gallery of Ontario, Toronto 82/217
Gift of John Andre, 1982

PROVENANCE: by descent in Berczy family; John Andre;
 gift to AGO, 1982.

While these two hands cannot be identified, in all
likelihood they were intended for the grand-ducal
family portrait: they are drawn in the same manner
and on the same paper as all the other sketches of
hands. Possibly they were made for rejected poses. It
is also possible that Berczy may have drawn them for
some of the individual portraits of the grand-ducal
family, now lost (LW 35, 36, 40, 41).

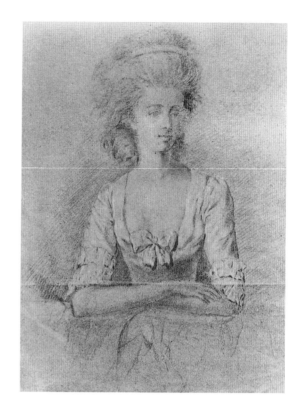



Cat. 9

*Study for "The Family of the Grand Duke
Peter Leopold of Tuscany", No. 5* 1781

Charcoal, heightened with white chalk on blue laid
 paper
21.4 × 27.1 cm
Art Gallery of Ontario, Toronto 82/216
Gift of John Andre, 1982

PROVENANCE: by descent in Berczy family; John Andre,
 1960s; gift to AGO, 1982.
REFERENCES: Andre 1967, repr. as "Two Hands".

The hands depicted are studies for the left hand of
the Grand Duchess Maria Louisa and the right hand
of her daughter, the Archduchess Maria Anna. In
the group portrait, Maria Anna keeps her arms fold-
ed. In comparison to the male hands, these hands
look somewhat softer and more elegant.

Cat. 10

Maria Anna, Archduchess of Tuscany 1781

Black chalk and graphite, heightened with white chalk
 on blue-grey laid paper
25.4 × 20.2 cm (sight)
Private collection
Not in exhibition

PROVENANCE: by descent in Berczy family.
REFERENCES: Andre 1967, p. 97 and repr. as "Charlotte
 Allamand-Berczy".

In 1791, Maria Anna (1770–1809) became Princely
Abbess of the Convent for Ladies of the Nobility
("Fürstäbtissin des adeligen Damenstifts vom
Sternkreuz") in Prague. In this position, only a few
days after her own installation, she performed her
traditional right of crowning the new Queen of
Bohemia – her mother Maria Louisa.

Berczy wrote that he was making individual
sketches of each of the sitters for the grand-ducal
family portrait.[1] This sketch of Archduchess Maria



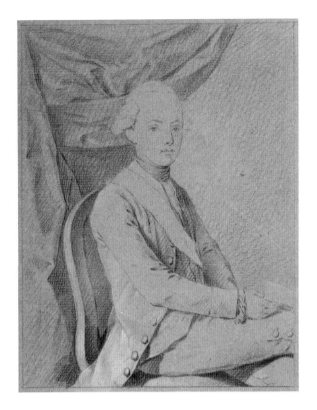

Cat. 11
Grand Duke Peter Leopold of Tuscany
1781–82

Black chalk, heightened with white chalk on blue laid
 paper
24.8 × 16.5 cm
National Gallery of Canada 16560

PROVENANCE: by descent in Berczy family; John Andre;
 purchased NGC, 1970.
REFERENCES: Andre 1967, repr. as "A Nobleman";
 NGC 1988, p. 81, repr. as "Seated Young Man".

Peter Leopold, Grand Duke of Tuscany, was born
on 5 May 1747, the third son of the Empress Maria
Theresa and the Emperor Francis I. On the death of
his elder brother Charles in 1761, Peter Leopold was
designated his father's heir to the Grand Duchy of
Tuscany, which Francis had received in exchange for
his native Lorraine in 1735. The designation was also
part of Peter Leopold's marriage settlement to Maria
Louisa, daughter of Charles III of Spain. On the

Anna is the only one that has come down to us. In
comparison to her appearance in the family portrait,
where she is portrayed with a somewhat superficial
smoothness and a colourless expression, here she is
drawn quite freely and without hesitation. Maria
Anna is shown as a lively-looking individual. The
sketched portrait and the final execution are similar
but not precisely the same. The neckline of her
bodice has been changed from square to V-shaped.
In the family portrait the arms are kept close to the
body and the coiffure is more elaborate.

Unfortunately, it is difficult to determine the
exact nature of the drawing at present. A compari-
son of the photograph taken by John Andre in the
1960s (reproduced here) with another taken in 1989
indicates that the drawing has recently been over-
drawn, particularly in the facial features. The image
has become sharper and harder, losing its sensitivity
and balance.

1. KIF, Berczy to Gruner, Florence, 28 Apr. 1781,
 p. 267; 14 May 1781, p. 236; 21 May 1781, pp. 273f.;
 26 June 1781, p. 299; and 2 July 1781, p. 301.

death of his father in 1765, Peter Leopold succeeded to the Grand Duchy, becoming the first of his father's family actually to reside in Tuscany.

Considered an enlightened ruler par excellence, he was widely praised for the wisdom of his policies and his progressive reforms. Upon the death of his brother Joseph II in 1790, Peter Leopold ascended the throne of the Holy Roman Empire as Leopold II. His reign was a troubled one. He attempted to repair the damage caused by the rushed reforms of his brother, while at the same time trying to still the political upheavals brought about by the French Revolution, which engulfed his sister and brother-in-law, Marie Antoinette and Louis XVI. Leopold II died on 1 March 1792.

This drawing is in all likelihood the preparatory sketch for the portrait of Grand Duke Peter Leopold (LW 35) that Berczy mentioned in his letter of 11 March 1782.[1] Besides the family portrait, he had already finished a half-figure of the grand duke – a small picture, about the size of the sheet of paper on which he was writing (23.4 × 18.4 cm). The similarity of size between this drawing and the letter, coupled with the presence of incised lines on the drawing, suggests that this may have been the transfer drawing for Peter Leopold's portrait. Other indications are the similarity of facial features, especially the broad, high forehead, and the sash – possibly the same as the one Peter Leopold wears in the family portrait – which identifies him as a member of the Military Order of Maria Theresa. This distinction was granted to Peter Leopold in 1765 by his brother Joseph II, not for military service but in recognition of the fact that Peter Leopold was his likely successor.

1. KIF, Berczy to Gruner, Florence, 11 Mar. 1782, p. 428.

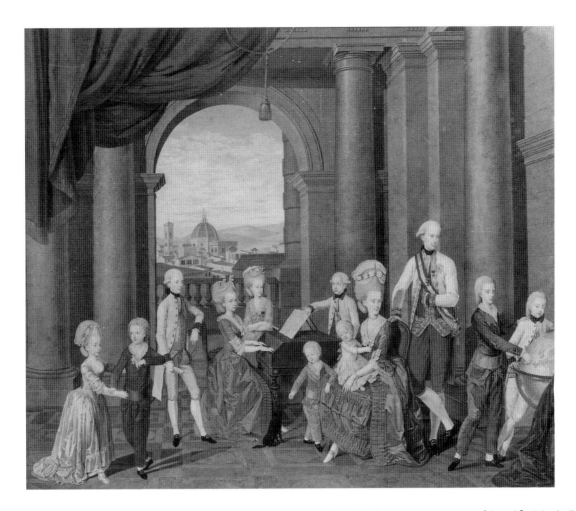

Cat. 12
The Family of the Grand Duke Peter Leopold of Tuscany 1781–82

Gouache on vellum, mounted on board
55.2 × 64.5 cm
Galleria d'Arte Moderna, Palazzo Pitti, Florence
Inv. Ogetti d'Arte Petraia, anno 1911, no. 141

PROVENANCE: commissioned by the Grand Duke Peter Leopold, Palazzo Pitti.

EXHIBITIONS: 1979 Pitti.

REFERENCES: Pitti 1979, p. 124, as "Quadretto con ritratto 'in conversazione' della famiglia granducale", and col. repr. pl. V; Stock, X:2, 1983, pp. 126–28; Wandruszka, vol. I, repr. between pp. 304–05; Niccolò Capponi, "Appunti sulle uniformi dei Cavalieri di Santo Stefano e della Guardia del Corpo Granducale: secoli XVIII–XIX," *La Galleria Del Costume, Informa 3* (Florence: Centro Di, 1990), repr. p. 10.

When William Berczy arrived in Florence on 18 December 1780, he was a completely unknown painter.[1] Within four short months he was painting the grand duke and heir presumptive to the throne of the Holy Roman Empire, his wife Maria Louisa, daughter of Charles III of Spain, and all of their ten children (pl. I). This extraordinary commission, originally intended as a gift to the King of Spain, reflects not only Berczy's remarkable ability to make the right contacts, but is also a fair indication that Berczy came to Florence as a reasonably accomplished artist.

Berczy probably received this commission through the good graces of his new-found friends, Baron Matthäus von Störck and his wife, who served the grand-ducal family as court physician and governess respectively. Upon the acceptance of a general scheme for the composition, Berczy formally received the commission for a "conversation piece" comprising twelve figures, to be executed in gouache, and measuring approximately two-and-a-half feet ("pieds") wide by two feet high.[2]

The twelve members of the grand-ducal family are represented in a magnificent indoor setting, with giant columns and pilasters suggesting the grandeur of their residence, the Pitti Palace. To the left, an

27.

Grand Duke Peter Leopold of Tuscany with his Family, 1773,
by Venceslao Verlin.
Collection: Kunsthistorisches Museum,
Schloss Ambras, Innsbruck.

archway opens to a rooftop view of Florence, dominated by Brunelleschi's famous dome on the cathedral of Santa Maria del Fiore. In the distance, up in the hills, Fiesole can be seen.[3] From left to right, the members of the family are as follows: Maria Clementina (1777–1801), who in 1797 married her Bourbon cousin Francis, heir to the throne of Naples. Joseph (1776–1847), seen here dressed in red, would become Palatine of Hungary in 1796 following the death of his brother Alexander Leopold. Next is Francis II (1768–1835), the eldest son, who became emperor in 1792.

It was the custom for young archdukes to wear a kind of military uniform ("Hof-Interim"). As they grew older, they were presented with more and more of the attributes of officers. Francis is shown in a full officer's uniform with sword and sash, and wears as well the Order of the Golden Fleece.[4] He is holding in his right hand a rolled sheet of music, while resting his left elbow on the back of the chair in which his eldest sister Maria Therese (1767–1827) is seated. She is playing a keyboard instrument.[5] In 1787, Maria Therese married Prince Anton of Saxony (see cat. 13). At her side, in a yellow dress and with arms folded, is Maria Anna (1770–1809), who in 1791 became Princely Abbess of the Convent for Ladies of the Nobility in Prague (see cat. 10). Reaching over the keyboard, holding the sheet of music, is Charles (1771–1847). He led the Imperial forces against the French revolutionary armies with considerable success and, having been adopted by his aunt, Archduchess Marie Christine, and her husband, Duke Albert, inherited the latter's title of Duke of Saxe-Teschen.

The central group consists of the two youngest members of the family and the grand-ducal couple. Antony (1779–1835), who in 1809 became Grand Master of the Teutonic Order, keeps close to his mother the Grand Duchess Maria Louise (1745–1792), and to his little sister Amalia (1780–1798), seated on her mother's lap. Grand Duke Peter Leo-

pold (1747–1792) wears the uniform of an Imperial Field Marshal. The white sash with the red borders and the large star pinned to his white coat belong to the Military Order of Maria Theresa. The smaller order is the Tuscan Order of St. Stephen. Hanging on a ribbon around his neck is the Hapsburg house-order, the Golden Fleece. The grand duchess and Archduchess Maria Anna are adorned with the "Sternkreuz" – the Order of Ladies of High Nobility ("Hochadeliger Damenorden vom Sternkreuz").

At the extreme right is Ferdinand III (1769–1824), the second son and successor to the title of Grand Duke of Tuscany, which he would assume in 1791. He is pointing to Spain on the globe beside him, probably a reference to his grandfather Charles III, the intended recipient of this painting. Looking on is his brother Alexander Leopold (1772–1795), who was to become Palatine of Hungary.

Berczy began this work at the end of April 1781 by making individual sketches of each sitter. The first to be drawn was the eldest archduke, Francis; within three weeks Francis was followed by his three brothers Ferdinand, Alexander Leopold, and Charles. These four sketches caused the artist no difficulty and were rapidly completed in eighteen hours. Berczy then sent the four sketches to the

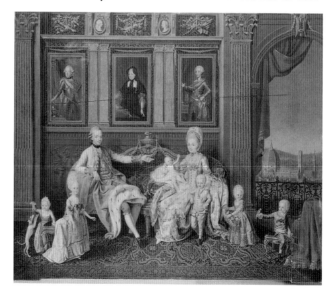

grand duchess, who communicated her satisfaction to him. This greatly pleased the artist, as he considered these sketches the best likenesses he had ever done. Following these four portrait sketches, he continued with the two youngest children, Antony and Amalia.[6]

Berczy sketched the grand duke and duchess along with the remaining four children, Maria Therese, Maria Anna, Maria Clementina, and Joseph, at their summer residence, the Villa Poggio Imperiale, just outside Florence. For a month he went there almost daily, beginning work at nine o'clock with the young archduchesses and continuing until he was called away to sketch the grand duchess herself, normally at about eleven o'clock. At one o'clock he usually dined with his friends, the Baron and Baroness von Störck. At five o'clock he went back to work for another two hours.[7]

By the beginning of August 1781, Berczy had finished the twelve heads as well as other studies that served as models for the family portrait. He used the evenings to plan the architectural setting of the picture and to make costume studies under artificial light. The costumes were mostly of satin, which is difficult to render because of its shimmering quality.[8]

Although Berczy was industrious and eager to finish this important commission – which he thought would make his reputation – it was more than a year before he could finally deliver the family portrait, in August 1782.[9] A major cause of the delay was the chosen technique. To paint a gouache of this size with twelve figures in an elaborate setting in miniature technique was most time consuming. As his practice and experience in the medium grew, Berczy became increasingly critical and more demanding in his work and put in much more time and effort than he had originally calculated.[10]

The Hapsburg-Lorraine family, especially the Empress Maria Theresa, was fond of having pictures of its members. It is, therefore, not surprising that Berczy's portrait is not the only one that was done of the growing grand-ducal family. The first, a portrait of the grand duchess and three of her children, Maria Therese, Francis, and Ferdinand, was painted in 1771 by Anton von Maron (1733–1808) (collection: Kunsthistorisches Museum, Schloss Schönbrunn, Vienna). Venceslao Verlin (d. 1780) painted the family in 1773 (fig. 27; collection: Kunsthistorisches Museum, Schloss Ambras, Innsbruck), and Josef Hauzinger (1728–1786) depicted them in about 1775–76 (collection: Kunsthistorisches Museum, Vienna). Easily the most splendid of all these paintings is the huge family portrait (3.25 × 3.98 m) of 1776 by Johann Zoffany (1733–1810) (collection: Kunsthistorisches Museum, Vienna). Probably the last portrait of the family was done in about 1784 (private collection, Stainz, Austria) by the same painters who later signed an engraving clearly based on it. Made in 1785, the engraving was a group effort by a number of artists: Giuseppe Piattoli, Giuseppe Fabbrini, and Anna Nistri Tonelli were the painters; Giovanni Battista Cecchi and Benedetto Eredi were the engravers.[11] Comparing those portraits with Berczy's portrayal of the grand-ducal family, it is obvious that he stands well within the tradition of courtly conversation pieces in a semi-private setting. The solemn interior, with its giant columns and purple drapery, reflects the noble rank of the sitters. Yet Berczy renounced all allegorical allusion, such as the Minerva in the above-mentioned engraving, and brought in elements that suggest a relaxed family group, gathered around Maria Therese at the keyboard. To the left, Maria Clementina and Joseph play with a bird, while Alexander Leopold leans against the globe. Although with less mastery, Berczy has tried to combine the intimate charm of Zoffany's English conversation pieces with the typically Hapsburg insistence on hierarchy and ceremony.[12]

1. KIF, Berczy to Gruner, Florence, 19 Dec. 1780, p. 197.

2. KIF, Berczy to Gruner, Florence, 15 Apr. 1781, p. 258. There were hints in previous letters that Berczy was preparing his way to receive this commission: Berczy to Gruner, Florence, 1 Feb. 1781, p. 215; 12 Feb. 1781, p. 217; 14 Feb. 1781, p. 233; and 8 Apr. 1781, p. 254.

3. KIF, Berczy to Gruner, Florence, 6 Aug. 1781, p. 321.

4. In exh. cat. Pitti 1979 (*Curiosità di una reggia*), the identification of the four eldest sons is incorrect. Information on uniforms, identification, and orders was provided by the late Dr Hans Bleckwenn, Münster, Dr Georg Kugler of the Kunsthistorisches Museum, Vienna, and Dr Rainer Egger of the Kriegsarchiv, Vienna.

5. According to Prof. Gerhard Stradner of the Kunsthistorisches Museum, Sammlung Alter Musikinstrumente, Vienna, Berczy has rendered the keyboard instrument in such an idealized way that it is impossible to determine if the archduchess is playing a harpsichord, a pianoforte, or a square piano.

6. KIF, Berczy to Gruner, Florence, 28 Apr. 1781, p. 267; and 21 May 1781, pp. 273f.

7. KIF, Berczy to Gruner, Florence, 24 July 1781, p. 315.

8. KIF, Berczy to Gruner, Florence, 10 June 1781, p. 294; and 6 Aug. 1781, p. 321.

9. KIF, Berczy to Gruner, Bagazzano, 28 Sept. 1781, pp. 359, 362; and Florence, 2 Nov. 1781, p. 376; 17 Dec. 1781, p. 395; 30 Dec. 1781, p. 404; 5 May 1782, p. 437; 17 June 1782, p. 449; and 13 Aug. 1782, p. 459.

10. KIF, Berczy to Gruner, Florence, 2 Nov. 1781, p. 376.

11. Re: the portrait, see exh. cat. for "Landesausstellung 1982," *Erzherzog Johann von Österreich* (Stainz, Styria, 1982), vol. 1, col. repr. p. 35, no. 1/9. An impression is in the collection of the print room of the Staatliche Kunstsammlungen, Dresden, as well as in the Porträtsammlung, Bildarchiv, Österreichische, Nationalbibliothek, Vienna.

12. Mary Webster, exh. cat. *Johann Zoffany 1733–1810* (London: National Portrait Gallery, 1977), p. 12. For the history of the conventions of court portraiture, see the excellent introduction by Günther Heinz in *Katalog der Gemäldegalerie. Porträtgalerie zur Geschichte Österreichs von 1400 bis 1800* (Vienna: Kunsthistorisches Museum, 1976), pp. 17-38.

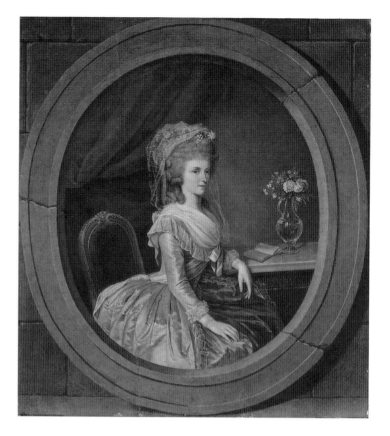

Cat. 13
Maria Therese, Archduchess of Tuscany
1782–87

Oil on panel
33.8 × 30.5 cm
INSCRIPTIONS: Verso: on frame, *M. Lavigne 473 Berczy, père pinxit.*
McCord Museum of Canadian History, Montreal
M986.288

PROVENANCE: William Bent Berczy by descent to Marie-Louise Panet (widow of Lamothe, later Mme Pierre Levesque); Mme Mélanie Levesque Dupuis; Roseance Dupuis; unknown dealer; purchased Jean Palardy; purchased McCord Museum, 1986.

EXHIBITIONS: 1887 Montreal, as "Princess Theresa-Josepha-Charlotta"; 1892 Montreal, as "Princess Theresa-Josepha-Charlotta".

REFERENCES: Montreal 1887, p. 42, no. 169; Montreal 1892, p. 30, no. 445.

In 1787, the Archduchess Maria Therese (1767–1827), Grand Duke Peter Leopold's eldest daughter,

married Prince Anton of Saxony. The couple had four children, all of whom died in childhood. Upon the death of his brother, Friedrich August III in 1827, Prince Anton ascended the throne of Saxony, at the age of seventy-two. His assumption of the title was not well received by his people, who wanted a younger and more dynamic ruler.

On 11 March 1782, Berczy wrote that he had completed individual portraits of the grand duke (see cat. 11 and LW 35), the archdukes Francis and Joseph (LW 36, 40), and the archduchess Maria Therese (LW 41). The size of Maria Therese's portrait was about the same as that of the grand duke's (approx. 23.4 × 18.4 cm). The archduchess was portrayed with a basket of flowers on a terrace of the Pitti Palace, overlooking the shrubbery of the Boboli Garden. Berczy was convinced that this was the most accurate likeness he had done to date.[1]

Obviously, the portrait of the archduchess described in March 1782 is not the painting under discussion. In this work (pl. II), Maria Therese, whose identity can be confirmed by comparison with other known portraits,[2] is depicted indoors, seated next to a table on which is placed a vase of flowers and a book. Instead of attracting the viewer's gaze to the Boboli Garden in the background, Berczy focuses attention by introducing a *trompe l'œil* stone frame. This was a popular device of the period, but more particularly of the seventeenth century, when it was used by Dutch painters such as Frans van Mieris (1633–1681) and Gerrit Dou (1613–1675). Berczy would employ the oval stone frame device again in his portrait of Joseph Brant (cat. 76).

The present portrait, evidently brought to Canada by William Berczy, underwent a variety of descriptive titles. In his will, William Bent Berczy accurately described the portrait as "Archduchess Theresa of Austria" painted in oils by his father.[3] The accurate title and name of the sitter were apparently forgotten by William Bent Berczy's descendants. They lent the portrait to exhibitions organized by the Numismatic and Antiquarian Society of Montreal in 1887 and 1892 as "Princess Theresa-Josepha-Charlotta" (she was baptized Maria Therese Josepha Carolina Johanna). Curiously, in an 1808 letter to her son William, Charlotte Berczy described the subject as the Queen of Saxony,[4] even though she did not attain this title until 1827.

The dating of the painting is problematic. In the catalogues for the two Montreal exhibitions it was dated as 1794 – an impossible date – if for no other reason than that this was the time when Berczy was deeply immersed in moving his German settlers from the wilderness of the Genesee to the wilderness of Upper Canada.

Stylistically and technically the painting is perfectly compatible with Berczy's European period: careful and subtle shading of colours through the meticulous application of layers of paint, creating fabrics of sumptuous quality and a fully developed sense of volume and depth. Even among the artist's best Canadian works, such as the full-length portrait of Joseph Brant (cat. 77), Berczy would not attempt to confer this high degree of finish to a painting.

The most vexing question about this portrait is, why did Berczy keep it? Perhaps he painted it specifically to use as a "sample of his wares." Indeed, it would have made an impressive demonstration of his talents to potential clients in Switzerland, or at other courts of Europe that he might visit.

1. KIF, Berczy to Gruner, Florence, 11 Mar. 1782, p. 428.
2. Galleria d'Arte Moderna, Florence, *Portrait of Maria Teresa di Toscana* by Vincenzo Giannini (Inv. 1890, no. 4249). Staatliche Kunstsammlungen, Gemäldegalerie Alte Meister, Dresden, *Portrait of Maria Theresia* by an unknown artist (cat. no. 2878). Dr Harald Marx has provided photographs of the different portraits of Maria Therese in Saxony.
3. Transcript of will of William Bent Berczy, 1 Dec. 1866. (Transcribed by Louis-François-Georges Baby; source of original unknown.)
4. SAUM, U/1414: Charlotte Berczy to WBB, Montreal, 1 Sept. 1808.

Cat. 14
Attributed to William Berczy
Castle in a Landscape c. 1781–85

Pen and brush with black ink over graphite on laid paper
22 × 31.2 cm
Art Gallery of Ontario, Toronto 83/279
Gift of John Andre, 1983

PROVENANCE: by descent in Berczy family; purchased
John Andre, 1960s; gift to AGO, 1983.
EXHIBITIONS: 1968 ROM; 1980 Market Gallery, as
"Landscape With A Castle"; 1987 AGO; 1989
AGO.
REFERENCES: Andre 1967, p. 88 and repr. as "Castle
Jajace"; Boyanoski 1989, p. 10, no. 3.

Many drawings by various artists can be traced
through the collections of Berczy's descendants.
Berczy not only collected the works of his European
friends and colleagues, but also is documented as
having made his own copies of the drawings of
other artists (see LW 20). In the midst of this welter
of works by various hands, the question of attribu-
tion for many drawings with a Berczy provenance
becomes difficult.

As early as the 1760s, Berczy is known to have
made pure landscape drawings (see LW 2). How-
ever, in Berczy's fully attributed drawings, the land-
scape is treated as a background for the figural scene.
If this drawing is by Berczy, then it is the only pure
landscape which has come down to us, and seems
different in style from his usual way of drawing. Yet
the fine and delicate use of brush-point and wash is
reminiscent of his *Pentolaccia* (cat. 4). Thus, this
drawing and the following stylistically similar draw-
ing do suggest a possible attribution to William
Berczy.

For his own pleasure and practice, Berczy habit-
ually carried a notebook wherever he went, in order
to be prepared to sketch anything of interest.[1] As he
travelled between Switzerland and Florence, it
would be surprising if the artist did not record the
picturesque Alpine landscape through which he
passed, as he was later to do in Canada. In Septem-
ber 1782, en route from Milan to Bern, he crossed
the St. Gotthard Pass, a region not dissimilar to the
landscape here depicted.[2] One may speculate that a
small sketch could have been worked up in his stu-
dio as a finished presentation drawing. The ease and
assurance with which Berczy has drawn the figures
fishing in the river or resting on the shore are
unusual for the artist, and suggest that he may have
added to his own composition by copying elements
from other sources.

1. KIF, Berczy to Gruner, Florence, 25 Mar. 1782,
p. 241.
2. KIF, Berczy to Gruner, Florence, 15 Apr. 1782,
p. 259; and Milan, 31 Aug. 1782, p. 465.

Cat. 15
Attributed to William Berczy
Landscape with Turkish Artillery c. 1781–85

Pen and brush with black ink over graphite on wove
 paper, mounted on card
14.7 × 20.2 cm
Art Gallery of Ontario, Toronto 83/282
Gift of John Andre, 1983

PROVENANCE: by descent in Berczy family; purchased
 John Andre, 1960s; gift to AGO, 1983.
EXHIBITIONS: 1968 ROM; 1980 Market Gallery, as
 "Landscape with Turks and a Canon"; 1989 AGO,
 as "Landscape with Figures".
REFERENCES: Boyanoski 1989, p. 10, no. 2.

For a discussion of the problems of attribution, see
catalogue 14, a drawing that is stylistically very close
to this one.

This drawing in brush-point and wash, is clearly
inspired by Berczy's copying Stefano della Bella
(1610–1664) and Jacques Callot (1592–1635) at the
Uffizi in Florence (see LW 20). The train of soldiers
diagonally crossing the picture plane with horses and
cannon or other equipment was a common motif of
Stefano della Bella, as well as Callot. The almost the-
atrical setting with the *repoussoir* motif of the rocks
in the foreground, in addition to the mountainous
back-ground, reminds one more of Callot. Berczy's
own contribution to this composition seems to be
the Turkish dress of the soldiers. However, the drum
carried by the soldier just behind the cannon is more
typical of European armies – perhaps it was a trophy
of war. Turks normally used kettledrums. This evi-
dent copying or strong influence of other artists is a
good example of the complications that arise in
attempting to attribute the drawing to Berczy.

The subject is perhaps an allusion to the many
attempts of the Ottoman Empire, over the course of
centuries, to expand into central Europe. Memories
of the siege of Vienna in 1683 and the victories of
Prince Eugene of Savoy over the Turks, the last of
which was the Battle of Belgrade in 1717, were still
alive in Christian Europe.

Cat. 16
An Allegory c. 1782–89

Grey watercolour wash over pen and grey wash on wove
 paper
44.7 × 53.5 cm
John Laurel Russell

PROVENANCE: unidentified dealer, Montreal; purchased
 by John Laurel Russell, late 1960s.

Despite its mysterious provenance, a comparison of
the drawing style and compositional elements clear-
ly shows this to be a drawing by William Berczy. It
is a curious composition, made up of elements pure-
ly of the artist's own imagination combined with
those borrowed from other works. The result is a
drawing peculiar to William Berczy, which defies all
standard interpretations.

Evidently borrowed are the classical landscape
and individual elements of the three central figures.
Berczy has apparently added the deformed tree and
the classical architectural fragment with giant col-
umns; added too are the tree trunk and the floral
elements in the foreground, which can be seen as

well in the costume study (cat. 2) done in Florence
and in the full-length portrait of Joseph Brant (cat.
77) done in Canada. The winged figure foreshad-
ows Eleonora Woolsey's pose (cat. 83, 84), albeit
with the opposite arm raised.

The dating of the work is difficult, but it can
probably be safely described as a European work. We
know that while he was in Florence in 1781–84,
Berczy was trying to turn from portrait painting to
history painting; he was practising this more highly
regarded genre in part by helping some of his col-
leagues with their paintings.[1] The subject of the pic-
ture can not be identified. The palm trees and the
classical ruins suggest the Holy Land, as does the
barefooted figure in the robe, who could be Christ.
Is he blessing, marrying, or preaching to the curi-
ously-dressed couple – she in contemporary cloth-
ing and he in antique dress? No literary source,
biblical or classical, that could link these four figures
has been found.

1. KIF, Berczy to Gruner, Florence, 25 Nov. 1781,
 p. 384; 17 Dec. 1781, pp. 394-95; and 12 Dec. 1783,
 p. 583.

Cat. 17
Charlotte Allamand Berczy c. 1782–83

Metal point with touches of graphite on prepared paper
14.3 × 11.4 cm
INSCRIPTIONS: Verso: *1/2 Ro.*
Royal Ontario Museum, Toronto 968.298.4
Sigmund Samuel Trust

PROVENANCE: William Bent Berczy by descent to
 Louisa Berczy Moore; Robert Albert Moore; Louisa
 A. Moore; purchased John Andre, 1960s; purchased
 ROM, 1968.
EXHIBITIONS: 1968 ROM; 1980 Market Gallery.
REFERENCES: Andre 1967, repr.; Allodi 1974, vol. 1,
 no. 142.

Charlotte Allamand was born on 16 April 1760 at
Lausanne. On 1 November 1785, she married
William Berczy at Chavanne-le-Veyron. Having
spent her youth under the loving care and guidance
of Marguerite Gruner in the quiet security of the
Swiss town of Bern, Charlotte certainly was to mas-
ter with bravura the adventurous and often difficult
life she would lead with William Berczy. After a
brief stay in Geneva and failure to make a living in

Bern, the Berczys moved to Florence in 1787; there
they lived comfortably until 1790 when they left for
London. In 1791, Berczy started to work for the
Genesee Association to bring German settlers to the
United States. But as soon as they set foot in the
New World, their hardships began in earnest.
Whenever Berczy travelled, he left the complicated
and trying affairs of the German settlers to the dili-
gence and care of Charlotte. While Berczy was mak-
ing new arrangements for his settlers to come to
Upper Canada, it was Charlotte, with the assistance
of the Lutheran minister, who had to take care of
the settlers and eventually organize their departure
to Canada. When Berczy's settlement scheme in
Upper Canada began to fail, he left his family alone
in Montreal from 1798 to 1802 while he tried to
defend his land claims in Quebec and London.

In order to care for herself and her two small sons,
Charlotte opened a girls' school, giving instruction
in languages, music, drawing, and painting. Being
an educated woman and having been taught paint-
ing by her husband, she was well equipped for this
task. She was on her own again in 1802–04, when
Berczy stayed in York with their son William, and
once more in 1808–09, when the two were in Que-
bec City. In the spring of 1812, Berczy left for New
York; he died there in February 1813. In a letter of
23 June 1815 to Marguerite Gruner, Charlotte con-
fides in her old friend: "I am the fortunate mother
of two virtuous sons, who are making their way
honourably in the world, and for three years have
been the grieving widow of my amiable Berczy,
whose loss I constantly bemoan; it gives me a horri-
ble emptiness that nothing in the world can cure."[1]
Charlotte lived the remainder of her life with her
sons at Amherstburg and finally at D'Ailleboust with
her son William and her daughter-in-law Amélie
Panet. She died on 18 September 1839. (See also
Appendix A, Genealogy.)

This portrait of Berczy's fiancée Charlotte Alla-
mand is clearly a labour of love and was probably

Cat. 18
Charlotte Allamand Berczy c. 1782–83

Graphite on thin laid paper
17.4 × 12.7 cm (oval)
Art Gallery of Ontario, Toronto 82/220
Gift of John Andre, 1982

PROVENANCE: by descent in Berczy family; purchased
John Andre, 1960s; gift to AGO, 1982.

Similarities between this drawing and the previous metal-point drawing of Charlotte incline one to consider her the subject here as well. The present work is more spontaneous, more fluently executed, probably the result of the softer, more flexible graphite in comparison to the stiffer, harder, and less manageable metal point.

The device of plucking a flower, with the right elbow leaning upon a table, is the same in both drawings; but here Berczy has the left hand holding and the right, plucking the flower, and he has varied the pose slightly.

done after he first returned to Bern from Florence in the late summer of 1782. This was at the time the twenty-two-year-old Charlotte accepted Berczy's proposal of marriage. With her short-cut bangs and long curly hair, she looks quite young and charmingly innocent. Indeed, her unpretentious coiffure lends a certain timeless quality to the portrait. This effect is strengthened by the quiet and pensive expression with which Charlotte is plucking a flower, a motif which offers itself to all kinds of interpretations – frivolity, coquetry, or, as Berczy's fellow painter Greuze might have had it, sentimentality.

1. KIF, letter (not bound), Charlotte Berczy to Marguerite Gruner, Montreal, 25 June 1815 (fifth letter). Twenty-five years after all communication between Charlotte Berczy and Marguerite Gruner had ceased, contact was re-established through a Bernese officer serving with the British Army in Montreal. [NA, MG24, L3, vol. 26, no. 016581: F. Kirchberger to Charlotte Berczy, Bern, 8 Oct. 1815.]

Cat. 19
Portrait of a Child c. 1782–98

Metal point with touches of graphite on prepared paper
8.8 × 7.2 cm
INSCRIPTIONS: Verso: in unknown hand, *Berczy père;* on
 label [*Miss Mary Ferris* ?]
Private collection

PROVENANCE: twentieth-century Montreal collectors.

Not many of Berczy's drawings survive, least of all
in metal point – a technique that reached its peak in
the second half of the fifteenth century. It then
experienced a weak revival in the eighteenth centu-
ry, particularly among miniaturists.[1] While the artist
never actually wrote about using metal point, his
artistic curiosity led him to try a greater variety of
techniques than we can find reference to in his let-
ters. After all, the metal point was very suitable for
his inclination towards a refined and accurate, preci-
sionist style. Except for the portrait of Charlotte
(cat. 17) and this small drawing of a little boy seen in

profile, no other drawing in metal point has come
down to us.

The dating of this charming study of a little boy
is problematic. The de Muralt boys (cat. 20, 21) and
the four archdukes in the *Family of the Grand Duke
Peter Leopold of Tuscany* (cat. 12) have similar haircuts.
But children's hair fashions did not change quickly,
and this drawing could well belong to the Cana-
dian period: the chubby-faced young boy somewhat
resembles Berczy's own son, Charles (cat. 82).

1. Walter Koschatzky, *Die Kunst der Zeichnung. Technik,
 Geschichte, Meisterwerke* (Salzburg: Residenz Verlag,
 1977), pp. 73f.

Cat. 20
Bernard Louis de Muralt 1782–83

Watercolour and gouache on vellum
7.8 × 6.5 cm (oval)
INSCRIPTIONS: Verso: on label, *BÉRÉTRI / Miniature de / Bernard Louis de Muralt, / fils ainé de Bernard-Louis / de Muralt et de Marguerite / de Tavel. Pour servir de mo-dèle aux portraits / sur cuivre. Fait éxécuter / par / Bernard Louis de Muralt / 1739–1829* [sic][1]
Private collection, Switzerland

PROVENANCE: by descent in family of the sitter.
REFERENCES: Stock, X:2, 1983, p. 131, repr. p. 132.

During Berczy's second stay in Bern, from September 1782 to June 1783, Bernard Louis de Muralt continued his patronage of the artist by commissioning a portrait of his wife (cat. 24) and a group portrait of three of his children (cat. 23). Other relatives of de Muralt were also painted (see cat. 25, 26) and, although we have as yet no proof, it is hard to believe that Monsieur de Muralt himself did not sit for a portrait.

As usual, Berczy began work by making individual studies of each of the sitters, and these three small gouache portraits of the de Muralt children (cat. 20–22) are in all likelihood the original studies. They have remained with the family, suggesting they were part of the commission or donated by the artist in gratitude for the largesse of this important patron.

When Berczy returned to Florence in 1783, he took the studies with him in order to complete the unfinished group portrait (cat. 23). He also needed them for a further commission, as de Muralt seems to have been so pleased with the little preparatory portraits that he ordered copies of them in oil. However, Berczy had another artist make these copies and he gave them only the finishing touches.[2]

Bernard Louis de Muralt (1777–1858),[3] the eldest of the three children and his father's namesake, was six years old when his portrait was painted. The expression of the boy's face shows an alert and determined child. He followed a political career, typical for Bernese patricians. In 1803, he became a burgher, the prerequisite for entering such a career, and in the same year was appointed bailiff of the town of Wangen. In 1810, he held the same position

Cat. 21
Bernard Carl de Muralt 1782–83

in Thun. In the peace negotiations of 1814 leading to the Treaty of Paris, he acted as Envoy Extraordinary for the Bernese Government. In 1817, he became a member of the Executive Council in Bern, and from 1826 to 1831 held the position of treasurer. Bernard Louis de Muralt retired from politics in 1831 and became a wine merchant. In 1802 he had married Marguerite-Marie-Charlotte de Watteville, heir of Castle Chardonne near Vivis in the Canton Waadt. They had four children. Given to bouts of depression, his wife committed suicide by jumping from the roof of their house in Bern. Her last words are said to have been, "Adieu mes enfants." In 1820, Bernard Louis took a second wife, Madeleine-Caroline de Goumëns, by whom he had one daughter.

1. The correct dates are 1749–1816.
2. KIF, Berczy to Gruner, Florence, 7 Feb. 1784, p. 611; and Naples, May 1784, p. 643; 15 June 1784, p. 653; and 29 Aug. 1784, p. 669.
3. *Historisch Biographisches Lexikon der Schweiz,* vol. v, p. 211; Burgerbibliothek Bern, B. Rodt, vol. 4, pp. 190-91, no. 22; Quervain, p. 44; Karl Howald, *Die Stadtbrunnen Berns...,* Mss. h.h. xxib 362 (1846), p. 138, and 363 (1848), p. 297; Mss. Mül. 643.52, fol. 25.

Watercolour and gouache on vellum
7.7 × 6.3 cm (oval)
INSCRIPTIONS: Verso: on label, *BÉRÉTRI / Miniature de / Bernard Carl de Muralt / 2e fils de Bernard / Louis de Muralt et de / Marguerite de Tavel. Pour / servir de modèle aux por- / traits sur cuivre. / Fait éxécuter par / Bernard Louis / de Muralt / 1739–1809* [sic][1]
Private collection, Switzerland

PROVENANCE: by descent in family of the sitter.
REFERENCES: Stock, x:2, 1983, p. 131, repr. p. 132.

It was a long-standing Swiss tradition to pursue a military career in foreign service. Bernard Carl de Muralt (1778–1802), second son of Bernard Louis and Marguerite de Muralt, became an officer in the British Army and died in 1802, at the age of twenty-four, at Alexandria in Egypt.[2]

The slightly round-faced Bernard Carl was five years old when Berczy portrayed him. In comparison to his elder brother Bernard Louis, he still has an innocent and child-like expression.

1. The correct dates are 1749–1816.
2 Burgerbibliothek Bern, B. Rodt, vol. 4, pp. 190-91, no. 23; Mss. Mül. 643.52, fol. 24; Archiv von Muralt 10/11.

Cat. 22
Henriette Margarete de Muralt 1782–83

Watercolour and gouache on vellum
7.7 × 6.4 cm (oval)
INSCRIPTIONS: Verso: on label, *BÉRÉTRI / Miniature de / Henriette Margarete de / Muralt, fille de Bernard Louis de Muralt et de / Marguerite de Tavel, / pour servir aux portraits / sur cuivre. Fait éxécuter par / Bernard Louis de Muralt 1739 – 1809* [sic][1]
Private collection, Switzerland

PROVENANCE: by descent in family of the sitter.
REFERENCES: Stock, X:2, 1983, p. 131, repr. p. 132.

Henriette Margarete (1780–1834) married Bernhard Albrecht Stettler in 1805; he was a retired officer in the service of Piedmont. From 1803 to 1832, he pursued a career in government. Convicted of fraud, Stettler was imprisoned until 1834, the year in which Henriette Margarete died. Their only child, Albertine Margarete, had died a year earlier at the age of twenty.[2]

The portrait of the astonished-looking little Henriette Margarete, painted in fresh yet delicate colours, is charming. It clearly shows that the three miniatures of the de Muralt children were, although quite accomplished, only preparatory studies. Upon close examination, the sketchy treatment is obvious: the material of the hat and the flowers that adorn it are adequately suggested but lack the precision of Berczy's finished works, while the girl's blonde, curly hair is only hinted at.

1. The correct dates are 1749–1816.
2. Burgerbibliothek Bern, B. Rodt, vol. 5, pp. 147–48, no. 72.

Cat. 23
The Three Eldest Children of
Bernard Louis de Muralt 1782–83

Oil on copper
51 × 38 cm
INSCRIPTIONS: Verso: on label, *Bernhard, Ludwig; Bern-*
hard Carl und / Henriette, Margaritha von Muralt /
Kinder: / des Bernhard, Ludwig und der Margarita von
Tavel; on label, on back of frame, added c. 1950,
Robert Gaston de Muralt / Attribué à L. Antoine Brun de
Versoix / (1758 – 1805) / Peintre de Marie Antoinette
Private collection, Switzerland

PROVENANCE: by descent in de Muralt family;
unrecorded art dealer, Bern; purchased by father of
present owner, c. 1955–57.
REFERENCES: Quervain, p. 44; Inventaire de Multengut,
Inventaire descriptive et estimatif pour la famille de Muralt
(unpublished manuscript, c. 1960), no. 17, as
"Enfants de Muralt"; Stock, X:2, 1983, pp. 131–34,
col. repr. p. 133.

When Berczy returned to Bern in September 1782
following his successful first sojourn in Italy, he
brought with him some of the works of art he had
made in Florence to show to his friends and poten-
tial clients.[1] Berczy's success with the grand-ducal
family portrait may have kindled in Bernard Louis
de Muralt a desire to have a group portrait of his
three children (pl. III). Before he went back to Italy
in June 1783, Berczy had probably presented an
overall scheme for approval. Monsieur de Muralt
seemed to be quite eager and impatient to receive
"his picture," according to Berczy. On 23 October
1783, the artist wrote of the near completion of the
painting, and five weeks later he could report on its
departure for Bern. Its price was twenty Florentine
pounds.[2]

The shipment of the painting took longer than
expected and Berczy began to worry about the
effects of the journey on its condition. Through
Marguerite Gruner, he sent a message to de Muralt

28.
Albert and Nicolas Rubens, n.d.,
by Gustav Adolph Müller after Rubens.
Collection: Bibliothèque Nationale, Paris.

that in case the lighter sections of the picture should yellow slightly, Berczy would retouch it with varnish, on his return to Bern.[3] However, there is no evidence that this was necessary.

Berczy shows the three children in an entrance hall not unlike those of Bernese patrician houses. The colour of the greenish-grey sandstone and the vaulted flight of stairs rising from the first landing, conform to the local architectural style. Yet the two giant columns on a high pedestal and a faintly visible pilaster in the shadowed area behind them are not typical. Berczy took the motif of a column, as well as the posture of the two boys, from Peter Paul Rubens' portrait of his two sons Albert and Nicolas. From 1767 on, this picture was in the Liechtenstein Collection, in Vienna, and Berczy could have seen it there. However, the almost identical rendering of

FILIOS HOS SUOS P.PRU... BENS IPSEMET PINXIT
in pinacotheca Vinna Princip: *Lichtensteiniana existentes*

Rubens' composition makes it quite clear that Berczy did not work from memory but likely copied an engraving after the painting (fig. 28).

We do not know if de Muralt was aware that the Rubens served as model for his boys. However, as he had already ordered copies from Berczy of other well-known pictures (see LW 16), and as copies were then much more appreciated than today, it is very likely that he knew of the model and had even heartily approved of it.

At first it would seem that Berczy had copied Rubens slavishly. However, the artist made a few minor changes and depicted the de Muralt boys clothed in the latest French fashions. Even if the pose of the children is almost identical, the atmosphere is quite different. Rubens' sons fill almost the whole picture – the younger boy's left foot extends to the picture's lower edge – and the giant column is used only as an architectural backdrop, suggesting some space and grandeur. Berczy, on the other hand, integrates this architectural device in a larger, clearly-defined domestic interior. With the receding floor pattern, he leads the viewer's eye into the picture and beyond the children into the interior of a precise architectural setting. The de Muralt children, therefore, do not convey the immediate presence of the Rubens children nor their healthy vitality, but are part of a more complex composition. Still, they reflect, as do the Rubens boys, the courtly ideal of their time. The boys' little sister, Henriette Margarete, wearing an elaborately adorned hat and long dress, attentively watches the flying bird on a string and tries, with outstretched arms, to keep her balance.

1. KIF, Berczy to Gruner, Milan, 31 Aug. 1782, p. 466.
2. KIF, Berczy to Gruner, Florence, 23 Oct. 1783, pp. 560–61; 27 Nov. 1783, p. 577; and 3 Dec. 1783, p. 582.
3. KIF, Berczy to Gruner, Florence, 7 Feb. 1784, pp. 611f.

Cat. 24
Marguerite de Muralt 1782–83

Gouache on vellum

13.5 × 11.8 cm (oval)

INSCRIPTIONS: Verso: on label, *Margarita /* [name obliterated] *des Bernh. Ludwigs, des Landvogt / zu Bipps Gattin und Tochter des / Peter Ludwig von Tavel / cop. 8 Febr. 1775 / geb. 13 Nov. 1759, gest. Nov. 1837.*

Private collection, Switzerland

PROVENANCE: by descent in de Muralt family; Bernhard Pia, Bern; sold at Galerie Jürg Stuker, Bern, 11–27 Nov. 1982, lot 2374, to present owner.

REFERENCES: Galerie Jürg Stuker, Bern, *Auktionen 215–227*, 1982, no. 2374, as "Berner Miniaturist. Brustbild einer Berner Aristokratin"; Stock, x:2, 1983, p. 134, repr. p. 135; Beate Stock, "Hat William Berczy Ihre Vorfahren gemalt?" in *Galerie Stuker Blätter*, no. 19 (April 1988), col. repr. p. 9.

As far as we know, Berczy painted portraits of three de Muralt women (cat. 24–26). All three are head-and-shoulder poses before a plain background with just a glimpse of a chair back in view, and placed in an oval or round format. The women all wear light-blue dresses with white accessories. Despite these similarities, Berczy managed to capture each sitter's individual personality.

Marguerite de Muralt, née de Tavel (1759–1837), Bernard Louis de Muralt's wife and mother of the three children in catalogue 23, appears to be a cautious and shy person. Yet from under her hat, tastefully decorated with feathers and bow, she looks directly at the viewer. The de Muralts were married in 1775 and had eleven children.

Her husband, Bernard Louis de Muralt (1749–1816), known as Bernhard Ludwig von Muralt in German-speaking circles, seems to have been Berczy's most important Bernese client, and followed the typical career of a Bernese patrician. After having become a burgher in 1785, he was active as a notary, as bailiff in Bipp (half-way between Bern and Basel), and in the Great Council of Bern. He appears to have retired from public life around the turn of the century.[1]

1. *Historisch Biographisches Lexikon der Schweiz,* vol. v, p. 211; Quervain, p. 44; Burgerbibliothek Bern, B. Rodt, vol. 4, p. 192, no. 20.

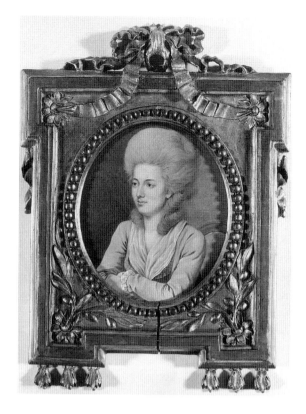

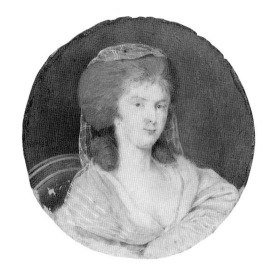

Cat. 26
Emilia Elisabeth de Muralt 1783

Gouache on ivory, mounted on card
5.6 × 5.8 cm (circle)
INSCRIPTIONS: l.l., *Berczy pinxi 1783;* Verso: on vellum,
 *Madame / la trésorière / de Muralt / née de Sinner / plus
 tard / Mme Thormann*
Private collection, Switzerland

PROVENANCE: by family descent to present owner.

In 1775, Emilia Elisabeth de Sinner (1757–1845)
married Guillaume Bernard de Muralt (1737–
1796), brother of Maria (cat. 25). Upon Guillaume
Bernard's retirement from the French Army with
the rank of major, he entered public service and
became bailiff in Gottstatt. He also commanded
Bernese troops in 1790–92. His wife was given the
sobriquet "la belle Trésorière," or "la Générale."
Following the death of her husband, she married
Friedrich Emanuel Thormann (1763–1833), an
officer in the French service and later appeal-court
judge in Bern.

In this portrait, "la belle Trésorière" is dressed in
blue and adorned with a veil. She looks appealingly
at the viewer. Her left arm is wrapped in a white fur
stole, and rests on an unseen support. In this first
known signed and dated work, in contrast to his
self-portrait of the same date (cat. 27), Berczy used
the characteristics of the ivory support in the skin
tones. Face and décolleté are painted with very thin
and light colours allowing the luminosity of the
ivory to come through.

Cat. 25
Maria de Muralt 1782–83

Gouache on vellum
13.2 × 11.2 cm (oval)
INSCRIPTIONS: Verso: on paper backing, *Mademoiselle de
 [name obliterated] / Marianne von /* [name obliterat-
 ed] *geb. 13 Juni 1730 gest. Jaenner 1803 / unverehelicht
 Tochter des Johann Bernhard und / der Maria Manuel*
Private collection, Switzerland

PROVENANCE: by descent in de Muralt family; Bernhard
 Pia, Bern; sold at Galerie Jürg Stuker, Bern, 11–27
 Nov. 1982, lot 2375, to present owner.
REFERENCES: Galerie Jürg Stuker, Bern, *Auktionen 215–
 227, 1982,* no. 2375, as "Berner Miniaturist. Damen-
 brustbildnis"; Stock, x:2, 1983, p. 134, repr. p. 135.

Maria (or Marianne) de Muralt (1730–1803) was
a spinster of fifty-two when Berczy painted her.
Posed with crossed arms, she conveys the impression
of an active, purposeful, and self-assured woman.
Her carefully dressed hair is the only acknowledge-
ment of her status. Maria de Muralt was the daugh-
ter of Jean Bernard de Muralt (1702–1755). Her
brother, Guillaume Bernard (1737–1796) was mar-
ried to "la belle Trésorière" (cat. 26).[1]

1. Burgerbibliothek Bern, B. Rodt, vol. 4, p. 190,
 no. 14.

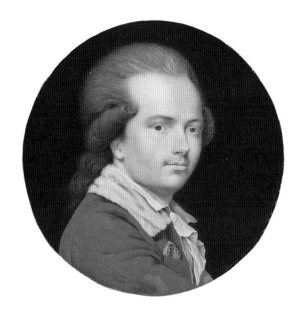

Cat. 27
Self-portrait 1783

Watercolour and gouache on ivory

11.6 × 11.5 cm (circle)

INSCRIPTIONS: l.r., *Berczy peint par sois même à Florence 1783*

Royal Ontario Museum, Toronto 989.282.1

Purchased with the assistance of a grant from the Government of Canada under the terms of the Cultural Property Export and Import Act.

PROVENANCE: by descent in de Muralt family; private collection Jürg Stuker, Gerzensee, Switzerland; sold at Galerie Jürg Stuker, Bern, 26–31 Oct. 1989, lot no. 5197, to ROM.

REFERENCES: *Catalogue des portraits et miniatures à Chardonne,* unpublished manuscript compiled by Dina de Muralt, c. 1910–20 ("Berczy peintre en miniature, peint par soi-même à Florence 1783; très belle miniature en vêtement rouge et jabot blanc."); Galerie Jürg Stuker, Bern, *Privatsammlung Jürg Stuker Altes Schloss Gerzensee. Nachlass des Kammerherrn Baron Robert Stuker Pascha,* vol. II, 1989, no. 5197, pl. 40; *Kunstpreis Jahrbuch 1990,* part I, vol. XLV (Munich: Weltkunst Verlag, 1990), p. 443, repr.

This striking self-portrait (pl. IV) is unquestionably one of William Berczy's finest works. Depicted close-up and glancing over his shoulder, his eyes firmly fixed on the viewer, Berczy appears forceful and self-assured. He offers no allusion to his profession as a painter, but rather appears as a man of energy, determination, and pride. Berczy wears a crimson jacket with a golden tassel for a button and a white fur collar, as well as a white shirt with a jabot. His hair is carefully groomed in the fashion of the time and lightly powdered. This little work is highly finished, with flesh tones applied in many shades of wonderfully luminous colours. The face itself is done in miniature technique, with very delicate hatching and dotting in watercolour. By contrast, in order to achieve the rich, fully saturated colours of the clothing and the uniform black background, the artist used several layers of gouache painted in broad, smoothly blended brushstrokes. With this miniature, Berczy stands in the best European tradition. This portrait, one of only two known signed works by Berczy, is one of a series of self-portraits, some of which came to Canada and remained with the family until the mid-twentieth century. Curiously, all had lost their identification as William Berczy, and only now with the discovery of this signed self-portrait in 1989 can they be properly attributed.

During his first stay in Florence, from 19 December 1780 to 20 August 1782, Berczy mentioned two self-portraits, but the details he offers on these two works are inconsistent, and in the end it is not clear how many self-portraits he actually painted. In May 1781, Berczy was working on a self-portrait in oil (LW 29) that he intended to give to the *Accademia del Disegno;*[1] by December, he had changed his mind and was planning to deposit a self-portrait in gouache (LW 32), but not before he had had it copied as an engraving. In the December 1781 letter, Berczy also mentioned an unfinished self-portrait in oil (the same one as in the May letter?) that he wanted to donate to the Uffizi.[2] None of these portraits has been found in the Florentine collections, nor is there any record of an engraved self-portrait. Therefore, it is impossible to tell what their relationship could be to this signed and dated self-portrait executed in 1783. This work is not mentioned in any of Berczy's correspondence. It was most likely a gift to his patron-friend Bernard Louis de Muralt.

1. KIF, Berczy to Gruner, Florence, 23 May 1781, p. 282.
2. KIF, Berczy to Gruner, Florence, 17 Dec. 1781, pp. 393, 395.

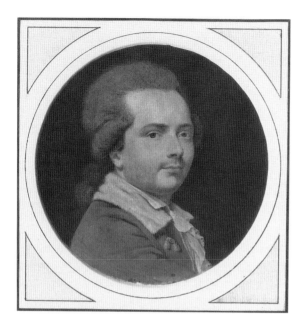

Cat. 28
Self-portrait c. 1783

Gouache on vellum
11 cm diam. (sight)
Private collection

PROVENANCE: by descent in Berczy family to Elizabeth
 Waldron; Louisa A. Moore; John Andre; G. Blair
 Laing; present owner.
EXHIBITIONS: 1968 ROM; 1980 Market Gallery, as
 "Portrait of a Young Man".
REFERENCES: Andre 1967, repr. as "Bernhard Moll?";
 G. Blair Laing, *Memoirs of an Art Dealer* (Toronto:
 McClelland and Stewart, 1982), vol. II, repr. opp.
 p. 70 as "Portrait of a Nobleman".

This second self-portrait came down through
Berczy's descendants, but lost its identification. This
is surprising considering that William Berczy's
memory was cherished by his descendants, who
incorrectly identified several other likenesses as self-
portraits of their artist-ancestor.

Most likely this work is either the preparatory
work for the self-portrait (cat. 27), or a copy of it.
There is, of course, the possibility that both portraits
derive from a common prototype. Whatever its
source, in comparison to the exquisite miniature
technique of the ROM self-portrait, this version is
more broadly painted in a manner resembling a
larger painting.

This particular version may have been sent to
William Bent Berczy from Marguerite Gruner.
Following William Berczy's death, contacts with
Mlle Gruner were re-established in 1814 through
the chance intermediation of a Bernese officer in
Montreal. In 1820, William Bent Berczy wrote to
Mlle Gruner, acknowledging the gift of a self-por-
trait: "I have received the priceless gift of my dear
father's portrait."[1] This provenance could equally
apply to the following self-portrait of William
Berczy with a hat (cat. 29). The only other known
self-portrait (cat. 47), which was with the family,
belongs to Berczy's Canadian period, and was there-
fore painted after his last contact with Marguerite
Gruner.

1. KIF, letter (not bound), WBB to Marguerite
 Gruner, Sandwich, Upper Canada, 25 Dec. 1820.

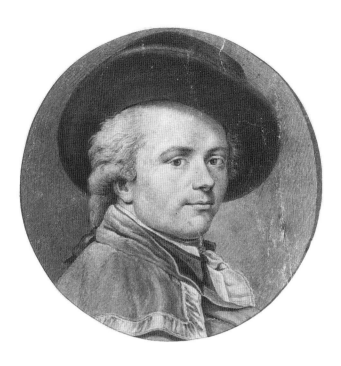

Cat. 29
Self-portrait with Hat c. 1783

Brush, red and brown watercolour on wove paper
14 × 13.3 cm (circle)
Art Gallery of Ontario, Toronto 70/149

PROVENANCE: William Bent Berczy by descent to
Louisa Berczy Moore; Louisa A. Moore; John
Andre; purchased AGO, 1970.
EXHIBITIONS: 1968 ROM; 1980 Market Gallery, as
"Young Man with a Hat"; 1982 AGO, as "Young
Man with Hat".
REFERENCES: Andre 1967, p. 97f. and repr. as "Bernhard
Moll?"; AGO 1982, p. 21, no. 7, as "Young Man
with Hat".

This carefully-drawn and finely-modelled image is a
head-and-shoulders portrait posed similarly to cata-
logues 27 and 28. The differences are in size, tech-
nique, and costume. Here, Berczy is fashionably
dressed, wearing a broad-brimmed hat and a great-
coat with a trimmed cape. The hair is a little less
neatly groomed and is tied at the back with a barely
visible bow.

It would seem that Berczy was inspired by Peter
Paul Rubens' self-portrait in the Uffizi. The pose
and the hat are similar. We know that in 1781
Berczy copied one of the two Rubens self-portraits
in this collection (LW 5), and this Berczy self-
portrait is our best indication in determining which
one he chose to copy.[1]

1. AGF, f. XIV (1781) a 96. Uffizi 1979, Peter Paul
Rubens, *Self-portrait* (Inv. no. 1884).

Cat. 30
Attributed to William Berczy
Head of a Young Woman c. 1785

Grey watercolour over graphite on off-white laid paper
11.2 × 16.6 cm
John Laurel Russell

PROVENANCE: unidentified dealer, Montreal; purchased by John Laurel Russell, 1960.

The drawing shares the same undocumented provenance as the allegorical drawing (cat. 16), which is unquestionably by Berczy. Although more elaborate, this work is stylistically close to the quick portrait sketch, *Man Smoking* (cat. 55).

This lively work is in all likelihood a preparatory sketch for a portrait, and it clearly catches the sitter's personality. It seems that Berczy's way of proceeding was to sketch the sitter first with pencil, then to add washes to define the features and to create volume and tone. The shading of the background suggests that an oval format was intended.

Cat. 31
Charlotte Berczy c. 1785–91

Oil on walnut panel
23.8 × 18.7 cm
INSCRIPTIONS: Verso: on panel, u.r., *Mrs. Kelso / tues… / morn…* [?] + *3 Do / 90;* l.l., in second hand, *Charlotte*
Royal Ontario Museum, Toronto 968.298.3
Sigmund Samuel Trust

PROVENANCE: William Bent Berczy by descent to Louisa Berczy Moore; Robert Albert Moore; Louisa A. Moore; John Andre; purchased ROM, 1968.
EXHIBITIONS: 1968 ROM; 1980 Market Gallery.
REFERENCES: Andre 1967, p. 97 and repr.

Charlotte Allamand and William Berczy were married on 1 November 1785. This portrait shows Charlotte with the same hair style as in the earlier drawings (cat. 17, 18), but she now looks more composed, self-assured, and a few years older. The image was most likely painted between 1785 and 1791, the last years she and Berczy spent in Europe.

Cat. 32
Charlotte Berczy with Hat c. 1785–91

Oil on copper
13 × 10.5 cm (oval)
Private collection

PROVENANCE: by descent in Berczy family.
EXHIBITIONS: 1980 Market Gallery, as "Portrait of Charlotte Berczy".
REFERENCES: Andre 1967, p. 97 and repr. as "Charlotte Berczy"; Stock, x:2, 1983, p. 135.

This captivating depiction of Charlotte Berczy is one of the artist's loveliest portraits (pl. V). Berczy shows his wife in a pose similar to the previous portrait in oil (cat. 31). From under her fashionable white broad-brimmed hat, Charlotte gazes into the distance with a melancholy air.

This small portrait is painted in a refined oil technique with smooth brushstrokes. Highlights and some modelling in the white collar and the blue ribbon of the dress are painted in very lightly toned varnish. The faint shadow cast by Charlotte's head on the dark olive-green background contradicts the direction of the light illuminating her face. Obviously, for Berczy, the shadow was purely a decorative device conceived to create the illusion of space.

X-ray photography has revealed that Berczy made some alterations. Originally, Charlotte's hair was painted less voluminously, with shorter bangs and hanging down her back. She wore a ruffled neckerchief instead of a ruffled collar. It also looks as if Berczy experimented with a "dryer" in the oil paint, which may have caused the painting to wrinkle more than usual.[1] The face proves an exception, it is relatively well-finished and modelled, with eyebrows painted in subtle tones of green and mauve; the collar, too, is finished to a certain degree. In comparison with Berczy's other work, this picture conveys a rather unfinished impression. The dress is poorly defined and sketchy; it seems as if he could not, at first, make up his mind about hair, collar, and background. On the left side is a formless dark curtain; a clear definition of the surrounding space is lacking. Some trees, painted in with faint washes, probably in watercolour, appear on the right side of the painting, suggesting a receding landscape. The picture, with its strong contrast of light and dark, reminds us that Berczy copied Dutch paintings.

1. References to Berczy experimenting: KIF, Berczy to Gruner, Florence, 17 Dec. 1781, p. 393; SAUM, série S, boîte 11447 (recipe for drying oil colours expeditiously, inserted in a book which served Berczy as notebook/diary).

Cat. 33
An Unknown Man c. 1785–91

Gouache and watercolour, over graphite on vellum
8.9 × 8.1 cm (oval)
INSCRIPTIONS: Verso: in pencil, *Miss Moore / 151 Alfred*
House of York Antiques, Toronto
Not in exhibition

PROVENANCE: by descent in Berczy family; G. Blair
Laing; private collection; sold Sotheby's (Toronto),
31 May 1990, lot 133, to House of York Antiques,
Toronto.
REFERENCES: Sotheby's (Toronto), *Important Canadian
Art,* 31 May 1990, lot 133.

This unfinished miniature of an unknown man most
likely belongs to the artist's late European period, as
is suggested by the style of his hair and coat. The
work is of primary interest because it is a fine exam-
ple of Berczy's miniature technique.

After having outlined head, face, and shoulders
with lines lightly drawn in pencil, he applied the first
layers of colour in watercolour as well as gouache. At
this stage he did not take great care to distribute the
colours evenly over the background and the cloth-
ing. However, from the start he worked very care-
fully on the face, modelling it with delicate hues of
ochre, blue, and red.

A second coat was applied to the face, using
hatches or smooth brush strokes in slightly different
or stronger tones in such areas as the cheeks and for
shadows. Characteristically, Berczy then began to
secure zones by painting them over with media such
as gum arabic and gouache, sometimes with both
mixed together. Had he not discontinued work on
the portrait, this process would have been repeated
as often as necessary to achieve a smooth, highly-
finished image with both strong and delicate
colours. Coloured varnish would have supplied the
last accents and highlights.

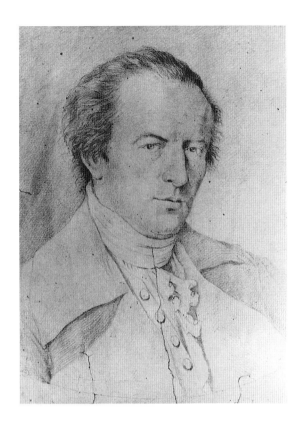

Cat. 34
An Unidentified Man c. 1790

Black chalk with touches of graphite on cream wove
 paper
27.1 × 21.5 cm (sight)
INSCRIPTIONS: said to be inscribed on verso by a family
 member, identifying portrait subject as William
 Berczy.
Private collection
Not in exhibition

PROVENANCE: by descent in Berczy family.
REFERENCES: Andre 1967, p. 97 and repr. as "Self-
 Portrait".

Once thought to be William Berczy, this attribution
cannot stand in light of the recent discovery of the
signed self-portrait (cat. 27). The oval format par-
tially indicated on the drawing suggests that it
may have been a preparatory study for one of the
portraits Berczy made around the time of his first
sojourn in London. The style of the clothing corre-
sponds to the period as well.

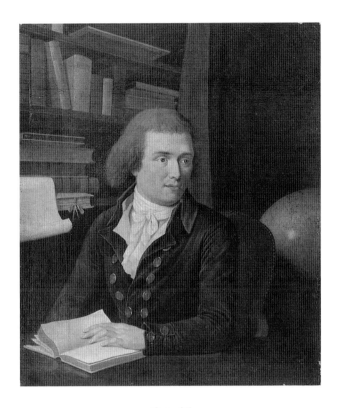

Cat. 35
A Man in His Library with a Globe c. 1790

Oil, probably on canvas, mounted on wood
23.3 × 19.9 cm (sight)
Private collection
Not in exhibition

PROVENANCE: by descent in Berczy family.
REFERENCES: Andre 1967, repr. as "A Scholar".

This portrait would seem to belong to Berczy's first
London period of 1790–91. In contrast to the artist's
many portraits painted with neutral, unspecified,
foil-like backgrounds, here the sitter is seen in his
library. It is interesting that the part of the picture in
which the book and most of the sitter's figure are
placed contains a great variety of colours, with a
noticeable amount of red. The remaining section,
more than a third, is given to mostly dark, yet none-
theless lively tones, such as blue, green, and brown.

In the foreground, a man sits at a table; he is
wearing a rich blue jacket offset by brass buttons and

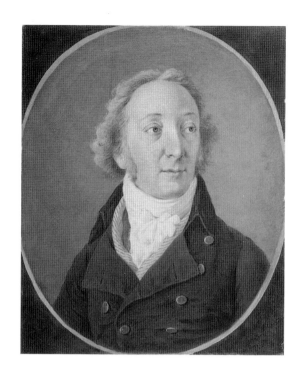

Cat. 36
Vincenzo Federici 1790–91 or 1800–01

a red collar. He has stopped reading and gazes into the distance. His rather delicate left hand rests on an open book. While no title is visible on any of the books, the globe is clearly turned so that we can see the North American continent. Although this portrait depicts neither Sir William Pulteney nor Patrick Colquhoun, the principal directors of the Genesee Association and Berczy's employers, the unknown sitter evidently had connections to North America.

Watercolour and gouache with gum arabic over graphite on wove paper

16.8 × 13.9 cm

INSCRIPTIONS: Verso: on paper backing in ink, *Mr T / Signor Federici / a Celebrated Italian / Composer of Music / by Mr Bertzy*

National Gallery of Canada 35062

PROVENANCE: Mark Sampson, New York, after 1972; sold Sotheby's (New York), 26 Oct. 1990, lot 65, to NGC.

REFERENCES: Sotheby's (New York), *Property of a European Foundation*, 26 Oct. 1990, lot 65.

The Italian composer Vincenzo Federici (1764–1826) came to London in the 1780s. His family had intended him to study law, but he left home at sixteen and, having studied the harpsichord, he supported himself by giving music lessons. By 1790, he held the position of "Maestro al Cembalo" at the King's Theatre, and his opera *L'usurpator innocente* was performed fifteen times at the Little Haymarket Theatre. Federici stayed in London until 1802, when he settled in Milan, where his operas were regularly performed at *La Scala*. In 1808 he was named counterpoint and harmony master at the Milan Conservatory, and by 1824 he had become composition master and in 1825 acting director at

the same institution. Federici wrote fourteen serious and one comic opera as well as cantatas.

The pendant portraits of Vincenzo Federici and his wife (pl. VI, VII) belong to one of Berczy's London periods, but it is not clear if he painted them during his first sojourn in 1790–91 or when he came back to London in mid-1799 to try to settle his land claims. The fact that he spent more than seven of the sixteen months of his second stay in London in debtors' prison, and that he was very occupied in arranging his affairs, would point to his first London sojourn. Also, during the later period he never made mention of any artistic activities in his letters to his wife. On the other hand, even in 1799, Berczy had to earn his living; and the composer's appearance in this portrait is more consistent with that of a man of thirty-five, than with the twenty-seven-year-old the composer would have been in 1791.

The portraits of the Federicis reflect Berczy's development from the more stylized late Rococo portrait to the more personal perception of the individual. The way that the head and shoulders are set in opposite directions combines with the composer's aloof and world-weary gaze to make this a most striking portrait. The effect is strengthened by the colours of the sitter's clothing. Signor Federici wears a rich blue jacket with brass buttons; this contrasts with his white shirt, yellow waistcoat, and a slash of vivid red jacket lining.

Berczy seems to have had a predilection for strong colours for men's clothing. In the first recorded portrait of 1767 (LW 1) the sitter is described as wearing a red jacket and a yellow waistcoat. The artist portrayed himself in 1783 (cat. 27) in a bright crimson jacket, and in various of his later portraits of men, we find the same taste for vivid colours.

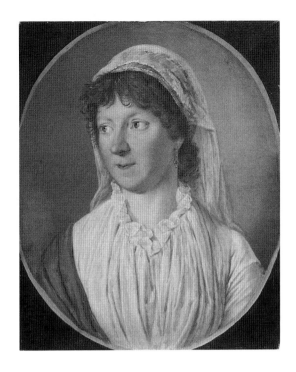

Cat. 37
Signora Federici 1790–91 or 1800–01

Watercolour and gouache over graphite on wove paper
16.8 × 13.9 cm
INSCRIPTIONS: Verso: on paper backing in ink, *Mrs Federici / by Mr Bertzy*
National Gallery of Canada 35063

PROVENANCE: Mark Sampson, New York, after 1972; sold Sotheby's (New York), 26 Oct. 1990, lot 65, to NGC.
REFERENCES: Sotheby's (New York), *Property of a European Foundation,* 26 Oct. 1990, lot 65.

In contrast to the rich colours Berczy often liked to use for male clothing, the reddish-blond-haired Signora Federici wears a white blouse, veil, and lilac shawl (pl. VII). She reflects Berczy's preferred "feminine" colour scheme, which tended more to the pale, soft, or at least subdued scale of the spectrum.

Back in 1781, Berczy had written that he was making over-sized drawings to get more knowledge of the details of the body.[1] Signora Federici's face, built up and shaped with great care down to the smallest detail, seems to bear witness to this exercise: it looks as if conceived for a larger-sized painting.

1. KIF, Berczy to Gruner, Florence, 26 July 1781, p. 318.

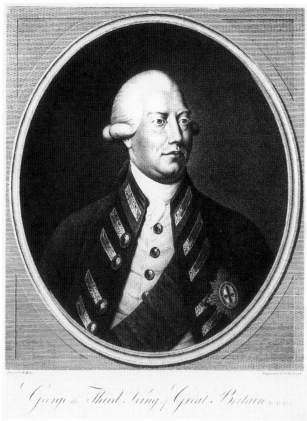

George the Third, King of Great Britain

Cat. 38
After William Berczy
George the Third, King of Great Britain 1791

Etching, roulette, and stipple engraving on laid paper
31.7 × 24.2 cm (image); 49.7 × 36.6 cm (sheet)
INSCRIPTIONS: in plate below image l.l., *Painted by W Berczy;* l.c., *GEORGE the THIRD KING of GREAT BRITAIN, &c&c&c / Published Novr 1st 1791. by Messrs Moltens Colnaghi & Co. No. 132 Pall Mall;* l.r., *Engravd by G.S & J G Facius.*
Rex Nan Kivell Collection, National Library of Australia

REFERENCES: O'Donoghue, vol. II, p. 302; Andre 1967, repr.

In November 1791, at a time when Berczy had abandoned painting and was already in Germany looking for settlers to take to North America, an engraving after Berczy's "painting" of King George III was published. Berczy's painting was, in fact, a copy after Thomas Gainsborough's full-length portrait of George III (collection: Windsor Castle), which had first been shown at the Royal Academy in 1781. Soon after this exhibition many copies were made, including engravings. It is impossible to tell which of the many available versions served as Berczy's model. Berczy chose only to show the head and shoulders of the King, set in a simple oval frame with a neutral dark background.

Berczy's intention to publish a portrait of the King may have been purely for public relations – to establish himself in London society and the art community. His choice of subject reflects his previous modus operandi of depicting rulers in order to win commissions from other patrons.

The engraving was published by Moltens Colnaghi, who by 1791 was one of the most prominent print sellers.[1] The engravers were the German-born brothers Georg Siegmund and Johann Gottlieb Facius, who arrived in London in 1776 and worked mainly for the successful engraver and publisher John Boydell (1719–1804).

1. Re: Colnaghi, see exh. cat. *Art. Commerce. Scholarship. A Window onto the Art World. Colnaghi 1760 to 1984* (London: Colnaghi & Co. Ltd., 1984), p. 17. At the time of the publication of Berczy's print, the former Milanese print seller, Paul Colnaghi, was in brief partnership with another Italian, Anthony Molteno, a collector of drawings.

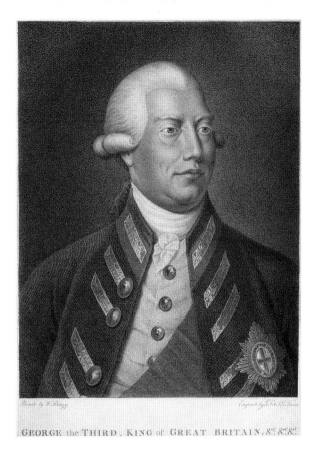

Painted by W. Berczy

Engrav'd by G. & I.G. Facius

GEORGE the THIRD, KING of GREAT BRITAIN, &c. &c.&c.

Cat. 39
After William Berczy
George the Third, King of Great Britain
c. 1791

Etching, roulette, and stipple engraving on laid paper
31.7 × 24.2 cm (image); 35.4 × 24.8 cm (sheet, trimmed within platemark)
INSCRIPTIONS: in plate below image l.l., *Painted by W,, Berczy;* l.c., *GEORGE the THIRD, KING of GREAT BRITAIN, &c.&c.&c.;* l.r., *Engravd by G,,S & J,,G,, Facius*
National Gallery of Canada 30511
Gift of David Alexander, York, U.K., 1989

Printed from the same copper plate, this is a second version of Berczy's engraving of George III. The plate has been altered, with the oval frame and all the text below the image burnished out. The title and the engravers' and painter's credits have been re-etched in a different style of script.

The presence of Berczy's name along with the Facius brothers indicates that they were involved

with the publication of this version. The absence of the original publisher's name – Moltens Colnaghi – suggests that this was possibly a pirated print, made without their knowledge. However, it is also perfectly possible that once the contract with Colnaghi was fulfilled, Berczy and the two engravers were entitled to publish an altered version for their own profit.

We cannot tell for certain when this altered print was published. It could have been either in 1791 or in 1800 when Berczy was back in London incarcerated in debtors' prison and obviously in need of money.

CANADIAN WORKS 1794–1812

by Mary Macaulay Allodi

Cat. 40
Part of Newark, Upper Canada 1794

Pen and brown ink on laid paper
21.3 × 33 cm
INSCRIPTIONS: l.c., *Part of Newark taken from Valaces Tavern the 9th June 1794.*
Agnes Etherington Art Centre, Kingston, Ont. 25–55

PROVENANCE: by descent in Berczy family (interleaved in book belonging to William Bent Berczy in 1842); book presented to Queen's University Archives by William M. Nickle; drawing transferred to Agnes Etherington Art Centre.

This drawing illustrates a building yard, with squared timbers in the foreground and stacked lumber in the background near some completed buildings. The scene was probably most typical of the newly founded town of Newark (now Niagara-on-the-Lake).

The "Valaces" mentioned in the inscription may be the Newark tavern licensed to W. Wallace in 1793.[1] The tavern stood near the house of William

Jarvis, provincial secretary and issuer of tavern licenses. The inscription is in Berczy's hand, but the date quoted is inaccurate if it refers to a spot drawing; Berczy was in Canevagis, N.Y., on 9 June 1794, arranging for the departure of his German settlers from that state, and he did not return to Newark until the following week.[2] However, he had visited and described Newark the day after his first arrival in Upper Canada, on 20 April 1794:

> *After my arrival at Newark … I went to pay a Visit to Mr. Jarvis, secretary of the Province … whom however I found not at home.… From Mr. Jarvis's house I made a walk through the town which is pleasantly situated on the left point of the River right oposite the fort of Niagara. This town is laid out well, and promises to become a handsom place of some consequence; until now it consist of a little more than 100 houses of which several are well and elegantly built – Here live the greatest part of the offices of Government, some merchants and mechanicks.…*[3]

The density of the drawing is unusual for Berczy as we know him; it is more than a rough sketch, and may have been finished at a later date, with publication in mind.

1. MTL, William Jarvis Papers, SW9 B52: Licenses Issued 1793, fol. 58.
2. SAUM, boîte 11447, pp. 2–3: diary, "1794 From March upwards."
3. SAUM, S/21–22, boîte 11443, pp. 29–32: diary, "Volume Second of America. 1st Part."

Cat. 41
Two Profiles and a Box c. 1797

Pen and brown ink on laid paper
25.5 × 20.3 cm
WATERMARK: crown over shield
INSCRIPTIONS: l.l., *Propaganda;* l.r., *Queenstown;* Verso: names of tradesmen, sums, a slight doodle, and, *Il faut une plume capricieus la quelle ne marque pas toujour*
National Archives of Canada, Ottawa

PROVENANCE: estate of William Bent Berczy to L.-F.-G. Baby; gift to NA, 1886.
REFERENCES: NA, MG23, H II 6, vol. 1, between pp. 128, 129.

This drawing was made on one sheet of a manuscript titled, "List of the Settlers which I brought in the Province of Upper Canada in the month of June 1794 and which I settled in the County of York in the Township of Markham Nov:1794." The list, drawn up by William Berczy, contains eighty-eight names and a text explaining how he had to "maintain them at very heavy Expense at Queenstown &

Cat. 42
Sioux Saddle c. 1798

Pen and brown ink on laid paper
18.7 × 12.1 cm
WATERMARK: *GR / WICKWAR*
INSCRIPTIONS: above drawing, *Sattel der Sious & Nou-*
 dowassy', eine Nation / die an der Westseite des Missisip-
 py gegen den Missury / fluss lebt.
Service des archives de l'Université de Montréal

PROVENANCE: estate of William Bent Berczy to L.-F.-G.
 Baby; bequest to Université de Montréal, 1906.
REFERENCES: SAUM, série S, boîte 11446, p. 138: note-
 book re: "Statistical Account of Canada."

This sketch is included on page 138 of an unbound
notebook of Berczy's observations on Canada,
which he intended for eventual publication. Written
in German, it was probably one of the earliest drafts
of his manuscript, because later he wrote in English
so that his friends could read and correct his facts
and grammar; however, this passage is not repeated

Chipeway" prior to settlement at Markham. The
text also records that some settlers left the Markham
area in November and December 1795, due to hun-
ger. The document was probably written for presen-
tation to the Executive Council of Upper Canada in
June of 1797 regarding the cancellation of his land
grant.

The profiles, one of which is incisively carica-
tured, may represent members of the Executive
Council. Berczy often doodled profiles in the mar-
gins of his work papers.

in any English version seen. As the entry comes just after some remarks on commerce in Montreal, it would seem that Berczy filled this sheet while visiting that area in 1798, basing his drawing and text on notes and sketches he had taken earlier in Upper Canada. Berczy's text translates as follows:

> *Saddle of the Sious and Noudowassy',[1] a nation that lives on the west side of the Missisippy near the Missury river.*
>
> *This saddle was actually carved out of hard wood and covered with leather, which was sewn together neatly with animal tendons. The leather strap a b c is fastened to the saddle by means of leather thongs and there is not the slightest bit of iron [metal] to be found in this saddle. It seems that the leather has been sewn while wet.*
>
> *The strap a b c which is to be found on each side serves to fasten the laden packs.*

These wooden saddles were in use among virtually all the Northern Plains tribes. The saddle is of the form used by women as a pack-saddle; the high pommel in front anchored the poles of the travois. The "laden packs" referred to would have been rawhide cases.[2]

1. "Noudowassy" is an antiquated term synonymous with "Sioux".
2. For identification of various features of this saddle, I am indebted to Mr Arni Brownstone, Ethnology Department, ROM; and Dr John C. Ewers, Arlington, Virginia.

Cat. 43
Lot Plan for Houses and Orchards
c. 1797–98

Pen and brown ink on laid paper
20.2 × 12.5 cm
INSCRIPTIONS: to right of drawing, *1,1,1,1, Häuser / 2,2,2,2, Klarungen von 5 Ackern*
Service des archives de l'Université de Montréal

PROVENANCE: estate of William Bent Berczy to L.-F.-G. Baby; bequest to Université de Montréal, 1906.
REFERENCES: SAUM, série S, boîte 11446, p. 208: notebook re: "Statistical Account of Canada."

This drawing appears on p. 208 of the same manuscript as catalogue 42. Berczy's accompanying text, in German, explains his illustration of a farm-settlement plan; translated, it reads:

> *The houses on two adjacent lots must be built in such a way that the 5-acre clearing on each lot joins with that of the next lot, whereby the dwellers on both lots each enjoy the advantage of a 10-acre clearing. And the same*

Cat. 44
Jesuit Church, Montreal 1799

Pen and brown ink on laid paper
15.8 × 10.1 cm
WATERMARK: *F FIN …*
INSCRIPTIONS: in image u.c., *il faut plus d'es / pace …. porte*; l.c., below image, *le front de l'Eglise 36. pieds de long 12 pieds de chaque cote / Tout le front de l'Eglise 60 pieds / Front de l'Eglise des Jesuites à Montréal 1799 / le Couvent. 56. pieds la Chapelle 26. / Le Jardin 186. pieds. / Les Jesuites occuppent donc dans cette / rue en longeur – Jardin – 186 / Chapelle – 26; Couvent – 56; Eglise 60 / 328 pieds / le Clocher est Octogone.*; a scale of measurement; *13 5/7 feet to 1 inch*; Verso: notes in German.
Service des archives de l'Université de Montréal

PROVENANCE: estate of William Bent Berczy to L.-F.-G. Baby; bequest to Université de Montréal, 1906.
REFERENCES: SAUM, Q2/42, boîte 11643.

Berczy admired this building, and remarked in one of his notebooks:

> *The church of the Jesuits was given on request of the Government by the remaining priests of this order to*

arrangement must be followed on the lots on the other side of the road, so that each of the four occupants might enjoy the advantage of having about his house a 20-acre clearing, which at the same time would make their dwellings much more healthful and agreeable, they would also be less plagued by mosquitos. These arrangements should be made in such places where the lie of the land and the soil permit it.*

The orchards that Berczy had in mind were for the cultivation of sugar maples. This new crop was to be described in the chapter on agriculture in his proposed publication on Upper and Lower Canada, accompanied with illustrations of a plan for the orchard and sugar house, machinery for collecting sap, the inner part of a sugar house, and machinery for transporting the sap to the sugar kettles (see Appendix E).

Cat. 45
Charles Berczy c. 1798–99

Oil on copper
8.1 × 6.6 cm (oval)
Private collection

PROVENANCE: by descent in Berczy family to present owner.
EXHIBITIONS: 1980 Market Gallery.
REFERENCES: Andre 1967, p. 97.

The subject of this portrait is Charles Albert Berczy (1794–1858), the younger son of the artist. He was born at Newark (now Niagara-on-the-Lake) a few weeks after his family's arrival in Upper Canada. During the War of 1812, he was a clerk in the British commissariat at Montreal, and served as acting deputy-assistant commissary-general in 1815–16. By 1818 he had settled at Amherstburg, Upper Canada, where he was in business with his brother William. He became a justice of the peace in 1826, and postmaster in 1831. In 1835 he was given the newly cre-

the Anglican Episcopal congregation which had transformed it into an Anglican church at the cost of about £400 Sterl. It is now the best Anglican church in America and very nicely finished. There are even many Anglican churches in Old England which cannot compare with this one.

This church is being served by an Anglican priest who is Rector of Christ Church of Montreal.[1]

When the above-mentioned building was destroyed by fire in 1803, William Berczy was awarded the contract for planning a new building for the Anglican church (cat. 62). A more comprehensive sketch of the Jesuit complex of buildings by Berczy must have been handed down to his son William, who copied it for Jacques Viger in about 1839 (see WBB 37).

1. SAUM, série S, boîte 11446, p. 93 (trans. from German).

ated position of post office surveyor for all the territory west of Kingston, and was stationed at Toronto. In 1838 he became postmaster of Toronto, and soon gained other influential appointments. He was a director of the Bank of Upper Canada, a president of the Toronto Building Society, and a founder and major shareholder of the Toronto, Simcoe and Lake Huron Union Rail-Road Company. In 1848 he became first president of the newly created Consumers' Gas Company of Toronto. In 1851 he headed a joint-stock company that bought the City of Toronto Gas Light and Water Company; the firm defaulted on mortgage payments and was repossessed in 1853. He lost his postmastership in 1853, and in 1856 his directorship in Consumers' Gas ended. Charles Berczy took his own life in 1858, leaving his wife, one son, and seven daughters.[1]

Charles is portrayed here at the age of about four years. The image is painted in thin and even brush strokes, in earth colours and red, blue, and white. Some of the colour is applied in glazes, especially in the reddish-brown of the costume.

1. Eric Jarvis, "Charles Albert Berczy," in DCB, vol. VIII, pp. 83–85.

Cat. 46
William Bent Berczy c. 1798–99

Watercolour with touches of gouache, varnished, on thin wove paper bordered with gold foil circles and laid down on wood
12.3 × 10.7 cm (oval); 19.3 × 16.3 cm (wood panel)
Private collection

PROVENANCE: by descent in Berczy family to present owner.
EXHIBITIONS: 1980 Market Gallery.
REFERENCES: Andre 1967, p. 97.

William Bent Berczy (1791–1873) was the much loved first-born son of William and Charlotte Berczy. He was his father's constant companion and studio assistant; see p. 259 for a catalogue of his works and a biography. He is portrayed here at about seven years of age – a sensitive, fine-featured child. The varnish, probably applied by Berczy, has yellowed with time and obscures some of the more delicate brushwork. The face is modelled in a barely

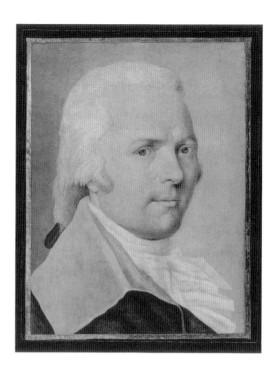

Cat. 47
Self-portrait c. 1798—99

visible blue-green, and the white shirt and vest are shaded in grey-green. The jacket is painted in tones of brown over cream. Dark touches indicate nostrils and the centre line of his lips. The eyes are outlined in brushpoint, with a faint indication of lashes, and subtle shading to give volume to the eyeball – a technique seen in other watercolour portraits by Berczy.

The small portrait was probably mounted in its present format shortly after it was painted. The paper oval is solidly laid down on wood panel and outlined with a decorative border of small gold foil circles. The foil circles were in place before the watercolour was varnished and also before the wood support was painted black. This embellishment might be by Charlotte Berczy, who would have taught similar decorative crafts at her finishing school in Montreal.

Watercolour and gouache over graphite on wove paper, with border of black gouache and applied gold foil
16.7 × 13.2 cm
WATERMARK: *C WILMOTT*
Art Gallery of Ontario, Toronto 81/544
Gift of John Andre, 1981

PROVENANCE: by descent in Berczy family; John Andre, 1960s; gift to AGO, 1981.
EXHIBITIONS: 1968 ROM; 1980 Market Gallery, as "Portrait of an Official".
REFERENCES: Andre 1967, repr. between pp. 24–25 as "An Official".

Here, an older William Berczy (pl. VIII) gazes out at the viewer with the same boldness seen in his earlier self-portraits. As before, he looks over his shoulder and strengthens the forcefulness of his presence by placing himself close-up and filling the picture. The penetrating intensity of the gaze is heightened by the very slight protrusion of the left eye. The

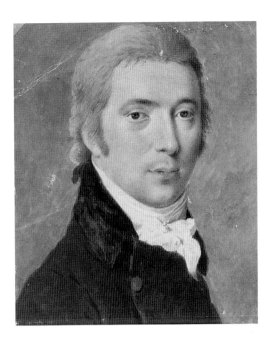

Cat. 48
Man with Powdered Hair c. 1798–99

Watercolour and gouache over graphite on wove paper
12.4 × 10.2 cm
Royal Ontario Museum, Toronto 968.298.1
Sigmund Samuel Trust

PROVENANCE: by descent in Berczy family to Louisa A. Moore; John Andre; purchased ROM, 1968.
EXHIBITIONS: 1968 ROM; 1980 Market Gallery.
REFERENCES: Andre 1967, p. 96, as Berczy "Self-portrait"; Allodi 1974, no. 140, as Berczy "Self-portrait".

The subject of this portrait was misidentified in the 1960s as being the artist himself; the recent discovery of a signed self-portrait of William Berczy (cat. 27) shows that the artist was very different in appearance from the unknown gentleman depicted here.

This portrait has been cut down unevenly; spandrels at the upper corners indicate that it was to be contained in an oval format. The graphite drawing is toned with watercolour and finished in gouache. The face is painted in miniature style, with the costume and background painted more broadly and possibly unfinished. The plum colour of the jacket is one favoured by Berczy.

fresh skin tones make an attractive contrast with the white shirt and the bluish-tinted white hair. The lips and the wide collar, a delicate salmon colour, contrast pleasantly with the dark blue-green of the coat.

The border of gold foil was a device also used to decorate other portraits painted in 1798–99 (see cat. 46, 49). The image was once heavily varnished,[1] as were the two portraits of his son William (cat. 46, 78). Given the style of the watercolour and the technical details of its presentation, it would seem to belong to the same period as the portraits of his sons, likely made prior to his departure for London in 1799.

1. This portrait was once backed with laid paper and glued to a wood panel; the panel has the fragment of a still-life composition painted on its verso, probably by a member of the Berczy family (collection: AGO).

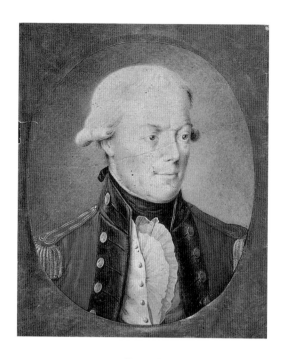

Cat. 49
Robert Prescott 1798–99

Watercolour and gouache over graphite on laid paper,
 mounted on card
14 × 11.5 cm (oval); 15.4 × 12.9 cm (backing card)
INSCRIPTIONS: Verso: on backing in ink, *Lord Dorchester*
Musée du Séminaire de Québec Pf 984.27

PROVENANCE: William Bent Berczy to Jacques Viger,
 1828; Hospice-Anthelme Verreau, 1860; bequest to
 Séminaire de Québec, 1901.
EXHIBITIONS: 1945 NGC; 1946 Albany.
REFERENCES: Laval/Carter 1908, no. 220, as "Lord
 Dorchester"; Maheux 1939, pp. 879–80; Morisset
 1941, p. 85, as "Gouverneur Haldimand"; NGC
 1945, p. 18, no. 39; Albany 1946, p. 19, no. 8; Harp-
 er 1966, pp. 70, 74; Andre 1967, pp. 97–98.

Robert Prescott (c. 1726–1815) was a British army
officer and colonial administrator. He took part in
the capture of Louisbourg in 1758, and in 1759 be-
came aide-de-camp to General Amherst, whom he
accompanied in the advance to Montreal in 1760.

During the American Revolution he participated in
many actions, and in 1794 became civil governor of
Martinique. In 1796 he was appointed governor-in-
chief of the Canadas, New Brunswick, and Nova
Scotia, as well as commander of the British forces
in North America. During his governorship he at-
tempted to regulate a chaotic land-granting process
by distinguishing between actual settlers and mere
speculators. Although his suggested scheme of pro-
portioning the size of grants to the expenses for
development incurred by the applicants was agree-
able to most claimants, including Berczy, speculators
on his Executive Council came into open conflict
with the governor. He was recalled to England in
April 1799 for consultations, and never returned to
Lower Canada.[1]

 William Berczy's principal reason for visiting
Quebec City in the summer of 1798 was to get sup-

port for his application for legal title to the lands he was developing in Upper Canada. His portrayal of Prescott and other members of his family would have been Berczy's most natural method of attempting to gain the governor's attention and the hoped-for espousal of his cause.[2] A watercolour portrait of Prescott was probably started in December 1798, because Berczy refers to it as nearly finished in early January 1799.[3] It was an oval portrait,[4] undoubtedly the watercolour now in the Musée du Séminaire de Québec collection:

For myself, I have begun the copy of the General in oils and another in a colour wash, very finished, that I will show you. This last-mentioned portrait would have turned out very well, but I haven't finished it since by accident the board on which it was being stretched fell down, split and tore the portrait through the middle of the face. I reglued it onto another paper as well as I was able, but it is not worth finishing completely, the head is almost done, and at least sufficiently to make a perfect likeness....[5]

The Berczy family kept the repaired portrait of Prescott. It is referred to in 1808 as framed and hanging in their Montreal house,[6] and shortly afterwards as being shown to General Craig in Quebec, because he was an old friend of General Prescott.[7] The artist must have painted another portrait for Prescott, and he also did a version in oil, but the location of these replicas is unknown (see cat. 50).

In commenting on his Quebec portraits of 1799, Berczy declared them to be perfect likenesses, and at the same time claimed that he had portrayed each model to such advantage as to assure complete satisfaction.[8] This explains the relatively youthful appearance of the seventy-four-year-old Prescott, who was then in poor health. The portrait is painted in subtle tones, with a combination of hatching and outline for the head and background, and a more broadly painted costume in vermilion-red gouache. The watercolour sheet is torn from left to right, through the centre of the subject's face. As described by Berczy, the sheet has been mounted on card, possibly a book board, and the tear is carefully joined. The image is framed with a gold foil mat cut in an oval.

Almost twenty years later, Prescott's portrait continued to play a role in the Berczy family activities: in 1827 Jacques Viger asked William Bent Berczy to contribute to his album "Gallery of Portraits," by adding images of Joseph Brant (WBB 7) and Robert Prescott to it. William replied from Amherstburg that he would copy the portraits and send them. The following spring he sent the Prescott portrait with his compliments. It is possible that he decided to send his father's original watercolour because Viger had mentioned that he owned no work by his old friend, Berczy Senior.[9]

1. DCB, vol. v, pp. 690–93.
2. John Robertson of Chambly, who also had land-grant problems, urged Berczy to paint portraits of other members of the Prescott family as well, stating that it would be "time and trouble well spent...." [SAUM, U/10457: Robertson to Berczy, Chambly, 29 Dec. 1798.]
3. SAUM, U/1430: Berczy to Charlotte, Quebec, 3 Jan. 1799.
4. SAUM, U/1430: Berczy to Charlotte, Quebec, 3 and 5 Jan. 1799. He described the Prescott water-colour portrait as a half-length figure in an oval, ten inches long. The paper was probably trimmed down in size when Berczy was repairing it after it tore.
5. SAUM, U/1433: Berczy to Charlotte, Quebec, 6 Feb. 1799 (trans. from French).
6. SAUM, U/1414: Charlotte to WBB, Montreal, 1 Sept. 1808.
7. SAUM, U/1478: Berczy to Charlotte, Quebec, 7 Dec. 1808.
8. SAUM, U/1433: Berczy to Charlotte, Quebec, 6 Feb. 1799.
9. SAUM, U/12374: J. Viger to WBB, Montreal, 28 Sept. 1827. ASQ, Fonds Viger-Verreau, Saber-dache bleue, vol. 8, pp. 199–201, 218: WBB to J. Viger, Amherstburg, 27 Oct. 1827 and 17 April 1828.

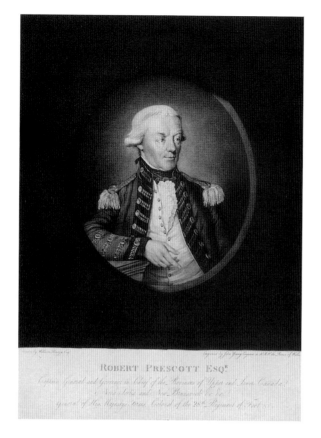

ROBERT PRESCOTT ESQ.

Cat. 50
After William Berczy
Robert Prescott Esq. c. 1800–01

Mezzotint on laid paper
33.4 × 30.3 cm (image); 40.5 × 30 cm (plate)
INSCRIPTIONS: in plate l.l., *Drawn by William Berczy Esqr.*; l.c., *ROBERT PRESCOTT ESQR. / Captain General and Governor in Chief of the Provinces of Upper and Lower Canada, / Nova Scotia, and New Brunswick, &c. &c. / General of His Majestys Forces, Colonel of the 28th. Regiment of Foot.*; l.r., *Engraved by John Young, Engraver to H.R.H. the Prince of Wales.*
National Archives of Canada, Ottawa C-12562

REFERENCES: *New England Magazine*, 1894, new series, 11:8, repr. only.

Today, I have almost completely finished my portrait of the General and have much advanced the copy that I am to take to London for engraving. Yesterday Madame Prescott sent me ... the portrait of Lord St. Vincent to ask if I were not of the opinion that the one of the General should be engraved by the same artist and in the same size, which is an attractive format.[1] *The subscrip-*

tion will be done soon, I hope, and will help me, I flatter myself, to advance my cause....[2]

The mezzotint shows a half-length figure, set in a classical oval. It was probably based on an oil version of the portrait that Berczy painted for himself and brought to England.[3] He loaned it to Samuel Gale (LW 66) briefly to show around.[4] Before leaving Canada he had also sought out subscribers for the print.[5]

Berczy's oil painting of Prescott has not been found. There is, however, an oil portrait of Prescott in the Weir collection (Weir Foundation, Queenston, 982.5) which, despite an interesting provenance,[6] differs markedly from Berczy's known technique. It is painted *alla prima* – in one layer using free brushwork – with juxtaposed colours used to define the image, rather than the building up in layers typical of Berczy. The brushwork is expressive and freely applied, again in contrast to Berczy's smoothly glazed surfaces. It seems to be an early copy of the mezzotint, possibly executed for a member of the Prescott family.

1. The print of Sir John Jervis, Earl of St. Vincent, could have been the mezzotint by R. Laurie after Gilbert Stuart, published in London by Laurie and Whittle in 1794; or else the same subject after a painting by Francis Cotes, published in 1797, with no engraver named (collection: British Museum).
2. SAUM, U/1430: Berczy to Charlotte, Quebec, 5 Jan. 1799 (trans. from French).
3. SAUM, U/1430: Berczy to Charlotte, Quebec, 3 Jan. 1799; U/1433: 6 Feb. 1799; U/1434: 10 Feb. 1799.
4. SAUM, série S, boîte 11447: Berczy to Samuel Gale, London, 3 Jan. 1800.
5. SAUM, série S, boîte 11445: John Robertson to Berczy, Chambly, 9 Jan. 1799.
6. First mention of this oil was made in the Stansted Hall Catalogue (1893), no. 142; its owner, William Fuller Maitland (1813–1876), was married to Lydia Prescott, only daughter of Lieut.-Col. Serjentson Prescott, possibly a son or nephew of Robert Prescott.

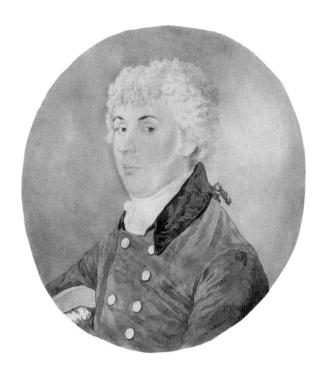

Cat. 51
Louis Charland c. 1799–1802

Watercolour over graphite on wove paper
22.1 × 20.4 cm
INSCRIPTIONS: Verso: in pencil, geometric design for an
 oval; on label on wood backing to old frame, *Louis
 Charland*
Musée du Séminaire de Québec Pf 984.26

PROVENANCE: Jacques Viger to Hospice-Anthelme
 Verreau; bequest to Séminaire de Québec, 1901.
EXHIBITIONS: 1887 Montreal; 1892 Montreal; 1952
 Quebec City; 1965 NGC.
REFERENCES: Montreal 1887, p. 14, no. 548; Montreal
 1892, p. 14, no. 238; Laval 1906, p. 43, no. 32; Laval/
 Carter 1908, p. 154, no. 241; P. Scribe, "Louis
 Charland", BRH, vol. 34 (1928), p. 331 (attr. to
 Dulongpré); Maheux 1939, p. 880, 882 (attr. to
 Berczy); Quebec City 1952, p. 27, no. 26 (attr. to
 Dulongpré); Harper and Hubbard 1965, no. 16;
 Andre 1967, repr. between pp. 72–73.

Louis Charland (1772–1813) was a surveyor working
in the Quebec City area when he first met William
Berczy. Charland had collaborated with William
Vondenvelden in preparing a topographical map of
Lower Canada, and they entered an agreement with
Berczy to have the map engraved and published in
London (see Intro. p. 61). In June of 1799, Charland
became the first surveyor of highways, streets, and
lanes in Montreal, a post which he held until his
death. He drew up a plan of the city, was intimate-
ly linked with its development, and prepared plans
for a number of public buildings.[1]

Although this watercolour has faded in tone, the
portrayal of Charland is lively and expressive. The
subject does not face the viewer directly, but glances
over his shoulder with an expression that is wary,
amused, and supercilious – all at the same time. The
face is carefully painted in short hatched strokes,
with some pencil work around the nose and mouth;
horizontal graphite lines of a preliminary drafting
indicate placement of the eyes, nose, mouth, and
chin. The deep blue eyes, dark eyebrows, pointed
nose, and pursed mouth combine to create a most
individual representation of personality.

This portrait may be unfinished; the ear is only
defined in outline, the area below the chair back is
blank, and drawing outside the subject oval seems to
indicate that a painted oval frame was intended. As
we know that the artist painted William Vonden-
velden's portrait (LW 77) in Quebec in 1799, it is
possible that he portrayed his colleague Charland at
that time. However, Berczy remained friendly with
Charland in Montreal, and could also have painted
his portrait there in 1802, or later. Jacques Viger suc-
ceeded Charland as surveyor of highways in Mon-
treal, and may have acquired the portrait from the
sitter's family.

1. DCB, vol. V, pp. 183–84.

Cat. 52
Louis Genevay 1799–1802

Oil on copper
29.2 × 23.2 cm
INSCRIPTIONS: in subject l.c. in brushpoint, *Louis Genevay Ecy / Dy Pay Mr Gl / Montreal;* l.r. in brushpoint, *Sir / Montreal 18 April / 1803*
Musée du Séminaire de Québec PC 983.4

PROVENANCE: Jacques Viger to Hospice-Anthelme Verreau; bequest to Séminaire de Québec, 1901.
EXHIBITIONS: 1887 Montreal; 1892 Montreal; 1952 Quebec City; 1965 NGC.
REFERENCES: Montreal 1887, p. 15, no. 131; Montreal 1892, p. 18, no. 291; Laval 1905, p. 33, no. 48; Laval 1906, p. 42, no. 15; Laval/Carter 1908, p. 154, no. 223, as "Louis Gonneray"; Laval 1913, p. 48, no. 205; Laval 1923, p. 55, no. 206; Laval 1933, p. 92, no. 343; IBC, p. 9164 (attr. to unknown English artist); Quebec City 1952, p. 24, no. 10, as "Louis Gonneray"; Harper and Hubbard 1965, no. 14, as "Louis Gonneray"; Andre 1967, p. 99 and repr. between pp. 88–89.

Jean-François Louis Genevay (pl. IX) was born in Montreux, Switzerland, in 1739. He served with the 60th Regiment Royal Americans, 1756–62, and probably arrived in Canada in 1759. He was a commercial agent in Lower Canada from at least 1769, and in 1775 became an adjutant in the Quebec City militia. He served under Governor Haldimand, 1779–82, was a captain in Butler's Rangers in 1781, and on 1 June 1782 was named barrack master for Montreal and Chambly. He also served as assistant deputy paymaster-general for Montreal, from an unspecified date.[1]

Genevay is identified by an inscription in the composition, which also gives his position in an abbreviated form. The letter that he is shown writing is datelined "Montreal 18 April 1803." Genevay died in Montreal on 23 April 1803, after an illness of several months; Berczy was in York at the time. Microscopic examination shows that the date is a later addition, probably added to commemorate Genevay's death, even though it is incorrect by a few days. The inscriptions were misread in early descriptions of this painting, so that "Genevay" became "Gonneray"; and the abbreviated *Dy Pay Mr Gl* was interpreted to mean Deputy Postmaster General, instead of Deputy Paymaster General.

The composition is compact and attractive. The interior setting, with a Georgian-style mantle in the background, forecasts the Woolsey family portrait of 1809 (cat. 84), while the smaller format and use of oil on copper echo his European paintings. The colours are rich, the paint smoothly applied, with touches of impasto for highlights. Still-life details, such as the glass inkwell, are skillfully interpreted.

1. The Genevay biography has been compiled by René Chartrand of Parks Canada, Ottawa, from the following sources: re: early military service: British Museum, Add. Ms. 21827; re: commercial transactions: NA, Index to *Gazette de Québec* for 1769 and 1774; and re: military service in Canada: NA, MG21, B85-2. See also Émile Henri Bovay, *Le Canada et les Suisses: 1604–1974* (Fribourg: Éditions universitaires, 1976), p. 9; F.J. Audet, "Jean-François-Louis Genevay," in BRH, XXIX:11 (1923), p. 347; and *Montreal Gazette,* 2 May 1803, obituary.

Cat. 53

Man with a Bookcase c. 1798–1804

Watercolour and gouache over graphite on wove paper
27 × 21.6 cm
WATERMARK: *J WHATMAN / 179[4 or 1]*
INSCRIPTIONS: Verso: u.l., *Owner Mary W. Winter / 36
 Dromor Crescent Hamilton Ontario;* by John Andre,
 u.r., *This is a self-portrait of / William Berczy; ca. 1790 /
 bought by John Andre / in 1967*
Royal Ontario Museum, Toronto 968.298.2
Sigmund Samuel Trust

PROVENANCE: by descent in Berczy family to Louisa
 Berczy Moore; her son Robert Albert Moore; his
 daughter Mary Waldron Moore Winter; John
 Andre; purchased ROM, 1968.
EXHIBITIONS: 1968 ROM; 1980 Market Gallery, as
 Berczy "Self-portrait".
REFERENCES: Andre 1967, p. 96, as Berczy "Self-por-
 trait"; Allodi 1974, no. 141, as Berczy "Self-portrait".

This portrait was thought to be of Berczy himself
until the recent discovery of a signed self-portrait
(cat. 27). The watermark indicates a date of execu-
tion around the time of his immigration to Ameri-
ca. The informal pose and expression relate to por-
traits painted after 1798, and notably after his visit to
England of 1799–1801. The only hint at the identi-
ty of the subject are two volumes of *Bacon* in the
background bookcase; likely a reference to the essays
of Francis Bacon (1561–1626), the English philoso-
pher, statesman, and essayist, who was also a barris-
ter. It is tempting to think that the portrait might
represent William Warren Baldwin – a doctor, law-
yer, and politician, who married Phoebe Willcocks
(cat. 60) in 1803.[1]

The composition is carefully balanced in tone, so
that the detailed background does not distract at-
tention from the subject. The face is painted in
gouache over watercolour, in hatched strokes that
follow its contours and structure. The flesh tones are
warm and light. The bookcase is drafted in graph-
ite and broadly painted in gouache, with a mottled
effect used to convey the texture of the book bind-
ings. The colours used are earth tones, with red and
blue-green detailing. The costume and hand are
unfinished.

1. There is a general resemblance to the portrait of
 William Warren Baldwin (1774–1844), painted
 c. 1849 by Théophile Hamel (collection: Law Soci-
 ety of Upper Canada), and published as a lithograph
 by F. Davignon, New York, c. 1850.

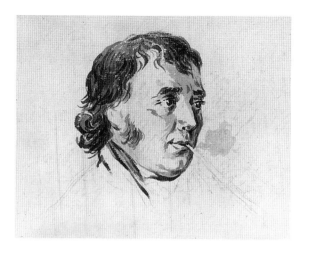

Cat. 54
View of an Inn and Horse-drawn Carriages
c. 1799–1801

Graphite on laid paper
18.7 × 24.5 cm
WATERMARK: crest with lily over *GR*
Service des archives de l'Université de Montréal
Not in exhibition

PROVENANCE: estate of William Bent Berczy to L.-F.-G.
Baby; bequest to Université de Montréal, 1906.
REFERENCES: SAUM, série S, boîte 11447: between
pp. 30, 31 of travel diary.

This drawing was sketched in the section of Berczy's
travel diary that contained notations made in Lon-
don. Although the drawing is faint and rubbed, the
composition is carefully constructed. Converging
lines drawn through the row of coaches on the left
recede to a variable vanishing point. The building
on the right is crisply drawn, almost ruled. In front
of it stands a sign depicting a bull's head, naming the
inn. Figures are sketched with freedom and the
landscape is suggested with a few strokes.

Cat. 55
Man Smoking c. 1801

Grey wash over graphite on laid paper
18.4 × 24.3 cm
INSCRIPTIONS: Verso: page of manuscript diary.
Service des archives de l'Université de Montréal

PROVENANCE: estate of William Bent Berczy to L.-F.-G.
Baby; bequest to Université de Montréal, 1906.
REFERENCES: SAUM, série S, boîte 11447: in travel
diary, opposite page re: 56th day of voyage (5 Nov.
1801); and on verso of 74th day of voyage (24 Nov.
1801).

This quick portrait sketch was made in the diary that
Berczy kept during his return voyage from England
in 1801. The head of a man smoking a pipe is freely
rendered in grey wash over graphite. It is one of
the few examples found of Berczy's informal por-
trait studies, which he sometimes made at social
gatherings:

> *After tea I took a pencil and some paper and to amuse
> the Company I made half a dozen sketches, very good
> likenesses of the main personages ... I was so absorbed
> that if I had not had to leave at 9 1/2 because the gates
> of the city close at 10, I think that I would have drawn
> all the rest of the Company and would even have sum-
> moned the Servants, the dogs, cats, &c., &c....*[1]

1. SAUM, U/1430: Berczy to Charlotte, Quebec,
3 Jan. 1799.

Cat. 56
Snowshoe and Building Plans c. 1801–03

Pen and brown ink on laid paper
18.5 × 24.4 cm
Service des archives de l'Université de Montréal
Not in exhibition

PROVENANCE: estate of William Bent Berczy to L.-F.-G.
 Baby; bequest to Université de Montréal, 1906.
REFERENCES: SAUM, série S, boîte 11447: in address
 book, on page marked "T-U".

Throughout his Canadian career Berczy added notes to his address book. The drawing of a snowshoe might have been made to record his mode of travel across the Gaspé in the winter of 1801. The roughly sketched floor plan of a building on an embankment, lower right, suggests the house that Berczy is thought to have designed for Attorney-General Thomas Scott, on the shores of Lake Ontario at York in 1803.[1] A structure of the same shape appears on George Williams' 1813 map of York

(NA, C-15981); the house is depicted in Robert Irvine's oil painting of York in about 1817 (AGO, 52/32), showing it to have the same number of windows as in this sketch.

Although no elaborated designs for private dwellings have been found, reminders of his work in this field survive among the Berczy papers; for example, a drawing of the section of a house showing bracing;[2] and the floor plan for a house with a thirty-by-sixteen-foot dining room.[3]

1. MTL, D.W. Smith papers, A/10, pp. 19, 299; Andre
 1967, p. 82; Arthur and Otto 1986, p. 241.
2. SAUM, série S, boîte 11445: unbound manuscript
 sheet facing page titled "No 1. page 106," graphite
 on laid paper, 18.4 × 15 cm.
3. SAUM, Q2/32, boîte 11643: pen and brown ink on
 wove paper, 20.4 × 11.9 cm.

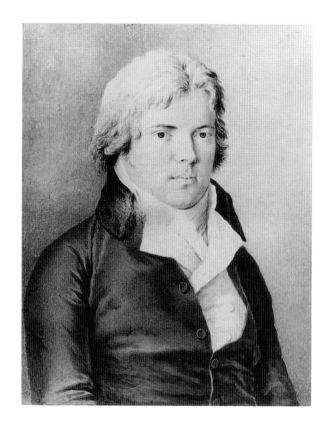

Cat. 57
Robert Isaac Dey Gray 1803

Watercolour over graphite with touches of gouache on
wove paper, with original paper mat painted in black
gouache and yellow watercolour

27.9 × 24.7 cm

INSCRIPTIONS: on inner border of the artist's original
mat in pencil, numbers at two-centimetre intervals;
Verso: on strips of paper cut to reinforce edges of
portrait and to attach it to mat, in ink, fragments of
music scores and manuscript text.

Royal Ontario Museum, Toronto 970.85.2
Sigmund Samuel Trust

PROVENANCE: by descent in family of Alexander
McDonell to Catherine McDonell Shipman; pur-
chased ROM, 1970.

EXHIBITIONS: 1899 Toronto; 1968 ROM; 1980 Market
Gallery; 1984 AGO.

REFERENCES: SAUM, U/1454: Berczy to Charlotte,
York, 26 April 1803. Toronto 1899, nos. 90, 271;
Andre 1967, p. 98; Allodi 1974, no. 145; Reid and
Vastokas 1984, p. 30, no. 93.

Robert Isaac Dey Gray (c. 1772–1804), the son of
Loyalists from New York State, became solicitor-
general of Upper Canada.[1] He was drowned in the
wreck of the schooner *Speedy* on Lake Ontario on
7 or 8 October 1804. Berczy described painting
Gray's portrait (pl. X) and that of Alexander
McDonell (cat. 58) at York in the spring of 1803:

> *The embarrassing situation in which I have found
> myself the whole time I am far from Montreal with
> respect to lodgings has prevented me from engaging in
> the slightest practice of the charming art of painting – it
> is only in the last 10 days that I have taken up the brush
> again and I have done two portraits, the Sheriff and the
> Solicitor General of this Province; and they have suc-
> ceeded beyond my expectations – if you see them, you
> will agree that you have never seen anything so well exe-
> cuted by my hand – They are astonishingly good like-
> nesses and, as I have just said, much better done than
> anything I have ever done up to this time – I attribute
> this largely to my excellent old paints that I found among
> the Debris of our baggage....*[2]

Berczy has created a subtle portrait, with back-
ground and costume in low-keyed greys and blues.
The soft, sensuous face is painted in delicately
hatched flesh tones, with blue shading. The image
is ruled and numbered at two-centimetre inter-
vals, presumably for transfer, although no larger or
smaller version of this portrait has been found.

1. DCB, vol. v, pp. 388–89.
2. SAUM, U/1454: Berczy to Charlotte, York,
 26 April 1803 (trans. from French).

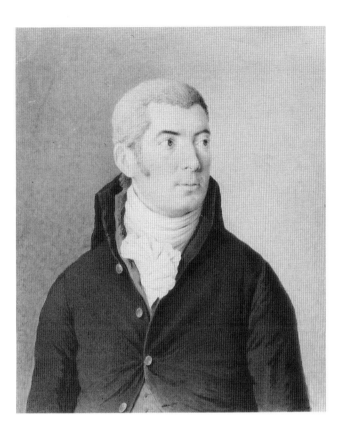

Cat. 58
Alexander McDonell 1803

Watercolour and gouache with gum arabic over graphite
 on wove paper, with original paper mat painted in
 black gouache
28.2 × 25.1 cm
INSCRIPTIONS: Verso: partial Berczy signature [*Be....*],
 in ink on one of the strips of paper cut from the
 artist's correspondence and used to secure the mat to
 the portrait.
Royal Ontario Museum, Toronto 970.85.1
Sigmund Samuel Trust

PROVENANCE: by descent in McDonell family to
 Catherine McDonell Shipman; purchased ROM,
 1970.
EXHIBITIONS: 1899 Toronto, 1968 ROM; 1980 Market
 Gallery; 1984 AGO.
REFERENCES: SAUM, U/1454: Berczy to Charlotte,
 York, 26 April 1803. Toronto 1899, no. 272; Andre
 1967, p. 98; Allodi 1974, no. 144; Reid and Vastokas
 1984, p. 30, no. 92.

Alexander McDonell (1762–1842), army and militia
officer, office holder, politician, and land agent, was
appointed sheriff of the Home District of Upper
Canada by John Graves Simcoe in 1792. In 1800 he
was elected to the House of Assembly for Glengarry
and Prescott, and sat for over twenty years.[1]

An example of one of Berczy's most finished
works on paper, this vivid portrait contrasts with the
nearly monochrome watercolour of Robert Gray
(cat. 57), painted at the same period. McDonell
wears a deep blue coat, painted in short strokes and
shaded with gum arabic; his clear red vest is painted
in gouache. The head has a sculptural quality in its
precision of outline and definition of volume.

1. DCB, vol. VII, pp. 554–56.

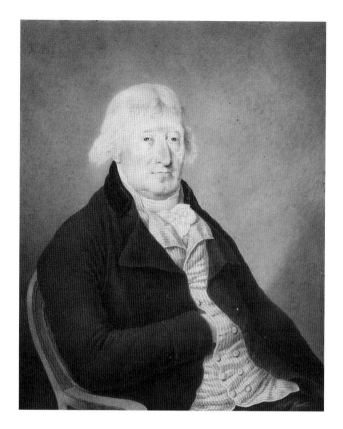

Cat. 59
Peter Russell 1803–04

Watercolour with touches of gouache on wove paper
30.2 × 24.4 cm
Private collection

PROVENANCE: from sitter to his sister Elizabeth Russell; Phoebe Willcocks Baldwin; by descent in Baldwin family to present owner.
EXHIBITIONS: 1968 ROM; 1980 Market Gallery.
REFERENCES: Andre 1967, p. 98.

Peter Russell (1733–1808), office holder, politician, and judge, was born in Ireland and entered the army at an early age.[1] In 1772 he travelled to America as one of the secretaries to Sir Henry Clinton; he returned to England at the close of the American Revolution. Russell came to Canada in 1791 with General John Graves Simcoe, as inspector general of Upper Canada. He was appointed member of the Executive and Legislative Councils of the province in 1792; and 1796–99 was the administrator of the government, with the title of president. He died at

York, leaving his property to his sister Elizabeth; she in turn left it to the daughters (see cat. 60) of their cousin, William Willcocks.

Berczy had many dealings with Peter Russell regarding his colonizing business. In addition, in 1796, he contributed to the design of the Russell house in York, known as "Russell Abbey" (see fig. 11, p. 56).[2] In 1804 he invoiced Russell for eighty dollars for two drawings of unspecified subjects.[3] The present portrait is painted in watercolour, with gouache highlights on the brass coat buttons and in the eyes. The coat is deep blue, the striped vest a paler blue, and the background a subtle tone of blue-grey.

1. DCB, vol. v, pp. 729–32.
2. MTL, Peter Russell Papers, A 38: Russell to McGill, West Niagara, 15 Mar. 1797; Edith G. Firth, *The Town of York, 1793–1815: A Collection of Documents of Early Toronto,* Ontario series 5 (Toronto: The Champlain Society, 1962), pp. 39–40; Arthur and Otto 1986, pp. 24, 241.
3. MTL, Peter Russell Papers, L 18, Box 3, file 3/6: Berczy's receipted invoice to Russell, York, 3 Sept. 1804.

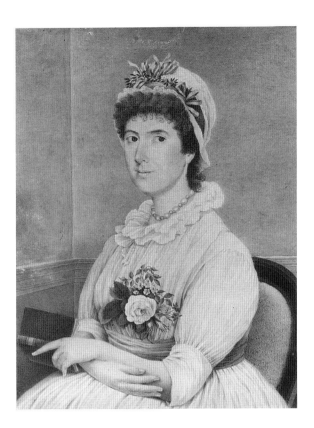

Cat. 60
Phoebe Willcocks Baldwin 1803–04

Watercolour and gouache over graphite on wove paper
27.9 × 22 cm
Private collection

PROVENANCE: by descent in Baldwin family to present
owner.
EXHIBITIONS: 1968 ROM; 1980 Market Gallery.
REFERENCES: Andre 1967, p. 98.

Margaret Phoebe Willcocks (1771–1850) was the
daughter of William Willcocks,[1] who was a cousin
of Peter Russell (cat. 59). When Berczy returned to
York in June of 1802, he stayed with the Willcocks
family. In a letter to his wife, he remarked that the
youngest daughter, "Miss Phoebe," was the prettiest
of the family and a most amiable girl.[2] His portrait
of Phoebe depicts a poised young woman; it was
done at about the time of her marriage to Dr Wil-
liam Warren Baldwin, which took place on 31 May
1803. Their son Robert Baldwin (1804–1858) be-
came a leading Canadian statesman.

Phoebe wears a white dress, livened with a spray
of summer flowers "à la Redouté" and a blue sash.
Flowers and ribbons also adorn her cap. She is posed
in a simple interior setting of yellow-beige wain-
scoting; the chair is upholstered in pink. The out-
lines of the figure are carefully defined, and the
image is painted in Berczy's usual combination of
miniature hatching and broader graphic washes.
Phoebe's right arm is strangely shortened.

1. William Willcocks (c. 1735/36–1813) invested in
 some of Berczy's Markham lands. An oil portrait of
 Willcocks (private collection) may be a copy after a
 watercolour by William Berczy; its pose and expres-
 sion suggest Berczy as the author, but the oil paint-
 ing technique is broader than his known style.
2. SAUM, U/1447: Berczy to Charlotte, York, 7 June
 1802.

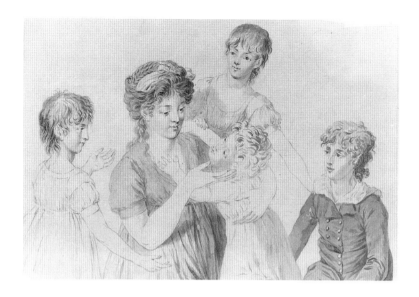

Cat. 61
The McTavish Family (?) c. 1800–05

Grey wash over graphite on wove paper
20.3 × 29.8 cm (sheet, unevenly trimmed)
INSCRIPTIONS: Verso: in red crayon, probably recent,
 Cir.
Royal Ontario Museum, Toronto 968.298.5
Sigmund Samuel Trust

PROVENANCE: by descent in Berczy family to Edward
 Alfred Moore; his sister-in-law Elizabeth Waldron;
 John Andre; purchased ROM, 1968.
EXHIBITIONS: 1968 ROM; 1980 Market Gallery.
REFERENCES: Andre 1967, p. 91; Allodi 1974, no. 143;
 M. Allodi, "Canadian Faces: Some Early Portraits,"
 in *Rotunda*, 11:1 (spring 1978), p. 23.

The identification of this family group was suggested by John Andre, but it remains speculative. Berczy certainly knew and had dealings with Simon McTavish (1750–1804);[1] he was thought to have designed the McTavish mansion, tomb, and column in Montreal (see Intro. p. 66). McTavish and his wife Marie-Marguerite Chaboillez (sister of Mrs Roderick Mackenzie) had four children, William (1795–1816), Mary (c. 1798–1819), Anne (1800–1819), and Simon Jr. (1803–1828). In 1805 they would have

been ten, eight, six, and two-and-a-half years, ages compatible with the children portrayed. Following her husband's death, Marguerite McTavish left Montreal for England sometime after the end of May 1805.[2] She remained there with her children, and married Captain William Smith Plenderleath early in 1808.

The wash drawing is unfinished. The careful posing of the interlaced figures suggests that this is not a first sketch from the life, but rather one of several preliminary drafts in preparation for a group portrait. The underdrawing shows some adjustments in placement of the figures at the left and right. The grey wash is used to delineate features and indicate volume, in a free manner that reminds one of the head of a *Man Smoking* (cat. 55), drawn in his European travel journal. The emotional warmth conveyed is unusual in Berczy's œuvre.

1. DCB, vol. v, pp. 560–67.
2. *Montreal Gazette,* 27 May 1805, notice re: sale of some household effects because of an intended voyage.

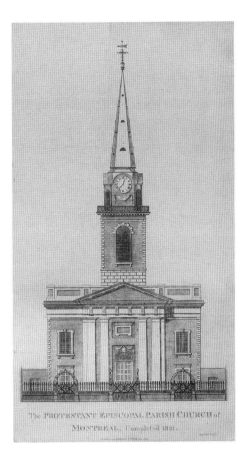

Cat. 62
After William Berczy
The Protestant Episcopal Parish Church
of Montreal 1805 and 1822

Etching on wove paper
41.5 × 22.6 cm (plate)
INSCRIPTIONS: in plate l.c., *The PROTESTANT EPIS-
COPAL PARISH CHURCH of / MONTREAL.
Completed 1821. / Printed and Published by T.G.
Preston 1822;* l.r., *204 Feet high.*
Musée du Séminaire de Québec 1991.6

REFERENCES: Allodi 1980, no. 22, p. 47.

The Anglican "Christ Church," the first Palladian-
style church in the Montreal area, was built from
designs furnished by William Berczy.[1] It reflects
Berczy's architectural studies in Italy, as well as the
influence of the Neo-Classical plans and façades
published in James Gibbs' *Book of Architecture* (1728).[2]

An 1822 print of the front elevation was issued the
year after the building was completed. Its printer-
publisher was neither an artist nor an architect, and
his image must be based on Berczy's original presen-
tation drawing. Unfortunately, this drawing does
not appear to have survived the fire that destroyed
the church in 1856.

Berczy was awarded the contract for the design of
the new church in January 1805.[3] On 19 March
1805 he was paid £30 for "Sundry drafts and plans
for the Church."[4] The cornerstone was laid in June
1805, and the masonry walls were erected during
1805–06; by 1808 the tin roof was completed. In
April of 1812 specifications for the interior work
were put out to contract, and at least one of the pro-
posals makes it evident that Berczy had designed
interior detailing as well as overall plans and eleva-
tions: "3 front Doors 3 Inner Doors and 2 Doors at

the end, all to be folding Doors the five that appear inside of the Church to be with Architraves Caps and Trusses after Mr. Berczy's Plan...."[5] The spire was not installed until 1819–20. In 1825 a journalist described the building at length and concluded:

> *The interior is not less tastefully finished than the outside. Simplicity and neatness are the prevailing features, and where any ornament is introduced, it is in perfect unison with the style of architecture, and harmonizes with the rest.... The Altar ... is an elegant specimen of taste and workmanship.... The whole presenting a grandeur of design and delicacy in execution seldom surpassed. This part is finished from a plan furnished by Mr. Berzey [sic], who also drew the plan for the other parts of the building....*[6]

1. Adams 1941.
2. James Gibbs, *A Book of Architecture Containing Designs of Buildings and Ornaments* (London, 1728). See also Nathalie Clerk, *Palladian Style in Canadian Architecture* (Ottawa: Parks Canada, 1984), p. 72, no. 23.
3. Adams 1941.
4. McCord Museum Archives: Anglican church collection, Folder I: "Statement of Account of Monies expended in erecting the Protestant Episcopal Church in the City of Montreal, by the Committee appointed for erecting the Same."
5. McCord Museum Archives: Anglican church collection, Folder I: "Proposal for Work to be done in the New English Church," entry no. 7 by builder/ architect John Try, dated 27 April 1812. The same builder's "Estimate for carpenters & joiners" includes his draft of an interior ground plan.
 Among the Berczy papers there is a roughly drawn floor plan that corresponds in many respects to Christ Church, but might be an idea for some other public building [SAUM, Q2/12, boîte 11643: pen and brown ink on laid paper, 32.3 by 19.9 cm, inscription on verso, *Mr Reids papers,* and with caricatured profiles drawn on same sheet].
6. *Canadian Magazine and Literary Repository,* 24:4 (Montreal, June 1825), pp. 525–31.

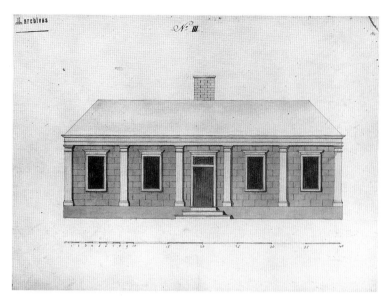

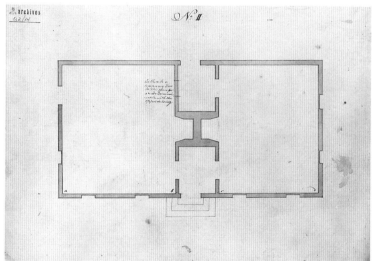

Cat. 63
Attributed to William Berczy
Floor Plan and Elevation c. 1805–08

Pen and brown ink with grey wash on laid paper
34.2 × 24.2 cm (each of two sheets)
WATERMARK: crown over lily on shield
INSCRIPTIONS: on floor plan u.c. in brown ink, *No II;* c.l., *Let there be a / temporary Door / in this place for / a ready Communi / cation with the opposite wing;* on elevation u.c. in brown ink, *No III;* l.c., a scale of measurement.
Service des archives de l'Université de Montréal

PROVENANCE: estate of William Bent Berczy to L.-F.-G. Baby; bequest to Université de Montréal, 1906.
REFERENCES: SAUM, Q2/14, boîte 11643.

These plans were handed down with the Berczy papers, but it is not known whether he designed

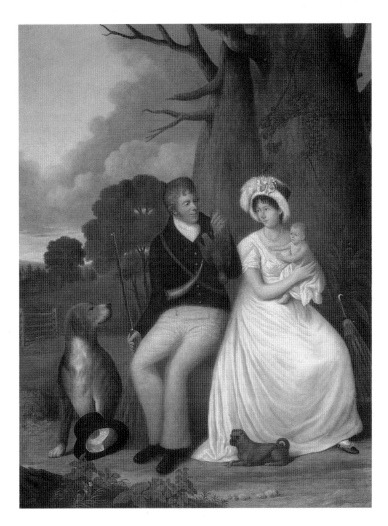

Cat. 64
William McGillivray and His Family
c. 1805–06

Oil on canvas

122.4 × 92.4 cm

McCord Museum of Canadian History, Montreal
M18683

PROVENANCE: by descent in family of Mrs McGillivray to her brother John McDonald of Garth; Antoine Eustache de Bellefeuille MacDonald, 1875; Archibald de Lery MacDonald; purchased McCord Museum, 1925.

EXHIBITIONS: 1887 Montreal; 1892 Montreal; 1987 McCord.

REFERENCES: Montreal 1887, p. 2, no. 34–232 (attr. to Dulongpré); Montreal 1892, p. 26, no. 386 (attr. to Dulongpré); Dunlap 1930, pp. 554–55, 558–63, 568–70; Jules Bazin, "Un peintre américain à Montréal en 1820," in *Vie des Arts*, XIV (1966), pp. 19–23; Andre 1967, pp. 90–92; Paul Bourassa, "The Vexed Question of Attributions," in Robert Derome et al,

the building, or only advised on the construction by writing some comments on the floor plan. The structure looks like a military guardhouse, such as the guardhouse with six columns that stood on Notre-Dame Street, Montreal, from about 1808.[1] At this period, Berczy's friend Louis Charland (cat. 51) was in charge of several architectural projects in Montreal, including the design and construction of the jail on Notre-Dame Street,[2] adjacent to the guardhouse. As he was a surveyor by profession, Charland may well have consulted Berczy regarding architectural design.

1. The guardhouse is visible at the right in *North East View of Notre Dame Street, Montreal,* etched by Adolphus Bourne after John Murray, published in 1850. Note that it is not identical to the drawing; for example, it has portico columns rather than pilasters.
2. Nathalie Clerk, *Palladian Style in Canadian Architecture* (Ottawa: Parks Canada, 1984), p. 81.

Dulongpré: A Closer Look (Montreal: McCord Museum, 1988), pp. 12–15.

William McGillivray (1764–1825), born in Scotland, was brought to Montreal in 1784 by his uncle Simon McTavish, founder of the North West Company of fur traders. With his uncle's encouragement he climbed up through the ranks to become the principal director of the company in 1804. He also acquired property on a grand scale, and in 1808 represented Montreal West in the Lower Canadian House of Assembly. During the War of 1812 he obtained the rank of lieutenant-colonel in the Corps of Canadian Voyageurs. In 1814 he was appointed to the Legislative Council of Lower Canada. During his directorship of the North West Company there was a continuous struggle for control of the fur trading business, which in 1821 led to a merger with the Hudson's Bay Company. At the time of McGillivray's death in London, he was deeply in debt.[1]

In 1800, McGillivray married Magdalen McDonald (d. 1810), the sister of John McDonald of Garth. Their first child to survive birth was Anne Marie, born on 19 May 1805 – an event which was celebrated a few months later with the painting of a family portrait. One might suppose that the park grounds depicted are those surrounding his residence, the Château St. Antoine; however, it appears that Berczy took a shortcut and based his general composition on an English genre print representing "Autumn."[2]

In the original Berczy composition, McGillivray is shown in a contrapposto pose, with his legs crossed at the ankles, and his torso turned toward the mother and child, offering them something (a basket of fruit or a pineapple?) that he holds with both hands. Regrettably, in 1820, McGillivray paid a mediocre artist, William Dunlap (1766–1839), to paint over his figure: "He has employed me to expunge a figure from a groupe and paint another in its place – it is his portrait full length. A lady with an infant & two dogs form the groupe...."[3]

In Dunlap's version, apart from costume changes, McGillivray acquired hunting gear, that is, a gun, a powder horn, and a dead game bird, to replace the fruit. The changes in the position of the right arm and leg have resulted in a very awkward pose. The other figures do not seem to have been altered, but they have suffered damages, and have been overpainted. It is difficult to judge Berczy's authorship because of the heavy overpainting; nonetheless, the passage in the lower left foreground showing a fallen tree trunk covered with foliage is a device that Berczy used in several works, notably in the full-length portrait of Joseph Brant (cat. 77).

1. DCB, vol. VI, pp. 454–57.
2. The composition is based on an English print published by Laurie and Whittle in 1794, or an American version of the same, of c. 1800. See Paul Bourassa, in *Dulongpré: A Closer Look* (Montreal: McCord Museum, 1988), note 26; and E. McSherry Fowble, *Two Centuries of Prints in America, 1680–1880. A Selective Catalogue of the Winterthur Museum Collection* (Charlottesville: University of Virginia Press, 1987), no. 351.
3. Dunlap 1930, pp. 554–55.

Cat. 65
Amélie Panet Berczy c. 1805

Oil on copper
15.5 × 14.6 cm
National Archives of Canada, Ottawa C-123828
Not in exhibition

PROVENANCE: William Bent Berczy to Marie-Louise Panet (widow of Lamothe, later Mme Pierre Lévesque); by descent to Laetitia Lévesque Faribault; gift of Dr Claude Faribault to NA, 1987–88.
EXHIBITIONS: 1980 Market Gallery.
REFERENCES: Andre 1967, pp. 99–100.

In his last will, William Bent Berczy mentioned this portrait specifically: "I bequeath to my niece Dame Marie Louise Panet widow of the late Arthur Lamothe Esq. ... the portrait in oils of my dear wife painted on Copper by my father...."[1]

Louise-Amélie Panet (1789–1862) was admired throughout her life, as a vivacious, intelligent, and generally enchanting woman. William Berczy, who expressed his affection for her in many of his letters, has depicted a grave young woman, probably not yet twenty years old. She studied painting with the artist, and in 1819 married his son, William Bent Berczy.

According to family memory, the portrait was "retouched" sometime during the late nineteenth century by Marie-Louise Panet, who first inherited the painting. Part of the overpainting was probably applied because of earlier paint loss around the subject's right eye and in the background. However, the additions to the neckline of the dress were evidently made to hide the low décolletage. Whatever the reasons, the overpaint is disfiguring and partly irreversible. A miniature version of this portrait (cat. 66) allows us to see the intended image.

1. Manuscript copy of L.-F.-G. Baby's translation of the will, owned by descendants of William Bent Berczy. See Andre 1975, p. 174, note 23.

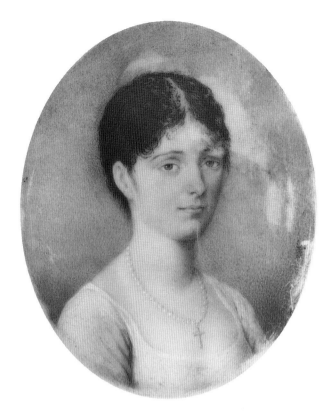

Cat. 66
Amélie Panet Berczy c. 1805

Watercolour and gouache on ivory
6.7 × 5.5 cm
INSCRIPTIONS: Verso: on ivory in ink, *Amélie Panet (Mde Berczy);* on label on back of frame in ink, *Mme de Berczy (Amélie Panet)*
Royal Ontario Museum, Toronto 977.234.2
Sigmund Samuel Trust

PROVENANCE: by family descent from M.-E.-G.-A. Chartier de Lotbinière; Archibald de Lery MacDonald; Mrs J.M. Gurd (née MacDonald); purchased ROM, 1977.
EXHIBITIONS: 1978 ROM.

This miniature portrait repeats the image painted by Berczy in oil on copper (cat. 65), but the face is subtly different in expression. The woman portrayed on copper is (from what one can judge in its present state of conservation) self-confident, serious, and also slightly amused; on ivory, she has become a "jeune fille," mild and tender.

This miniature is painted with the lightest touch, and the colours are subdued, possibly faded. The flesh tones, with a soft rosy-peach blush to the cheeks and nose, are washed in, and hatched strokes of blue shading are applied sparingly. The dress is painted in white gouache, and the folds on the sleeve at the left repeat those details visible in the oil on copper. In some areas, such as the outline of the eyes or centre line of lips, the brushwork seems hesitant in its stippled line. Is this portrait by the father or the son? They worked together on miniatures, with William Junior completing costume and background for his father, and he may have been allowed to contribute more on this portrait of a lady whom they both admired and loved. In 1815, William Bent painted another miniature portrait of a noticeably older Amélie (WBB 3).

Amélie's portrait miniature was handed down through the Chartier de Lotbinière family, together with a small portrait of Angélique de Lotbinière, painted by Amélie herself (APB 1). A photographic enlargement of the miniature of Amélie Panet, finished in chalk, was given to the Château Ramezay collection (CR 1756) by Judge Baby in 1900.

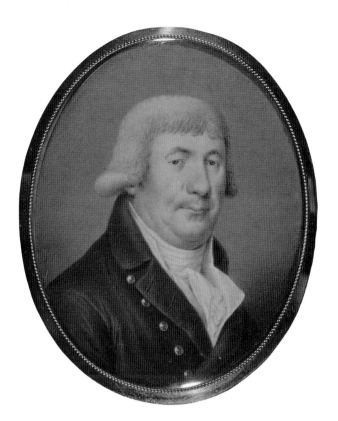

Cat. 67
James McGill c. 1805–11

Watercolour and gouache with gum arabic on ivory
6.1 × 5.3 cm
CASE: gilded copper with reverse bezel; centre decoration missing.
McCord Museum of Canadian History, Montreal
M1150

PROVENANCE: David Ross McCord, c. 1888–95.[1]
EXHIBITIONS: 1981 McCord; 1987 McCord.
REFERENCES: Rosenfeld 1981 (attr. to John Ramage); McCord 1981, typescript exh. cat. by Robert Derome, no. 9 (attr. to Ramage); Derome 1982, pp. 44–46 (attr. to Ramage); DCB, vol. v, p. 529 ("James McGill"), and p. 706 ("John Ramage").

James McGill (1744–1813), born in Scotland, was in Montreal by 1766. He was one of Montreal's leading fur traders, and a founder of the North West Company. In 1776 he married Marie-Charlotte Guillemin (1747–1818), the widow of Joseph-Amable Trottier, *dit* Desrivières. There were no children of this union, and McGill left large bequests to his wife, her sons by her first marriage, and her grandson. He also left an endowment and a large Montreal property for the founding of an institution for advanced learning, to be known as McGill College.[2]

This is a subtle and masterly portrayal of an older man wearing a grey-blue coat, and posed against a lighter grey background. The face is modelled in blue hatching, applied over carnation flesh tones. Similarly, the hair is painted in brown strands over a translucent underlayer of very pale grey; the darkest tones of hair frame the face, and highlights are painted with touches of white gouache. Watercolour is used for the head, with costume, background, and some details painted in gouache. This miniature has at times been attributed to John Ramage, although it shows none of the rich colouring, strong contrasts, and linear style we associate with that artist.

1. Probably by family descent from François-Amable Desrivières (1764–1830), eldest stepson of James McGill, whose granddaughter Caroline Desrivières (1842–1902) married Judge Thomas McCord (1828–1886) in 1877; in the period 1888–95, Caroline Desrivières McCord and Eugénie Desrivières sold historic material to David Ross McCord.
2. DCB, vol. v, pp. 527–30.

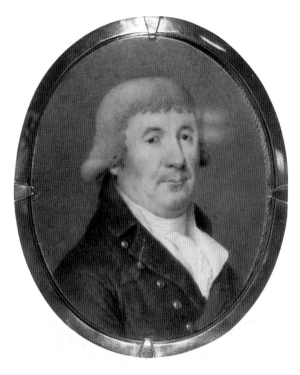

Cat. 68
James McGill c. 1805–11

Watercolour and gouache with gum arabic on ivory
6.5 × 5.2 cm
CASE: gilded copper with back missing.
INSCRIPTIONS: on card backing to miniature case in
 pencil, probably twentieth-century, *Jas McGill /
 Founder of McGill / University – died / 19" Dec. 1813 /
 age 69*
Department of Rare Books, McGill University, Montreal
Not in exhibition

PROVENANCE: by family descent from Mrs James
 McGill to Thérèse Bouchette Desrivières Reynolds;
 H.M. Reynolds; George F. Macdonald, 1929; gift to
 McGill University.
EXHIBITIONS: 1981 McCord; 1991 Quebec City.
REFERENCES: McCord 1981, typescript exh. cat. by
 Robert Derome, no. 10 (attr. to John Ramage);
 Derome 1982, pp. 44–46 (attr. to John Ramage);
 Quebec City 1991.

This miniature is virtually identical to catalogue 67,
and is evidently a duplicate by William Berczy. The
present version is slightly less finished. McGill left
all his household contents, including pictures, to
his wife. The miniatures were handed down to her
eldest son, and to the widow of her younger son –
no doubt McGill had these recipients in mind when
he ordered duplicates. Further evidence that McGill
paid attention to commemorating his memory is
found in a clause of his will, in which he left twelve
"mourning rings," to be distributed as the executors
and his widow saw fit.[1]

1. McGill University Archives, no. 1766, ref. S/2:
 "Notarized copy of Last Will & Testament of the
 Late Honble. James McGill. 1847."

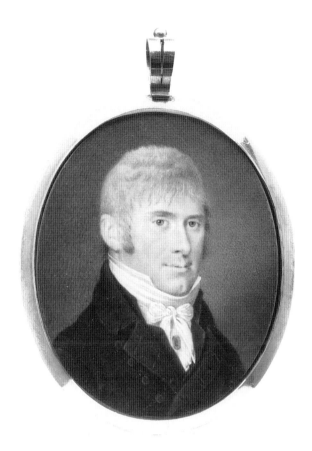

Cat. 69
Jean-Marie Mondelet c. 1805–11

Watercolour and gouache with gum arabic on ivory
6.5 × 5.1 cm
CASE: gilded copper locket with reverse bezel framing a
woven hair ornament and a smaller bezel of blue-
black glass with traces of an applied monogram,
JMM.
Musée du Château Ramezay, Montreal CR 1962

PROVENANCE: purchased Musée du Château Ramezay,
1901.
REFERENCES: Château Ramezay 1931, p. 77, no. 86;
Château Ramezay 1932, p. 80, no. 86; Château
Ramezay 1939, p. 78, no. 86; Château Ramezay
1957, p. 132, no. 1821; Paikowsky 1985, p. 56,
no. 129.

Jean-Marie Mondelet (c. 1771/73–1843) was a Mon-
treal notary, civic official, and politician.[1] He began
his career in his native Saint-Marc-sur-Richelieu,
but moved to Montreal about 1803. In 1804 he was
elected to the House of Assembly, which he contin-

ued to serve until 1809. Mondelet occupied numer-
ous government appointments in Montreal: in 1805
he was a commissioner for the Lachine turnpike, and
in 1807 a commissioner to remove the Montreal
fortifications. In 1810 he became joint president of
the Montreal Court of Quarter Sessions; in 1811 a
police magistrate; and in 1812 coroner for Mon-
treal. During the War of 1812 he served as a major
in the militia. His public service continued through
the rest of his life. Politically he was a moderate
nationalist, a position which alternately alienated the
support of the Château and the Canadian groups.
He was a close friend of Jacques Viger, and moved
in a social circle well known to William Berczy. His
name appears on Berczy's list of influential friends
to whom he sent résumés of his land-petition
experiences in Upper Canada.[2]

Mondelet's handsome features are painted with
short strokes of parallel hatching, in delicate pink
flesh tones with blue shading. The upper lip is care-
fully modelled with some shading, and touches of
red-brown indicate the centre line; the lower lip
reflects the tone of the ivory. The fashionable hair
style, short on the crown and longer at the front and
sides, is described with graphic strokes of varying
lengths. The cravat is outlined with white gouache,
and ivory is showing in the other areas of the linen.
The grey background is lighter in tone at the right,
rendered with short curved strokes that appear mot-
tled; the darker background at the left and lower
right is painted with longer parallel strokes. Gum
arabic is used more liberally than usual, especially in
the dark coat and the background, but also in the
hair.

1. DCB, vol. VII, pp. 621–24.
2. NA, MG23, H II 6, vol. 1, p. 269.

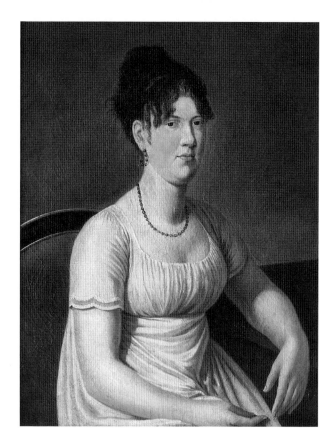

Cat. 70
Maria Sutherland Hallowell c. 1805–06

Oil on canvas
79 × 61 cm
Royal Ontario Museum, Toronto 988.96.2
Gift of the Jeanne T. Costello Trust and of William J.C.
 White, Q.C.

PROVENANCE: from sitter to her daughter Margaret
 Mary Hallowell Wood; by descent in the Wood fam-
 ily; purchased ROM, 1988.

Maria Sutherland was the daughter of fur trader
and merchant Daniel Sutherland and Margaret
Robertson of Montreal, who had married in 1781.
Maria married James Hallowell (1778–1816) some-
time before 1814. She and her younger sister Louisa
inherited the fortune of their grandfather Daniel
Robertson (c. 1733–1810), an army officer and land-
owner. The Robertson, Sutherland, and Hallowell
families were especially friendly with William
Berczy, his wife and children, and they are fre-
quently mentioned in the Berczy correspondence.

 This portrait shows the influence of Neo-Classi-
cism on Berczy's painting; the simple composition,
low-keyed tones, and rounded chair back are remi-
niscent of European models. The heavy arms and
hands are well drawn and convincing, in contrast to
the awkward arms of Mrs Woolsey (cat. 84). The
three-quarter-length format, seated and showing
both hands, corresponds to the 1808 portraits of the
De Bonnes (cat. 79, 80). The painting may date as
early as 1805, as the dress worn by Maria is of the
earlier Empire style (note the full flow of gown at
the back), fashionable from 1800 to 1805.

 The portrait has been extensively overpainted
during its lifetime, altering Berczy's original surface
treatment and colour scheme. At date of writing,
the painting is being restored. From spot tests, it
would seem that Berczy's background is a toned-
down blue-green; and that he painted the shaded
folds of the white dress in tones of aqua and dusty
rose. The upholstery fabric is a deep rose. For the
lips he used a more orange red, which draws atten-
tion to the face.

 Portraits of Maria and her husband are not men-
tioned in the Berczy letters. However, portraits in
miniature on ivory of the couple were exhibited in
Montreal in 1887 (nos. 615, 616) and in 1892 (nos.
300, 301). Were they miniature versions of these oil
portraits by Berczy?

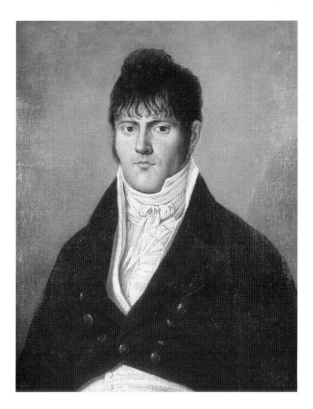

Cat. 71
Pierre de Rastel de Rocheblave 1806–07

Oil on canvas

69 × 53.1 cm

INSCRIPTIONS: on label attached to stretcher in red ball-point, *Philippe François de Rocheblave / son of Jean Joseph (1 of 14 sons) / Portrait by Delongchamp / Best Portrait of that Period / R.*

National Archives of Canada, Ottawa C-132756

PROVENANCE: by descent in family of the sitter to his daughter Louise-Elmire de Rocheblave; Charles Bouthillier; Randolph F. Routh; sold at Pinney's Auctions, Montreal, 22 March 1988, lot no. T138, to NA.

EXHIBITIONS: 1887 Montreal; 1892 Montreal; 1990 NA.

REFERENCES: Montreal 1887, pp. 27–29, no. 41; Montreal 1892, p. 30, no. 452; *Art canadien et européen / Canadian and European Art,* Montreal, Les Encans Pinney's Auctions, 22 March 1988, lot no. T138; Burant 1991, pp. 182–86, no. 54.

Pierre de Rastel de Rocheblave (1773–1840) was the son of Philippe-François de Rastel de Rocheblave, a French colonial officer who later served with the British in Illinois and moved to Lower Canada about 1780. At an early age, Pierre looked after his father's fur trading interests in Detroit, and in 1798 became a founder of the New North West Company (XY Company) of fur traders.[1] William Berczy mentioned the Rocheblave name while he was in York in the 1790s, in connection with plans for improving communications in Upper Canada for the fur trade, but does not seem to have met him at this period.[2] As a "wintering partner" in the fur-trade business, Pierre de Rocheblave spent much of his time in western Canada. His portrait must have been painted between September 1806 and early May 1807, when he was visiting Montreal; at no other appropriate date did Rocheblave and Berczy coincide in Lower Canada. In later years Rocheblave became a close friend of William Bent Berczy, Amélie Panet, and the Panet-Lévesque family.

Rocheblave is dressed in the height of fashion, with his many folds of neckcloth, and his waistcoat and jacket of elegant cut. His hair is trimmed short and curled "à la Titus," a style that has been exaggerated by later overpainting. The bust portrait is otherwise quite simple and straightforward; Berczy's attention to facial features and proportions has made the personality of the sitter the centre of attention. Early cleanings and repaints disturb the original harmony of this painting.

1. DCB, vol. VII, pp. 735–39.
2. Andre 1967, p. 140.

Cat. 72
Horse's Head c. 1806–11

Etching
9.5 × 6.6 cm (plate)
INSCRIPTIONS: in plate u.l., in reverse, *Berczy;* in later
 hand, l.r. in ink, *W. Berczy, père.*
Bibliothèque municipale de Montréal, Viger Album
Not in exhibition

PROVENANCE: Jacques Viger; Misses Lennox, 1858;
 Raphaël Bellemare, 1860; Bellemare heirs; BMM,
 1943.
REFERENCES: BMM, Viger Album; Allodi 1980, p. 25,
 no. 12.

Berczy periodically announced his intention of en-
graving a series of copper plates with illustrations of
Canadian views and costumes. In June of 1809 he
asked his wife to order six copper plates prepared for
engraving (measuring about 18 × 30.5 cm), which
seems to indicate that he intended to do the etching
himself.[1] This project was never launched, to our
knowledge, and the only etching found is this tiny
but quite sure-handed drawing of a horse's head, of
classical inspiration. The doodles of a woman's head
in the upper left, accompanied by Berczy's signa-
ture, and of some foliage at the lower centre indicate
that he was practising on this plate.

1. SAUM, U/1507: Berczy to Charlotte, Quebec,
 24 June 1809.

Cat. 73
Rear Admiral Sir Horatio Nelson 1807–08

Oil on canvas
209.5 × 136 cm
Hudson's Bay Company, Toronto

PROVENANCE: Hudson's Bay Co., at Fort William,
 c. 1816–21; at York Factory, 1821–1928; at Win-
 nipeg, 1928–74; in Toronto since 1974.
EXHIBITIONS: 1980 Market Gallery.
REFERENCES: SAUM, U/2734: T. Christian to Berczy,
 Fredericton, 13 January 1808. Ross Cox, *Adventures
 on the Columbia River, including the Narrative of a
 Residence of Six Years on the Western Side of the Rocky
 Mountains, among various Tribes of Indians hitherto
 unknown: Together with a Journey Across the American
 Continent* (London: Henry Colburn and Richard
 Bentley, 1831), p. 288; Maheux 1939, p. 881;
 MacLeod 1948, pp. 8–11; Andre 1967, pp. 61,
 89–90.

Horatio Nelson was fatally wounded at the Battle
of Trafalgar, on 21 October 1805. The news of the
battle and of his heroic death reached Quebec in
December 1805. The hero and his victory were
commemorated at "Trafalgar Celebrations" held in
Quebec City, Montreal, and Trois-Rivières in Jan-
uary 1806.[1] Accounts of the events describe displays
of prints and transparencies depicting Nelson and
his naval engagements; Berczy's name is not men-
tioned, nor is there any reference to oil paintings.[2]

Patriotic feelings were at a high pitch in Janu-
ary of 1806, and a subscription fund was launched
for the building of a monument to Lord Nelson.[3]
Among the Berczy papers is a faint sketch of a mon-
ument to a military hero (fig. 29); it is an obelisk
with a medallion containing the bust of a man with
medals, framed with laurels and surmounted by a
laurel wreath. At the foot of the obelisk are military
trophies. This may have been a preliminary idea for
a Nelson monument, but the contract was awarded
elsewhere,[4] and Berczy wrote a draft letter over top
of his discarded drawing.[5]

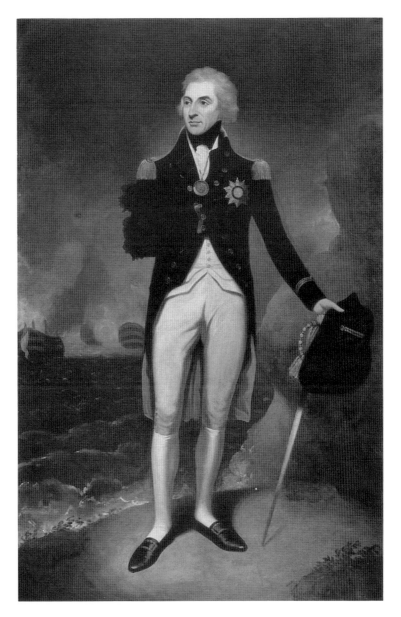

Nevertheless, the artist did not miss out on this historic occasion completely: he evidently undertook to paint large canvases depicting Nelson and the Battle of Trafalgar (cat. 74) in 1806 or 1807. The only pertinent reference to be located in his correspondence, a letter from Thomas Christian, describes a portrait of Nelson as almost finished in late 1807:

> *Your Letter by the hand of Mr. Woolrich dated the 19th of November 1807 advises me that the large and monumental Picture of Lord Nelson was to be completed in three weeks. I congratulate you on this.*
>
> *As the Post is leaving unexpectedly I have but a moment to write a line, that Mr. Woolrich has given me an account of money already paid amounting to 110£.14S.4P Current.*
>
> *I have asked him to give you the rest of the sum, amounting in total to 180£. current.*
>
> *As I would not want to miss the chance of communicating with you, I will be obliged to inform you of what I have written to Mr. Woolrich[6] in due course, regarding the Picture....[7]*

Thomas Christian's connection with the Nelson painting is not clear. He was a captain in the New Brunswick Fencibles and had been stationed in Montreal from September 1804 until 1807, in charge of recruiting for his regiment. His superiors were uneasy about the way in which he conducted business and kept accounts. Was he spending mili-

29. *Design for a Monument,* n.d., by William Berczy. Collection: National Archives of Canada, Ottawa. Photo of tracing done by Catherine Wyss, ROM.

30. *Portrait of the Right Honorable Admiral Horatio Nelson, K.B.,* 1799, by W. Barnard after L.F. Abbott. Collection: British Museum, London.

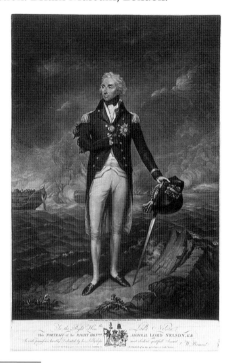

tary funds on paintings for the regimental mess? By 1808 he had returned to the Atlantic provinces.[8]

The large oil portrait in this exhibition was commissioned by William McGillivray for the North West Company. It was hanging in the dining hall at the western headquarters of the Company at Fort William in 1816: "A full-length likeness of Nelson, together with a splendid painting of the battle of the Nile [sic], also decorate the walls, and were presented by the Hon. William McGillivray to the Company...."[9] The portrait and battle scene remained in the ownership of the fur trading company after it joined with the Hudson Bay Company.

As far as we know, this is the first monumental-sized painting attempted by Berczy in Canada. However, he had already painted large canvases while living in Florence, so that this work would not have daunted him. The Nelson portrait is based on a painting by Lemuel Francis Abbott (1760–1803), as reproduced in the 1799 etching (fig. 30) by William S. Barnard (1774–1849). The subject is painted broadly, without Berczy's usual densely applied layers and attention to detail. The seascape and land in the foreground are summarily painted; the cliff at the right (an addition which does not appear in the print) is lacking in structure. The portrait seems to have been painted for general effect, as if for stage scenery; it is possible that Berczy first conceived this portrait and its companion battle scene as temporary showpieces for the Trafalgar celebrations.

1. *Montreal Gazette,* 27 Jan. and 3 Feb. 1806; *Quebec Mercury,* 13 Jan. and 3 Feb. 1806; and *Quebec Gazette,* 9 and 16 Jan. 1806.
2. Berczy's friend and sometime pupil, Lewis Foy, painted an allegory of Victory in the form of a large transparency for the Quebec festivities. [*Quebec Mercury,* 13 Jan. 1806.]
3. *Montreal Gazette,* 6 Jan. 1806.
4. The designer chosen for Nelson's column was British architect Robert Mitchell. See Elizabeth Collard, in *Country Life* (24 July 1969), pp. 210–11.
5. NA, MG23, H II 6, vol. 4, pp. 728–29: Berczy to [?], c. 1808.
6. James Woolrych (1762–1823) was a well-known Montreal merchant.
7. SAUM, U/2734: T. Christian to William Berczy, Fredericton, 13 Jan. 1808 (trans. from French).
8. York-Sunbury Historical Society Collection, Provincial Archives of New Brunswick, Fredericton, N.B., MC300, MS 15/3; and W. Austin Squires, *The 104th Regiment of Foot 1803–1817* (Fredericton: Brunswick Press, 1962), App. A, p. 189. For this information, I am indebted to Dale Cogswell and Denis Noël, Provincial Archives of New Brunswick.
9. Ross Cox, *Adventures on the Columbia River, including the Narrative of a Residence of Six Years on the Western Side of the Rocky Mountains, among various Tribes of Indians hitherto unknown: Together with a Journey Across the American Continent* (London: Henry Colburn and Richard Bentley, 1831), p. 288.

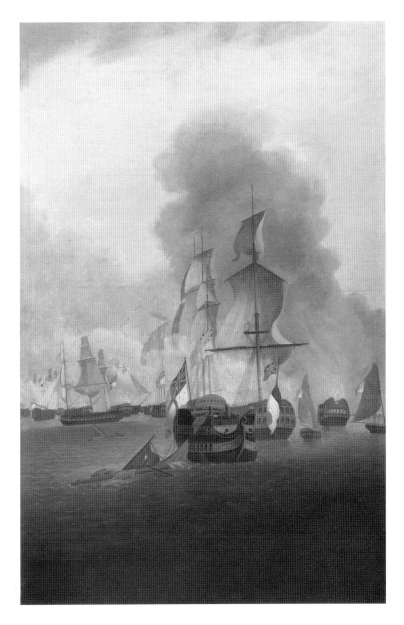

Cat. 74
The Battle of Trafalgar 1807−08

Oil on canvas
210 × 135.7 cm
Hudson's Bay Company, Toronto

PROVENANCE: Hudson's Bay Co., at Fort William, c. 1816−21; at York Factory, 1821−1928; at Winnipeg, 1928−74; in Toronto since 1974.
EXHIBITIONS: 1980 Market Gallery.
REFERENCES: Ross Cox, *Adventures on the Columbia River, including the Narrative of a Residence of Six Years on the Western Side of the Rocky Mountains, among various Tribes of Indians hitherto unknown: Together with a Journey Across the American Continent* (London: Henry Colburn and Richard Bentley, 1831), p. 288, as

"Battle of the Nile"; MacLeod 1948, pp. 8−11; Andre 1967, pp. 61, 89−90.

Berczy's *Battle of Trafalgar* is based on an aquatint by and after Robert Dodd, published by Dodd in London on 1 March 1806.[1] The print's title describes the scene: "Victory of Trafalgar, in the Rear. This View of the total defeat of the Combined Fleets of France and Spain, with the Tenders of the British Fleet saving their conquered Enemies from the Flames of their own Vessel (*L'Achille* a French 74)...." In copying the horizontal composition, Berczy compressed the action into the vertical for-

Cat. 75
Joseph Brant c. 1797–1808

mat needed to make it a companion-piece to his portrait of Admiral Nelson (cat. 73). This was accomplished with the loss of only a few ships at the left and right.

The battle painting is more detailed and colourful than the portrait. The waves are green, the flames pink and yellow, and grey clouds float against a yellow-green sky. This seascape and its companion portrait have suffered over time, and there are some noticeable old damages and retouches.

1. A proof impression of this aquatint is in the collection of the National Maritime Museum, Greenwich, England. Reproduced in John Tremaine, *Trafalgar* (London: Sidgwick & Jackson Ltd., 1976), pp. 162–63.

Oil on wove paper, varnished
23.8 × 18 cm (oval)
INSCRIPTIONS: on label glued to composition-board backing in ink, *Captain Joseph Brant, (Tyendenaga) Chief of the Mohawks / one of the Six Nations of Iroquois Indians of North America. celebrated for / the part he took in the revolutionery war of the United States / Portrait taken from the life by my father, an excellent …;* on backing in ink, *Brant ou Tayadanaga … / de guerre des Mohawk …*
Royal Ontario Museum, Toronto 972.80
Sigmund Samuel Trust

PROVENANCE: by descent in Berczy family to Robert Gordon Moore; purchased ROM, 1972.
EXHIBITIONS: 1968 ROM.
REFERENCES: Lesser 1984, pp. 23–25.

Joseph Brant (c. 1742/43–1807), whose Indian name was Thayendanegea, was a Mohawk war chief and leader. He fought for the British during the Seven Years' War and the American Revolution, after which the loyalist Six Nations Indians settled in Upper Canada and received a huge tract of land

along the Grand River. He visited England in 1776 and 1785, was generally lionized, and had his portrait painted by such well-known artists as George Romney and Gilbert Stuart. In America, he was portrayed by Charles Willson Peale in 1797, and by Ezra Ames in 1805–06.[1]

Berczy's first portrait-sketch of Brant could have been made as early as 1794. On 24 June 1794 they met at Newark, and Berczy described the Mohawk leader at length. Of Brant's physical appearance, he noted:

> He is by nature entirely framed for a warior being Six English feet high and in all the parts of his body proportionally formed, possessing an uncommon strengths; his head well proportioned to his figure, presents a face, though entirely denoting his origins, is uncommonly expressive and discovers the energy of his soul … When I consider sometimes Brand and others of the Indians living in North America I can not help to find a great resemblance between their features and those of the Chinese, as far as I know that latter Nation from pictures and Sculptures made by their own Artists … he has succeeded to form the mohocks into a regular corps of militia, who on days of review and ex[er]cise are all clothed uniformly; and this uniform he almost constantly wears himself consisting of a Gray coat with a belt of purple wampoms and read [red] leggens….[2]

It is not possible to say whether this painting is Berczy's first sketch of Brant. It is the model for his half-length oil on canvas (cat. 76), and the head itself is repeated in all five Brant portraits by Berczy and his son (cat. 75–77 and WBB 7, 8). In this version, Brant is depicted wearing civilian dress and a crossbelt, corresponding with Berczy's 1794 description of his usual attire; his hand resting on a tomahawk emphasizes his military leadership. His stance is formal within the classical oval, but his expression is pensive and sad.

The procedure that Berczy used in painting this oil-on-paper portrait is the same as seen in his preparatory sketch for *The Triumph of the Virgin* (cat. 90). The paper is coated with a white ground, on which the outline of Brant's figure is drawn. The imprimatura, or preliminary colour layer, is then laid in: a blue-grey for the background and costume areas, pale cream for the face and hands, and yellow for the oval 'frame.' Each area is then built up with several layers of paint: for example, the features are drawn in a brown brushpoint, the shading is added in a grey-green, and then the flesh tones are applied, with more shading to create volume. Curiously, the least build-up occurs around the features which, once drawn in, are left that way, with flesh tones encapsulating the underdrawing rather than covering it. In the process of building up his image, Berczy varnished the painting more than once and some of the varnish contains pigment. Later repairs and overpaints by another hand are visible, notably in the dark vertical streaks in the face. X-rays show that the hand and hatchet were moved slightly to the left, and reveal a careful underdrawing for the woven fabric of the crossbelt, which may originally have been more readable as a wampum belt of shell beads.

1. George Romney's portrait of 1776 is in NGC collection, 8005. Gilbert Stuart's portraits of 1786 are in New York State Historical Collection, Cooperstown, and collection of Duke of Northumberland, Syon House, Middlesex, England. Portrait by Charles Wilson Peale of 1797, collection of Independence Hall, Philadelphia. The 1805–06 oil by Ezra Ames is only known through copies by other artists, and as engraved by Archibald Dick. See Thompson 1969, pp. 49–53.
2. SAUM, S/22, boîte 11442, pp. 70–72: draft narrative titled "The Traveler, Letter Eleventh," Queenston, 24 June 1794. For another description of Joseph Brant written by Berczy in 1799, see Appendix D.

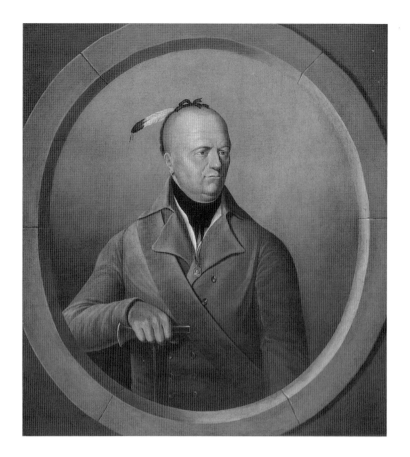

Cat. 76
Joseph Brant c. 1808

Oil on canvas
38.7 × 35.6 cm (oval)
Private collection
Ottawa venue only

PROVENANCE: Ward C. Pitfield; Mrs W.C. Pitfield;
present owner.
REFERENCES: Harper 1966, p. 70; Andre 1967, pp. 62,
87–88; Lesser 1984, pp. 23–25.

Brant's image has become a still-life, precise and
sculptural in definition (pl. XII). The rigid pose and
hard outline are further emphasized by the juxtapo-
sition of the striking apple-green coat against a cold
grey background. This is a more finished version of
the portrait on paper (cat. 75), with the addition of
a gold George III medal, hanging from a pink rib-
bon, and a pink-tipped feather attached to the scalp
lock. The earlier sketch's suggestion of an oval
framing has become a carefully painted stone tondo,

a traditional European portrait setting. Brant's
expression is more aggressive than in the portrait on
paper, although his eyes are still dreaming.

Portraits of Brant by Berczy, father and/or son,
were shown in loan exhibitions in Montreal during
the nineteenth century. As these works were neither
described nor illustrated in catalogues or reviews,
it is not possible to say whether the bust-length or
full-length portrait was on view. The medium was
not always correctly described at the time, so that
"pastel" may mean watercolour.

Portraits of Brant exhibited in the nineteenth cen-
tury, and evidently by William Berczy or William
Bent Berczy, are:

1860 MONTREAL: *Lower Canada Provincial Exhibition,*
" 'Brant' by the Hon. W. Berczy [William Bent], oil
painting."[1]

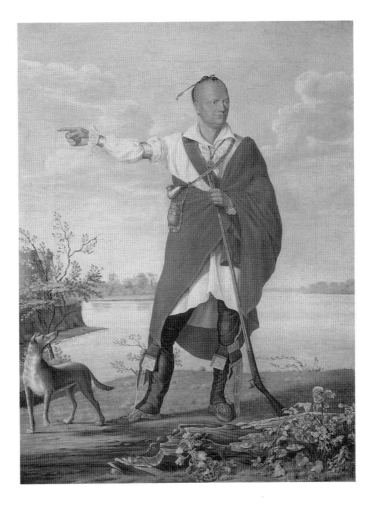

Cat. 77
Joseph Brant c. 1807



1887 MONTREAL: *Loan Exhibition of Canadian Historical Portraits,* p. 16, no. 532, "BRANT. Pastel ... painted in 1797 by William Berczy, Sr., at York, Ont. Loan by M. L'Abbé Verreau" (see WBB 7); and p. 17, "BRANT, CAPTAIN JOSEPH, TYENDENAGA. Oil painting by Wm Berczy. Loan of P.T. Levesque" [presumably by William Berczy, although it could be a version by William Bent Berczy].

1892 MONTREAL: *Canadian Historical Portraits,* p. 13, no. 228, "BRANT, CAPTAIN JOSEPH, TYENDENAGA. (Oil)" [lender and artist not named].

A replica of the half-length portrait by an unskilled painter, once owned by Mrs W.H. Boulton (AGO, GS 42), may be the same picture that was catalogued as "John Brant, the Indian Chief," in a Toronto loan exhibition of September 1852 (p. 3, no. 78).

1. *Montreal Gazette,* 5 Oct. 1860, review of exhibition with prize listing, Class VII, Section A.



Oil on canvas

61.8 × 46.1 cm

INSCRIPTIONS: Verso: in hand of William Bent Berczy, on label, *Captain Joseph ... Chief of the Mohawk Indians / Note Colonel ietor of the New York Commercial / Adverti... of Brant. This portrait was / fr.... father Wm Berczy* [label torn].

National Gallery of Canada 5777

PROVENANCE: John Laurel Russell; purchased NGC, 1951.

EXHIBITIONS: 1967 London, Ont.; 1967 MMFA; 1968 ROM; 1969 NGC; 1975 Cleveland; 1984 AGO.

REFERENCES: NGC 1960, p. 16; Hubbard 1964, pp. 52–53; Betcherman 1965, pp. 57–58 (cf. 60); Harper 1966, p. 70, and 2nd ed. 1977, p. 62, fig. 24; Andre 1967, pp. 87–89; Harper 1967, pp. 16–22 (cf. 20); MMFA 1967, no. 84; Wayne J. Ready, *Early Canadian Portraits* (Ottawa: National Gallery of Canada, 1969), no. 4; Thompson 1969, pp. 49–53 (cf. 52–53); Reid 1973, p. 38; Paul Duval, *High Realism in Canada*

(Toronto and Vancouver: Clark, Irwin & Co. Ltd., 1974), pp. 9–11; Barry Lord, *The History of Painting in Canada: Towards A People's Art* (Toronto: NC Press, 1974), pp. 83–84, fig. 76; Hugh Honour, *The New Golden Land: European Images of America from the Discoveries to the Present Time* (New York: Pantheon Books, 1975), pp. 130– 31, fig. 123; *The European Vision of America* (Cleveland: Cleveland Museum of Art, 1975) no. 341; *L'Amérique vue par l'Europe* (Paris: Secrétariat d'État à la Culture, Éditions des musées nationaux, 1976), no. 189a; Trudel 1976, p. 21, fig. 8; Lesser 1984, p. 9–28 (cf. 17–22); Reid and Vastokas 1984, no. 94; NGC 1988, p. 82.

The full-length portrait of Joseph Brant is the culmination of Berczy's abilities as an interpreter of the human spirit (pl. XIII). The Mohawk leader died on 24 November 1807, and this event may have impelled Berczy to paint a full-length portrait showing Brant dramatically posed against a lakeshore landscape. The low horizon and even lower shoreline impart a monumental stature to the figure. The sense of drama is heightened by the grandiose gesture of Brant's outstretched arm, in the classical pose of imperial authority, and by the visual impact of the brilliant red blanket/toga.

Berczy has paid much attention to each costume detail, no doubt drawing on earlier notebook studies of native dress that he intended to use to illustrate a publication on the history of Canada. In brushpoint he meticulously describes the decorated garters and moccasins, the silk tassels on the leather pouch, and the woven strap of flechée design that holds the powder horn. This love of detail extends also to the plant life in the foreground; the fallen tree and foliage are a compositional device that Berczy had used in Florence (see cat. 2). The portrait is densely painted in smooth brushstrokes, with impasto touches for highlights. The dominant colours are red and green; Brant's clear red robe is set against a

sky of muted grey-green, with rolling pink clouds. The site depicted is generalized, as is the stone "fort" seen at the left background. The body of water is too vast to represent the Grand River, a site often suggested as the locale in this painting.

Because Berczy often used prints as compositional sources, it is possible that costume, pose, and the presence of an animal and flintlock gun are references to the eighteenth-century mezzotint of Brant's ancestor Sa Ga Yeath Qua Pieth Tow.[1] However, he had no doubt seen Brant's brilliant costume at first hand; also, Berczy would have had many possible models in English portraits of country squires with dog and gun.

The allusion to the proprietor of the *New York Commercial Advertiser* on a label attached to this painting, while now obscure because it is incomplete, is a reminder of Berczy's efforts to publish his writings and drawings, and may suggest that this image of Brant was intended for publication. In his address book, Berczy had made short lists of book and newspaper publishers in various eastern seaboard cities of the United States;[2] among these is the name of "Lewis, Commercial Advertiser," a reference to Zechariah Lewis, proprietor of that daily from 1803 until 1840. Berczy's entry was made during his last voyage to New York, in 1812.

1. Note that the clan symbol is the bear, not the dog. The *Portrait of Sa Ga Yeath Qua Pieth Tow,* 1710, oil on canvas, by John Verelst (1648?–1734) (collection: NA, Ottawa), was issued as a mezzotint by John Simon, London, 1710. The print went through three editions, and was widely distributed. See W. Martha E. Cooke, *The Four Indian Kings, Catalogue with an Introduction* (Ottawa: NA, 1977); and John G. Garratt, *The Four Indian Kings / Les Quatre Rois Indiens* (Ottawa: NA, 1985) .
2. SAUM, série S, boîte 11447.

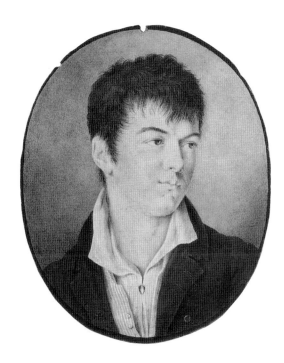

Cat. 78
William Bent Berczy c. 1808

Watercolour and gouache over graphite on wove paper
14.6 × 11.8 cm (oval)
Private collection

PROVENANCE: by descent in Berczy family.
EXHIBITIONS: 1980 Market Gallery.
REFERENCES: SAUM, U/1414: Charlotte to WBB, Montreal, 1 Sept. 1808; U/1470: Berczy to Charlotte, Quebec, 3 Sept. 1808; U/1478: 7 Dec. 1808; and U/1486: 27 Jan. 1809. Andre 1967, p. 97.

This portrait of seventeen-year-old William Bent Berczy must be the likeness that his father painted in Quebec City during the summer of 1808. Charlotte Berczy's letter from Montreal expresses her great joy on receiving the little painting of her son:

The Likeness of my William? The Likeness of that dear Child? Oh, my William, embrace that tender Papa time and time again for me, & tell him that this gift has every virtue with me. It is a masterpiece of art, that

recalls the beloved features at all times to my sight … Charles … has set the portrait in General Prescott's frame, which serves as a support at the back, & hung it at the feet of the Queen of Saxony; so here is William in Effigy supported and protected as he deserves … Mélanie [Panet], coming in, took her first look at this likeness and was struck by it; but she hopes that the seriousness that she notes in it is not the usual thing … Mademoiselle Amélie [Panet] … seeing your portrait, told me that she was set on copying it, she finds it a very good likeness & and considers it as an artist.[1]

Subsequent correspondence discusses and praises a copy of this portrait which was painted by Amélie Panet and later touched up and varnished by William Berczy.

Only the present version of the portrait has been found, and stylistically it has all the traits of a work by William Berczy. He has depicted his son as a soulful young artist wearing a casual open-necked shirt, blue-striped vest, and plum-coloured coat. The face is sensitively painted, to convey every nuance of the modelling of the flesh, such as the surface of the lips or the muscles in the neck. Each lock of the chestnut hair is graphically described, with the richest highlights added in gouache. Charlotte Berczy mentioned temporarily housing the portrait in the frame used for *Robert Prescott* (cat. 49) – it would have been just the right size. The image, which was obscured by a layer of discoloured varnish, has recently been restored. In the conservation process, the portrait was separated from three layers of backing paper, made up of cuttings from one of Berczy's architectural drawings (see cat. 89).

1. SAUM, U/1414: Charlotte to WBB, Montreal, 1 Sept. 1808 (trans. from French).

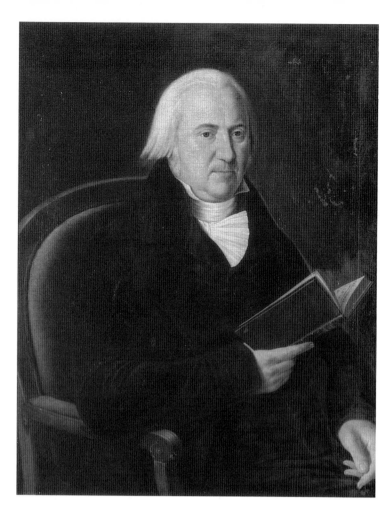

Cat. 79
Pierre-Amable De Bonne 1808

Oil on canvas
81 × 65 cm
Dr Guy Marcoux, M.D., Beauport, Que.
Quebec City venue only

PROVENANCE: by family descent from Louise-Élizabeth
Marcoux De Bonne; her nephew l'abbé André-
Amable Marcoux; his brother Louis-Philippe Mar-
coux; his son Joseph-Désiré Marcoux; his son
Adolphe Marcoux; to present owner.
REFERENCES: SAUM, U/1470: Berczy to Charlotte,
Quebec, 3 Sept. 1808; U/1473: 21 Sept. 1808;
U/1474: 12 Nov. 1808; and U/1475: 23 Nov. 1808.

Pierre-Amable De Bonne (1758–1816), judge, sei-
gneur, and office holder, was the leading member of
the "Château clique" in the Legislative Assembly of
Lower Canada, which strongly supported the Brit-
ish government administration. His political skill
and his ties to the administration made him a hated
adversary of the "parti Canadien."[1] De Bonne had

an excellent library, which contained French works
of critical and rationalistic philosophy, as well as
treatises on law, medicine, history, and literature.
Berczy has portrayed him holding a volume in-
scribed on the open page *DE L'ESPRIT DES LOIS
/ LIV. XII / D...*; and on the spine *... / d / MONT*
and *T.I.* This is a flattering association of Judge
De Bonne with Montesquieu's famed treatise on
legal and political subjects, written in a spirit of tem-
perate and tolerant desire for human improvement.[2]

William Berczy painted the oil portraits at Judge
De Bonne's country estate of "La Canardière" at
Beauport, near Quebec, and thus described his ac-
tivities in letters to his wife:

*Early Monday morning, I began straight away to pre-
pare what was needed to begin my work, and towards
evening, Mr. De Bonne's portrait was sketched in a
manner which is a very good likeness; enough, at least,
to please the whole family. The size of these pictures
obliges me to make them half-lengths with two hands,
which increases my work, but increases the proceeds at
the same time, since according to the prices that I have set
for my works, I am paid 12 Guineas for a half-length, so
that my stay here, with the portrait of Mme. De Bonne's
mother that I have to touch up, will fetch me 39 Guineas
or £45.10. On Tuesday, I sketched the entire portrait of
Mr. De Bonne, well enough so that from a short distance*

Cat. 80
Louise-Élizabeth Marcoux De Bonne 1808

Oil on canvas
81 × 66 cm
Dr Guy Marcoux, M.D., Beauport, Que.
Quebec City venue only

PROVENANCE: by family descent from Louise-Élizabeth Marcoux De Bonne; her nephew l'abbé André-Amable Marcoux; his brother Louis-Philippe Marcoux; his son Joseph-Désiré Marcoux; his son Adolphe Marcoux; to present owner.

REFERENCES: SAUM, U/1470: Berczy to Charlotte, Quebec, 3 Sept. 1808; U/1473: 21 Sept. 1808; U/1474: 12 Nov. 1808; and U/1475: 23 Nov. 1808.

Louise-Élizabeth Marcoux (1782–1848) was the daughter of André Marcoux, a farmer, and Louise Bélanger of Beauport. She married the much older Judge De Bonne in 1805, when she was twenty-three years old. Pierre-Amable De Bonne's first wife had been Louise Chartier de Lotbinière, and their 1781 marriage had failed after one year. De Bonne

it looked like a finished picture to them, especially since they are not accustomed to seeing finished pictures that have so much effect. Since Mr. De Bonne had to go into town today for the Criminal Court, I sketched Madame in his absence, no less successfully than her husband and which pleased them no less. — These people are quite astonished with the speed at which I do my work. . . . there is a good Billiard table in the house, and I usually play in the morning, the evening and after supper a couple of games with Mr. or Mme. De Bonne. The time is very regularly organized in this house; we rise early, breakfast at 8 o'clock in the morning, usually eat at noon, except when the Judge is obliged to attend Court, and at 7 o'clock in the evening we dine and drink tea at the same time. At table, we eat completely in the French style, always with good soups that suit us very well. Up to this time, we have not had a lot of Company, but I have a fine time with the master of the house, who is a highly educated man and likes to talk — besides, as I do not aspire to make him a friend, I use what good he has in him in spite of what people may be right in advancing against him. . . .[3]

1. DCB, vol. V, pp. 230–36.
2. Charles-Louis de Secondat, Baron de la Brède et de Montesquieu, *L'Esprit des lois : ou du rapport que les lois doivent avoir avec la constitution de chaque gouvernement, les mœurs, le climat, la religion, le commerce, etc.*, 1st ed. (Geneva, 1748).
3. SAUM, U/1473: Berczy to Charlotte, Quebec, 21 Sept. 1808 (trans. from French).

Cat. 80A
Louise-Élizabeth Marcoux De Bonne 1808

Watercolour and gouache on ivory
6.3 × 5.1 cm
Dr Guy Marcoux, M.D., Beauport, Que.

PROVENANCE: see cat. 81.
REFERENCES: see cat. 81.

was reputed to be loose living, and one affair ended in a notarial settlement. His second marriage was thought by some to be politically motivated, to dispel rumours that he had joined the ruling British "Château clique." Their marriage contract guaranteed Louise-Élizabeth an annual allowance of 3,000 livres in the event of his death, and she was not a beneficiary in his last will.[1] She ended her own life in 1848, while suffering from a severe anxiety attack.[2]

The bird perched on Madame De Bonne's finger is an attribute that Berczy had used in his European portraits; a child in the grand-ducal family portrait (cat. 12) holds a bird, and the de Muralt children (cat. 23) have a pet bird. The round-backed chairs in both De Bonne portraits are of the same style as chairs seen in earlier Berczy portraits. In this pair, the Judge's chair is upholstered in pink, whereas his wife's is blue-green. The background in each oil is painted in a yellow-green. In spite of compositional references to European works, the figures in these two oil portraits show none of the rococo lightness of his earlier – and admittedly smaller scale – paintings; they have acquired a more earth-bound physical presence, a sense of weight and volume.

Considered lost (see LW 86), this miniature, companion piece to cat. 81, was located just as the catalogue was going to press.

Set against a soft grey background, Madame De Bonne – with a light pink dress and deep blue eyes – has a more etherial air than in her portrait in oil.

1. Judge De Bonne's estate went to a distant relative, Marie-Anne Hervieux Hertel de Rouville (cat. 93).
2. DCB, vol. v, pp. 230–36.

Cat. 81
Pierre-Amable De Bonne 1808

Watercolour and gouache on ivory
6.3 × 5 cm
CASE: gilded copper locket; on back is sheaf-of-wheat motif composed of two colours of hair, and flowers of laid-down hair, embellished with seed pearls, on a ground of opalescent glass.
Dr Guy Marcoux, M.D., Beauport, Que.

PROVENANCE: by family descent from Louise-Élizabeth Marcoux De Bonne; her nephew l'abbé André-Amable Marcoux; his brother Louis-Philippe Marcoux; his son Joseph-Désiré Marcoux; his son Adolphe Marcoux; to present owner.
REFERENCES: SAUM, U/1470: Berczy to Charlotte, Quebec, 3 Sept. 1808; U/1473: 21 Sept. 1808; U/1474: 12 Nov. 1808; and U/1475: 23 Nov. 1808. Pierre-Georges Roy, "L'Honorable Pierre-Amable de Bonne," BRH, 10:1 (Jan. 1904), p. 17–19; Pierre-Georges Roy, *Les Juges de la Province de Québec* (Quebec City, 1933), p. 63 and repr. facing.

This miniature painting was commissioned at the same time as the oil portrait (cat. 79). It faithfully reproduces the bust portion of the oil, but with less facial modelling and a slight variation of expression. Berczy was intending to leave this work for his son to complete, and indeed William Bent most probably painted the background and costume.

The dark-coated figure is posed against a grey background that tends to blue. The watercolour flesh tones are delicately rendered in diluted reds, with blue shading. The hair and eyebrows are drawn in strands of watercolour, with touches of gouache. Gouache is also used for the coat, the highlights in the eyes, and to outline details of the white linen.

Cat. 82
Charles Berczy c. 1809

Watercolour with touches of gouache over graphite on
 wove card
10.2 × 9.2 cm
Private collection

PROVENANCE: by descent in Berczy family to present
 owner.
EXHIBITIONS: 1980 Market Gallery.
REFERENCES: Andre 1967, p. 97.

In May 1809 fourteen-year-old Charles Berczy trav-
elled from Montreal to Quebec City to visit his
father and brother, who were then working in the
provincial capital. Charles was put to work sketching
the principal buildings in town. Although his father
was busy finishing the Woolsey family composition
and other commissions, it may well be at this date
that he portrayed his younger son.

In this work, graphite is used to outline the figure
and to shade in parts of the face. The watercolour is
applied in fine short strokes that follow the contours
of the face. The background is also painted in even-
ly hatched strokes that flow diagonally from upper
right towards lower left, except in the area adjoining
the figure, where they follow its outline. The hair is
graphically rendered in sinuous strands. The colour-
ing is subdued and evenly lighted; Charles, wearing
a deep blue jacket, white vest and shirt, is posed
against a grey background. The chair back is painted
in brown gouache, with a grey edging.

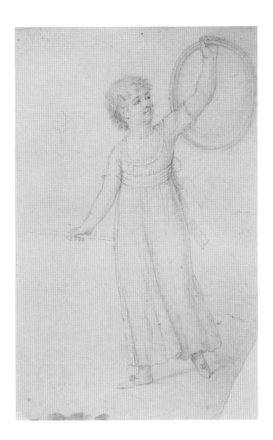

Cat. 83
*Study for "The Woolsey Family":
Eleonora Woolsey* 1808

Graphite on laid paper
30.9 × 19.9 cm (irregular)
WATERMARK: *Elias Y Ca*
National Gallery of Canada 16609

PROVENANCE: by descent in Berczy family to Mary
 Waldron Moore Winter; John Andre; purchased
 NGC, 1970.
EXHIBITIONS: 1977 NGC.
REFERENCES: Andre 1967, p. 95; Trudel 1976, pp. 17, 19;
 NGC 1988, p. 82.

Berczy described his preliminary sketches for the
figures in the Woolsey family portrait (cat. 84) in a
letter to his wife:

*The Woolsey family.... To get on quickly, I have
already done correct outlines of all the figures on paper in
their relative proportions, which I will shade in for stud-
ies after tracing them onto canvas. Many parts, especial-
ly the clothing, I will try to finish first; for having
completed studies in front of me, they will come all the
more spirited and luminous.*[1]

This is one of the transfer drawings to which Berczy
referred, and the only one that has been found. It is
the same size as the figure in the oil painting, and
pressure marks in the paper show evidence of trac-
ing or transferring to another surface. The drawing
is principally an outline study, with the head sec-
tioned into proportions. Here, the child holds a stick
in her right hand, a logical accompaniment to the
hoop; in the oil painting the stick is replaced by a
doll, probably the child's most treasured possession.

Eleonora Woolsey was born on 22 September
1805. She may be the four-year-old girl whom
Berczy said he was painting in June of 1809.[2] She
married Samuel Judge Burton, an officer of the
76th Regiment, in 1822, and died of consumption
on 6 January 1828.

1. SAUM, U/1471: Berczy to Charlotte, Quebec,
 4 Sept. 1808 (trans. from French).
2. SAUM, U/1507: Berczy to Charlotte, Quebec,
 24 June 1809.

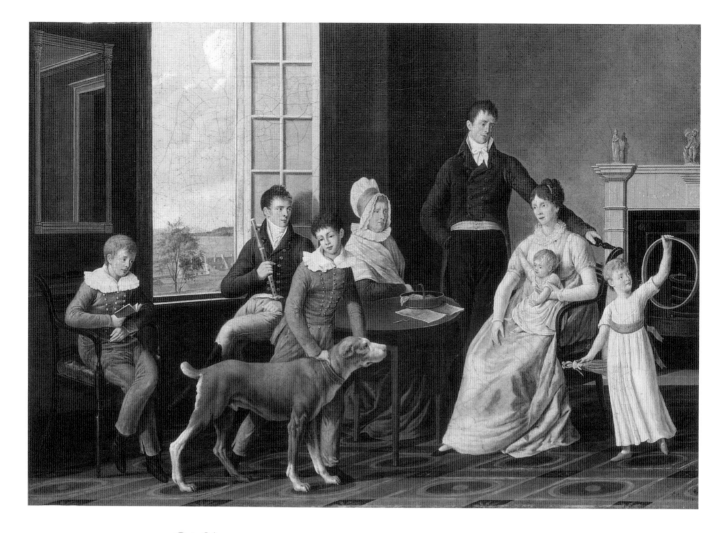

Cat. 84
The Woolsey Family 1809

Oil on canvas

59.9 × 86.5 cm

INSCRIPTIONS: c., on dog's collar, *I.W. WOOLSEY
1809;* Verso: by John William Woolsey in 1848, on
label in ink, *The Family Group represented in this Pic-
ture, was painted in 1809, by Mr Berczy, an amateur, /
assisted by his Son William. The Eight portraits cost Ten
pounds each, the Dog brador was / added without Cost. /
The elderly Lady siting on the opposite of the Table, is the
Grand Mother of the Four Children, her / maiden name
was Josephette Rottot born in 1743, died on the 6th Novem-
ber 1826, buried in Beauport / Church. / Mrs Julie
Lemoine Woolsey, siting with the Child John Bryan on her
Lap was born / the 6th January 1774, married in Mon-
treal to her cousin in the second degree the 19th March 1797,
/ died of a decline tending to a dropsy on the 8th September
1840, buried in Chateau Richer Church. / John William
Woolsey standing near the Chair, on which his spouse is sit-
ing with the / Child on her lap, was born the 26th July
1767. / The four Children are namely, William Darley,*
*seated with a book in his hand, born the 16th / December
1799, died of a pleurisy the 23rd December 1825, was
buried in the Cathedral, within the railing / of the alter in
St Ann's Chapel, being an Eclisiastic. / William Henry
holding the Dog by his collar, born the 20th June 18[02?],
was Drowned bathing in / the River St Charles the 23rd
June 1818, in the absence of his parents, who were gone to
St Denis, to be / present at the nuptials of his Cousin
Sophia Guerout (since dead,) to Narcisse Duchesnay, he
was buried / in the same Church and Chapel as his Broth-
er, beneath the Family pew N 4. / Eleonora with the hoop
and doll in her hands, born the 22nd September 1805, was
married to Samuel / Judge Burton an Officer of the 76th
Regiment in 1822, died on the 6th January 1828, of a con-
sumption at the / Island of Jersey on her way to the South
of France. (Burton died the 10th November 1844.) / John
Bryan born the 25th March 1808, died of a Liver complaint
the 26th October 1846, was buried / in the Ursuline
Church. / Benjamin Lemoine the Childrens Uncle, siting
near the window, holding a Flute in his hand / was born in*

Inscription for *The Woolsey Family*. Photograph taken in 1946 of the note written by John William Woolsey, 1848.

1785. He and J. W. Woolsey, are the only Survivres of this Group on 21st November 1848. / Inherited from my ancestors in Ireland, a Silver Caudle Cup, with a coat of Arms engraven on it, / with an injunction, that it is to decend to the eldest male of the Family in succession. Quebec 1848. JW Woolsey.; on second label, *John W. Woolsey*

National Gallery of Canada 5875
Gift of Major Edgar C. Woolsey, Ottawa, 1952

PROVENANCE: by descent in Woolsey family to Major Edgar C. Woolsey; gift to NGC, 1952.

EXHIBITIONS: 1950 Washington, D.C.; 1953 NGC; 1959 Vancouver; 1966 Vancouver; 1967 NGC; 1968 ROM; 1977 NGC; 1984 ROM.

REFERENCES: RAPQ 1940–41, pp. 1–93 (cf. pp. 41, 46–47, 52, 54, 57, 67, 76, 83, 84); Hubbard 1950, no. 4; NGC 1953, no. 5; Julian Park, *The Culture of Contemporary Canada* (Toronto: The Ryerson Press, c. 1957), p. 118; Morisset 1959, no. 102; NGC 1960, p. 17; Harper 1962, pp. 405–53 (cf. 414); Hubbard 1964, pp. 297–323 (cf. 308); Hubbard/NGC 1964, pp. 52–53; Betcherman 1965, pp. 57–68; Harper 1966, 2nd ed. 1977, pp. 63, 145; Doris Shadbolt, *Images for a Canadian Heritage* (Vancouver: VAG, 1966), no. 17; Andre 1967, pp. 92–94; Harper 1967, pp. 16–22 (cf. 20); Hubbard and Ostiguy 1967, no. 51 (pp. 38–39); Jean Sutherland Boggs, *The National Gallery of Canada* (Toronto: Oxford University Press, 1971), pp. 44, 104–05; Reid 1973, p. 31, pl. v; Barry Lord, *The History of Painting in Canada: Towards a People's Art* (Toronto: NC Press, 1974), pp. 29–31, 84 and fig. 19; Patricia Godsell, *Enjoying Canadian Painting* (Don Mills, Ontario: General Publishing Co. Ltd., 1976), pp. 51–52; Trudel 1976; Peter Mellen, *Landmarks of Canadian Art* (Toronto: McClelland and Stewart, 1978), p. 108, pl. 41; Guy Robert, *La Peinture au Québec, depuis ses origines* (Sainte-Adèle: Icona, 1978), p. 21; Donald Blake Webster, *Georgian Canada: Conflict and Culture 1745– 1820* (Toronto: Royal Ontario Museum), 1984, pp. 162–63, no. 168; NGC 1988, p. 83; David Burnett, *Masterpieces of Canadian Art from the National Gallery of Canada* (Edmonton: Hurtig Publishers, 1990), pp. 18–19.

The "conversation piece" portrait of the Woolsey family (pl. XI) was one of Berczy's most ambitious efforts, on which he spent many months. The commission was evidently one of the principal reasons for his 1808 visit to Quebec City, because although he had not yet met the Woolseys, his letters refer to them from the day of his arrival there; he was introduced and no doubt recommended to them by his friend Judge Pierre-Louis Panet of Montreal, a nephew of Mrs Woolsey.

The head of the family, John William Woolsey (1767–1852), was the son of a Quebec merchant and at this date himself a prosperous merchant, auctioneer, and broker. He is depicted with his wife Julie Lemoine, daughter of a Montreal merchant, his mother, his brother-in-law Benjamin Lemoine (1785–1856), and his four children, whose deaths and places of burial are so touchingly recorded by their father on the reverse of the canvas.

This small oil painting is the only group portrait in an interior setting to be found in the annals of early Canadian art. The "conversation piece" genre was not new to Berczy, and there are obvious parallels and contrasts with his 1782 portrait of the grand-ducal family of Tuscany (cat. 12), as the scene moves from palace to parlour. In the Canadian painting the furnishings are those which would have been found in a merchant-class house in 1808: an Adam-style

mantle, Regency chairs, patterned floor, which in this case is probably a painted floor covering.

The family group is carefully placed and balanced, in a pleasing harmony of form and colour. Nevertheless, they remain curiously isolated from each other and resemble mannequins, each gazing vacantly into space. While this effect of figures poised in space was to be found in late eighteenth-century European conversation pieces,[1] Berczy's method of working may also have contributed to the staged result. The architectural setting was drawn in first, and the graphite lines of this structure are visible in some areas. Each family member was sketched separately, and the figure drawings were then traced onto the canvas (see cat. 83). Once the figures were painted, the background was completed around them; this way of proceeding can be seen in the brushwork, which follows their outlines.

According to his letters, Berczy went over the faces until the very last minute, correcting and re-working. Some faces have suffered paint loss, and others show the muddy retouches of another hand. Graphite drawing, visible on some of the faces, may have once been covered with glazes. A comparison of the painting today with a nineteenth-century photograph of it shows that several of the faces, notably Mr Woolsey's wife and his mother, have suffered a considerable loss of expression – no doubt due to early overcleaning. For a technical analysis and description of this work, see Appendix C.

1. See, for example, *Portrait de famille devant le port de Palerme* (collection: MMFA, 1975-16), attributed to Swiss painter Jacques Sablet; and other works by this artist, discussed by Claudette Hould, "Un tableau de Jacques Sablet au Musée des beaux-arts de Montréal," in RACAR, VI:2 (1979–80), pp. 97–105.

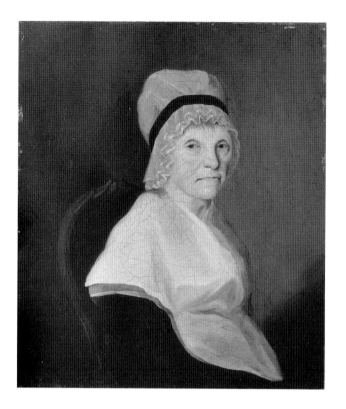

Cat. 85
Charlotte Boucher de La Perrière c. 1809

Oil on canvas
24 × 21.8 cm
INSCRIPTIONS: Verso: on label attached to frame, *Par / le peintre William / Von Moll Berczy;* on second label, *Charlotte B. de LaPerrière, veuve en première / Noces de François Vassal de Monviel, tué au / siège de Québec en 1759, épouse secondes noces de Pierre René De La Bruère, mère de René Bou / cher de La Bruère, grand-mère de Pierre Boucher / de la Bruère et arrière grand-mère de l'Honorable / Boucher de La Bruère, Surintendant de l'Instruction / Publique de la province de Québec.*
Musée Pierre Boucher du Séminaire de Trois-Rivières, Que. L 77 31 P

PROVENANCE: by descent in Boucher family; gift of Montarville Boucher de La Bruère to Monseigneur Albert Tessier, 1934; gift to Séminaire Saint-Joseph, Trois-Rivières, 1973.
EXHIBITIONS: 1986 Musée Pierre Boucher.
REFERENCES: Andre 1967, p. 99; Morisset 1941, p. 85; Morisset 1960, p. 136.

Charlotte Boucher de La Perrière (1737–1820) was the daughter of François Clément de La Perrière and Charlotte Pécaudy. In 1758 she married Germain-François Vassal de Monviel, who was killed at the battle of Quebec in 1759. She married a second time in 1765, René Boucher de La Bruère, her cousin. She died at Quebec, aged eighty-two years.[1]

Trois-Rivières was a stopping place for Berczy on his trip from Quebec City to Montreal in the summer of 1809. He had been asked to portray members of the wealthy Hart family;[2] and while there is no evidence that he did so, such a commission would have been considered worthy of a pause, and would have provided the opportunity of painting a portrait of the elderly Madame Boucher, descendant of founders of Trois-Rivières.

The portrait is small and modest, painted on a fine-weave linen with a very even ground. Although Charlotte Boucher's complexion is smooth for her seventy-two years, the set of her mouth and the bleak expression of the hooded eyes reveal old age. The colour range is limited to flesh tones and very dark greens, greys, and browns, relieved by the white of the costume linens. The Louis XVI-style chair adds a brief reference to an elegant setting.

1. Archives du Séminaire de Trois-Rivières, "Généalogie," pp. 142, 183.
2. SAUM, U/1465: Berczy to Charlotte, Quebec, 18 Aug. 1808.

Cat. 86
Christic on the Cross 1809

Oil on canvas
112.6 × 84.6 cm
Vieux Monastère des Ursulines de Québec

PROVENANCE: commissioned by the Ursulines of Quebec from the artist.
REFERENCES: SAUM, série S, boîte 11445: Berczy to [?], [1809]; *Les Annales des Ursulines de Québec,* vol. 1 (1639–1822), 1809, p. 395; Ursulines de Québec, *Journal des recettes et dépenses* (1803–1820), entry for October 1809; "Inventaire des tableaux des Ursulines de Québec," 1935, no. 81, p. 10. IBC, pp. 9092, 9149; Claude Thibault, *Trésors des communautés religieuses de la ville de Québec* (Musée du Québec, 1973), p. 88.

This Crucifixion scene appears to be the first religious subject undertaken by Berczy in Canada. During his 1808–09 stay in Quebec City, he made numerous visits to the Ursuline Chapel and convent, and was asked to restore their principal altar painting and two portraits. At the same time, he was commissioned to paint a Crucifixion for the refectory, for which he was paid £12.10; the Ursuline annals record that this sum was raised from the sale of handicraft work on birchbark by the young nuns.

Berczy mentions working for the Ursulines in many of his letters to his wife. On 13 April 1809 he refers to an altar frontal that he might paint for them, representing the Descent from the Cross; this has not come to light, and may never have been carried out.[1] On 13 July 1809 he records a discussion about a commission for a small altar painting of the Crucifixion with the Virgin and St. John.[2] No painting of this description has been found, and it is possible that the Ursulines decided on a simplified and less expensive version of the Crucifixion, without additional figures. Berczy left Quebec on 28 July 1809, and completed this painting soon after his return to Montreal. It was already hanging in the refectory by October 1809 when the Ursulines paid

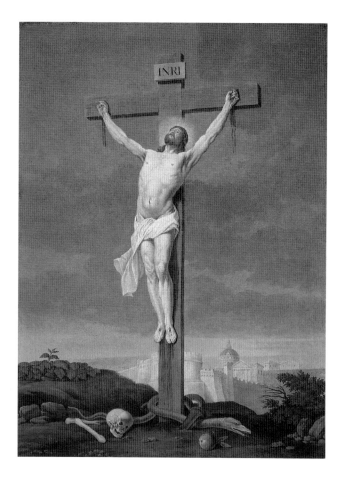

for it. From Montreal, Berczy wrote, "At this time I am sending the picture for your reverend Ladies which some time ago I told you was completed, and which I hope will reach its destination safe and sound. The Captain and the merchant who are sending it at least seem very content to have this great protector on board...."[3]

The present painting was evidently based on a print such as the engraving by S. Thomassin after a painting by François Girardon, which was published by N.-J.-B. Poilly, Paris (collection: Ursulines de Québec).[4] Berczy's composition is not identical to the engravings mentioned – his background buildings, foreground details, and the position of Christ's body all vary. The basic theme, however, of the Crucifixion in the foreground, with a serpent, apple, and sometimes a skull at the base of the cross, and the city of Jerusalem on the horizon, is repeated here from one or more sources.

The contrasting tones and clear-cut demarcation between foreground, backdrop, and figure are typical of Berczy's approach to his compositions. Light and colour are used for dramatic effect, and the dark foreground landscape contrasts sharply with the pink-toned city seen on the distant horizon. Reversing the order of contrasts, the figure of Christ on the foreground plane is brightly lit and cleanly outlined against a dark and dramatic background; dark grey clouds are shot with red, and the sky itself is a dense blue. The architectural elements – city and cross – have been carefully drafted before painting, in contrast to the more freely painted landscape. The detailed foliage and the rocks, which are not very convincing in volume, are also elements that appear in other Berczy paintings.

1. SAUM, U/1496: Berczy to Charlotte, Quebec, 13 April 1809.
2. SAUM, U/1509: Berczy to Charlotte, Quebec, 13 July 1809.
3. SAUM, série S, boîte 11445: undated letterbook draft, probably Montreal, 1809 (trans. from French). As was so often the custom at this period, payment was made in the form of a bill of exchange.
4. See also the Hôtel-Dieu collection, Quebec City, for an engraving of a similar composition. Information courtesy Denis Martin.

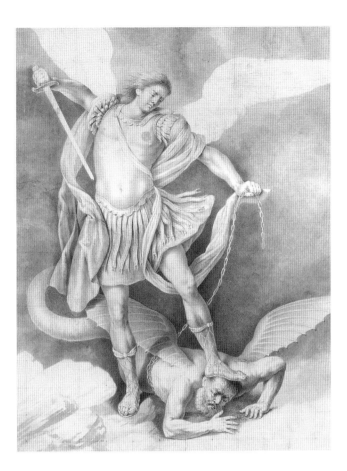

Cat. 87
Study for "The Archangel St. Michael" 1809

Black ink wash with touches of watercolour over graph-
 ite on wove paper, squared for transfer in black chalk
43.2 × 33 cm
Montreal Museum of Fine Arts Dr. 970.242
Purchase, Horsley and Annie Townsend bequest

PROVENANCE: by descent in Berczy family to Louisa A.
 Moore; John Andre; purchased MMFA, 1970.
EXHIBITIONS: 1968 ROM.
REFERENCES: Andre 1967, pp. 94–95, repr. opp. p. 104.

Berczy's preparatory drawing for his large oil of
the same subject (cat. 88) is based on a painting by
Guido Reni, probably as reproduced in an engrav-
ing. The drawing is squared for the transfer of the
subject to a larger scale.

 In this study, most of the emphasis has been given
to the delineation of contours. The pale red wash is
applied in brushpoint, to outline the composition
and to indicate details. Grey wash is applied in short
hatched strokes for shading, which defines muscula-
ture and texture. The general tonal effect is similar
to the oil painting – a lighter figure outlined against
a cloudy background.

Cat. 88
The Archangel St. Michael 1810

Oil on linen canvas
287 × 252.7 cm
INSCRIPTIONS: stamped on verso of canvas, *J [E or B]*
MUDIE / S…. MAST[ER?]; and figure of eagle or
phoenix.
Church of Saint-Michel de Vaudreuil, Que.

PROVENANCE: commissioned for the Church of Saint-
Michel de Vaudreuil from the artist.
REFERENCES: SAUM, U/1497: Berczy to Charlotte,
Quebec, May 1809; and U/1498: 7 May 1809;
Archives de la fabrique Saint-Michel de Vaudreuil,
Livres de comptes et délibérations, vol. 1, pp. 57, 167,
171. Viger 1850, p. 2; Maheux 1939, pp. 881–82;
Morisset 1941, p. 85; Adair 1943, pp. 38–49; Andre
1967, pp. 94–95, repr. after p. 104; Noppen 1977,
pp. 280–82.

In the spring of 1809, William Berczy was corre-
sponding with the parish priest of Saint-Michel de
Vaudreuil, who wished to commission a large altar
painting (pl. XIV) of their patron saint.[1] Berczy's
name had probably been recommended by the
seigneur of Vaudreuil, Michel-Eustache-Gaspard-
Alain Chartier de Lotbinière, who had posed for a
portrait that same spring (LW 93). The artist was still
in Quebec City, but began to plan for the execution
of the large canvas on his return to Montreal, and
wrote to his wife about studio space:

*I am very relieved that your attic is nine feet high, since
this will be enough to enable me to paint the eleven-foot*

picture if I come to an agreement with the Curé who is asking me for it. And in that case, I could always work on this picture from sunrise until towards three o'clock in the afternoon, since the windows face the sunset; and with my rollers, I will arrange suitable scaffolding readily and at little cost....[2]

On 21 May 1809 the parish council voted in favour of the commission, and allotted 1,200 livres (£50) for the painting, as well as 165 livres for its framing. The painting was probably completed by 18 March 1810, when the parish council voted again on a frame, this time at a cost of 350 "chelins anciens," for the adornment of the newly acquired work of art.[3]

The subject of St. Michael triumphing over Satan is taken from a well-known painting by Guido Reni, which is in the Church of Santa Maria de la Concezione in Rome. Although Berczy may well have seen the painting when he visited Rome, his model in Canada would have been a reproductive engraving of the subject.[4] While following the Italian model closely, he has also changed the mood of the painting. In comparison with Reni's gracefully mannered angel, Berczy has portrayed a lean, muscled, and frowning figure – a militant St. Michael; also in comparison, Berczy's rendering is simplified in the foreshortening of Satan's figure, and the drapery appears to be flatter.

The present oil painting differs in some respects from Berczy's preparatory drawing (cat. 87), notably in the depiction of the demon. Here, the demon's face is quite satanic, whereas in the drawing it is that of a suffering old man; and Satan's bat wings are more detailed in the drawing.

Although working on a very large canvas, Berczy painted the subject in his most subtle manner. Flesh tones are shaded in grey, green, and blue to describe musculature, and every feather of the saint's wings is carefully described. The clouds are smokey grey, variously hued by underpainting in red or yellow, and with a darker central background to create depth around the figure of the archangel. The rocks are stage props, as they are in other Berczy canvases.

The large linen canvas is composed of three pieces which are joined vertically. The artist's underlying drawing of a grid, for transfer of the composition, is visible in some places. During the conservation of this painting, it became apparent that its framing had been modified at some unknown date, and that its format had been changed at the top from an arched shape to a rectangle.

1. SAUM, U/1497: Berczy to Charlotte, Quebec, May 1809.
2. SAUM, U/1498: Berczy to Charlotte, Quebec, 7 May 1809.
3. Archives de la fabrique Saint-Michel de Vaudreuil, *Livres de comptes et délibérations,* vol. 1, pp. 57, 167, 171.
4. See for example the engraving by P. de Ballin, reproduced in Ludwig Schudt, *Italienreisen im 17. und 18. Jahrhundert* (Munich: Schroll-Verlag, 1959), p. 374.

Cat. 89
Elevation for a Façade c. 1809–10

Pen and black ink with grey wash on wove paper
Drawing cut into three ovals, each 12.5 × 14.4 cm
Private collection
Not in exhibition

PROVENANCE: by descent in Berczy family.

The surviving portion of this architectural drawing
corresponds in many respects to the façade that was
applied to Notre-Dame church in Montreal, during
interior and exterior renovations which began in
1809. However, it differs considerably at the ground
level, which suggests either that it was for another
building altogether, or that Berczy discarded this
idea for Notre-Dame's façade in favour of a vari-
ant design. The drawing was found cut into three
oval pieces and used as a backing, glued to Berczy's
c. 1808 portrait of his son William (cat. 78).

 In 1809, Berczy was negotiating with the parish
council of Notre-Dame about a painting for the
cupola (cat. 91). At this period, extensive redecora-
tion of the interior of the church was being planned,

32.
Notre-Dame Church, Montreal, 1827,
by John Poad Drake.
Collection: Archives du Séminaire de Québec,
Album Verreau.

and in 1811–12 a new Palladian-style façade was ap-
plied to the front of the building.[1] Berczy was al-
ready known for his classical design for the Anglican
church in Montreal (cat. 62), and it is not surprising
that he might have been asked to submit a design in
this latest fashion for Notre-Dame. An 1824 archival
reference records that Louis Charland supplied a
drawing for the façade; it is possible that as surveyor
of roads for Montreal, he asked Berczy to create the
design.[2] An 1827 watercolour by John Poad Drake
(fig. 32) shows the façade as it existed from 1812
until the demolition of the old parish church in 1830.

1. Noppen 1977, p. 41; Toker 1970, p. 9.
2. Archives de la fabrique Notre-Dame, Montréal,
 Livre des délibérations…, boîte 23, chemise 6: letter
 from Mme Louis Charland to the parish council,
 14 April 1824. For a discussion regarding the author-
 ship of the design for the façade, see Laberge 1982,
 pp. 183–85.

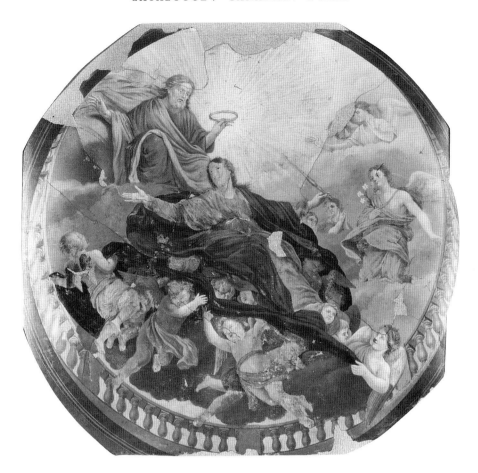

Cat. 90
Study for "The Triumph of the Virgin"
1809–10

Oil over graphite on paper
54 cm diam. (irregular circle)
Royal Ontario Museum, Toronto 968.298.6
Sigmund Samuel Trust

PROVENANCE: by descent in Berczy family to Louisa A.
 Moore; John Andre; ROM, 1968.
EXHIBITIONS: 1968 ROM; 1980 Market Gallery.
REFERENCES: Archives de la fabrique Notre-Dame,
 Montréal, boîte 23, chemise 2: letter of 27 Nov.
 1809; and *Livre des délibérations...*, vol. B (1778–
 1833), p. 190: "Assemblée des marguilliers," 18 Mar.
 1810; NA, MG23, H II 6, vol. 4, p. 832: Berczy to
 [?], [c. 1809–10]. Viger 1850, p. 22; Maurault 1920,
 vol. VI, p. 250; Maurault 1957, p. 21; Andre 1967,
 pp. 94, 96; Toker 1970, p. 91; Laberge 1982, pp. 166,
 168–70.

This oil sketch was painted in preparation for the
large composition that Berczy finished for the cupo-
la of Notre-Dame church in Montreal (cat. 91). It is
based on a seventeenth-century painting by Charles
Le Brun, executed for the chapel of the Seminary of
St-Sulpice in Paris, showing the Assumption and
crowning of Mary, and titled *The Triumph of the
Virgin*. The Sulpicians of Montreal, who were in
charge of Notre-Dame church, would have supplied
Berczy with the 1698 engraving by "L. Simonneau
Junior" (fig. 33), after Le Brun's composition.[1] In
copying the composition, Berczy reduced the num-
ber of figures and introduced some of the angels in
the lower foreground from other sources or from his
own invention. In place of Le Brun's semicircle of
saints, he used the architectural device of a balus-
trade to reduce the rectangular composition to a cir-
cular format.

33.
The Assumption of the Virgin, 1698,
by L. Simonneau after Charles Le Brun.
Collection: British Museum, London.

The sketch, which is only partly toned in colour and grisaille, reveals the artist's method of building up his compositions. Each figure is carefully drawn in outline, and placed against a background of balustrade and sky. The drawing is in brushpoint, with graphite used for the architectural elements. The absence of pentimenti suggests that this painting is based on other preparatory sketches, and that it may be the presentation design that Berczy showed to the parish council.

1. An impression of this print, titled *L'Assomption de la Vierge,* is in the collection of Le Vieux Séminaire de Montréal, adjacent to Notre-Dame church and also administered by the Sulpician order. [IBC, Cote A-151, neg. no. 78-607-35/28-30.]

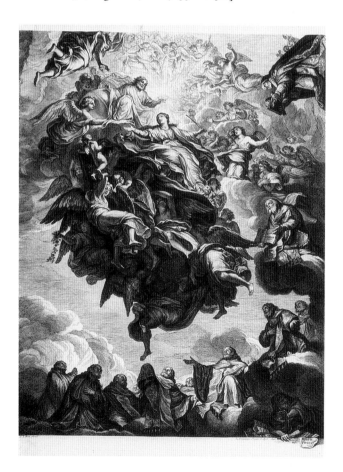

Cat. 91
The Triumph of the Virgin 1810

Oil on canvas
Approx. 4 m diam.
Church of Notre-Dame de Montréal
Not in exhibition

PROVENANCE: commissioned by the church of Notre-Dame de Montréal from the artist.

REFERENCES: Archives de la fabrique Notre-Dame, Montréal, boîte 23, chemise 2: letter of 27 Nov. 1809; and *Livre des délibérations...,* vol. B (1778–1833), p. 190: "Assemblée des marguilliers," 18 Mar. 1810. Viger 1850, p. 22; Maurault 1920, vol. VI, p. 250; Maheux 1939, p. 882; Morisset 1941, p. 85; Maurault 1957, p. 21; Andre 1967, pp. 94, 96; Toker 1970, p. 91; Laberge 1982, pp. 166, 168–70.

In late November of 1809, Berczy wrote to Jean-Philippe Leprohon of the parish council of Notre-Dame de Montréal regarding a painting for the cupola of the church:

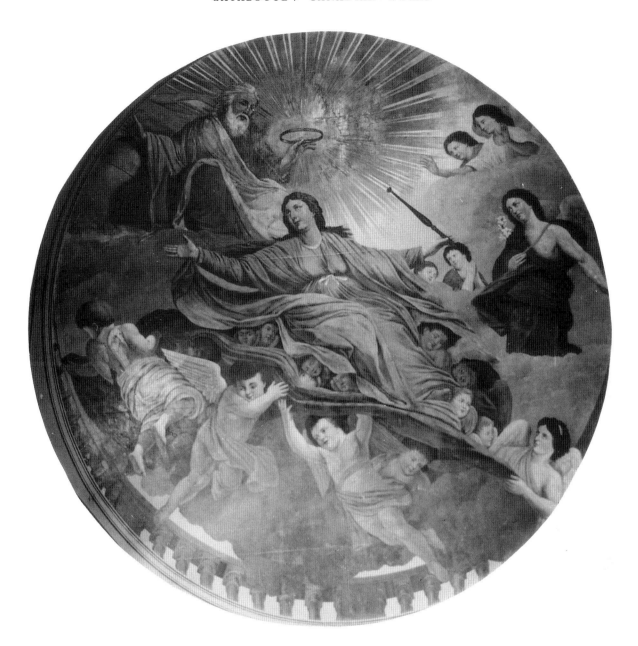

On mature reflection, I have decided to do the picture representing the Assumption[1] of the Holy Virgin for the parish of this city at the price of one hundred and twenty Louis; or as I had the honour of telling you yesterday, one hundred and five Louis, a piece of the best Russian canvas of the strongest quality, a good place to work with a stove and the wood needed to keep it warm enough. For my part, I promise to put as many figures in this painting as the space in the picture and the distance from the onlooker's Eye will allow, being prepared for my own satisfaction to do everything possible to make this picture as valuable as my talent can produce.

If the parish council decides to conclude with me on the above-mentioned conditions it would be good to reach a determination as soon as possible so that I can make the necessary preparations without delay, such as preparing the canvas and doing the studies, so that the picture is in condition to be put in place in the month of July next....[2]

The council approved the proposed work by Berczy on 18 March 1810.[3]

This commission was part of an ambitious plan of interior refurbishing of the old church initiated in

1808, with carvings by Louis-Amable Quévillon, and decorative embellishments designed by painter Louis Dulongpré.[4] It is possible that Berczy also created some of the interior design.[5] In 1819, Thomas Doige described the circular ceiling painting as having full-sized figures.[6] Edward Allen Talbot commented on the powerful effect created by this work of art, which he said inspired a spiritual reverence; however, he attributed this to the placement of the painting rather than to the work itself.[7] When the church was replaced by a new building in the 1820s, the Triumph was transferred to the parish church at Longueuil; in 1928 it was returned to Notre-Dame and placed in the ceiling of the sacristy.[8] It remained there until damaged in the fire of 1978; it is now in storage.

1. Berczy (and subsequent writers) usually referred to *The Triumph of the Virgin* as the "Assumption," most probably because this was the title of the engraving that the artist copied (see cat. 90).
2. Archives de la fabrique Notre-Dame, Montréal, *Livre des délibérations...*, boîte 23, chemise 2: Berczy to Jean-Philippe Leprohon, Montreal, 27 Nov. 1809 (trans. from French).
3. Archives de la fabrique Notre-Dame, Montréal, *Livre des délibérations...*, vol. B, p. 190: "Assemblée des marguilliers," 18 Mar. 1810.
4. Maurault 1957, p. 21.
5. See Laberge 1982, pp. 178–80.
6. Thomas Doige, *An Alphabetical List of the Merchants, Traders, and Housekeepers, residing in Montreal. To which is prefixed, a descriptive sketch of the Town* (Montreal: James Lane, 1819), p. 14.
7. Edward Allen Talbot, *Five years' residence in the Canadas: including A Tour through Part of the United States of America, in the year 1823* (London: Printed for Longman, Hurst, Brown and Green, 1824), pp. 67–68.
8. Maurault 1957, p. 90.

Cat. 92
Jean-Baptiste-Melchior Hertel de Rouville
c. 1810

Oil on canvas
62.5 × 49 cm
McCord Museum of Canadian History, Montreal
M966.62.3

PROVENANCE: by descent in the Hertel de Rouville family; Mme Claire Bertrand; purchased McCord Museum, 1966.
EXHIBITIONS: 1887 Montreal; 1892 Montreal; 1966 Vancouver; 1967 MMFA; 1987 McCord.
REFERENCES: Montreal 1887, p. 12, no. 195; Montreal 1892, p. 31, no. 457; Harper 1966, pp. 74, 78; Doris Shadbolt, *Images for a Canadian Heritage* (Vancouver: VAG, 1966), no. 19; Andre 1967, pp. 65, 95; Harper 1967, pp. 16–21.

Jean-Baptiste-Melchior Hertel de Rouville (1748–1817), son of René-Ovide Hertel de Rouville, was the third seigneur of Rouville. He also owned part of the seigneury of Chambly. He entered the

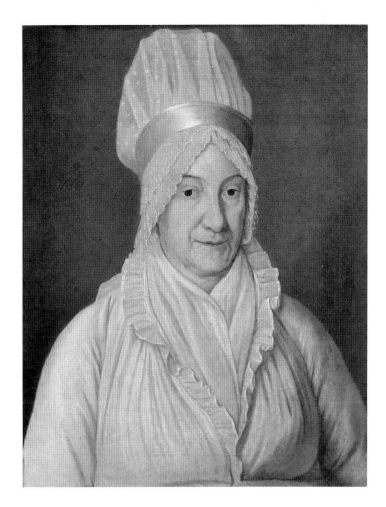

French forces as an ensign in 1760 and went to France shortly after 1763. He returned to Canada in 1772 and became a supporter of the new régime. In 1792 he became a member of the first House of Assembly of Lower Canada, and in 1812 a justice of the peace for the district of Quebec, Montreal, and Trois-Rivières.[1] About 1810, he made a gift to the church on his Rouville seigneury of a magnificent altar painting of St. John the Baptist, the work of William Berczy (LW 99). It seems reasonable to assume that he would have commissioned portraits of himself and his wife from the same artist at this time.

In this portrait, Berczy has moved closer to his subject, and the head occupies more canvas space. Outlines and facial features are precisely delineated; however, some of the harsher outlines, such as the dark brown shading from the ear down to the chin, have been reinforced by a later hand. The careful balancing of colours is typical of Berczy: pale putty tone for the background at the right, as well as for eyebrows and hair; deeper grey-green backdrop at the left echoing the shading used in face; the blue eyes and blue coat – everything is in a subtle harmony.[2]

1. DCB, vol. v, pp. 421–22.
2. For naïve but interesting replicas of the Rouville portraits, see record photographs of IBC, A-2, 02504 and A-5, 02508.

Cat. 93
Marie-Anne Hervieux Hertel de Rouville
c. 1810

Oil on canvas
62 × 49 cm
McCord Museum of Canadian History, Montreal
 M966.62.4

PROVENANCE: by descent in the Hertel de Rouville family; Mme Claire Bertrand; purchased McCord Museum, 1966.
EXHIBITIONS: 1887 Montreal; 1892 Montreal; 1966 Vancouver; 1987 McCord.
REFERENCES: Montreal 1887, p. 13, no. 192; Montreal 1892, p. 31, no. 458; Harper 1966, p. 78; Doris Shadbolt, *Images for a Canadian Heritage* (Vancouver: VAG, 1966), no. 18; Andre 1967, pp. 65, 95; Harper 1967, pp. 16–21.

Marie-Anne Hervieux (d. 1819) was the daughter of Jean-Baptiste Hervieux, a Montreal merchant. In 1784 she married J.-B.-M. Hertel de Rouville, and was well enough endowed to be accorded separate property in the marriage contract.

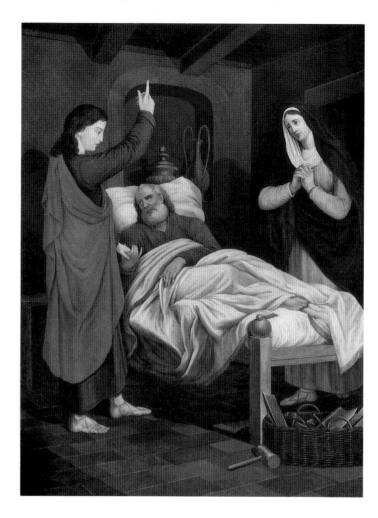

Cat. 94
The Death of St. Joseph 1810–11

Oil on canvas
141 × 105.7 cm
Church of Notre-Dame de la Visitation, Champlain, Que.

REFERENCES: SAUM, U/4224; série S, boîte 11445; Archives de la fabrique Notre-Dame de la Visitation, Champlain, *Comptes de la fabrique,* vol. 24, pp. 70, 75; NA, MG23, H II 6, vol. 4, p. 832. Viger 1850, p. 22 (Viger's marginal note: BMM, Gagnon Collection); *Histoire de la Paroisse de Champlain* (Quebec City, 1890), vol. 2, pp. 291, 295; Morisset 1941, p. 85.

This portrait is a study in greys and whites, understated and subtle in its colour range. The ribbon in the coiffe reflects a silver light, and Marie-Anne's dark eyes command attention. The pursed lips and the expression of a restrained smile is reminiscent of Berczy's portrait of Signora Federici (cat. 37). As a pair with her husband's image (cat. 92), Madame Hertel de Rouville is paler and cooler in tone. The curved shadow cast in the lower-right background is a convention that is repeated in many Berczy portraits. The underdrawing is visible in some places; the coiffe is outlined in grey-blue brushpoint. A naïve replica of this portrait shows that the Berczy canvas has been slightly trimmed at the top and bottom.[1]

1. The replica is an oil painting photographed many years ago by Gérard Morisset for the IBC, see neg. FM 2508, A-5. Present location of copy unknown.

In his letterbook record of his journey from Quebec City to Montreal, William Berczy described his meeting with Father P. Vézina, the curé of Champlain parish, on 31 July 1809 at nearby Cap-de-la-Madeleine:

My intention was to stop at the half-way point with Mr. Vesina, the Curé of Champlain, who some time ago asked me for an altarpiece ... Mr. Vesina adds much to our Company ... He is a very handsome man, who has good taste and accordingly would wish to commit his parishioners of Champlain to spare nothing to have a fine picture, but he sincerely confided to me that his parish was not rich. As a result I promised to make my work partly a work of charity, and I am persuaded to this largely in order to finally get a start with the parish Churches, since if once, one or two of them have good pictures, many others will want to have the same so as not to be outdone. – He will assemble his people and will write me what he has been able to do with them; he wishes and hopes to make them understand that there is a great difference between a 'barbouillage' and a painting, especially as they have already shown a strong desire to have a picture by my hand. We shall soon see what comes of this.[1]

In an undated letter from Montreal, probably written in late 1809 or early 1810, Berczy reported that his painting of the Death of St. Joseph was well advanced.[2] The subject of the painting was also referred to by Berczy's friend Lewis Foy in a letter to Berczy of 12 November 1810, and one would assume that the painting was in place by that time.[3] The parish records list the payment for the painting under general expenses for 1811, but the specific date of payment is not indicated.

For his work, Berczy was paid 180 livres, which translates into £7.10 sterling. A comparison of fees paid for his religious paintings shows that he did indeed make his *Death of St. Joseph* as a work of charity – it no doubt served as a promotion piece, too – as it was by far the lowest priced of his church paintings. The carved wood frame by François Normand cost the parish 72 livres, or £3 sterling.

The subject of the Death of St. Joseph was current during the seventeenth and eighteenth centuries in Europe. Berczy may have combined elements from more than one source; his central composition showing the dying man lying on a couch, attended by Jesus and Mary, is found in numerous paintings. The recumbent figure of Joseph is adapted from the much copied *Death of St. Joseph* by Marcantonio Franceschini.[4] Paintings on this theme were to be seen in Quebec; the Hôtel-Dieu owned two versions from an early date.[5] Berczy's interior setting is not the usual background found in paintings of this subject.

Before conservation the painting was in deteriorated condition, having been both overcleaned and overpainted. The face of Jesus was heavily touched up, and the head of St. Joseph had lost much of its surface paint. However, the Virgin's face was evidently not retouched and showed Berczy's original brushwork. Graphite underdrawing is visible in Mary's face and hands, in the bedpost and rails, and in vertical reference lines.

1. SAUM, série S, boîte 11445: draft letter from Berczy to Charlotte, Trois-Rivières, 31 July 1809 (trans. from French). Father P. Vézina was curate at Champlain from 1 Nov. 1806 until his death on 20 Oct. 1814.
2. NA, MG23, H II 6, vol. 4, p. 832.
3. SAUM, U/4224: Lewis Foy to Berczy, Quebec, 12 Nov. 1810.
4. *The Death of St. Joseph,* c. 1686, by Marcantonio Franceschini (1648–1729), is in the Church of Corpus Domini, Bologna.
5. See Marie-Nicole Boisclair, no. 20 (acquired by the Hôtel-Dieu in 1694), and no. 45 (copied after Franceschini, reversed composition).

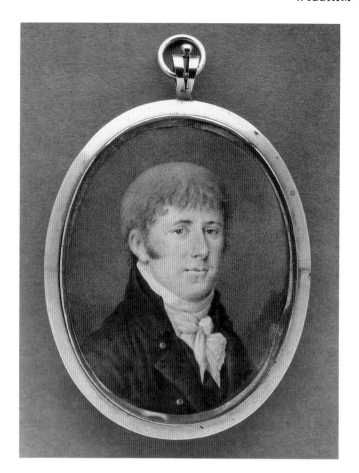

Cat. 95
Roderick Mackenzie 1811

Watercolour and gouache on paper
6.4 × 5.2 cm (image, sight)
CASE: gilded copper locket, with reverse bezel framing a
 braided hair ornament; and a smaller bezel framing
 gold filigree and seed-pearl monogram, *RMcK* on a
 backing of blue glass. Engraved inscription on
 reverse rim of locket, *Some smile on me and all the*
 while / It is on you they wish to smile / And wish they
 were what they can't be / The golden chain that holds up
 me.
M. François Rimaud, Paris

PROVENANCE: from sitter to his daughter Marie-Rachel
 Mackenzie Bruyère; her son Ernest Bruyère; his
 daughter Renée Bruyère Rimaud; her son François
 Rimaud.
REFERENCES: SAUM, U/1516: Berczy to Roderick
 McKenzie, Montreal, 21 Nov. 1811.

Roderick Mackenzie (c. 1761–1844) (frequently
written "McKenzie") was a fur trader, author, and
politician. He was a first cousin of Sir Alexander
Mackenzie, the explorer; three of his brothers were
fur traders, as was his father-in-law, Charles-Jean-
Baptiste Chaboillez, his brother-in-law Charles
Chaboillez, and his relative by marriage Simon
McTavish. In 1801 he retired from active participa-
tion in the fur trade, and in 1804 he settled in Terre-
bonne near Montreal. He spent considerable energy
collecting historic material on the fur trade.[1]

In October of 1811, William Berczy visited
Mackenzie in Terrebonne, while gathering data on
the seigneuries in that area for his history of Cana-
da.[2] The following month he wrote to Mackenzie
from Montreal, thanking him for his help, asking
further questions about Terrebonne, and referring
to a miniature that fits the description of this por-
trait: "I found a man for engraving the few lines
upon your miniatur for which he asked two Dollars
on finding this demand not out of the way I agreed
to it. If Mr. H:M: whom I saw this morning goes

not away before this engraving and the few alteration which I wish to make about the hair, are finished I will give it to him...."[3] The miniature portrait painted at Terrebonne would have been brought to Montreal for suitable framing and maybe also for finishing of the image. The engraved dedication on the locket refers to the person who was to wear it, no doubt Mackenzie's young wife Marie-Louise-Rachel Chaboillez, whom he had married in 1803 when she was seventeen years old.[4]

Mackenzie would have been fifty years old at the time of this portrayal; Berczy's talent for emphasizing the most attractive features of his subjects, while retaining a faithful likeness, is evident here. Signs of age are indicated by the subtle crease marks around the eyes, but otherwise the man portrayed is shown in the full vigour of youth. The bust-length figure is set against a grey-green background, which deepens to grey-brown at the lower left and right. The coat

is a dull black-grey, and the stock, white. Mackenzie has grey eyes, and the strands of hair are picked out in brown against a cream-grey underlayer. The delicate gradations of colour, the short hatched strokes over a washed ground, and the use of gouache are all stylistic traits found in slightly larger portraits on paper by Berczy.

1. DCB, vol. VII, pp. 565–67.
2. ASQ, Fonds Viger-Verreau, Saberdache bleue, vol. 2, p. 65: Berczy to J. Viger, Montreal, 28 October 1811. Berczy describes his trip to the seigneuries of St-Sulpice, l'Assomption, La Chenaie, and Terrebonne between 12 and 27 Oct. 1811, for the purpose of gathering statistics for his manuscript history of Canada.
3. SAUM, U/1516: Berczy to R. McKenzie, Montreal, 21 Nov. 1811.
4. A photograph has survived of a miniature portrait of Marie-Louise-Rachel Chaboillez, but the original has not been located.

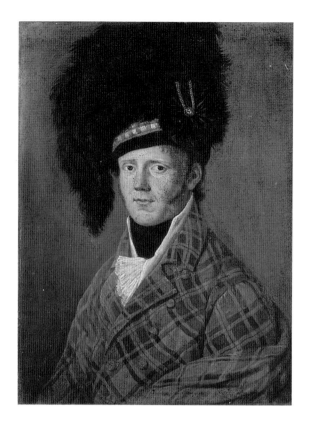

Cat. 96
John Mackenzie 1811

Oil on paper, mounted on card
31.7 × 24 cm
Mme Luce Mercille Léger

PROVENANCE: from sitter to his daughter Marie-
Catherine Mackenzie Mercille; her son Robert
Mercille; his daughter Isabelle Mercille Racine; her
niece Luce Mercille Léger.

John Mackenzie (pl. XV) (also spelled McKenzie)
was the son of Roderick Mackenzie and his first
wife, a native woman from the Lake Athabaska area
of western Canada. This union lasted from 1788 to
1801 and three children were born, a son and two
daughters. When Roderick returned to the east
about 1801, he brought his son to live with him at
Terrebonne. John was listed as a lieutenant in the
Canadian Fencibles, on half-pay from 1816. He
married about 1823–24, and for many years was
postmaster at Terrebonne. He died in 1871.

Berczy has depicted a fair young man with blue
eyes and shaggy eyebrows that are almost white. The
picturesque Scottish costume inspired him to use
expressive brushwork; the tartan jacket and shawl
are of dark green and very clear red, and the feath-
er bonnet is in black with green highlights. The
background is a uniform olive-green.

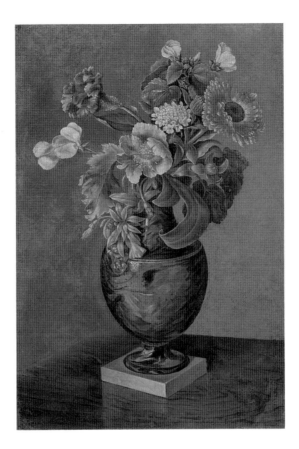

Cat. 97
Flowers in a Creamware Vase n.d.

Oil on leather, mounted on card
34.5 × 23.6 cm
INSCRIPTIONS: Verso: in older hand in ink, *Int.;* partly
 erased, *…czy / …R.M. Moore.*
John Laurel Russell

PROVENANCE: by descent in Berczy family to Louisa
 Berczy Moore; her son Edward Alfred Moore; his
 sister-in-law Elizabeth Waldron; John Andre; John
 Laurel Russell.
EXHIBITIONS: 1968 ROM; 1980 Market Gallery, as
 "Flowers, c. 1805".
REFERENCES: Andre 1967, p. 93, note 356.

Two flower paintings (see also cat. 98) are the only
still-life subjects found among surviving works by
Berczy. They are difficult to date, as they echo sev-
enteenth- and eighteenth-century flower paintings,
with the subject placed at the front of the picture
plane.

In style these two paintings are consistent with
Berczy's other oils; here he has used a leather-
covered papercard book cover as the support, and
applied a beige priming layer and a blue-grey
imprimatura. The image is painted in thin layers
of opaque colours in smooth strokes, with some
impasto in the highlights. Outlines are clean and
hard for the wood-grained table and the creamware-
type vase. The flowers are painted in tones of rose,
orange, yellow, and blue, with yellow-green and
blue-green foliage. The background is a muted
grey-brown.

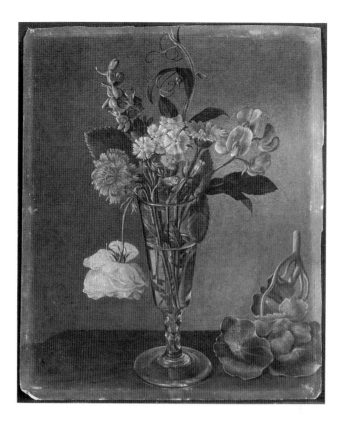

Cat. 98
Still-life with Flowers n.d.

Oil on papercard panel
28 × 23 cm
INSCRIPTIONS: Verso: in pencil, *Wm. de Berczy / R M Moore;* and some measurements.
Montreal Museum of Fine Arts 970.1647
Purchase, Horsley and Annie Townsend bequest

PROVENANCE: by descent in Berczy family to Louisa Berczy Moore; her son Edward Alfred Moore; his sister-in-law Elizabeth Waldron; John Andre; purchased MMFA, 1970.
EXHIBITIONS: 1968 ROM; 1980 Market Gallery.
REFERENCES: Andre 1967, p. 93, note 356; Paul Dumas, "La peinture canadienne d'hier dans les collections du Musée des beaux-arts de Montréal," in *Vie des Arts,* XX:82 (1976), repr. p. 32, no. 2.

This still-life composition is painted on a laminated card, which is probably a book cover. In subject, style, and size, it forms a pair with catalogue 97. Although Berczy is not known to have painted oth- er still-life subjects, he depicted flowers in a glass vase in his portrait of the Archduchess of Tuscany of 1782–87 (cat. 13), and a spray of summer flowers in the 1803–04 watercolour of Phoebe Willcocks (cat. 60).

The flowers in this painting represent varieties that would have been available in the early nine- teenth century, including a pink rose, a carnation, a cluster of pinks or sweet william, and a stalk of lark- spur to the left, a tendril of sweet pea at the top and a cluster at the right, beside it a calendula blossom with a bud. A nasturtium lies on the table.

LOST WORKS
1767–1791

by Beate Stock

LW 1
Portrait of a Man 1767

Miniature on ivory, medium unknown
4 × 3.2 cm (oval)
INSCRIPTIONS: Verso: *Eq. de Moll pinx, Jenae 1767*
REFERENCES: *Katalog der Jubiläums Ausstellung des Mannheimer Altertumsverein* (Mannheim: Verlag des Mannheimer Altertumsvereins, 1909), p. 45, no. 353; Ernst Lemberger, *Die Bildnisminiatur in Deutschland von 1550 bis 1850* (Munich: F. Bruckmann A.G., 1910), p. 216; *Sammlung H. Leonhard, Mannheim: II Teil, Kunstgewerbe* (Munich: Galerie Helbing, 1910), p. 112, no. 1755.

A miniature from Berczy's student days at the University of Jena. The description in the Helbing catalogue reads, "Head and shoulders *en face* [full face]. In red jacket and yellow waistcoat." However, it is possible the miniature could have been by the artist's brother, Bernhard Albrecht Moll, who was also at Jena in 1767.

LW 2
Landscape Drawings c. 1766–70

Medium unknown
REFERENCES: SAUM, S/19, boîte 11442: "Lettres sur la Pologne," second letter, pp. 8ff.

During his stay at the University of Jena, Berczy visited Berlin, where his drawings of Berlin landscapes attracted the attention of the Polish Countess Walewska.

LW 3
Samuel Rudolf Frisching 1780

Medium unknown
REFERENCES: KIF, Berczy to Gruner, St. Blaise, 1 Nov. 1780, p. 171; and Florence, 22 Jan. 1781, p. 210. Hermann von Fischer, "Anna Charlotte Fischer née Fischer d'Oberried," in *Stettler*, p. 232.

On his way from Bern to Florence in the autumn of 1780, Berczy visited not only Gottlieb Fischer in Oberried near Belp but also another patrician, Samuel Rudolf Frisching von Rümlingen (1746–1809), in St. Blaise on the shore of the Lake of Neuchâtel. Perhaps Frisching intended his portrait to be a farewell gift to his family, for a few weeks after Berczy's departure he deserted his wife and children and ran off with Catherina, the wife of Gottlieb Fischer.

LW 4
Putti 1780

Miniature, medium unknown
REFERENCES: AGF, f. xv (1780) n. 154/57.

Berczy had asked for permission to copy in miniature a painting of some putti by Adriaen van der Werff (1659–1722). The putti were most likely a detail of van der Werff's *Adoration of the Shepherds* [Uffizi 1979, P1778].

LW 5
Peter Paul Rubens 1781

Gouache
REFERENCES: AGF, f. xiv (1781) a 96; KIF, Berczy to Gruner, Florence, 27 May 1781, p. 282; 4 June 1781, p. 285; and 9 July 1781, p. 308.

There are two self-portraits of Rubens in the Uffizi. A comparison of Berczy's own *Self-portrait with Hat* (cat. 29) with the Rubens works suggests he copied Rubens's self-portrait with hat [Uffizi 1979, A793]. Monsieur Manuel of Bern acquired the copy for six louis.

LW 6
Anthony van Dyck 1781

Gouache
REFERENCES: see LW 5.

Copy after van Dyck's self-portrait [Uffizi 1979, A973]. The copy was bought by Monsieur Manuel of Bern for six louis.

LW 7
Rembrandt van Rijn 1781

Medium unknown
REFERENCES: AGF, f. xiv (1781) a 96.

Copy after one of Rembrandt's self-portraits in the Uffizi.

LW 8
Nicolas de Largillière 1781

Medium unknown
REFERENCES: AGF, f. xiv (1781) a 96.

Copy after a self-portrait by Nicolas de Largillière (1656–1746) [Uffizi 1979, A510].

LW 9
Michelangelo da Caravaggio 1781

Medium unknown
REFERENCES: AGF, f. xiv (1781) a 96.

At the time Berczy copied it, the painting was thought to be a self-portrait of Michelangelo da Caravaggio (1573–1610). In the Uffizi catalogue, it is listed as unattributed and as the portrait of an unknown man [Uffizi 1979, A841bis].

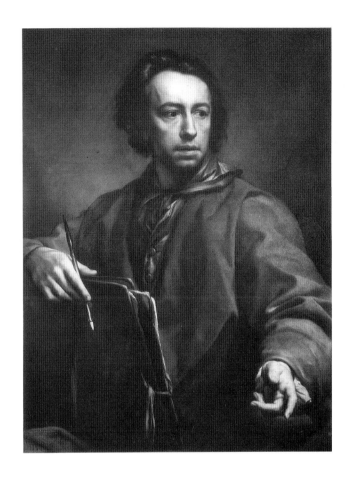

LW 10
Annibale Carracci 1781

Medium unknown
REFERENCES: AGF, f. XIV (1781) a 96.

There are two self-portraits of Annibale Carracci (1569–1609) in the Uffizi; it is not known which one Berczy copied.

LW 11
Johann Zoffany 1781

Medium unknown
REFERENCES: AGF, f. XIV (1781) a 96.

Copy after a self-portrait by Johann Zoffany (1733–1810) [Uffizi 1979, A1031].

LW 12
Anton Raffael Mengs 1781

Medium unknown
REFERENCES: AGF, f. XIV (1781) a 96; KIF, Berczy to Gruner, Florence, 10 June 1781, pp. 290ff.

Copy after a self-portrait (fig. 34) by Anton Raffael Mengs (1728–1779) [Uffizi 1979, A595]. This portrait and its painter had a special significance for Berczy, and he wrote of them:

> *I consider him the foremost painter of our Century and also that he was a scholar & man of letters, and you will be astonished that one man could be equal to acquiring such excellence in such varied branches of Learning, any one of which is enough to take up the untiring efforts of the lives of most men, simply to absorb it to a degree surpassing the mediocre. I have copied a portrait of this famous man from an Original done by himself & as far as heads are concerned this may be his masterpiece; I made it in the same size as the two portraits in gouache [Rubens and van Dyck] that I sent to you by the last post. It is my favourite piece and I will never part with it, both out of love of the painting and love for the person it represents.*

LW 13
Sir Joshua Reynolds 1781

Medium unknown
REFERENCES: AGF, f. XIV (1781) a 96.

Copy after a self-portrait by Sir Joshua Reynolds (1723–1792) [Uffizi 1979, A746].

LW 14
Angelique Via… (?) 1781

Medium unknown
REFERENCES: AGF, f. XIV (1781) a 96.

In the Uffizi records, the inscription indicating the artist of the self-portrait that Berczy copied is illegible; thus the artist cannot be identified.

LW 15
Christian Seybold 1781

Medium unknown
REFERENCES: AGF, f. XIV (1781) a 96.

Copy after a self-portrait by Christian Seybold (1697–1768) [Uffizi 1979, A882].

LW 16
Dutch Courtesan 1781

Gouache on vellum
REFERENCES: AGF, f. XIV (1781) a 96; KIF, Berczy to Gruner, Florence, 27 Mar. 1781, p. 247.

Copy after Frans van Mieris's (1633–1681) *Dutch Courtesan* [Uffizi 1979, P1820]. This copy was destined for purchase by Bernard Louis de Muralt. The gouache is described as "a picture 9 in. ['pouce'] high and 8 wide representing a young actress, almost entire, sleeping on a settee beside a table where there are Musical instruments etc. in the Back of the Room we see an old woman with a man who is giving her money." Its price was fifteen louis.

LW 17
Hélène Fourment 1781

Medium unknown
REFERENCES: AGF, f. XIV (1781) a 96.

Copy after a portrait by Rubens, thought to be his second wife Hélène Fourment [Uffizi 1979, P1385].

LW 18
Judith 1781

Medium unknown
REFERENCES: AGF, f. XIV (1781) a 96.

Copy after Cristofano Allori's (1577–1621) *Judith* [Lanzi, p. 133; Uffizi 1979, P49].

LW 19
Mary Magdalene 1781

Medium unknown
REFERENCES: AGF, f. XIV (1781) a 96. Lanzi, p. 203.

Copy after Francesco Furini's (c. 1600–1646) *Mary Magdalene* in the Uffizi. Although this work was mentioned by Lanzi in his 1782 publication, no such painting can be found today in the Uffizi collection. There is, however, a *Mary Magdalene* presently in the Pitti Palace; it was formerly attributed to Furini and is now given to Simone Pignoni.[1] It seems very likely this work is the Magdalene that Berczy copied.

1. Gerhard Ewald, "Simone Pignoni, a Little-known Florentine Seicento Painter," in *The Burlington Magazine,* vol. CVI, 1964, pp. 222f. Dr Marco Chiarini of the Galleria Palatina in Florence kindly pointed out the new attribution.

LW 20
Sixty-two Drawings 1781

Medium unknown
REFERENCES: AGF, f. XIV (1781) a 96.

According to the Uffizi files, Berczy copied two drawings after Andrea del Sarto, four after Sanzio Raphael, four after Santi di Tito, three after Pietro da Cortona, thirty-three after Jacques Callot, and sixteen after Stefano della Bella. None of the drawings is specifically identified by title or subject.

LW 21
Genre Piece 1780–81

Medium unknown
REFERENCES: KIF, Berczy to Gruner, Florence, 29 Dec. 1780, p. 205.

Only described as a "very pretty piece of two figures with a Cat & a Parrot," which Berczy intended to send to Bern.

LW 22
Two Peasant Girls 1780–81

Gouache
REFERENCES: KIF, Berczy to Gruner, Florence, 29 Dec. 1780, p. 205.

For Bernard Louis de Muralt, Berczy had begun "a piece of my invention in gouache, being two pretty peasant girls in rustic dress of the vicinity of Florence, which is most pleasant." This work has to be seen in context with catalogues 2 and 3, and LW 23, 24.

LW 23
Costume Studies of the Florentine Region 1781

Watercolour, brush point
REFERENCES: KIF, Berczy to Gruner, Florence, 4 June 1781, pp. 285, 286, 288.

In partnership with a local engraver, Berczy intended to publish a series of hand-coloured costume prints, representing peasants of the Florentine countryside. The series was to comprise four volumes, each containing four prints showing two to four figures (see cat. 2).

LW 24
Costume Study 1781

Pencil on paper
Approx. 8.9 × 14 cm (oval)
PROVENANCE: by descent in Berczy family; in private collection in Kingston, Ont., in 1967.
REFERENCES: Andre 1967, repr. as "Sister Eleonore".

This drawing belongs with the costume studies, catalogues 2 and 3.

LW 25
Two Drawings 1781

Wash in "clair obscure"
REFERENCES: KIF, Berczy to Gruner, Florence, 19 Feb. 1781, pp. 221, 222.

Berczy sent to Mlle Gruner in Bern two drawings "en clair obscure," which were probably wash drawings in chiaroscuro style. They were intended for Fischer d'Oberried, and the price was three louis neuf for the two.

LW 26
Head of an Old Man 1781

Gouache
REFERENCES: KIF, Berczy to Gruner, Florence, 19 Feb. 1781, pp. 221, 223; 19 Mar. 1781, p. 238; and 27 Mar. 1781, p. 248.

Berczy first offered both Fischer d'Oberried and de Muralt the option of buying a *Head of an Old Man.* However, the work was finally sold to Monsieur Manuel for five louis neuf.

LW 27
Nude Woman 1781

Gouache on vellum
Approx. 29.7 × 24.3 cm
REFERENCES: KIF, Berczy to Gruner, Florence, 27 Mar. 1781, p. 247; and 20 Aug. 1781, p. 330.

A gouache painted for Fischer d'Oberried. Berczy describes it as "a full nude woman with a forest landscape." He gives the dimensions as "11 inches ['pouce du Roi'] × 9 inches." It was eventually bought by Bernard Louis de Muralt for fifteen louis.

LW 28
A Head 1781

Oil
REFERENCES: KIF, Berczy to Gruner, Florence, 15 Apr. 1781, p. 261; and 27 May 1781, p. 282.

Probably a first attempt in oil paint. Berczy intended to keep this head done from life as a memento.

LW 29
Self-portrait 1781

Oil
REFERENCES: KIF, Berczy to Gruner, Florence, 27 May 1781, p. 282; and 17 Dec. 1781, p. 395.

One of the first two portraits that Berczy did in oil was a self-portrait. Later he mentioned another self-portrait in the same medium which he was working on; this could have been the portrait he intended to donate to the Uffizi (see cat. 27).

LW 30
A Woman Artist 1781

Miniature, medium unknown
REFERENCES: KIF, Berczy to Gruner, Florence, 4 June 1781, p. 285; 17 Dec. 1781, pp. 396ff; and 1 Feb. 1782, p. 414.

Originally sent to Bern, this miniature of a woman painter, priced at twelve louis, was eventually sold in Naples.

LW 31
Cartoon for a Church Painting 1781

Medium unknown
Approx. 2.70 × 3.60 m
REFERENCES: KIF, Berczy to Gruner, Florence, 25 Nov. 1781, p. 384.

Assisting an unnamed artist friend in his commission for a church painting, Berczy created a composition that contained about forty figures and an extensive architectural setting. He made the large cartoon the exact size of the painting, which measured "12 feet long and 9 feet high."

LW 32
Self-portrait 1781

Gouache
REFERENCES: KIF, Berczy to Gruner, Florence, 17 Dec. 1781, p. 393.

Self-portrait in gouache which Berczy intended to give to the *Accademia del Disegno* in Florence.

LW 33
William Berczy / Gesualdo Ferri
Untitled January–March 1782

Oil on canvas
Approx. 2.40 × 1.50 m
REFERENCES: KIF, Berczy to Gruner, Florence, 19 Jan. 1782, p. 406; and 25 Mar. 1782, p. 242.

Berczy helped his friend and colleague Gesualdo Ferri (1728–c. 1788), "provveditore" (superintendant) of the *Accademia del Disegno*,[1] with a large oil painting containing nine figures. According to him it measured "8 feet ['pieds de Roi'] × 5 feet." There is a painting by Gesualdo Ferri, executed in 1782, in the Capella della Providenza of the church of Santa Maria del Carmine, Florence, which measures 3.25 × 2.02 metres. The subject is the Emperor Heraclius bringing Christ's Cross back to Jerusalem, and the painting contains nine principal figures. The overall impression is certainly in Ferri's style, but the page to the left seems to be somewhat anomalous. The more meticulous execution and the colour scheme could suggest Berczy's collaboration.

1. Archivio di Stato, Florence, Atti de "conferma annuale degli uffiziali e ministri dell'Accademia," in "Giornale dei decreti e deliberazioni del Magistrato dell'Accademia del Disegno, 1778–1784," *Accademia del Disegno,* n. 14. For Ferri, see entry of Silvia Meloni Trkulja in *La Pittura in Italia. Il Settecento (Biografie)* (Milan: Electa, forthcoming). Numerous references may be found in Borroni, *Memoralisti…*; Borroni, *A passo…*; and Borroni, *Il coinvolgimento….*

LW 34
Mary Magdalene (?) 1782

Gouache
REFERENCES: KIF, Berczy to Gruner, Florence, 28 Jan. 1782, p. 409; 11 Mar. 1782, p. 427; 20 Apr. 1782, p. 434; 5 May 1782, p. 439 (in this letter, Berczy mentioned a Saint Mary Magdalene he had done); 27 May 1782, pp. 441f; and 3 June 1782, p. 446.

Described as a weeping woman with red hair, this painting in miniature was done in the most refined technique. Berczy painted it with one of his chief Bernese patrons in mind. Its unfavourable critical reception there hurt the artist deeply and he vowed to keep the work for himself.

LW 35
Peter Leopold, Grand Duke of Tuscany 1782

Medium unknown
Approx. 23.4 × 18.4 cm
REFERENCES: KIF, Berczy to Gruner, Florence, 11 Mar. 1782, p. 428.

A half-figure portrait of the grand duke made to approximately the same size as the paper on which Berczy was writing. (For biographical information on the grand duke, see cat. 11.)

LW 36
Francis, Archduke of Tuscany 1782

Medium unknown
REFERENCES: KIF, Berczy to Gruner, Florence, 11 Mar. 1782, p. 428.

A portrait of the archduke. It was about half the size of his father's portrait (LW 35). (For biographical information on Archduke Francis, see cat. 12.)

LW 37
Francis, Archduke of Tuscany 1782

Medium unknown
REFERENCES: KIF, Berczy to Gruner, Florence, 25 Mar. 1782, p. 241.

Portrait of the archduke for his fiancée, Princess Elisabeth Wilhelmine von Württemberg-Mömpelgard.

LW 38
Francis, Archduke of Tuscany 1782

Medium unknown
REFERENCES: KIF, Berczy to Gruner, Florence, 25 Mar. 1782, p. 241.

Portrait of the archduke for his future sister-in-law, the Grand Duchess Maria Fiodorovna, wife of the future Czar Paul I.

LW 39
Francis, Archduke of Tuscany 1782

Wash in "clair obscure"
REFERENCES: KIF, Berczy to Gruner, Florence, 25 Mar. 1782, p. 241.

Copy of the two preceding portraits of the archduke, probably rendered as a wash drawing in a chiaroscuro style, which Berczy kept for himself.

LW 40
Joseph, Archduke of Tuscany 1782

Medium unknown
REFERENCES: KIF, Berczy to Gruner, Florence, 11 Mar. 1782, p. 428.

A portrait, approximately half the size of the grand duke's likeness (LW 35).

LW 41
Maria Therese, Archduchess of Tuscany 1782

Medium unknown
Approx. 23.4 × 18.4 cm
REFERENCES: KIF, Berczy to Gruner, Florence, 11 Mar. 1782, p. 428.

In the words of Berczy, the portrait of the archduchess was "the best piece I ever did in all my life with regard to likeness." It showed her sitting on a terrace with a basket of flowers, with the Boboli Garden behind the Pitti Palace in the background (see cat. 13).

LW 42
Baroness von Störck 1782

Medium unknown
Approx. 23.4 × 18.4 cm
REFERENCES: KIF, Berczy to Gruner, Florence, 11 Mar. 1782, p. 428; 24 July 1781, pp. 315ff; and 1 Feb. 1782, pp. 412ff.

Wife of the court physician Baron Matthäus von Störck, the baroness was governess to the daughters of Grand Duke Peter Leopold. Berczy painted her portrait shortly before her untimely death at the age of thirty-eight. Its size was the same as that of the grand duke's picture (LW 35).

LW 43
Russian Aide-de-Camp 1782

Gouache
REFERENCES: KIF, Berczy to Gruner, Florence, 5 May 1782, p. 438.

Portrait of the aide-de-camp from the entourage of Grand Duke Paul, the future Czar Paul I. Berczy made the acquaintance of the aide-de-camp during the Russians' visit to Florence in March–April 1782.

LW 44
Madonna 1783

Medium unknown
REFERENCES: AGF, f. XVI (1783) a 68.

Copy of a Madonna after Titian. According to the Uffizi 1979 catalogue, there were two paintings by Titian of the Madonna in the Uffizi at the time of Berczy's stay in Florence. It is not known which one Berczy copied.

LW 45
Landscape 1783

Medium unknown
REFERENCES: AGF, f. XVI (1783) a 68.

Berczy is recorded as having copied a landscape after "Vovermann" in the Uffizi. This is probably the *Return from the Hunt* by Pieter Wouwerman (1623–1682) [Uffizi 1979, P1901]. The catalogue indicates that the picture had only been in the gallery since 1784; but, in the meantime, Dr Marco Chiarini of the Galleria Palatina in Florence has been able to trace the painting's documentation in the Uffizi collection back to 1765.

LW 46
Two Portraits 1783

Medium unknown
REFERENCES: KIF, Berczy to Gruner, Florence, 8 Aug. 1783, p. 514.

After his nine-month stay in Bern in 1782–83, Berczy returned to Italy at the beginning of June 1783 with a number of unfinished portraits for his Swiss patrons. Two months later, in August, he sent a parcel to Bern containing two undescribed portraits for Monsieur de Mülinen.

LW 47
Marie Marianne de Bonstetten 1783

Medium unknown
REFERENCES: KIF, Berczy to Gruner, Florence, 8 Aug. 1783, p. 514; 8 Nov. 1783, pp. 567–69; and 12 Dec. 1783, p. 583.

Berczy made a portrait of Madame de Bonstetten (1758–1805), wife of the well-known statesman and philosopher Carl Victor de Bonstetten (1745–1832). The work caused trouble from the beginning because the family found the likeness very poor. Finally, however, they accepted the portrait.

LW 48
A Miniature 1784

Medium unknown
REFERENCES: KIF, Berczy to Gruner, Naples, 15 June 1784, p. 653.

While in Naples, Berczy announced on 15 June 1784 that he would soon send Monsieur Stettler the miniature he had ordered. It must have been an especially elaborate composition, as Berczy charged eighteen louis for it (his usual price for this kind of work was twelve to fifteen louis).

LW 49
Maria Theresa, Infanta of Naples-Sicily July 1784

Medium unknown
REFERENCES: KIF, Berczy to Gruner, Naples, 4 July 1784, p. 655.

Berczy began his commission for the Queen of Naples with a portrait of her eldest daughter, Maria Theresa, called Donna Theresa (1772–1807). In 1790, Maria Theresa married her first cousin, Archduke Francis of Tuscany, following the death of his

first wife, Elisabeth Wilhelmine. He became the Emperor Francis II.

LW 50
Maria Louisa, Infanta of Naples-Sicily
July 1784

Medium unknown
REFERENCES: KIF, Berczy to Gruner, Naples, 20 July 1784, p. 661.

The second item in the commission for the Queen of Naples was the portrait of the younger sister, whom Berczy called the Infanta Ludovica (1773–1802). She would marry her first cousin, Archduke Ferdinand of Tuscany (later Grand Duke of Tuscany). The two daughters of King Ferdinand IV of Naples and the two sons of Emperor Peter Leopold II (former Grand Duke of Tuscany) were married in Vienna in 1790, in a splendid double wedding.

LW 51
Maria Theresa, Infanta of Naples-Sicily 1784

Medium unknown
REFERENCES: KIF, Berczy to Gruner, Naples, 26 Sept. 1784, p. 675.

King Ferdinand IV and Queen Maria Carolina were greatly pleased with the likeness of their eldest daughter (LW 49) and asked Berczy to make a second portrait of her from life.

LW 52
Maria Carolina, Queen of Naples-Sicily 1784

Medium unknown
REFERENCES: KIF, Berczy to Gruner, Naples, 20 July 1784, p. 661; 26 Sept. 1784, pp. 675ff; and Caserta, 14 Dec. 1784, p. 691.

Berczy was also commissioned to make a portrait of Queen Maria Carolina (1752–1814) of Naples. On 14 December 1784, Berczy presented to the assembled court a half-figure, full-size portrait, which was enthusiastically received. The work presented was probably this portrait of the queen.

LW 53
Sophia Mathilda, Princess of Gloucester 1785

Medium unknown
REFERENCES: KIF, Berczy to Gruner, Geneva, 3 Oct. 1785, p. 69.

In the autumn of 1785, Berczy was in Geneva. There he received from the visiting William Henry, Duke of Gloucester and brother of King George III, a commission for a portrait of his twelve-year-old daughter, Princess Sophia Mathilda (1773–1844). The work proved to be a great success and, in consequence, Berczy was swamped with commissions.

Princess Sophia Mathilda never married. For many years she held the Rangership of Greenwich Park.

LW 54
Portrait of an Artist 1790

Miniature, medium unknown
REFERENCES: *The Exhibition of the Royal Academy M.DCC.XC.* (London: T. Cadell, Printer to the Royal Academy, 1790), no. 366; Graves, p. 184.

Berczy exhibited a miniature entitled *Portrait of an Artist* at the annual exhibition of the Royal Academy, London, 1790.

LOST WORKS
1794–1812

by Mary Macaulay Allodi

LW 55
Miss Mary Nooth 1799

Coloured gouache
REFERENCES: SAUM, U/1430: Berczy to Charlotte, Quebec, 5 Jan. 1799; and U/1433: 6 Feb. 1799.

Mary Nooth (1791–1846), the daughter of Dr Mervin Nooth, was eight years old when depicted by Berczy.

LW 56
Dr Mervin Nooth 1799

Medium unknown
REFERENCES: SAUM, U/1434: Berczy to Charlotte, Quebec, 10 Feb. 1799; and série S, boîte 11447: Berczy to Sir Joseph Banks, London, 12 Aug. 1799.

Dr John Mervin Nooth (1737–1828), physician, army officer, and scientist, lived in Quebec City from c. 1788 until August 1799. He gave William Berczy a letter of introduction to Sir Joseph Banks, and Berczy presented "a sketch of Dr. Nooth's likeness" to Sir Joseph in London.

LW 57
Miss Charlotte Holland 1799

"Craion" on paper
REFERENCES: SAUM, U/1430: Berczy to Charlotte, Quebec, 3 Jan. 1799.

Charlotte, eldest daughter of Surveyor-General Samuel Holland, died unmarried in 1833. When Berczy writes of "craion," he is likely referring to the tool that holds the drawing medium.

LW 58
Miss Holland 1799

"Craion" on paper
REFERENCES: SAUM, U/1430: Berczy to Charlotte, Quebec, 3 Jan. 1799.

Berczy does not specify which of Samuel Holland's several daughters he sketched here.

LW 59
Mr Holland, Officer 1799

"Craion" on paper
REFERENCES: SAUM, U/1430: Berczy to Charlotte, Quebec, 3 Jan. 1799.

Berczy describes this subject as a son of Samuel Holland, and an officer in Prince Edward's Regiment; it was possibly Frederick Braham Holland (1774–1836), whose first wife, Miss de St. Laurent, was a ward of Edward, Duke of Kent. In 1799 he was a lieutenant on half-pay, having served with the 60th and 7th Regiments of Foot.

LW 60
Officer, Fiancé of the Eldest Miss Holland 1799

"Craion" on paper
REFERENCES: SAUM, U/1430: Berczy to Charlotte, Quebec, 3 Jan. 1799.

LW 61
Joseph Bouchette 1799

"Craion" on paper
REFERENCES: SAUM, U/1430: Berczy to Charlotte, Quebec, 3 Jan. 1799.

Joseph Bouchette (1774–1841) succeeded his uncle Samuel Holland as surveyor-general of Lower Canada.

LW 62
Mme Joseph Bouchette 1799

"Craion" on paper
REFERENCES: SAUM, U/1430: Berczy to Charlotte, Quebec, 3 Jan. 1799.

Adelaïde Chaboillez married Joseph Bouchette in 1797. She was the daughter of fur trader Charles-Jean-Baptiste Chaboillez (1736–1808), and sister of Mrs Simon McTavish (see cat. 61) and Mrs Roderick Mackenzie (see cat. 95).

LW 63
Mrs Robert Prescott 1799

India ink
REFERENCES: SAUM, U/1433: Berczy to Charlotte, Quebec, 6 Feb. 1799.

LW 64
Son of Mrs Prescott 1799

India ink
REFERENCES: SAUM, U/1433: Berczy to Charlotte, Quebec, 6 Feb. 1799.

LW 65
Nephew of Mrs Prescott 1799

India ink
REFERENCES: SAUM, U/1433: Berczy to Charlotte, Quebec, 6 Feb. 1799.

LW 66
Samuel Gale 1799

India ink
REFERENCES: SAUM, U/1433: Berczy to Charlotte,
Quebec, 6 Feb. 1799; and U/1434: 10 Feb. 1799;
U/4336: S. Gale to Berczy, London, 16 Dec. 1799;
série S, boîte 11447: Berczy to S. Gale, London,
3 Jan. 1800; and série S, boîte 11447: Berczy to
Mrs Barrow, London, 7 Jan. 1800.

Samuel Gale (1747–1826), surveyor and land claims
agent, was at this time secretary to General Robert
Prescott. Berczy made a copy of his portrait of
Samuel Gale and brought it to England, where he
gave it to a Mrs Barrow of "Woolwick," evidently a
close friend and possibly a relative of the Gale fam-
ily. At that time he said that he wanted to make a
copy of it to keep for himself; this suggests that there
could be three versions of Berczy's portrait drawing
of Samuel Gale.

LW 67
Mrs Samuel Gale 1799

India ink
REFERENCES: SAUM, U/1433: Berczy to Charlotte,
Quebec, 6 Feb. 1799; U/4336: S. Gale to Berczy,
London, 16 Dec. 1799; and série S, boîte 11447:
Berczy to Mrs Barrow, London, 19 Dec. 1799.

Rebecca Wells (d. 1826), daughter of Samuel Wells
of Brattleboro, Vermont, married Samuel Gale in
1773. The 1799 correspondence cited reveals that
Berczy's drawings of members of the Gale family
were in a small chest, which was lost as he travelled
through the United States en route to England.

LW 68
Samuel Gale Jr. 1799

India ink
REFERENCES: SAUM, U/1433: Berczy to Charlotte,
Quebec, 6 Feb. 1799.

Samuel Gale Jr. (1783–1865), only sixteen at the
time of this drawing, became a noted judge and
author.

LW 69
Miss Gale 1799

India ink
REFERENCES: SAUM, U/1433: Berczy to Charlotte,
Quebec, 6 Feb. 1799.

LW 70
Mr Coffin 1799

India ink
REFERENCES: SAUM, U/1433: Berczy to Charlotte,
Quebec, 6 Feb. 1799.

This drawing could represent John Coffin (1730–
1808), prominent businessman and Loyalist, or one
of his many sons.

LW 71
Major James Green 1799

India ink
REFERENCES: SAUM, U/1433: Berczy to Charlotte,
Quebec, 6 Feb. 1799.

Berczy refers to his profile outline of Major Green
(1751–1835), who at this date was military secretary
to General Robert Prescott.

LW 72
Son of Major Green 1799

India ink
REFERENCES: SAUM, U/1433: Berczy to Charlotte, Quebec, 6 Feb. 1799.

Among the children of Major James Green was William Green (1787–1832), who became a Quebec City lawyer. This work is a profile outline.

LW 73
Mrs James Green 1799

India ink
REFERENCES: SAUM, U/1433: Berczy to Charlotte, Quebec, 6 Feb. 1799.

Maria Green was the wife of Major James Green.

LW 74
Daughter of Mrs Green 1799

India ink
REFERENCES: SAUM, U/1433: Berczy to Charlotte, Quebec, 6 Feb. 1799.

One daughter of Major and Mrs James Green, Eliza Maria, married John Stewart (1794?–1858), legislative and executive councillor of Lower Canada.

LW 75
Marquis De Bouillé 1799

India ink
REFERENCES: SAUM, U/1433: Berczy to Charlotte, Quebec, 6 Feb. 1799.

Berczy describes his subject as the aide-de-camp to Governor Prescott. This is most probably Francis De Bouillé, lieutenant in the 64th Regiment in 1794,

who returned to England with Prescott in 1799. He is listed as "Major de Bouille, Manchester Street No. 7, Manchester Square" in Berczy's London address book [SAUM, série S, boîte 11447].

LW 76
George Pyke 1799

India ink
REFERENCES: SAUM, U/1433: Berczy to Charlotte, Quebec, 6 Feb. 1799; and U/1436: Berczy to Vondenvelden, Pointe Olivier, 25 Feb. 1799.

George Pyke (1775–1851), a young lawyer at this time, became a noted jurist. A few weeks after drawing this portrait, Berczy referred to a copy of it drawn by Quebec City cartographer William Vondenvelden.

LW 77
William Vondenvelden 1799

Coloured gouache
REFERENCES: SAUM, U/1433: Berczy to Charlotte, Quebec, 6 Feb. 1799.

Berczy cited this as the best work of his artistic career to date. William Vondenvelden (c. 1753–1809) was a printer and surveyor who had business dealings with Berczy.

LW 78
General Robert Prescott 1799

Oil
REFERENCES: SAUM, U/1430: Berczy to Charlotte, Quebec, 3 and 5 Jan. 1799; U/1433: 6 Feb. 1799; and U/1434: 10 Feb. 1799.

Berczy refers to two portraits of Prescott, one in oil and the other in watercolour. The oil version

35.
William Logan, 1808,
by William Berczy.
Copy photograph, ROM.

in the Weir collection (Weir Foundation, Queenston, 982.5) appears to be a copy of the mezzotint (cat. 50), rather than the oil that Berczy painted in Quebec City.

LW 79
James Givins c. 1803–04

Medium unknown
REFERENCES: NA, MG23, H II 6, vol. 4, p. 814: Berczy to William Chewett, Quebec, 20 June 1809.

Berczy asked William Chewett for "the favour to return to Captain Givens his portrait hanging in one of my rooms," in his house at York. It is not clear whether the portrait was painted by Berczy, nor even that it depicted Givins himself. James Givins (1759?–1846) was an officer in the Queen's Rangers and an aide to General Simcoe; he later became chief superintendent of Indian Affairs for Upper Canada.

LW 80
Design for Christ Church, Montreal 1805

Probably pen and ink
REFERENCES: see cat. 62.

LW 81
Samuel Gale Jr. 1807

Miniature, medium unknown
REFERENCES: SAUM, série S, boîte 11445: Berczy to S. Gale Sr., 26 Apr. 1807.

It is assumed that this miniature represents Samuel Gale Jr.; it is invoiced to Samuel Gale Sr. as "a Miniature for his son," at a value of £6.

LW 82
William Logan 1808

Oil on canvas
REFERENCES: SAUM, U/1464: Berczy to Charlotte, Quebec, 17 Aug. 1808; U/1487: 1 Feb. 1809; U/1488: 19 Feb. 1809; and U/1489: 28 Feb. 1809.

William Logan (1759–1841) came to Canada with his parents in about 1784; from them he inherited a large property in Montreal known as the Logan Farm. He married Janet Edmond in 1794, and they had nine children, of whom two are mentioned in Berczy letters. The eldest son, William Edmond, became first director of the Geological Survey of Canada, and was knighted.

The portrait of William Logan must have been painted in the spring of 1808, just before Berczy left for Quebec City. While in Quebec, Berczy had a frame made for the portrait which he then shipped back to Montreal. William Logan returned to England in 1815, taking the portrait with him; it was destroyed in a fire in 1962. We know the image from a slide (see fig. 35).

LW 83
Dr George Longmore 1808

Miniature, medium unknown
REFERENCES: SAUM, U/1464: Berczy to Charlotte, Quebec, 17 Aug. 1808; and U/1465: 18 Aug. 1808.

George Longmore (1758–1811) was a physician, army officer, and landowner. Berczy indicated that this miniature would be contained in a locket.

LW 84
Members of the Gibb Family 1808

Miniatures, medium unknown
REFERENCES: SAUM, U/1465: Berczy to Charlotte, Quebec, 18 Aug. 1808.

Berczy was buying lockets for Mr Gibb, which suggests that he had painted miniature portraits of some members of that family; he also promised to portray one of the Gibb daughters on his return to Montreal. Merchant-tailor Beniah Gibb (1755–1826) married in 1790, and had four sons and two daughters. Also in 1808, Gibb and his son Beniah Jr. were portrayed in pastel profiles (collection: McCord Museum, Montreal) by Gerrit Schipper (see Appendix B).

LW 85
Eliza Tremain 1808

Miniature, medium unknown
REFERENCES: SAUM, U/1464: Berczy to Charlotte, Quebec, 17 Aug. 1808; U/1471: 4 Sept. 1808; U/1474: 12 Nov. 1808; and U/1489: 28 Feb. 1809.

Eliza Tremain was the future wife of Berczy's friend George Pyke (LW 76), and the artist undertook the task of portraying her without her knowledge. This was accomplished by observing her as she played chess, and also by using a silhouette image of her as a reference. The portrait miniature is probably in profile; Berczy refers to it as his "Chess Player." Eliza Tremain and George Pyke were both natives of Halifax, N.S. They married on 10 May 1809, and lived in Montreal.

LW 86
Louise-Élizabeth Marcoux De Bonne 1808

Miniature, watercolour and gouache on ivory
REFERENCES: SAUM, U/1470: Berczy to Charlotte, Quebec, 3 Sept. 1808; U/1473: 21 Sept. 1808; U/1474: 12 Nov. 1808; and U/1475: 23 Nov. 1808.

Portrait miniature found recently; see cat. 80A.

LW 87
Drawings to Illustrate Travel Book 1808

Medium unknown
REFERENCES: NA, MG23, H II 6, vol. 4, pp. 720–23: SAUM U/1471: Berczy to Charlotte, Quebec, 4 Sept. 1808; Berczy to Fitch Hall, Montreal, 22 and 29 May 1808; NA, MG23, H II 6, vol. 4, p. 743: Berczy to Boudinot, Quebec, 23 Nov. 1808.

These drawings were done on commission for Edward Augustus Kendall and illustrated life in Upper and Lower Canada. They were possibly landscapes and Indian portraits or genre studies.

LW 88
Miss Sarah Mountain 1809

Miniature, medium unknown
REFERENCES: SAUM, U/1487: Berczy to Charlotte, Quebec, 1 Feb. 1809; and NA, MG23, H II 6, vol. 4, p. 808: Berczy to Bishop Mountain, Quebec, 8 June 1809.

Miss Sarah Mountain (1748–1808) was the sister of the Anglican bishop Jacob Mountain. Shortly after her death, Bishop Mountain commissioned a miniature copy of an oil portrait in his possession. A few months later he also asked Berczy to clean and restore three pictures, including the oil portrait of Miss Mountain. The original might have been the 1778 oil on copper by John Downman (collection: NA, Ottawa, 1982-92-2).

LW 89
Unknown Subjects

Miniatures, medium unknown
REFERENCES: SAUM, U/1489: Berczy to Charlotte, Quebec, 28 Feb. 1809.

Berczy was asked to do one or two miniatures as a commission for the Ursulines of Quebec City; this may have been a request to restore existing works.

LW 90
Mr Wills' Family 1809

Miniatures, medium unknown
REFERENCES: SAUM, U/1490: Berczy to Charlotte, Quebec, 2 Mar. 1809; and U/1491: 5 Mar. 1809.

Just how many members of the family of Mr Wills were to be depicted in miniature is not known.

LW 91
Henrietta Maria, Queen of England 1809

Miniature, medium unknown
REFERENCES: SAUM, U/1491: Berczy to Charlotte, Quebec, 5 Mar. 1809.

"Mr. Jackson" of Quebec had acquired a painting at a local sale, which was said to be by van Dyck. He asked Berczy to paint a miniature copy of it, to send as a sample to London in order to promote the sale of the original. Berczy said that he would leave most of this copying work to his son William.

LW 92
Masonic Carpet 1809

Medium unknown
REFERENCES: SAUM, U/1494: Berczy to Charlotte, Quebec, 19 Mar. 1809; and U/1507: 24 June 1809.

The ceremonial "carpet" was ordered by a Mr Gilmore, probably William Gilmore of Montreal, the contractor for the building of Christ Church, which was designed by Berczy (see cat. 62).

LW 93
M.-E.-G.-A. Chartier de Lotbinière 1809

Oil on canvas
REFERENCES: SAUM, U/1496: Berczy to Charlotte, Quebec, 13 Apr. 1809; and U/1497: May 1809.

Michel-Eustache-Gaspard-Alain Chartier de Lotbinière (1748–1822) was a legislative councillor of Lower Canada and seigneur of Vaudreuil, Rigaud, and Lotbinière. Berczy described this portrait as being a bust-length oil painting.

LW 94
McTavish Tomb 1809

Medium unknown
REFERENCES: SAUM, U/1413: Charlotte to Berczy, Montreal, 17 July 1808 [1809]; U/1506: Berczy to Charlotte , Quebec, 10 June 1809; U/1507: 24 June 1809; U/1508: 28 June 1809; and U/1509: 13 July 1809.

Simon McTavish (c. 1750–1804), one of Montreal's most powerful fur trading merchants, was buried in a mausoleum on the slopes of Mount Royal at the head of present-day Peel Street. The original tomb was later improved, and a column was erected above it in about 1805–06. Berczy's involvement in making drawings of this tomb and monument suggests that he may have designed these structures. His price of ten louis for the drawing (or painting?) indicates that it was not a casual sketch. The purchaser seems to have been either James or William Hallowell, who were junior partners in the firm of McTavish, McGillivray & Co., and also relatives of Simon McTavish. Another prospective purchaser was Margaret Sutherland (LW 113), wife of Daniel Sutherland, a member of the North West Company. A drawing of this subject is said to have hung in Simon McGillivray's London house in 1819.[1]

1. Marjorie Wilkins Campbell, *McGillivray, Lord of the Northwest* (Toronto: Clarke, Irwin & Company Limited, 1962), p. 279.

LW 95
Descent from the Cross 1809

Medallion on silk, medium unknown
REFERENCES: SAUM, U/1496: Berczy to Charlotte, Quebec, 13 Apr. 1809.

Commissioned by the Ursulines of Quebec.

LW 96
Four-year-old Girl 1809

Medium unknown
REFERENCES: SAUM, U/1507: Berczy to Charlotte, Quebec, 24 June 1809.

The sitter may be Eleonora Woolsey (cat. 83), one of the figures portrayed in *The Woolsey Family* (cat. 84).

LW 97
Crucifixion with the Virgin and St. John 1809

Medium unknown
REFERENCES: SAUM, U/1509: Berczy to Charlotte, Quebec, 13 July 1809.

This subject was commissioned as a small altar painting for the Ursulines of Quebec; as there is no further record of its execution, it may not have been completed as described.

LW 98
Tomb of Mrs Henderson 1809

Probably oil on canvas
REFERENCES: SAUM, U/1468: Berczy to Charles Berczy, Quebec, 1 Sept. 1808; U/1470: Berczy to Charlotte, Quebec, 3 Sept. 1808; U/1471: 4 Sept. 1808; U/1472: 7 Sept. 1808; U/1507: 24 June 1809; and U/5633: W. Henderson to Berczy, Quebec, 22 Oct. 1809.

Mary Ann Henderson, wife of William Henderson of Montreal, died on 1 September 1806. The widower asked Berczy to paint a picture of her tomb in its graveyard setting, and the artist requested his younger son Charles, along with Amélie Panet, to sketch the locale for him while he was away in Quebec City. Upon receipt of the painting, Henderson wrote to Berczy, "On the Eve of embarking for the country that 'Cradled my Youth' I received the

drawing. I have not time to open and examine it but am certain that nothing unworthy of you will emanate from your pencil. Accept my hearty and Best thanks – On producing this letter Mr Gibb will pay you the Twenty five Pounds Wm. Henderson Junr."

William Henderson was most likely the partner in the firm of Hoyle, Henderson & Gibb, hardware and general merchants at 119 St. Paul Street, Montreal, in 1808. The price of the painting indicates that it was probably an oil on canvas.

LW 99
St. John the Baptist c. 1810

Oil on canvas
REFERENCES: NA, MG23, H II 6, vol. 4, p. 832: Berczy to [?], c. 1810; NA, Isidore Desnoyers manuscript, c. 1880, microfilm no. 2169, p. 38. Viger 1850, pp. 21–22.

This work was described by Jacques Viger in 1850 as a magnificent painting for the main altar. It was commissioned by Jean-Baptiste-Melchior Hertel de Rouville at a cost of £50 for the church of Saint-Jean Baptiste located on his seigneury of Rouville. It was removed at the time of an 1885–86 interior renovation of the church.

LW 100
St. Michael 1811

Oil on canvas
REFERENCES: NA, MG23, H II 6, vol. 4, pp. 831–32: Berczy to [?], c. 1810; Archives de la fabrique de Saint-Michel, "Journal 1807–1823," entry for 1810; ASQ, Fonds Viger-Verreau, Saberdache bleue, vol. 2, pp. 4–8: J. Viger to D.B. Viger, Montreal, 18 Feb. 1811. Lemoine, L'Album du touriste, 2nd. ed. (Quebec City, 1872), p. 275; Father Marie-Antoine, o.f.m., Saint Michel de la Durantaye (Quebec City, 1929), p. 99.

This painting was destroyed in a fire in 1872 at Saint-Michel de la Durantaye, also called Saint-Michel de Bellechasse. According to parish records, the large painting was commissioned for a price of 40 louis in 1810, and was put into place in August 1811. Berczy's copy of a letter he sent to an unidentified client in the Quebec City area describes a twelve-foot painting of St. Michael, for which he would, on request, lower his price from 50 to 40 louis (see Intro. p. 74).

LW 101
Portrait of a Man 1811

Medium unknown
REFERENCES: ASQ, Fonds Viger-Verreau, Saberdache bleue, vol. 2, p. 62: Berczy to J. Viger, Montreal, 16 Dec. 1811.

LW 102
David Page Jr. 1812

India ink
REFERENCES: SAUM, U/1522: Berczy to Charlotte, Middlebury, Vt., June 1812.

David Page Jr. was superintendent of a cotton mill in Middlebury, Vermont. The Page family were evidently old friends of the Berczys, and the artist stayed with them on his last journey to the United States. Berczy describes his profile portraits of Mr and Mrs Page – done to repay their hospitality – as carefully finished and executed in India ink.

36.
Tracing for a Portrait of an Unidentified Man, n.d.,
by William Berczy.
Collection: Art Gallery of Ontario, Toronto.
Gift of John Andre, 1982.

LW 103
Mrs David Page Jr. 1812

India ink
REFERENCES: SAUM, U/1522: Berczy to Charlotte,
Middlebury, Vt., June 1812.

LW 104
Miss Eliza Page c. 1805–12

India ink
REFERENCES: SAUM, U/1522: Berczy to Charlotte,
Middlebury, Vt., June 1812.

Eliza was the daughter of Mr and Mrs David Page Jr.
of Middlebury, Vermont. She must have spent some
time with the Berczys in Montreal, possibly at
Charlotte Berczy's finishing school for young ladies.
William Berczy refers to a profile portrait of Eliza,
which he had kept at his Montreal home.

LW 105
Flemish Warrior n.d.

India ink
REFERENCES: SAUM, U/1522: Berczy to Charlotte,
Middlebury, Vt., June 1812.

LW 106
Unidentified Man n.d.

Medium unknown
Approx. 18.5 × 15.2 cm

This portrait subject is known through a transfer
drawing (collection: AGO, 82/222, Gift of John
Andre) in pencil on laid paper, 18.5 × 15.2 cm
(oval), and inscribed u.l. in sepia ink, *Wm*. The
AGO drawing (fig. 36) is an outline of a middle-
aged man, bust-length. It is on paper that has been
oiled to render it transparent, evidently for the pur-
pose of tracing.

CATALOGUE
WILLIAM BENT BERCZY

by Mary Macaulay Allodi

ILLIAM Bent Berczy,[1] born in London, England, on 6 January 1791, was the eldest son of William Berczy and Charlotte Allamand. He served in the War of 1812 with the Corps of Canadian Chasseurs, and in later years was active with the militia. From 1817 to 1832 he lived at Amherstburg, Upper Canada, where he was involved in various business ventures. From 1828 to 1834 he was a member for Kent County in the Upper Canada House of Assembly. In 1819 he married Louise-Amélie Panet, and after 1832 they lived on the Panet seigneury at D'Ailleboust, although William spent much of the time at York until 1834. They had no children. William Bent Berczy died at D'Ailleboust on 9 December 1873.

William was his father's studio assistant and constant companion from an early age. He accompanied William Senior on his two-year stay in York (June 1802 to October 1804), and it is from that provincial capital that he sent his mother a drawing of Chambly in 1804 (LW-WBB 1), the first evidence of his artistic activity. The drawing is lost, but a copy of it seems to have survived; it is a water-colour by one of Charlotte Berczy's pupils which, in spite of its naïvete, shows that it had a well-balanced composition as its source.

In 1808, William was his father's apprentice in Quebec City, where he made himself useful by looking after the brushes and colours, laying in backgrounds for miniatures, transferring designs to canvas, and even taking dictation or making copies of his father's letters. He also sketched boats in the harbour (LW-WBB 2), and drew one urban view (LW-WBB 6) which his father described as especially interesting and "piquant," different from anything usually seen. These sketches and others of costumes, genre subjects, and landscapes made during their travels between cities were being gathered with publication in mind; William Senior hoped to leave his sons an income either from his own publication, or one which they would see through the presses in the future. While in Quebec, the younger Berczy also painted a St. Francis (LW-WBB 5), a subject that reflects his father's growing interest in securing religious commissions at this time.

In one of his last letters to his son, written from Vermont in 1812, William Senior encouraged him

37.
William Bent Berczy, c. 1861,
photograph by William Notman Studio.
Collection: Notman Photographic Archives,
McCord Museum of Canadian History, Montreal.

to persevere in that "enchanting art," which would open all doors to him. The same letter commented on the difficulty that William Junior had experienced in achieving a good likeness in a portrait of Margaret Robertson Sutherland (LW-WBB 7). Evidently he had not yet equalled his father's talent, nor was he as self-confident.

None of William Bent Berczy's early works have come to light, and the first example we have of his art is the posthumous portrait of Pierre-Louis Panet (WBB 1), painted in December of 1812. It is a very modest production, both technically and in expression. Three years later, he painted miniatures on

ivory of himself and his wife-to-be (WBB 2, 3), which are accomplished portraits reflecting his early training, but which lack the charm and grace of his father's portraits. In later years he copied some portrait prints for Jacques Viger, but he is not known to have continued with portraiture from life. His talents did not flourish in this branch of painting.

William's genius is to be found in three genre scenes (WBB 4–6) that he painted in the 1820s, while living in Amherstburg, Upper Canada. The paintings depict Indian customs and daily activities, set in lakeshore landscapes that include glimpses of the town in the distance. His father's habit of collecting data about life around him inspired William, and many of the ethnological details may come directly from sketches by William Senior, now lost. In addition, while working with his father in Quebec, William had met the artists practising in that city, including the topographical painter George Heriot; there is a suggestion of a Heriot source in one of the Amherstburg views (WBB 4). Despite possible influences, William's genre-landscapes are unique and unmatched for the period. The figure groups are well integrated into the landscape and are presented on the first plane in large enough scale to dominate the subject matter. Balancing the genre scene is a setting of water and sky, and of reflected trees and buildings. William Bent paints each object with an attention to detail and atmosphere that gives these paintings a magical, surreal attractiveness.

William Bent Berczy remained an amateur of art, giving more time to business, politics, farming, and the militia than to painting. After returning to Quebec, he continued to illustrate local scenes, but never equalled the Amherstburg paintings. Most of the work that has survived consists of tiny to medium-sized watercolours, some copied and others original, which he painted for Jacques Viger's scrapbook-albums. In 1860 he received an "honourable mention" for two oil paintings exhibited by the Art Association of Montreal, on the occasion of the visit

of the Prince of Wales: the anecdotal subject of *Columbus Breaking the Egg* (WBB 10), based on a Hogarth print, and a *Joseph Brant,* unlocated but obviously based on his father's portraits. He had not created a distinct artistic career for himself, but he had nurtured and reflected his father's memory. A visitor to D'Ailleboust in the late 1850s recalled the Panet-Berczy dwelling:

> *The drawing-room was simply but comfortably furnished. Large, elegant, commodious, on its walls were hanging, in frames without ornament, the portraits of ancestors who came from Old France, those of Indian chiefs renowned for their acts of bravery, and lovely historical scenes or pleasant landscapes from the skilled brush of Mr. Berczy's father or done by himself....*[2]

WBB 1
Pierre-Louis Panet 1812

Watercolour with touches of white gouache on wove card

12.7 × 10.5 cm

INSCRIPTIONS: Verso: in ink, *Hon. Pierre Louis Panet / fils de Méru Panet. né à / Montréal le 2 août 1761. / ordonné Juge de la cour du / Banc du roi à Montreal le 8 mai / 1795. / Marie à Montréal le 13 Aout / 1781 à Marie Anne. fille de / Gabriel Cerré et de Catherine Giard. / Monsieur le Juge Panet / est mort à Montreal le 2 / décembre 1812 d'une a..... / d'apoplexie en Mont.... / sur le banc*

Marthe Faribault-Beauregard

PROVENANCE: from Amélie Panet Berczy to her sister Mélanie Panet Lévesque; her son Pierre-T. Lévesque; his daughter Laetitia Lévesque Faribault; her daughter Eveline Faribault; her niece Marthe Faribault-Beauregard.

EXHIBITIONS: 1887 Montreal; 1892 Montreal; 1986 ANQ.

1. His signature appears as "W.B.E. Berczy" on some early letters, e.g., SAUM, U/1477: WBB to Charlotte Berczy, Quebec, 5 December 1808.
2. De Rainville 1892, p. 134.

REFERENCES: Montreal 1887, p. 17, no. 113 (described as an "oil"); Montreal 1892, p. 29, no. 431; Andre 1967, repr. after p. 136; Andre 1975, pp. 172, 174; Lafortune 1986, p. 70, no. 74; Faribault-Beauregard 1987, pp. 31, 51.

In an 1840 letter, Amélie Panet Berczy talked about this portrait of her father:

> *For twenty-eight years, I had kept in a trunk a portrait of my father, the Honorable Pierre-Louis Panet, painted by my husband from nature, when he [Mr. Panet] was exposed on his bier. I had never had the courage to bring it out to the light of day; I took this occasion [a celebration in honour of her husband] to hang it in the diningroom; it is a very faithful likeness....*[1]

In keeping with the sombre occasion, the portrait is painted in shades of black and grey, with the exception of the flesh tones. Family tradition says that Panet had a port-wine birthmark on the left side of his face, which would explain the especially dense shading of that area in the portrait.

Pierre-Louis Panet (1761–1812) was a lawyer, seigneur, politician, and judge, who was loyal to the British authorities. He often engaged in real-estate transactions, and owned handsome properties in Montreal, Quebec City and environs. He was friendly with the Berczy family, and helped them in hard times. His daughter Louise-Amélie and her husband William Bent Berczy eventually took over the seigneury of D'Ailleboust.

1. Faribault-Beauregard 1987, p. 51: Amélie Panet Berczy to Guillaume Lévesque, D'Ailleboust, 29 May 1840 (trans. from French).

WBB 2
Self-portrait c. 1813–14

Watercolour and gouache on ivory
6.5 × 5.3 cm
INSCRIPTIONS: Verso: in mauve ink, *William de Moll Berczy / et sa femme / Amélie Panet*
Dr and Mme C. Bertrand

PROVENANCE: by descent in Panet-Lévesque family to Céline Dupuis; Dr and Mme C. Bertrand.
REFERENCES: Andre 1975, pp. 168, 174.

William Bent Berczy enrolled in the 5th Battalion of the Lower Canada Select Embodied Militia as a lieutenant at the outset of the War of 1812. In July 1813 he became acting assistant adjutant-general at Montreal. He was promoted to captain on 26 September 1813. In April 1814 the 5th Battalion became the newly created corps of Canadian Chasseurs, and he would have completed his service in this corps.[1]

The artist has portrayed himself wearing a scarlet coat faced with black, with Light Infantry wings on

the shoulders and a whistle and chain on the shoulder belt. This is evidently the uniform of the 5th Battalion; when it became named Canadian Chasseurs in 1814, the officer's coat would have been a very dark green.[2]

The military uniform is painted in a detailed manner, in gouache. The face and head are painted in watercolour, with very short hatching; the background of subtle grey-green is rendered in a mottled network of strokes. The eyes and mouth lack the subtlety of expression seen in miniatures by William Berczy Senior.

1. L. Homfray Irving, *Officers of the British Forces in Canada during the War of 1812–15* (Toronto: Canadian Military Institute, 1908), pp. 100, 131–33.

2. René Chartrand, "The Lower Canada Select Embodied Militia Battalions, 1812–15," in *Military Illustrated, Past and Present,* no. 4 (London: Military Illustrated Ltd., 1987), pp. 38–42; and René Chartrand, "The Canadian Chasseurs, 1814–1815," in *Journal of the Society for Army Historical Research,* LXVII:272 (winter 1989), pp. 273–74.

WBB 3
Amélie Panet Berczy c. 1815

Watercolour with touches of white gouache, on ivory
5.8 × 4.5 cm
INSCRIPTIONS: on loose sheet of paper kept in locket, in ink, *Portrait de ma chère femme / peint par moimême / en 1815*
Dr and Mme C. Bertrand

PROVENANCE: by descent in Panet-Lévesque family to Céline Dupuis; Dr and Mme C. Bertrand.
EXHIBITIONS: 1887 Montreal; 1892 Montreal.
REFERENCES: Montreal 1887, p. 17, no. 134–712; Montreal 1892, p. 29, no. 432 (described as an "oil"); Andre 1975, pp. 168, 174.

In his last will, William Bent Berczy described one of his bequests as "the miniature portrait of my late wife with the golden locket containing it and my own miniature portrait made on ivory both made by myself...."[1] The locket containing the two portraits (WBB 2, 3) was left to his niece, Marie-Louise Panet.

Here, Amélie Panet (1789–1862) is portrayed in the same pose, and in the same style of dress as seen in early portraits of her by Berczy Senior, painted when she was about sixteen years old (cat. 65, 66). However, William Bent has not copied the face painted by his father; in 1815 he shows an Amélie who is noticeably older and less beautiful. The style of miniature painting is similar to his self-portrait (WBB 2). The background is a very soft grey, and the dress is blue.

1. Manuscript copy of L.-F.-G. Baby's translation of the will, owned by descendants of William Bent Berczy.

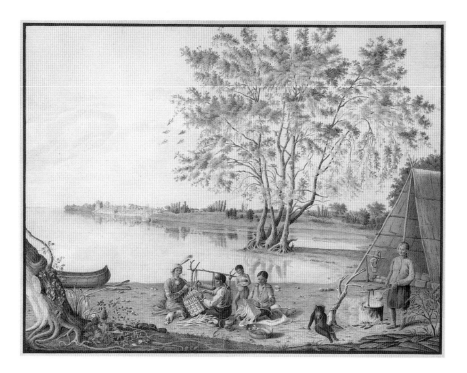

WBB 4
Indian Encampment near Amherstburg
c. 1819–30

Watercolour over graphite on wove paper
36.3 × 47.9 cm
INSCRIPTIONS: Verso: on label in ink, *Peinture faite par / William de Moll Berczy / époux d'Amélie Panet / appartenant à / Maman / Mélanie Lévesque Dupuis / Succession Panet-Lévesque* (same inscription repeated on a second label of more recent date)
Dr and Mme C. Bertrand

PROVENANCE: by descent in Panet-Lévesque family to Céline Dupuis; Dr and Mme C. Bertrand.
REFERENCES: Andre 1975, pp. 175–76.

The artist has divided his composition into three distinct areas: a foreground coulisse of land with figure studies; the middleground, which features a tall and graceful tree; and a background shoreline with houses.

An Indian family group occupies the central foreground: a man wearing a turban and silver ornaments smokes his pipe; two women weave woodsplint baskets; a child holds his pet squirrel, and a baby rocks in a cradleboard. Near the family, a small bear cub is tethered to a tree and examines his leash with interest. The older woman standing at the cooking fire on the right and the tent behind her (which is rather large to be made of bark), were

possibly adapted from the right-hand portion of a composition by George Heriot, titled *Costume of Domiciliated Indians of North America,* which was published in aquatint in 1807. The left foreground contains a tree trunk and plant life, an Ojibwa-type canoe, and a painted paddle.

The tree that occupies the middle distance is growing on a spit of land, which is probably Elliott's Point. In the background, the town of Amherstburg reflects in the lake like a distant dream. However, the buildings are drawn with care and precision. From left to right they are: the commissariat, c. 1816, but omitting the commissariat offices which were constructed in 1832; the Gordon house, with balconies, built about 1798. Beside it are two similar houses, which appear to be one house: one is the Park house of c. 1798–99, and the other is likely the house occupied by Charles Berczy in 1820. The large house near the poplars and behind a wall is "Belle Vue," the estate of Robert Reynolds.[1]

1. For information regarding early buildings in Amherstburg (WBB 4–6), I am indebted to Stephen A. Otto, Toronto; and H.J. Bosveld, Area Superintendent, Fort Malden National Historic Site.

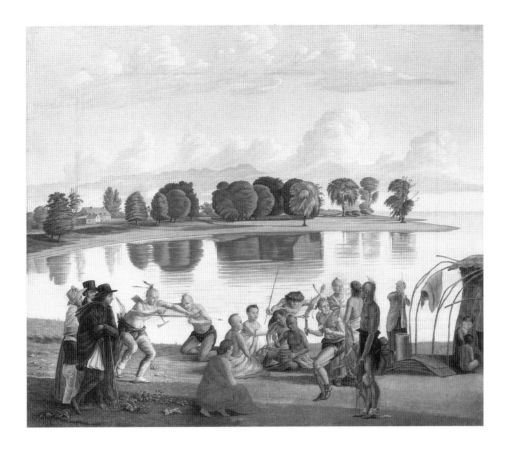

WBB 5
Indian Dance at Amherstburg c. 1825–28

Oil on canvas
58.7 × 68.5 cm
National Gallery of Canada 30860
Purchased with the assistance of a grant from the Government of Canada under the terms of the Cultural Property Export and Import Act.

PROVENANCE: by descent in the Panet-Lévesque family; sold at unknown date to Kennedy Gallery, New York; M. Knoedler & Co. Inc., New York; Northern Natural Gas Co. of Omaha (later called Enron Foundation Omaha); Gene Autry Western Heritage Museum, Los Angeles, 1989; purchased NGC, 1990.

EXHIBITIONS: 1887 Montreal; 1976 Omaha (attr. to James Otto Lewis).

REFERENCES: Montreal 1887, p. 16, no. 117; Mildred Goosman, *Artists of the Western Frontier* (Omaha: Joslyn Art Museum, 1976), p. 44, no. 62 (attr. to James Otto Lewis), repr. p. 22.

William Bent Berczy lived in Amherstburg, Upper Canada, from 1817 until 1832, and he chose this setting for three paintings depicting Indian themes. The view is of the shoreline just south of the town, looking towards Elliott's Point in the background, a land feature which no longer exists.[1] The buildings at the left must be the Elliott barns.

This painting (pl. XVI) is probably the oil that was exhibited in Montreal in 1887. The catalogue described it as "Indian Dance. oil painting. At Bois Blanc Island, near Detroit. Painted by Wm. Berczy, Jr., in 1828. Colln. Pierre-T. Lévesque."[2] Despite this title, the topography suggests that the site is the Amherstburg shoreline rather than nearby Bois Blanc Island.

The costumes date the painting to the 1820s. Among the clothing worn by the three white spec-

tators at the left, the woman's broad-brimmed bonnet only came into style about 1817; however, such bonnets, especially those in straw, were in ongoing use in non-fashionable groups from 1811 until about 1820. The man's and boy's costumes date to about 1825; the hats could be as early as 1818, and not later than 1830, unless very out of date.[3]

The composition, depicting nineteen figures, is carefully constructed and must have been the result of one or more preparatory studies. The white family in the left foreground is accompanied by a cloaked Indian guide; they are watching a ceremonial dance. An Indian with a painted face at the left aims an arrow at the figure carrying a gun-stock club, just right of centre. Another Indian kneeling at the left swings a pipe tomahawk. In the centre are four seated musicians, playing the water drum and gourd rattle, and singing. At the right is a domestic scene; a woman uses a mortar and pestle, and another woman and child are seated in a partly finished bark dwelling.[4]

The landscape in the background is sharp and clear, with each tree given its own surreal volume. Flecks of yellow add a sparkle of light to the foliage. The combination of a detailed Indian genre scene in the foreground and reflected landscape in the background was used by William Bent in two watercolour paintings, also set in the Amherstburg area (WBB 4, 6).

1. Matthew Elliott (d. 1814), native of Ireland, came to the United States in 1761, and was engaged in the Indian trade and government service at Fort Pitt. During the American Revolution he was an active leader of Indians for the Loyalist cause. After the American occupation of Detroit he settled just south of Amherstburg. He was Superintendent of Indian Affairs, 1796–97 and 1807–14. His home developed into a showplace in the region, and he eventually owned 4,000 acres. His first house was severely damaged during the War of 1812; his widow received war claims in 1824, and a second house was built, possibly as late as 1834. See Edith G. Firth, *The Town of York, 1793–1815: A Collection of Documents of Early Toronto,* Ontario series 5 (Toronto: The Champlain Society, 1962), p. 243.

2. Pierre-T. Lévesque was a nephew of Amélie Panet Berczy, being the son of Mélanie Panet and the husband of Marie-Louise Panet. Marie-Louise inherited a number of paintings from her uncle, William Bent Berczy.

3. Costume analysis is courtesy of Mary Holford, Toronto.

4. The identification of artifacts is courtesy of Kenneth Lister, Ethnology Department, ROM.

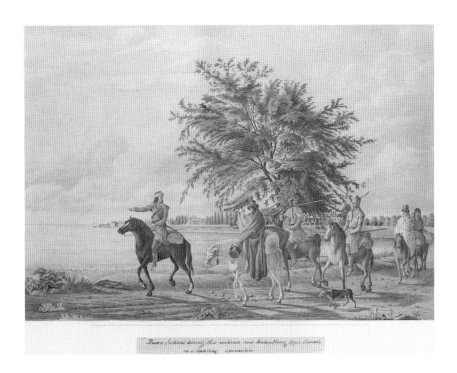

Huron Indians leaving their residence near Amherstburg, Upper Canada, on a hunting excursion

WBB 6
Huron Indians Leaving Their Residence near Amherstburg, Upper Canada, on a Hunting Excursion c. 1825–34

Watercolour over graphite on wove paper
30.1 × 43.1 cm
INSCRIPTIONS: l.c. on label, *Huron Indians leaving their residence near Amherstburg, Upper Canada / on a hunting excursion;* Verso: on backing sheet, in scattered areas, *AJP, AEP, JEEP* [in monogramme]; *Breton; Great St James St* [in reverse]; and a drawing of a head in profile
National Gallery of Canada 15305

PROVENANCE: Colin McMichael, Montreal; purchased NGC, 1967.
EXHIBITIONS: 1984 AGO.
REFERENCES: Andre 1975, pp. 174–75; Reid and Vastokas 1984, p. 30, no. 95; NGC 1988, p. 83.

The artist has created a delicate balance between landscape, townscape, and genre study. Six figures on horseback cross the front plane of the painting, the leading horseman pointing into the distance. Their facial features are only summarized but much care is lavished on costume detail, including powder horns, rifles, leather pouches, and a skin coat with shoulder fringes and silver armbands. Almost equal attention has been paid to the distant landscape of Amherstburg, so that the houses are identifiable. In the background, on the point of land at the left, can be seen the commissariat storehouse, built in 1816; and beside it a smaller building, which may be the commissariat office, built in 1832. In the space between the first and second figures stands "Belle Vue," the house that Robert Reynolds built in 1819.[1] The large house seen to the right of the foreground tree may be the second Elliott house, which was built sometime after 1824, and possibly as late as 1834. In spite of the quantity of descriptive detail, the artist has given a dominant place to nature in the form of a graceful central tree, stretching its leafy branches in all directions, under a vast cloudy sky.

1. Robert Reynolds (1781–1865) succeeded his father Thomas Reynolds as deputy assistant commissary general at Fort Malden, Amherstburg. He married Thérèse Bouchette of a prominent Quebec family, and widow of Thomas Hippolite Trottier Desrivières, who in turn was a stepson of James McGill. See cat. 68.

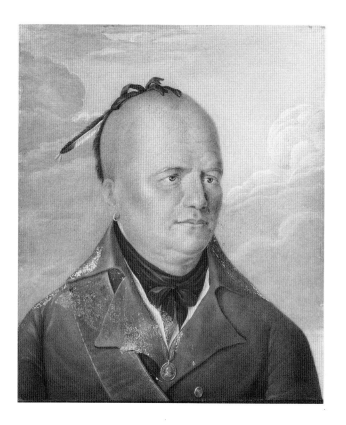

WBB 7
Joseph Brant 1828

Gouache over graphite on paper, laid down on card
14.7 × 12.4 cm

INSCRIPTIONS: on label formerly glued to wood frame back, in ink, *Brant Chef Mohawk / peint / [par]? / Mr. Wm. Berczy [père?] / à York ou Toronto / Haut Canada.* According to Gérard Morisset, the above note is in Jacques Viger's hand, and in 1941 it was transcribed as follows, *Brandt Chef ...hawk peint en 17*[erased] *par Mr. Wm. Berczy à York ou Toronto Haut-Canada.* Another hand inscribed the date "1842" in the margin; this was later crossed out and replaced with "1792". On verso of backing card, *Brant chef Mohawk / peint en 1797 / par / Mr. Wm. Berczy, père / à York ou Toronto, / Haut Canada / Ce qui précédé a été copie sur / un papier colle en arrière du / cadre et écrit de la main de Jacques Viger. / A.E. Gosselin Ptre / Arch.S.Q.*

Musée du Séminaire de Québec Pf 984.28

PROVENANCE: William Bent Berczy to Jacques Viger, c. 1828; Hospice-Anthelme Verreau, 1860; bequest to Séminaire de Québec, 1901.

EXHIBITIONS: 1887 Montreal (as "pastel by William Berczy Sr.")

REFERENCES: SAUM, U/12374: J. Viger to WBB, Montreal, 28 Sept. 1827; ASQ, Fonds Viger-Verreau, Saberdache bleue, vol. 8, pp. 199–201, 218: WBB to J. Viger, Amherstburg, 27 Oct. 1827 and 17 Apr. 1828; Montreal 1887, p. 16, no. 532. Laval 1906, p. 42, no. 11; Laval/Carter 1908, p. 11, no. 219; Maheux 1939, pp. 878–79, 882; Hamilton 1958, p. 132, note 29; Andre 1967, p. 62; Lesser 1984.

Jacques Viger, family friend, historian, and collector of Canadian artifacts, wrote to William Bent Berczy in September 1827 asking for portraits of Brant and Prescott for his "portrait gallery" album. William replied a month later, saying that he would make copies of these portraits – the originals were by his

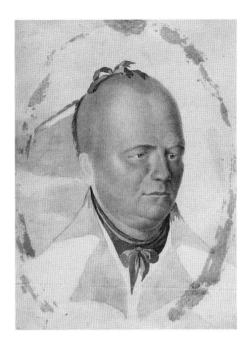

WBB 8
Joseph Brant c. 1828

father – and send them to Montreal. On 17 April 1828, William again wrote to Viger about the Brant portrait:

> *I have a portrait of Brant, begun by Papa; it is the original of the copy that you saw in oils. This one is painted in gouache; I have retouched and finished it but as I have only a few of Papa's works, I am hardly anxious to part with it, although I would do so, if I got its price (£12.1). It is a very finished work, in miniature style.*

Examination under untraviolet light confirms that this portrait has been extensively overpainted. While Viger considered it a work by Berczy Senior, it was so thoroughly retouched by the son that it has become his work.[1]

In expression, the treatment of the face is not as sensitive as usual in the work of Berczy Senior. The mouth, notably, has lost the determined set seen in the two oil-on-canvas portraits (cat. 76, 77) and the oil-on-paper sketch (cat. 75). The pose and costume can be seen in the half-length oil portrait, here cut off at bust level and with a foreground ledge added across the bottom of the composition. The background clouds and sky relate to the full-length painting of Brant (cat. 77).

1. In a footnote by Jacques Viger, appended to a copy of a letter from William Bent Berczy of 27 October 1827, in which WBB promises to make replicas of his father's portraits of Brant and Prescott, Viger states: "I have since received the originals, done by the hand of Mr. Berczy Senior. These are two excellent miniatures in watercolour."

Watercolour over graphite on wove paper, mounted on green wove paper
13.9 × 10.3 cm
Musée du Château Ramezay, Montreal CRX 978.31.1

PROVENANCE: estate of William Bent Berczy to L.-F.-G. Baby; bequest to the Numismatic and Antiquarian Society of Montreal.
EXHIBITIONS: 1989 Château Ramezay.
REFERENCES: SAUM, U/12374: J. Viger to WBB, Montreal, 28 Sept. 1827; ASQ, Fonds Viger-Verreau, Saberdache bleue, vol. 8, p. 199–201: WBB to J. Viger, Amherstburg, 27 Oct. 1827. Lesser 1984; Château Ramezay 1989, p. 25, no. 78.

This unfinished portrait is very close in size and pose to the head of Brant (WBB 7) that William Bent Berczy sent to Jacques Viger. The costume and background are sketched in watercolour. The more finished head is rendered in gouache over watercolour, with hatched strokes which, although following his father's technique, tend to a mechanical repetition that gives a rubbery structure to the face.

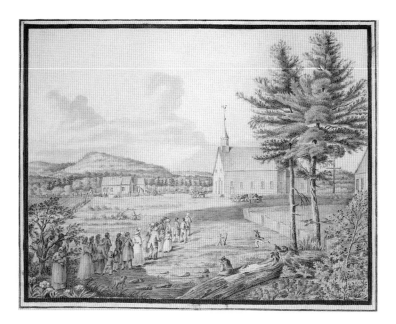

WBB 9
Harvest Festival c. 1840–50

Watercolour over graphite on wove paper
20.3 × 25.6 cm
INSCRIPTIONS: Back of mount, in twentieth-century
hand, *Harvest Festival*
National Gallery of Canada 16648

PROVENANCE: sold at Neilson auction, Quebec City,
c. 1942, to W.H. Coverdale for the Manoir Riche-
lieu Historical Collection of Canadiana, Murray
Bay, Que.; purchased from Canada Steamship Lines,
Montreal, by NGC, 1971.
EXHIBITIONS: 1942 Quebec City.
REFERENCES: Percy F. Godenrath, *Le Vieux Québec*
(Montreal: Canada Steamship Lines Limited [?],
1942), no. 152; Andre 1975, pp. 174–75; Cooke
1983, p. 24, no. 59; NGC 1988, p. 83.

This view probably represents the countryside
around D'Ailleboust, where the artist lived from
1834 onward. A procession of parishioners winds its
way to church, to give thanks for a plentiful harvest.

While combining figures with landscape, as he
had in his Amherstburg genre paintings (WBB 4–6),
William Bent has changed his scale to focus on the
milieu rather than the action. The foreground trees
have that same distinct personality, so noticeable
in the earlier paintings, and the church building is
prominently featured. However, the figures have
been reduced in size, and interest in their activity is
diminished within the composition as a whole.

WBB 10
Columbus Breaking the Egg c. 1850–60

Oil on wood panel
55.5 × 48.9 cm
INSCRIPTIONS: on old tag-label in ink, *From Mrs. R.
Vashon Rogers / a painting done by her / Great Grand.
Father / William Berczy*
Private collection

PROVENANCE: by descent in Berczy family to Mrs Rob-
ert Vashon Rogers; to present owner.
EXHIBITIONS: 1860 Montreal; 1968 ROM; 1973
Kingston; 1980 Market Gallery.
REFERENCES: *Montreal Gazette,* 5 Oct. 1860; Harper
1962, p. 414 (attr. to William von Moll Berczy);
Andre 1967, p. 65, 93–94, repr. opp. p. 136 (attr. to
William Berczy).

The story of Columbus and the Egg was illustrated
by many artists, from the sixteenth century onward,
to depict the ingenuity of Christopher Columbus.
The scene is set at the Spanish court, where envious
courtiers have made little of Columbus's discovery
of a new continent. To show that such an undertak-
ing required method and process, Columbus has
challenged those present to stand an egg upright on
the table, without instruction on how to do so. Two
courtiers hold onto their eggs to keep them upright,
whereas Columbus gives his egg a smart rap on the
table, and stands it in place on its cracked end.

William Bent Berczy's painting is based on a 1753
etching by William Hogarth, which was an illustrat-

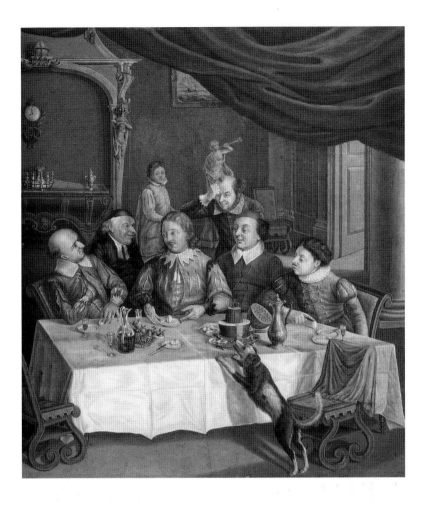

ed subscription ticket for his treatise *The Analysis of Beauty*.[1] This print was copied by numerous engravers through the eighteenth and well into the nineteenth century; any of these versions could have provided the source for the artist.[2] In his oil painting, William Bent has changed Hogarth's composition by creating a panelled room complete with furnishings. He has also transformed two of Hogarth's courtiers into clergy, and has added a standing figure in the background. Most of the dishes on the table are additions; absent is Hogarth's plate of sinuous eels, which referred to the "Line of Beauty."

William Bent Berczy loaned this painting to an exhibition organized by the Art Association of Montreal and held in August of 1860, on the occasion of the visit of the Prince of Wales: he received an "Honorable Mention" for his two submissions.[3]

The paint is applied in an impasto, with colours blended on the surface in a wet-in-wet technique not seen in his father's oil paintings. Still-life details, such as the apple on the plate, are left rough-edged and lacking in volume. However, the whole composition is well integrated, and one wonders whether the setting is entirely the artist's invention or whether it was copied after someone else who elaborated Hogarth's theme.

1. Witt Library, Courtauld Institute of Art, University of London, neg. no. 932/43(28).

2. A possible source for Berczy Junior is the *Magasin Pittoresque* (1833), p. 392: "Colomb cassant l'œuf, facsimile d'une gravure de William Hogarth." In 1839, the artist had copied another illustration (WBB 19) from an 1836 issue of this periodical.

3. *Montreal Gazette,* 5 Oct. 1860, Class VII, Section A, Lower Canada Provincial Exhibition, Fine Arts Department: "To the Hon. W. Berczy, for Oil Paintings, Portrait of 'Brant' and 'Columbus breaking the egg' – Honorable Mention." [This reference was called to my attention by Conrad Graham, McCord Museum.]

WBB 11
Still-life with Geranium c. 1860

Oil on softwood panel
33 × 31.8 cm
INSCRIPTIONS: Verso: on label in black ink, *Peinture par Mr. Bertcy / Co-Seigneur de D'Aillebout / vers 1860* (also a modern inscription, attributing the painting to Berczy Senior)
Private collection
Not in exhibition

William Bent Berczy's painting of a geranium in a glass tumbler is reminiscent of his father's still-life studies (cat. 97, 98). The central subject is well painted, but the composition lacks the eighteenth-century elegance of his father's works: for example, the table is shown as a solid block.

The wood support may have had an earlier use as a painted sign, because the letter "Q" can be seen at the left, in slight relief under the present paint layer. The background has been heavily overpainted at a later date in a flat grey.

WBB 12
Tree Trunk n.d.

Watercolour over graphite on laid paper
16 × 20 cm
Art Gallery of Ontario, Toronto 82/221
Gift of John Andre, 1982

PROVENANCE: Amélie Panet Berczy to her sister Mélanie Panet Lévesque; her son Pierre-T. Lévesque; his daughter Marie-Louise Lévesque de Martigny; her great-niece Marthe Faribault-Beauregard; purchased by John Andre; gift to AGO, 1982.
REFERENCES: Andre 1967, repr. following p. 72 (attr. to William Berczy).

This composition is evidently related to the oil painting of a tree trunk in the full-length portrait of Joseph Brant (cat. 77); for this reason, it was thought to be by Berczy Senior. However, the watercolour was originally bound in a sketchbook that contained watercolours and drawings (see WBB 13, 14), which are attributable to the hand of William Junior. The watercolour is painted in tones of sepia, green, grey, and grey-blue; in this rendering, the trunk is cut off at the right, so that a cross-section of the tree can be seen.

WBB 13
Cap Santé n.d.

Watercolour on laid paper
Approx. 16 × 19 cm
INSCRIPTIONS: l.l. in ink, *Cap Santé cote Nord du St Laurent*
Private collection
Not in exhibition

PROVENANCE: by descent in Panet-Lévesque family to Marthe Faribault-Beauregard; John Andre; to present owner.

The church at Cap Santé, and its picturesque situation on the St. Lawrence River, attracted the attention of painters in watercolour during the late eighteenth and early nineteenth centuries.[1] Berczy Senior praised the view in 1798, but did not mention sketching it at that date:

> *This mighty river, where it meets with others that are very substantial, forms truly grand scenes which yesterday I could not see without admiring between two great points or Capes that are 12 miles distant from one another: one is the Richelieu, where one sees the Church of Deschambault, and the other, Cap Santé. This is another place to do 4 or 5 of the most beautiful landscapes....*[2]

This sketch was made in a small notebook, which also contained a watercolour of a tree trunk (WBB 12) and three sketches of landscape (WBB 14). The inscription on the view of Cap Santé is not in the hand of Berczy Senior, but is not unlike the writing of William Bent Berczy. This may be one of the picturesque scenes that William Berczy set his sons to sketching during their voyage from Quebec to Montreal in 1809.

1. Gérard Morisset, *Le Cap-Santé, ses églises et son trésor* (Quebec: Medium, 1944; 2nd ed., Montreal: MMFA, 1980), pp. 282–83.
2. SAUM, U/1428: Berczy to Charlotte, Quebec, 7 June 1798 (trans. from French).

WBB 14.3

WBB 14
Three Landscape Studies n.d.
1. *Landscape with Fence*
2. *Hilly Landscape*
3. *Buildings and Stream*

Graphite on laid paper
Approx. 19 × 16 cm each
INSCRIPTIONS: colour notes on drawing no. 3, from l. to r., *clair, obscure, fort obscure, remplie de / de la clair clair de /, de la claire / obscure, dans l'ombre;* Verso of drawing no. 1, slight sketch of flower, in graphite
John Andre, Toronto
Not in exhibition

PROVENANCE: by descent in Panet-Lévesque family to Marthe Faribault-Beauregard; John Andre.

WBB 15
Arms of the City of Montreal 1833

Watercolour over graphite on green wove paper, with decorative lithographed borders
27.8 × 23 cm (sheet); 9.8 cm diam. (subject)
INSCRIPTIONS: in subject in brushpoint, *CONCORDIA SALUS / CORP.. MONTREAL / 1833;* l.r., *W.B.;* u.c. in pencil, *Armes de la Cité de Montréal;* l.c., *J. Viger ler. Maire de Montréal / Invenit*
Bibliothèque municipale de Montréal, Viger Album
Not in exhibition

PROVENANCE: Jacques Viger; Misses Lennox, 1858; Raphaël Bellemare, 1860; Bellemare heirs; BMM, Gagnon Collection, 1943.
REFERENCES: BMM, Viger Album, p. 9. Maurault 1944, p. 89.

Jacques Viger (1787–1858), a well-connected Montrealer, had formed a close friendship with William Berczy during the artist's first professional years in Lower Canada; the friendship continued with the entire Berczy family, and Viger saved examples of

Rive droite de l'Embouchure de la Rivière Ste Claire (Vue d'automne, 1832.)

art work and correspondence by William Senior, William Junior, and Amélie Panet Berczy.

Jacques Viger was an original personality, socially attractive, intelligent, and active in many fields.[1] In 1808–09 he worked as editor of the newspaper *Le Canadien* in Quebec City. During the War of 1812 he served with the Voltigeurs canadiens. In December 1813 he replaced Louis Charland as surveyor of highways, streets, lanes, and bridges of Montreal; this experience fostered an interest in town planning, and in Montreal's architectural history. From 1833 to 1836 he served as first mayor of Montreal, and designed the city's coat of arms, which William Bent Berczy illustrated for his album.

Throughout his life, Viger was fascinated by his country's history, and collected both facts and artifacts to create a record of Canadian events. Apart from his own publications, he collected early documents, letters, autographs, prints, drawings, and paintings relating to Canadian history. Some of these collections were mounted into albums or scrapbooks, such as his *Album de Souvenirs Canadiens* (BMM's "Viger Album"); *L'Album des Costumes des Communautés Religieuses de Femmes au Canada en 1853* (collection: BMM); the *Panorama de Montréal* album (ASQ's "Album Verreau"); the thirty-volume *Saberdache rouge* (collection: ASQ), and the thirteen-volume *Saberdache bleue* (collection: ASQ).

1. DCB, vol. VIII, pp. 909–13.

WBB 16
Autumn View, Right Bank of the Mouth of the River St. Clair 1832

Watercolour with traces of graphite, on card with embossed frame surround
27.9 × 22.3 cm (sheet): 7.2 × 11 cm (subject)
INSCRIPTIONS: l.r. in subject in ink, *W.B.;* below subject in ink, *Rive droite de l'Embouchure de la Riviere Ste. Claire. (Vue d'automne, 1832.);* l.l. printed, *De La Rue & Co.;* l.r., *London*
Bibliothèque municipale de Montréal, Viger Album
Not in exhibition

PROVENANCE: Jacques Viger; Misses Lennox, 1858; Raphaël Bellemare, 1860; Bellemare heirs; BMM, Gagnon Collection, 1943.
REFERENCES: BMM, Viger Album, p. 21. Maurault 1944, p. 98.

The St. Clair River connects Lake Huron with Lake St. Clair; the lake then flows into the Detroit River, not far from Amherstburg, where William Bent Berczy lived from 1817 to 1832.

The tiny view is an atmospheric study showing a log house and snake fence at the lake's edge, with a soft yellow sunrise and mauve clouds. The tones used in the composition – pink, yellow, and green – are reflected in the water.

WBB 17
Five Miniature Views n.d.
center: *Tombstone with Musical Notes*
left: *Hunter Shooting Birds*
upper: *McTavish Column and Tomb, Montreal*
right: *The Phantom Hunter*
lower: *Fort Niagara ?*

Watercolour on wove paper, within five printed frames
27.9 × 22.5 cm (sheet); 20.4 × 18.6 cm (subject area, irregular)
INSCRIPTIONS: l.r. of central subject, *W.B.*
Bibliothèque municipale de Montréal, Viger Album
Not in exhibition

PROVENANCE: Jacques Viger; Misses Lennox, 1858; Raphaël Bellemare, 1860; Bellemare heirs; BMM, Gagnon Collection, 1943.
REFERENCES: BMM, Viger Album, p. 37. Maurault 1944, p. 98.

There is most probably a personal reference attached to each of these tiny compositions. The McTavish column may have been designed by William Berczy, and he is known to have made a drawing of it (LW 94). The watercolour of a horse and hunter chasing a deer in the sky seems to be connected with the old German story of the Phantom Hunter, as written by M.E. Kittson on pages 41–42 of the same Viger Album.

WBB 18
Settlement on a Bay n.d.

Watercolour on card with punched border, laid down on album page
5.7 × 8.3 cm (card); 3.5 × 6.3 cm (image)
Bibliothèque municipale de Montréal, Viger Album
Not in exhibition

PROVENANCE: Jacques Viger; Misses Lennox, 1858; Raphaël Bellemare, 1860; Bellemare heirs; BMM, Gagnon Collection, 1943.
REFERENCES: BMM, Viger Album, p. 45.

WBB 19
Le pauvre Peintre 1839

Watercolour on card
27.7 × 22.3 cm (sheet); 8.5 × 14.8 cm (subject)
INSCRIPTIONS: l.r. in subject in ink, *W.B. 1839*
Bibliothèque municipale de Montréal, Viger Album
Not in exhibition

PROVENANCE: Jacques Viger; Misses Lennox, 1858; Raphaël Bellemare, 1860; Bellemare heirs; BMM, Gagnon Collection, 1943.
REFERENCES: BMM, Viger Album, p. 71. Maurault 1944, p. 98.

Jacques Viger noted in the album that William Junior copied this genre theme by the Dutch artist Andries Dirksz Both (1608–1650), as reproduced in a wood engraving in the French periodical, *Le Magasin Pittoresque,* of 1836, page 88. The grotesque caricature satirizes the life of the impecunious painter, who uses a basket for a chair and sits at his easel, while his wife irons what looks like a painting.

WBB 20
Butterfly on a Branch 1829

Watercolour and collage on wove blue-grey paper
27.9 × 22.5 cm (sheet); 9 × 9.9 cm (image, irregular)
INSCRIPTIONS: l.c. in ink, under butterfly, W.B.; under branch, *Papillon peint d'après nature – H.C. 1829*
Bibliothèque municipale de Montréal, Viger Album
Not in exhibition

PROVENANCE: Jacques Viger; Misses Lennox, 1858; Raphaël Bellemare, 1860; Bellemare heirs; BMM, Gagnon Collection, 1943.
REFERENCES: BMM, Viger Album, p. 85.

The artist has cut out his watercolour of a butterfly and glued it to the album sheet; the branch is painted directly on the sheet. This delicate work reminds us of the type of art lesson that Charlotte Berczy probably gave at her finishing school in Montreal, and which her son playfully repeated two decades later.

WBB 21
Camp of the Voltigeurs canadiens at Point Henry in 1813 c. 1839

Watercolour heightened with white on brown wove paper, with lithographed gold border
22.7 × 22.2 cm (sheet); 13 × 16.7 cm (subject)
INSCRIPTIONS: l.r. in subject in ink, *W.B.;* l.c. below subject, *Le Camp des Voltigeurs Canadiens à la Pointe Henry, vis-à-vis Kingston, H.C. / (1813)*
Bibliothèque municipale de Montréal, Viger Album
Not in exhibition

PROVENANCE: Jacques Viger; Misses Lennox, 1858; Raphaël Bellemare, 1860; Bellemare heirs; BMM, Gagnon Collection, 1943.
REFERENCES: BMM, Viger Album, p. 107.

Jacques Viger served with the Voltigeurs canadiens during the War of 1812, and his own sketches no doubt furnished the artist with a basis for his watercolour. On pages 105–06 of this album is Viger's description of the encampment at Point Henry, which is an extract from a letter written to his wife during the war and dated 10 June 1813:

> … *the site where the Camp of the Canadian Voltigeurs lies. It is made up of two rows of Marquees bordering left and right a broad street serving as Avenue to our Major's Quarters, tented at one of its ends: − the other end is closed off by a small entrenchment. Truly, on a fine day, our little camp is a pretty sight….*

William Bent Berczy made another sketch of this subject for Jacques Viger, which is dated 1839 (see WBB 33).

WBB 22
Marquis de Montcalm n.d.

Watercolour on wove paper, with embossed borders and columns
27.7 × 22.3 cm (sheet); 12.5 × 10.5 cm (portrait oval)
INSCRIPTIONS: l.r. below embossed frame, in ink, *W.B.;* l.c. in pencil, *Montcalm;* on embossed columns to l. and r., names and dates of battles, *Chouaguen ou Oswego / 14 Aout 1756; Fort George ou F. Wm. Henry / 9 Aout 1757; Ticonderoga ou Carillon / 2 Juillet 1758; Montmorency, 3 Juillet 1759 / Quebec 13 Sept. 1759;* Verso: crest of Montcalm in watercolour, gouache, and ink, in oval 12.5 × 10.5 cm; l.c. in subject, in brown ink, *Montcalm*
Bibliothèque municipale de Montréal, Viger Album
Not in exhibition

PROVENANCE: Jacques Viger; Misses Lennox, 1858; Raphaël Bellemare, 1860; Bellemare heirs; BMM, Gagnon Collection, 1943.
REFERENCES: BMM, Viger Album, p. 149.

For his portrait album of Canadian notables, Jacques Viger actively sought out early engravings depicting

WBB 23
Dragonfly and Housefly 1829

Watercolour with touches of gouache and gum arabic, and collage on blue wove paper
28 × 22.4 cm (sheet); 14.2 × 9.3 cm (subject area inside 'frame')
INSCRIPTIONS: in subject in ink, *W. / B.*; l.c., *Demoiselle peinte d'après nature par W.B. / H.C. – 1829*
Bibliothèque municipale de Montréal, Viger Album
Not in exhibition

PROVENANCE: Jacques Viger; Misses Lennox, 1858; Raphaël Bellemare, 1860; Bellemare heirs; BMM, Gagnon Collection, 1943.
REFERENCES: BMM, Viger Album, p. 167.

William Bent Berczy has decorated this page of the Viger Album with a work combining collage and *trompe-l'œil* painting. The dragonfly is cut out and laid down; the housefly and legs of the dragonfly are painted directly onto the album sheet. A border of embossed green paper is also added, to frame the subject.

long-dead heroes. On 12 February 1833 he recorded that John Neilson, owner of the *Quebec Gazette* newspaper and printing company, had procured an engraved portrait of Montcalm for him, and that he had commissioned a copy to be made of it.[1] In 1838 he was still trying to acquire engraved portraits from France, including one more of Montcalm.[2]

Louis Joseph de Montcalm-Gozon, Marquis de Montcalm (1712–1759), was captain-general and commander-in-chief of the French forces in Canada from 1756 to 1759. He defended the French colony against British forces until his death at the Battle of Quebec. The portrait of Montcalm is adapted from the 1790 etching by Antoine-Louis-François Sergent (1751–1847), with the image reversed, which suggests a variant print source.

1. ASQ, Fonds Viger-Verreau, Saberdache bleue, vol. 9, p. 149: J. Viger to Mme Viger, Quebec, 12 Feb. 1833.
2. ASQ, Fonds Verreau 62, no. 227; Denis Martin, *Portraits des héros de la Nouvelle-France: Images d'un culte historique* (Québec: Éditions Hurtubise HMH Ltée, 1988), p. 4.

WBB 24
Madame de Champlain 1840

Watercolour on wove paper, with paper-lace borders
17.3 × 11.2 cm (sheet); 13.3 × 7.7 cm (subject)
INSCRIPTIONS: u.r. in pencil, *Mad. de Champlain*
Bibliothèque municipale de Montréal, Viger Album
Not in exhibition

PROVENANCE: Jacques Viger; Misses Lennox, 1858;
 Raphaël Bellemare, 1860; Bellemare heirs; BMM,
 Gagnon Collection, 1943.
REFERENCES: BMM, Viger Album, p. 170; SAUM,
 U/12411: J. Viger to WBB, Montreal, 23 Mar.
 1840; U/12412: J. Viger to WBB, Montreal, 13 Apr.
 1840. Maurault 1944, p. 93.

Jacques Viger mentions the Champlain portraits in
letters of 23 March and 13 April 1840:

> *The whisper is everywhere that Mr. de Champlain is a*
> *delight, and that Madame, his gem of a wife is sweet*
> *enough to eat, so charming are they.... Shall I not con-*

sider myself very fortunate to have them, when you are
free to send them?

Although the identification of the subject is doubt-
ful, it was probably based on a print thought to be
Madame de Champlain in William Bent's day. He
has painted her in delicate miniature style.

WBB 25
Samuel de Champlain 1840

Grey wash with pink border on wove paper
17.2 × 11.2 cm (sheet); 8 × 7 cm (subject)
INSCRIPTIONS: l.c. in brown ink, *Samuel de Champlain*
Bibliothèque municipale de Montréal, Viger Album
Not in exhibition

PROVENANCE: Jacques Viger; Misses Lennox, 1858;
 Raphaël Bellemare, 1860; Bellemare heirs; BMM,
 Gagnon Collection, 1943.
REFERENCES: BMM, Viger Album, p. 170; SAUM,
 U/12411: J. Viger to WBB, Montreal, 23 Mar.
 1840; and U/12412: J. Viger to WBB, Montreal,
 13 Apr. 1840. Maurault 1944, p. 93; Denis Martin,
 *Portraits des héros de la Nouvelle-France; Images d'un
 culte historique* (Quebec City: Éditions Hurtubise
 HMH Ltée, 1988), p. 92, repr. p. 78 (attr. to un-
 known artist).

The portraits of the Champlains are not signed;
however, the monochrome rendering of Samuel de
Champlain (1567?–1635) corresponds in style to the
portrait of Montcalm (WBB 22) by William Bent
Berczy in the same Viger Album. The source of the
Champlain images has not been found; they appear
to be fictitious likenesses of the noted explorer and
his wife.

WBB 26
Chapel at Tadoussac; Stag and Doe n.d.

Watercolour on white wove paper; watercolour on
 brown wove paper
10.2 × 17.6 cm; 5.4 cm diam.
INSCRIPTIONS: l.r. in subject in pencil, *Chicoutimi*
Bibliothèque municipale de Montréal, Viger Album
Not in exhibition

PROVENANCE: Jacques Viger; Misses Lennox, 1858;
 Raphaël Bellemare, 1860; Bellemare heirs; BMM,
 Gagnon Collection, 1943.
REFERENCES: BMM, Viger Album, p. 274.

The landscape with the small chapel on the shores of
the Saguenay River in Chicoutimi County is paint-
ed in tones of blue-green. A second composition
representing a stag and doe is also rendered in the
style of William Bent Berczy.

WBB 27
Two Landscapes with Houses n.d.

Watercolour on pink wove paper, with embossed frames
3.9 × 5.7 cm (upper subject); 3.7 × 5.7 cm (lower subject)
Bibliothèque municipale de Montréal, Viger Album
Not in exhibition

PROVENANCE: Jacques Viger; Misses Lennox, 1858;
 Raphaël Bellemare, 1860; Bellemare heirs; BMM,
 Gagnon Collection, 1943.
REFERENCES: BMM, Viger Album, p. 298.

These two very small views are painted within em-
bossed borders, on the upper and lower parts of an
album sheet; stylistically they are similar to other
small illustrations by William Bent Berczy. They il-
lustrate Quebec scenes, showing houses and a way-
side cross, and a village with a church. A central and
larger subject is a watercolour by John Grant (active
c. 1825–1850) depicting habitants; its placement on
the same page led some early viewers of the album
to attribute the smaller compositions to Grant as
well, although they are painted in a much different
style.

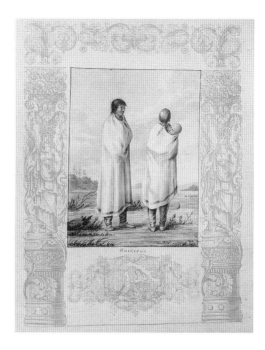

WBB 28
Salteaux n.d.

Watercolour on green wove paper, with lithographed
 decorative borders
27.7 × 22.4 cm (sheet); 14.2 × 10.5 cm (image)
INSCRIPTIONS: l.r. in subject in brushpoint, *WB;* l.c.
 below image, *Saulteux*
Bibliothèque municipale de Montréal, Viger Album
Not in exhibition

PROVENANCE: Jacques Viger; Misses Lennox, 1858;
 Raphaël Bellemare, 1860; Bellemare heirs; BMM,
 Gagnon Collection, 1943.
REFERENCES: BMM, Viger Album, p. 302. Maurault
 1944, p. 96 (attr. to James Duncan).

The Salteaux are a western branch of the Ojibwa
Indians, living in the woodlands of western Ontario.
The figures of the man and woman with infant are
disposed to show front and back views, as in cos-
tume illustrations.

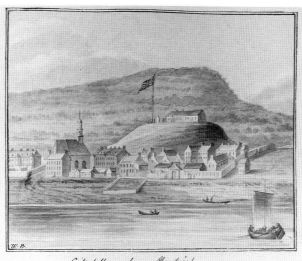

Citadelle de Montréal.

WBB 29
The Citadel, Montreal n.d.

Watercolour heightened with white on pink wove paper
27.7 × 22.2 cm (sheet); 12.1 × 14.9 cm (image)
INSCRIPTIONS: l.l. in subject in black ink, *W.B.;* l.c.
 below subject, *Citadelle de Montréal*
Bibliothèque municipale de Montréal, Viger Album
Not in exhibition

PROVENANCE: Jacques Viger; Misses Lennox, 1858;
 Raphaël Bellemare, 1860; Bellemare heirs; BMM,
 Gagnon Collection, 1943.
REFERENCES: BMM, Viger Album, p. 316. Maurault
 1944, p. 98.

Jacques Viger had replaced Louis Charland (cat. 51) as surveyor of highways, streets, lanes, and bridges of Montreal in 1813. In this capacity, he was involved in town planning, and when the mound where the citadel had stood was levelled, between 1817 and 1821, he drafted a plan for the use of the cleared land.[1] Even before he became the first mayor of the city, from 1833 to 1836, he had been interested in compiling a visual record of early Montreal, and he commissioned artists to paint views of its streets and buildings.

In his albums there are four sketches of Citadel Hill,[2] which illustrate the development of the city at different dates; these views are historic reconstructions, evidently compiled with the help of civic documents available to Viger. This view shows the site as it would have looked in about 1800. Citadel Hill was at the east of the old city; its location is now a parking lot at the east end of Notre-Dame Street, opposite Viger Square.

1. ASQ, Fonds Viger-Verreau, Saberdache bleue,
 vol. 5, pp. 242–49.
2. WBB 29, 36, 38, and a watercolour by James Dun-
 can (collection: MSQ, Pf 988.3).

WBB 30
Madame d'Youville n.d.

Grey wash over graphite on wove paper
21.6 × 17.2 cm (sheet); 11.1 cm diam. (subject, including 'frame')
INSCRIPTIONS: in index, p. XIII of this album, *Portrait de Made. De Youville, par Wm. Berczy, Fils, Ecr. p. 126*
Archives du Séminaire de Québec, Saberdache rouge

PROVENANCE: Jacques Viger; Misses Lennox, 1858; Hospice-Anthelme Verreau, 1860; bequest to Séminaire de Québec, 1901.
REFERENCES: ASQ, Fonds Viger-Verreau, Saberdache rouge, vol. E, facing p. 126. Bibaud 1858 (1891 ed., p. 309); Maheux 1939, pp. 880, 882; Ouellet 1955, no. 5, p. 45; Madeleine Major-Frégeau, *La vie et l'œuvre de François Malepart de Beaucourt (1740–1794)*, Civilisation du Québec, no. 24 (Quebec City: Ministère des Affaires culturelles du Québec, 1979), p. 65, repr. no. 9, p. 75.

Marie Marguerite Dufrost de La Jemmerais, Madame d'Youville (1701–1771), was born in Lower Canada, and was widowed in 1730. She then devoted her life to charity, and was placed in charge of the Hôpital-général in Montreal in 1747. Here she founded the order of Sisters of Charity, also known as the Grey Nuns. She was canonized on 9 December 1990, and became the first Catholic saint born in Canada.

Berczy Junior's watercolour is a copy of the 1792 portrait of Mother d'Youville by François Beaucourt (collection: Hôpital-général, Montreal). Viger commissioned James Duncan to copy the same Beaucourt portrait, which he kept in another album devoted to the religious communities of Montreal (collection: BMM). Both our artist and Duncan omit the figure of a second child from their copies of the Beaucourt.





WBB 31
L'abbé Louis Normant post-1845

Watercolour on wove paper

21.3 × 16.5 cm (sheet); 11.1 cm diam. (subject, including margins)

WATERMARK: *J DE WINNY ... / 1845*

INSCRIPTIONS: in index, p. XIII of this album, *7. Portrait de Mr. Louis Normant, ptre, par Wm. Berczy Fils Ecr. p. 152*

Archives du Séminaire de Québec, Saberdache rouge
Not in exhibition

PROVENANCE: Jacques Viger; Misses Lennox, 1858; Hospice-Anthelme Verreau, 1860; bequest to Séminaire de Québec, 1901.

REFERENCES: ASQ, Fonds Viger-Verreau, Saberdache rouge, vol. E, facing p. 152. Ouellet 1955, no. 6, p. 45.

Father Louis Normant du Faradon (d. 1759) of the Sulpician order was superior of the Seminary of St-Sulpice at Montreal from 1732. He was a supporter and patron of Madame d'Youville in her charitable works and in the founding of the order of Sisters of Charity (see WBB 30). William Bent's watercolour is after a posthumous portrait by Philippe Liébert (1732/34–1804), in the collection of the Hôpital-général, Montreal.





WBB 32
Elevation of the Cascades Bridge 1839

Grey wash over graphite on wove paper

21 × 13.3 cm (sheet): 10.9 × 13.3 cm (subject)

INSCRIPTIONS: u.l., *Elévation / du Pont des / Cascades.*; l.c., *Dessin de W. Berczy, Ecr. d'après mon Croquis original. 1839. (J.V.)*

Archives du Séminaire de Québec, Saberdache bleue
Not in exhibition

PROVENANCE: Jacques Viger; Misses Lennox, 1858; Hospice-Anthelme Verreau, 1860; bequest to Séminaire de Québec, 1901.

REFERENCES: ASQ, Fonds Viger-Verreau, Saberdache bleue, vol. 3, p. 4. Ouellet 1955, no. 2, p. 100.

This diagramatic drawing shows a bridge over the Soulanges canal, which links Lakes St. Louis and St. Francis at the junction of the Ottawa and St. Lawrence Rivers. First built in 1779, and later enlarged, this improvement in communication would have attracted the interest of Jacques Viger, both as roads commissioner and as historian. William Bent Berczy's wash drawing is based on a sketch by Viger, which may explain its strange perspective; the lower portion of the sheet contains a plan by Viger of the same site.





WBB 33
Redoubt, Telegraph, and Camp of the Voltigeurs at Point Henry in 1813 1839

Grey wash over graphite on wove paper
20.8 × 13.7 cm
INSCRIPTIONS: l.c. in ink, *Redoute, Télégraphe et Camp des Voltigeurs, / à la Pointe Henri, vis-à-vis Kingston. 1813.– ;* l.r., *Dessin de W. Berczy Ec: d'après croquis. 1839. (JV.)*
Archives du Séminaire de Québec, Saberdache bleue
Not in exhibition

PROVENANCE: Jacques Viger; Misses Lennox, 1858; Hospice-Anthelme Verreau, 1860; bequest to Séminaire de Québec, 1901.
REFERENCES: ASQ, Fonds Viger-Verreau, Saberdache bleue, vol. 3, p. 36. Ouellet 1955, no. 5, p. 100.

For a more general view of this subject, see WBB 21.

WBB 34
American Flintlock Musket and Cartridge Pouch
1839

Brown and grey washes over graphite on wove paper
20.1 × 13.3 cm
INSCRIPTIONS: l.l. in ink, *Fusil Américain.;* l.r., *Cartouche Américaine. / par M. W. Berczy. / 1839*
Archives du Séminaire de Québec, Saberdache bleue

PROVENANCE: Jacques Viger; Misses Lennox, 1858; Hospice-Anthelme Verreau, 1860; bequest to Séminaire de Québec, 1901.
REFERENCES: ASQ, Fonds Viger-Verreau, Saberdache bleue, vol. 3, p. 116. Ouellet 1955, no. 11, p. 100.

The composition shows an American flintlock musket with bayonnet attached, a model current about 1816 to 1822, of a Springfield make. Hanging from a tree is a cartridge pouch, inscribed *U.S.* on the flap. At the right is a section detail showing a paper cartridge with "buck and ball," that is, buckshot and three small balls.

WBB 35
Presbytery at Longue-Pointe 1828

Grey and black washes over graphite on wove paper
18.4 × 23.5 cm (sheet); 12.8 × 16.2 cm (image)
INSCRIPTIONS: in index to this album, *31. Presbytère de la
Longue Pointe, – premier Collège de Montréal.;* at end of
index, *Le 31ᵉ est de Mr. Berczy, fils. (Canadien)*
Archives du Séminaire de Québec, Verreau Album
Ottawa and Quebec City venues only

PROVENANCE: Jacques Viger; Misses Lennox, 1858;
Hospice-Anthelme Verreau, 1860; bequest to Sémi-
naire de Québec, 1901.
REFERENCES: ASQ, Verreau Album, p. 31. Andre 1975,
p. 175.

The index to this album is titled *Panorama de Mon-
tréal.* Inscribed in pencil on the first tissue-sheet of
the album is the notation, *par / Drake, anglais / 1826.
/ W. Berczy. /1828–.* The album contains thirty views
of Montreal buildings by John Poad Drake (1794–
1883), one by William Bent Berczy, and two by
James Duncan.

The watercolour shows the curé of Longue-
Pointe holding the sacrament as he travels in an open
carriage, perhaps to visit a sick parishioner; the
townspeople kneel at the roadside and in the door-
way of a background house. Whether the house
is represented as the old presbytery is not clear;
however, the composition is one of Berczy Junior's
more successful works. In keeping with the views by
John Poad Drake, he has restricted his colours to
monochrome black washes.

The first college of Montreal started in the pres-
bytery of the parish of Longue-Pointe in 1767,
under the direction of Monsieur Curatteau de la
Blaiserie, a Sulpician priest. In 1773 the college
moved to Montreal, where it was lodged in the
Château Vaudreuil on Saint Paul Street.[1]

1. Maurault 1942, p. 127.

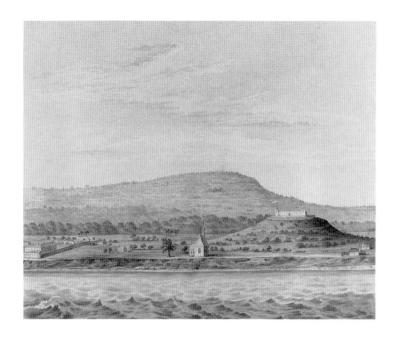

WBB 36
The Old Citadel of Montreal n.d.

Watercolour over graphite on wove paper
18.7 × 24.1 cm
INSCRIPTIONS: Verso: in hand of Jacques Viger, in ink, *Ancienne Citadelle de Montréal / Dessin de Duncan;* in pencil, *Grand Album de pièces originales, fol. 30;* and stamp of ASQ
Musée du Séminaire de Québec Pf 988.2

PROVENANCE: Jacques Viger; Misses Lennox, 1858; Hospice-Anthelme Verreau, 1860; bequest to Séminaire de Québec, 1901; transferred to MSQ 1988.
EXHIBITIONS: 1988 Château Ramezay.

Although this watercolour has been identified on the verso as the work of James Duncan, it shows none of Duncan's free and painterly style. It is rendered in short strokes and a careful miniaturist manner, in tones of blue-green and brown, consistent with the known work of William Bent Berczy. Jacques Viger did own a watercolour of the site by James Duncan, which shows the hill before the fortification was built (collection: MSQ, Pf 988.3).

This watercolour shows the Montreal Citadel, which dated from 1693, at a period when the city had not yet grown up around it. On the shoreline is the chapel of Notre-Dame-de-Bonsecours, and at the left the palisaded building, which from its placement seems intended to represent the house of Charles Le Moyne de Longueuil (1687–1755), governor of Montreal from 1749 to 1755. For other views of Citadel Hill by the artist, see WBB 29, 38.

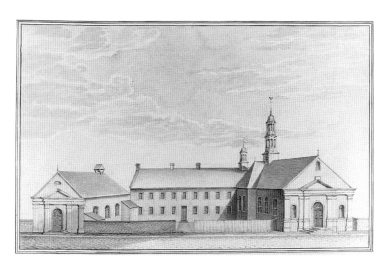

WBB 37
Church, Chapel, and Residence of the Jesuits at Montreal c. 1839

Watercolour, pen and ink, graphite, with ruled ink borders, on wove paper

16.6 × 25.2 cm

INSCRIPTIONS: Verso: in ink, *Eglise, Chapelle et Résidence des RR. PP. jj. / à / Montréal / Jacques Viger / Dessiné par Duncan*

Musée du Séminaire de Québec Pf 986.24

PROVENANCE: Jacques Viger; Misses Lennox, 1858; Hospice-Anthelme Verreau, 1860; bequest to Séminaire de Québec, 1901; transferred to MSQ, 1986.

EXHIBITIONS: 1988 Château Ramezay.

REFERENCES: SAUM, U/12407: J. Viger to WBB, Montreal, 6 May 1839.

Jacques Viger identified this drawing as by James Duncan. It seems more probable, however, that this slightly awkward 'elevation' is the work of William Bent Berczy, who had access to drawings of the Jesuit buildings from his father's sketches. The composition, which is documentary in intention, is carefully squared off in pencil. It is coloured in tones of pale beige-yellow, brown, blue, and grey.

In Viger's letter of 6 May 1839, he referred to various drawings that William Junior was to supply for his album, including one of the church of the Jesuits:

> *I have thought since, that your* Church of the Jesuits, *your façade of the* old Intendance *on the river side, and* my niche *for the* Bust of George III, *being antiques of the sort that make up my* Album, *not Mme V's — would be better put in mine than in hers, if you have the patience to do them on three pieces of paper as small as you please & they will then be glued on as many blank sheets of that* Album *of mine, there is room for them.*

Viger sometimes commissioned more than one artist to illustrate the same historic site. In 1827 he had asked William Bent Berczy for a copy of his father's elevation of the Château Vaudreuil ("l'ancienne Intendance").[1] A watercolour drawing of this building, in the *Saberdache bleue,*[2] has a setting of landscape with figures rendered in the fluid manner of James Duncan; in contrast, the building is drafted in architectural outline. As the Château Vaudreuil was destroyed by fire in 1803, Duncan must have based his illustration on an earlier source, probably an elevation by Berczy Senior.

1. SAUM, U/12374: J. Viger to WBB, Montreal, 28 Sept. 1827; and ASQ, Fonds Viger-Verreau, Saberdache bleue, vol. 8, p. 281ff.: WBB to J. Viger, Amherstburg, 17 April 1828.

2. *Chateau Vaudreuil,* grey-brown wash, pen and brown ink over graphite, 25.7 × 18.2 cm [ASQ, Fonds Viger-Verreau, Saberdache bleue, Reg. 049, p. 32].

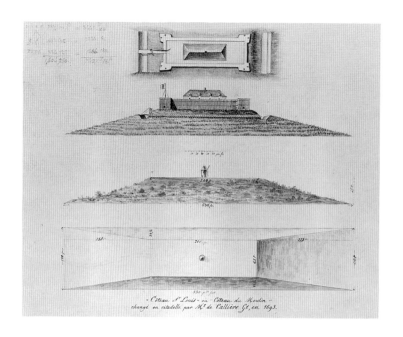

WBB 38
Windmill Hill Becomes Citadel Hill n.d.

Watercolour, pen and ink over graphite on wove paper
19.2 × 24.8 cm
INSCRIPTIONS: l.c., *"Côteau St Louis" ou "Côteau du*
 Moulin" / changé en citadelle par Mr de Callière Gr, en
 1693.; u.l. in pencil, references to dimensions; scale
 of measurement of ¾ of an inch to 50 French feet
Musée du Séminaire de Québec Pf 990.2

PROVENANCE: Jacques Viger; Misses Lennox, 1858;
 Hospice-Anthelme Verreau, 1860; bequest to Sémi-
 naire de Québec, 1901; transferred to MSQ, 1990.
EXHIBITIONS: 1988 Château Ramezay.

This sheet of four diagrams illustrates the plan and
section of Citadel Hill, Montreal, when the site was
occupied by a windmill, and later when the fort was
built. The upper two diagrams of the citadel em-
placement are drawn in pen and ink, and coloured
in tones of blue, green, yellow, brown, and pink.
The lower two drawings of the windmill emplace-
ment are in grey wash, pen and ink. In the elevation
of the windmill site, the four corners of the hill have
been pierced with a pin. For other illustrations of
Citadel Hill, see WBB 29, 36.

LOST WORKS

WILLIAM BENT BERCZY

LW-WBB 1
Fort Chambly 1804

Drawing, medium unknown
REFERENCES: SAUM, U/1412: Charlotte Berczy to
 WBB, Montreal, 5 July 1804.

Thirteen-year-old William Bent Berczy sent his mother a drawing of Chambly. Charlotte was pleased to report that the drawing met with much approval and was copied twice – no doubt by her drawing class. A view of Fort Chambly in watercolour, pen and brown ink (collection: Musée du Québec, QM-1-59.8D, Cote P. 1752), inscribed *Madame Berzy Mistress of Drawing in the town of Montreal,* is probably one of the copies of William's drawing.

LW-WBB 2
Schooner and 'Chaloupe de Guerre' in Quebec Harbour 1808

Drawings, medium unknown
REFERENCES: SAUM, U/1466: WBB to Charlotte
 Berczy, Quebec, 22 Aug. 1808.

These two drawings were sketched by the artist at a time when he was assisting his father in his Quebec City studio.

LW-WBB 3
Salomon Gessner 1808

Drawing, medium unknown
REFERENCES: SAUM, U/1477: WBB to Charlotte
 Berczy, Quebec, 5 Dec. 1808.

This is a drawing after an engraving. Salomon Gessner (1730–1788) was a Swiss poet, painter, and etcher, whose works were much appreciated by Charlotte Berczy.

LW-WBB 4
Intertwined Serpents 1808

Drawing, medium unknown
REFERENCES: SAUM, U/1477: WBB to Charlotte
 Berczy, Quebec, 5 Dec. 1808.

This vignette drawing is a decorative design that the artist sent to his mother.

LW-WBB 5
St. Francis 1809

Probably gouache on paper
REFERENCES: SAUM, U/1479: WBB to Charlotte
 Berczy, Quebec, 26 Dec. 1808; U/1485: 22 Jan.
 1809; and U/1486: 27 Jan. 1809.

LW-WBB 6
Quebec City View 1809

Drawing, medium unknown
REFERENCES: SAUM, U/1507: WBB to Charlotte
 Berczy, Quebec, 24 June 1809; and U/1508: 28 June
 1809.

A drawing described by Berczy Senior as interesting and "piquant."

LW-WBB 7
Margaret Robertson Sutherland 1812

Medium unknown
REFERENCES: SAUM, U/1518: William Berczy to
WBB, Middlebury, Vt., c. 27 May 1812.

Margaret Robertson was the daughter of Colonel
Daniel Robertson of Montreal, and sister of Berczy
Senior's friend John Robertson. In 1781 she married
Daniel Sutherland, a prosperous Montreal mer-
chant. In 1792 her portrait was painted by François
Beaucourt (collection: ROM, 988.96.1), and a por-
trait of her daughter Maria Sutherland Hallowell
(cat. 70) was painted by William Berczy.

LW-WBB 8
Miss Montpesant 1812

Medium unknown
REFERENCES: SAUM, U/1518: William Berczy to
WBB, Middlebury, Vt., c. 27 May 1812.

CATALOGUE
AMÉLIE PANET BERCZY

by Mary Macaulay Allodi

OUISE-Amélie Panet was born in Quebec City on 27 January 1789, the eldest child of Pierre-Louis Panet (WBB 1) and Marie-Anne Cerré. The family had moved to Montreal by 1795, where her father was a judge and landowner. Amélie's name is mentioned in the Berczy letters from an early date, and she evidently attended Charlotte Berczy's finishing school. Both Charlotte and William Berczy talked of her in terms of great affection, and William Senior also praised her artistic talents. In speaking of a copy that Amélie made of his portrait of William Junior (cat. 78), he said:

> *She* [Betsy Grant, a visitor to his Quebec City studio] *saw the portrait of William at my place and thought it was the one I had sent you — she did not hesitate one instant to recognize it and found it very fine — and was completely astonished when I told her that it was Mademoiselle Panet's work. Many other people who have seen it have also found it a good likeness and well done. Mr. Bayarge* [François Baillairgé, architect and artist] *... can scarcely be convinced that it was she who did it and at the time it was neither retouched nor varnished....* [1]

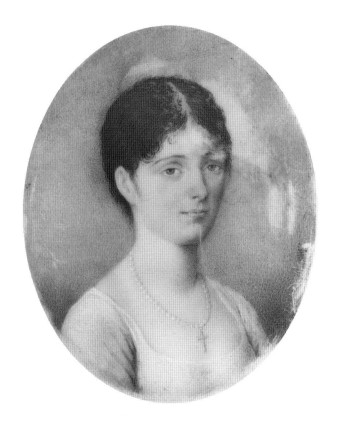

38.
Amélie Panet Berczy, c. 1805,
by William Berczy (cat. 66).
Collection: Royal Ontario Museum, Toronto.

In 1819, Amélie married William Bent Berczy, and they lived at Amherstburg, Upper Canada, until 1832, when she took over her family's property at D'Ailleboust. Although living at some distance from the urban centres of Quebec and Montreal, Amélie's personality evidently attracted a literary and artistic entourage. She was well read and was also versed in languages; she played the harpsichord, painted, wrote, and also managed the day-to-day affairs of the seigneury until her death on 24 March 1862.

A visitor to Amélie's house at D'Ailleboust in about 1859 described the setting:

> *The huge fireplace had a carved mantelpiece with the traditional mirror over it and contained precious objects that one would scarcely expect to see in such an isolated place. Pedestal tables made of old Spanish mahogany were covered with brushes, palettes for mixing colours, pencils, paper, delightful watercolours, sketches for drawings. This was the studio of the mistress of the dwelling, and at the same time, her drawing-room....*[2]

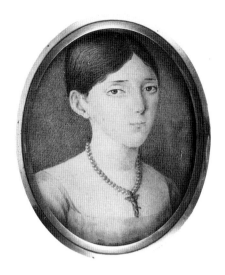

APB 1
Angélique de Lotbinière c. 1818

Watercolour over graphite on paper, laid down on card
7.2 × 5.9 cm

INSCRIPTIONS: on wove paper oval, inserted in frame behind the portrait, in ink, *Portrait d'Angelique de Lotbiniere, fille de L'honorable Chartier de Lotbiniere et de Charlotte Munro. Son amie Louise Amelie Panet la peignit en partie de memoire pour adoucir la douleur que ses parents malheureux ressentir par la mort arrivee en Mai 1818. elle naquit en Mars 1806;* Verso: printed label on frame, *430*

Royal Ontario Museum, Toronto 977.234.1
Sigmund Samuel Trust

PROVENANCE: by family descent from M.-E.-G.-A. Chartier de Lotbinière; Archibald de Lery MacDonald; Mrs J.M. Gurd (née MacDonald); purchased ROM, 1977.
EXHIBITIONS: 1978 ROM.
REFERENCES: M. Allodi, "Canadian Faces: Some Early Portraits," in *Rotunda*, 11:1 (spring 1978), p. 24.

Amélie Panet painted this miniature image from memory, after Angélique's death at the age of eleven years.[1] The face is striking for its stylized features: eyebrows drawn in a straight line, over large, almond-shaped eyes; a long ear, and small mouth. The image has faded, and modelling brush strokes are barely visible in some areas, which gives the face a flat look. The now colourless dress was originally pink.

1. SAUM, U/1486: William Berczy to Charlotte, Quebec, 27 Jan. 1809.
2. De Rainville 1892, p. 135.

1 Angélique was the daughter of Michel-Eustache-Gaspard-Alain Chartier de Lotbinière and Mary Charlotte Munro.

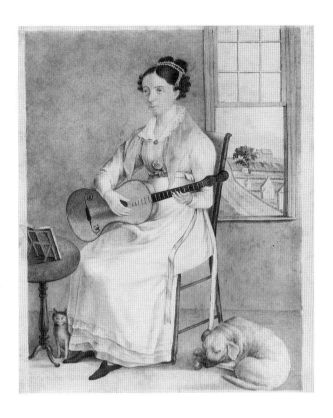

APB 2
Marie-Anne Panet with Guitar 1827

Watercolour over graphite on wove paper
24.6 × 20.5 cm
INSCRIPTIONS: Verso (now separated from recto): in ink,
Ce portrait de Marieanne Panet a été peint dans l'année
1827 dans le mois de Juin et appartient a L.A. Panet
Berczy; and a wash sketch of a woman's head,
unfinished.
Royal Ontario Museum, Toronto 980.196.11
Sigmund Samuel Trust

PROVENANCE: by descent in Panet-Lévesque family to
Céline Dupuis; Hélène L. Bertrand; purchased
ROM, 1980.
REFERENCES: Harper 1966, p. 75, repr. p. 71 (attr. to
William Bent Berczy).

Amélie Panet was living in Amherstburg in 1827;
evidently this charming portrait was painted during
a summer visit from her sister.[1] The drawing is very
careful and the composition is balanced; still, the
greatest charm of the painting is its naïvete, its indi-
viduality of expression. Influences can also be felt:
the landscape glimpsed through the window, as in
William Berczy's *Woolsey Family* (cat. 84); or possibly
a reference to decorative prints, such as a series pub-
lished by Carington Bowles in 1784, in which the
personification of the month of February sits by a
window playing the mandolin.[2] The guitar was not
fictitious, however, and Amélie describes her sister
Marie-Anne as travelling with this instrument, in
1840.[3]

1. Marie-Anne Panet (1806–1863) married Pierre-
 Horace Panet in 1830; was widowed in 1838, and
 married Maximilien Globensky in 1851.
2. Illustrated in E. McSherry Fowble, *Two Centuries of*
 Prints in America, 1680–1880. A Selective Catalogue of
 the Winterthur Museum Collection (Charlottesville:
 University of Virginia Press, 1987), no. 152.
3. Faribault-Beauregard 1987, p. 59.

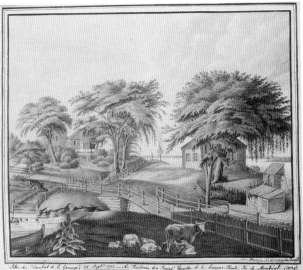

APB 3
Notes historiques c. 1819–47

Pen and brown ink on laid paper
13 × 21.4 cm
WATERMARK: *& Son*
INSCRIPTIONS: u.l. in pencil, *Notes Historiques;* c.l.,
 Md. Berczy
Service des archives de l'Université de Montréal

PROVENANCE: L.-F.-G. Baby bequest to Université
 Laval, Montreal, 1906.
REFERENCES: SAUM, A2/56, boîte 11347.

Two humorous profile sketches show how a straw
outdoor bonnet can be worn over a "mob-cap."
The drawing is on the outside page of a notebook,
in which Amélie made sporadic entries that date
variously from 1819 to 1847.

APB 4
Longue-Pointe, Site of the Battle of La Grange
1839

Watercolour on wove paper, with ruled ink borders
22 × 27.2 cm (sheet); 19.9 × 23.6 cm (subject)
INSCRIPTIONS: by Jacques Viger, l.r. in ink, *par Madame*
 W. Berczy (née Panet); l.l., *Site du – "Combat de la*
 Grange", 25 Septr. 1775. – Au "Ruisseau des Sœurs",
 Paroisse de la Longue-Pointe, Ile de Montréal. (1839)
Bibliothèque municipale de Montréal, Fonds Morisset
 FM-2195-1-2
Not in exhibition

PROVENANCE: Jacques Viger; Misses Lennox, 1858;
 Raphaël Bellemare, 1860; Bellemare heirs; BMM,
 Gagnon Collection, 1943.
REFERENCES: BMM, Viger Album, p. 272; SAUM,
 U/12407: J. Viger to WBB, Montreal, 6 May 1839.
 Maurault 1944, p. 94; Morisset 1957, p. 16; Morisset
 1959, p. 40, repr.

In a letter of 6 May 1839, Jacques Viger asked
Amélie Panet Berczy to adorn Madame Viger's

AMÉLIE PANET BERCZY

LW-APB 1
Portrait of a Cousin 1808

Medium unknown
REFERENCES: SAUM, U/1464: Berczy to Charlotte,
 Quebec, 17 Aug. 1808.

LW-APB 2
Portrait of Her Mother 1808

Medium unknown
REFERENCES: SAUM, U/1474: Berczy to Charlotte,
 Quebec, 12 Nov. 1808.

A portrait of Marie-Anne Cerré (Mme Pierre-Louis
Panet) in "coloured crayon" was exhibited in 1887
in Montreal [Montreal 1887, p. 17]. It may be the
same portrait as the image reproduced in Faribault-
Beauregard 1987 (front cover repr.).

LW-APB 3
William Bent Berczy 1808

Watercolour and gouache on paper
REFERENCES: SAUM, U/1478: WBB to Charlotte
 Berczy, Quebec, 7 Dec. 1808; and U/1486: 27 Jan.
 1809.

Amélie made a copy of William Berczy's portrait of
his son (cat. 78).

album with some of her charming drawings, includ-
ing the *Combat de la Grange*. This refers to the
skirmish that took place in 1775 at Longue-Pointe
on the southeast shore of Montreal Island, when
Americans led by Ethan Allen attempted to take
Montreal. Allen was taken prisoner, and the attack
temporarily repulsed.

Amélie has painted a peaceful and bucolic scene,
in a style that is similar to landscapes by her husband
William Bent Berczy. The watercolour is applied in
short hatched strokes, in tones of green, blue, yel-
low, rosy-beige, and brown. References to domestic
activities on the farm can be seen in the figure of the
woman milking the cow, and the line of washing
outside the house in the left background.

LW–APB 4
St. Mary Magdalene c. 1810
───────────

Medium unknown

REFERENCES: ASQ, Fonds Viger-Verreau, Saberdache bleue, vol. 2, pp. 1–3: J. Viger to D.B. Viger, Montreal, 16 Jan. 1811.

The picture represented the repentant saint in the desert, her long hair covering her nakedness. According to Jacques Viger, it was given as a present to Mme N. Panet of Trois-Rivières; this would be Marie-Jeanne Fraser, the widow of Narcisse Panet (1774–1809). Could it be a copy of William Berczy's version of the Magdalene by Furini? See LW 19.

LW–APB 5
Sleeping Child c. 1842
───────────

Medium unknown

REFERENCES: M. Bibaud, "Une Dame Canadienne Peintre," in *Encyclopédie Canadienne* (Montreal, 1842–43), pp. 74–75.

This work depicts a one-year-old child lying asleep against a cushion.

APPENDIX A

GENEALOGY

by Beate Stock

BIOGRAPHICAL NOTES

JOHANN MOLL was registered in the Harburg tax records of 1575 as the farmer with the most highly taxed property. [FÖWAH, SLB 891, fol. 65r.]

MICHAEL MOLL's descendants were active as Lutheran ministers for the next 150 years in the district of Oettingen. [Burger, pp. 73ff.; Michel; and Simon, pp. 326f.] Despite four generations of Lutheran pastors leading in a straight line to Berczy's grandfather Johannes Paulus, an artistic vein in the family can be found on his paternal grandmother's side. The father of Berczy's grandmother Susanne Catharina, Johann Michael Juncker, was a painter in Heilbronn (and became a burgher of that town in 1665). [Nuber, pp. 2–3; communication from Dr Andreas Pfeiffer of the Historisches Museum der Stadt Heilbronn.]

BERNHARD PAUL VON MOLL, Berczy's uncle, studied law at the Martin Luther University in Halle-Wittenberg. [Juntke, p. 298.] In his petition of 1738 to the Emperor Charles VI requesting that he be raised to the nobility, Bernhard Paul declared himself to be a Legation Privy Councillor and accredited minister ("Geheimer Legations-Rath and accreditierter Ministre") for the princely house of Braunschweig-Lüneburg and for the Duke of Schleswig-Holstein at the Imperial Court in Vienna. [Allgemeines Verwaltungsarchiv, Vienna, Nobilitierungsantrag Moll 1738; and *Repertorium...*, vol. II, pp. 19f.]

The title "von" was given only to Bernhard Paul von Moll and his immediate family. However, it was cus-

tomary in the eighteenth century for other members of the family branch to use the title *ad libidum*. Thus, members of William Berczy's family often appear as "von Moll" in sources.

BERNHARD ALBRECHT MOLL studied at the same time as his younger brother William Berczy at the Hof-Academie in Vienna ["Aufnahms-Protocoll für die academischen Schüler vom Jänner 1738 bis Juli 1785." Academie der bildenden Künste, Vienna, Archives, entry for 15 May 1762], and in 1766 at the University of Jena [Friedrich-Schiller-Universität, Register for 1766, entry for 9 Oct. 1766]. In contrast to William's refusal to enter a diplomatic career, Bernhard Albrecht served – at least temporarily – as aulic councillor ("Hofrat") and agent for the Duke of Mecklenburg-Strelitz. [HHSTA, RHR, OR.699.]

Bernhard Albrecht also seems to have been in the army briefly; a petition survives in which he seeks to be released from his military obligations as cadet on the grounds that he had been appointed as an artist (i.e., "Cabinettmahler") for the Imperial Natural History Collection. [Kriegsarchiv, Vienna, HKR, 1780 D 1065.] His cousin Carl von Moll worked there, and the collection was under the supervision of Ignaz von Born (the same mineralogist who had praised Berczy's father's natural history collection in 1770). In his position as "Cabinettmahler," Bernhard Albrecht received the sum of 800 gulden a year. [HHSTA., O.Ka.A., Karton 7, no. 162/1781.]

Like Berczy, Bernhard Albrecht had always kept up his painting as a hobby, in addition to his other activities.

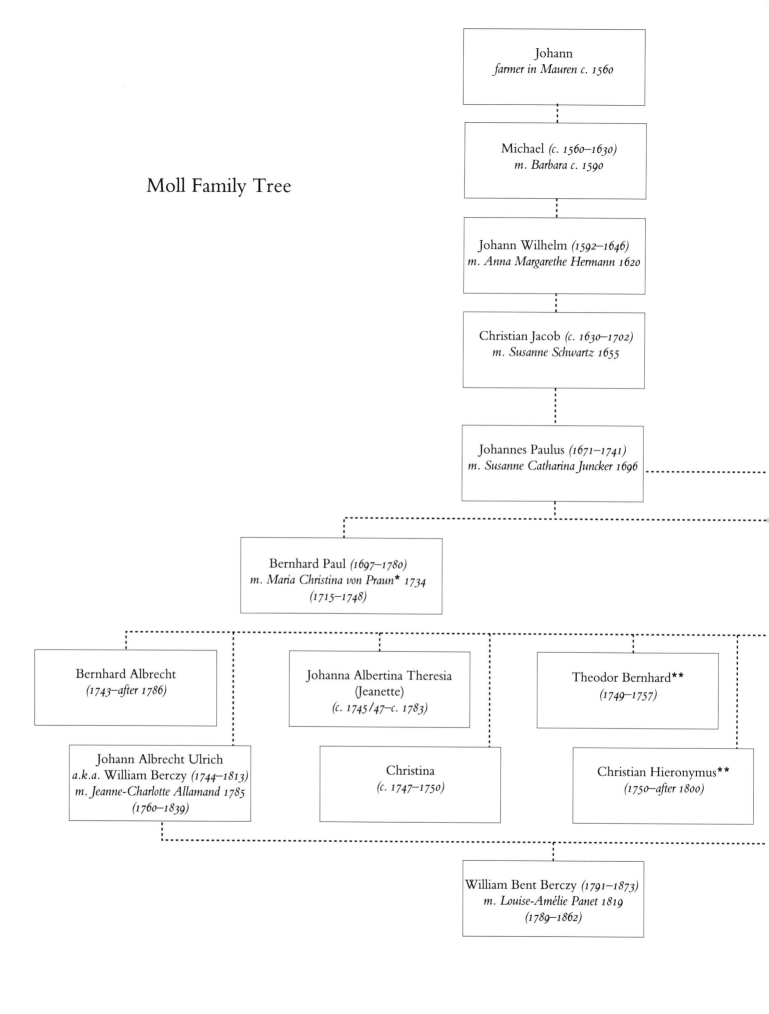

Moll Family Tree

Johann
farmer in Mauren c. 1560

Michael *(c. 1560–1630)*
m. Barbara c. 1590

Johann Wilhelm *(1592–1646)*
m. Anna Margarethe Hermann 1620

Christian Jacob *(c. 1630–1702)*
m. Susanne Schwartz 1655

Johannes Paulus *(1671–1741)*
m. Susanne Catharina Juncker 1696

Bernhard Paul *(1697–1780)*
m. Maria Christina von Praun 1734*
(1715–1748)

Bernhard Albrecht
(1743–after 1786)

Johanna Albertina Theresia
(Jeanette)
(c. 1745/47–c. 1783)

Theodor Bernhard**
(1749–1757)

Johann Albrecht Ulrich
a.k.a. William Berczy (1744–1813)
m. Jeanne-Charlotte Allamand 1785
(1760–1839)

Christina
(c. 1747–1750)

Christian Hieronymus**
(1750–after 1800)

William Bent Berczy *(1791–1873)*
m. Louise-Amélie Panet 1819
(1789–1862)

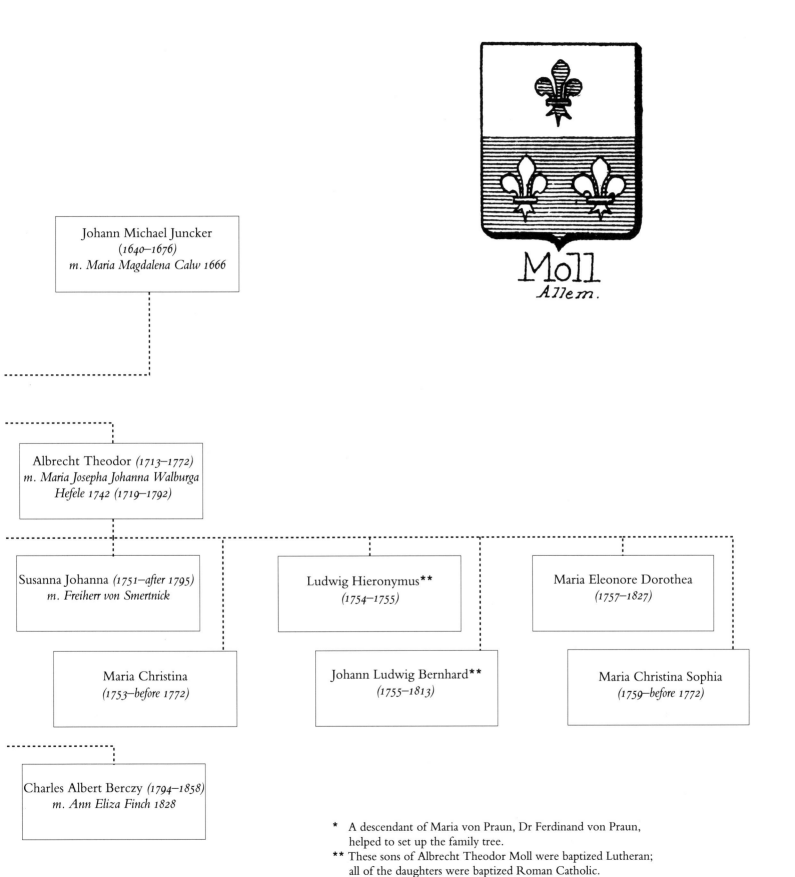

39.
Moll Coat of Arms from *V. and H.V. Rolland's illustrations
to the Armorial général by J.-B. Rietstap.*
London: Heraldry Today, 1967, vol. III, pl. CCXXIV.

Moll
Allem.

Johann Michael Juncker
(1640–1676)
m. Maria Magdalena Calw 1666

Albrecht Theodor *(1713–1772)*
*m. Maria Josepha Johanna Walburga
Hefele 1742 (1719–1792)*

Susanna Johanna *(1751–after 1795)*
m. Freiherr von Smertnick

Ludwig Hieronymus**
(1754–1755)

Maria Eleonore Dorothea
(1757–1827)

Maria Christina
(1753–before 1772)

Johann Ludwig Bernhard**
(1755–1813)

Maria Christina Sophia
(1759–before 1772)

Charles Albert Berczy *(1794–1858)*
m. Ann Eliza Finch 1828

* A descendant of Maria von Praun, Dr Ferdinand von Praun,
 helped to set up the family tree.
** These sons of Albrecht Theodor Moll were baptized Lutheran;
 all of the daughters were baptized Roman Catholic.

He specialized in the painting of natural history subjects; and he seems, by all accounts, to have been very good at it. Count Rosenberg recommended to the Emperor that Bernhard Albrecht be hired as the best in his specialty; von Born felt that he had no equal. [HHSTA, O.Ka.A., Karton 6, no. 99/1780, fols. 59v, 60r; Oberhofmeisteramt Sonderreihe 176, Expedition Märters, fol. 6v; and Fleischer, p. 195.]

In 1783, Emperor Joseph II was preparing to send a scientific expedition to America, and Bernhard Albrecht wished to accompany it. In a letter seeking permission to join the expedition, he explained that he had been longing to make such a voyage since his youth; he assured the Emperor that he was very adept at drawing plants and landscapes. [HHSTA, Oberhofmeisteramt Sonderreihe 176, Expedition Märters, fol. 20.] At about this time, he also advertised his talents in a Viennese paper, offering a series of landscape engravings for sale by subscription. [Borbély, p. 225. The author somewhat confuses Bernhard Albrecht Moll with his uncle Bernhard Paul von Moll.] Bernhard Albrecht's petition to the Emperor was granted, and he left Vienna in April 1783 for the New World. The spirit of freedom he found in the newly independent land enchanted him, so much so that he decided to remain there and support himself as a portrait painter. [Nationalbibliothek, Vienna, MS. Ser. no. 3517, Expedition Märter, letter from B.A. Moll to I. von Born, Philadelphia, 17 Sept. 1783.] He is last heard of in December 1786 at Charleston, South Carolina [see Andre and Froeschle]. An album of Moll's silhouette portraits is in the collection of the Royal Ontario Museum, Toronto.

CHRISTIAN HIERONYMUS MOLL, Berczy's younger brother, followed a theatrical career. He encouraged the movement to bring German theatre to Vienna and wrote several plays, including adaptions of Shakespeare's *Macbeth* and *A Midsummer Night's Dream*. [Deutsches Literatur-Lexikon, vol. x; and Kindermann, vol. v, p. 77.] At one point he managed the theatre in Pressburg (now Bratislava, Czechoslovakia) [Benyovszky, p. 45 ff.; and Kindermann, vol. v, p. 685] and, briefly, the Kärntnertortheater in Vienna. He is also mentioned as leader of a group of strolling players [Zechmeister pp. 377f., 569] and took the part of the third priest in the première of *The Magic Flute* [*Mozart: Bilder und Klänge,* Salzburger Landesausstellungen, 1991, p. 287]. He may have worked

in Pest and Ofen or Trieste in later years, but this cannot be confirmed. That he remained in none of these positions very long suggests insurmountable financial difficulties. [Re: debts, see HHSTA, Verlassenschaftsakten, Convolut 1793–95, fol. 62r.] Christian Hieronymus is recorded to have been in debt to Johann Rautenstrauch, an author, who was a colourful and active figure in Viennese cultural life. Rautenstrauch, wrongly assuming that Bernhard Albrecht was Christian's business partner, tried to claim his money from the actor's brother. [Archiv der Universität Wien, Vienna, Kons. Akten, Fasc. III/R, no. 162, 9 May–15 Dec. 1778.]

JOHANN LUDWIG BERNHARD MOLL, Berczy's youngest brother, was still a minor at the time of his father's death. He was accepted into the Imperial Engineering Academy in 1777, thanks to the intervention of Empress Maria Theresa, and a year later he entered the army as a "Fahnenkadett" in the Infantry Regiment Lacy. [Gatti, vol. 1, p. 310.] In 1787 he returned to civilian life and continued to work as an engineer. [Kriegsarchiv, Vienna, Aufgelöstes IR, 23 1787/ Ostlt., Fasz. 4422; re: his release from the army: Kriegsarchiv, Vienna, HKR 1787–48–43; and HKR 1787–48–49.]

A grey wash drawing dated September 1778 by Johann Ludwig Moll, copied after an engraving by Jan van Huchtenburgh of *The Battle of Cassano,* suggests that the younger Moll brother also had artistic inclinations. [Kriegsarchiv, Vienna, H III d 441; Andre 1967, repr. between pp. 56–57.] In 1793 he too registered at the Hof-Academie in Vienna. [Akademie der bildenden Künste, Vienna, Archives, Schülerprotokoll, vol. 2, p. 119, July 1793.]

JEANNE-CHARLOTTE ALLAMAND's life is described more fully in catalogue 17. William Bent Berczy once wrote that his mother was the niece of two famous professors, François-Louis and Jean-Nicolas-Sébastien Allamand. [AO, MS 526, Reel 1, William Berczy Papers: letter from WBB to Chevalier Hülsemann, Austrian chargé d'affaires to the United States, dated Washington, 22 August 1847.] However, according to Swiss genealogical research, it would seem that the two professors belonged to a quite different branch of the family. Charlotte belonged to the branch called "de la Lavanche" (the name of a village located in the "commune d'Ormont Dessus"). [In establishing the genealogy of the Allamand

family, I relied on the information provided by archivists François Dumur of Pully (VD), and Michel Depoisier, Archives Cantonales Vaudoises, Chavannes-près-Renens.]

ARCHIVAL AND MANUSCRIPT SOURCES FOR THE FAMILY TREE

Matrikelbuch, Katholisches Pfarramt St. Alban, Wallerstein.

Taufbücher, 1757 and 1759, St. Michael Pfarre, Vienna.

Taufbücher, vols. 79 and 80, St. Stephan Dompfarre, Vienna.

Todten Buch 1744–1756, Schottenstift, Vienna.

Taufbuch der dänischen Gesandschaftskapelle 1725–1783, Evangelischer Oberkirchenrat A.B. Wien, Vienna.

Taufbuch der schwedischen Gesandschaftskapelle 1733–1780, Evangelischer Oberkirchenrat A.B. Wien, Vienna.

Burger, Helene. *Oettingisches Pfarrerbuch. Die Evangelisch-Lutherische Geistlichkeit der Grafschaft und des späteren Fürstentums Oettingen* (unpublished typescript). Nuremberg: Landeskirchliches Archiv.

PUBLISHED SOURCES FOR THE BIOGRAPHICAL NOTES

Andre, John, and Hartmut Froeschle. "The American Expedition of Emperor Joseph II and Bernhard Moll's Silhouettes." In *The German Contribution to the Building of the Americas. Studies in Honor of Karl J.R. Arndt,* eds. Gerhard K. Friesen and Walter Schatzberg. Hanover, New Hampshire: Clark University Press, 1977.

Benyovszky, Karl. *Das Alte Theater, Kulturgeschichtliche Studie aus Pressburgs Vergangenheit.* Bratislava-Pressburg: Verlag von Karl Angermayer, 1926.

Borbély, Andor. "Beiträge zum Problem von Bernhard Molls Atlas Austriacus." *Mitteilungen der Geographischen Gesellschaft in Wien,* vol. 76. Vienna: Geographische Gesellschaft, 1933.

Deutsches Literatur-Lexikon. Biographisch-Bibliographisches Handbuch. Begründet von Wilhelm Kosch, 3rd ed. Bern: A. Francke AG Verlag, 1986.

Fleischer, Julius. *Das kunstgeschichtliche Material der geheimen Kammerzahlamtsbücher in den staatlichen Archiven Wiens von 1705 bis 1790.* Quellenschriften zur barocken Kunst in Österreich und Ungarn, vol. 1. Vienna: Krystall-Verlag, 1932.

Froeschle, see Andre.

Gatti, Friedrich. *Die Geschichte der K.K. Ingenieur-und K.K. Genie-Akademie 1717–1869.* Vienna: Wilhelm Brauhmüller, 1901.

Juntke, Fritz, ed. *Matrikel der Martin-Luther-Universität Halle-Wittenberg (1690–1730).* Halle: Universitäts- und Landesbibliothek, 1960.

Kindermann, Heinz. *Theatergeschichte Europas,* vol. v. Salzburg: Otto Müller Verlag, 1962.

Michel, Georg Adam. *Beyträge zur Oettingischen politischen-kyrchlichen- und gelehrten Geschichte, von dem Verfasser der Oettingischen Bibliothek gesammelt und herausgegeben. Zweeten Theils, 1. Sammlung.* Oettingen: Johann Heinrich Lohse, 1774.

Nuber, Axel H. "Johann Michael Juncker (1640–1676) ein Heilbronner Kunstmaler des Frühbarock." *Schwaben und Franken,* IV:12 (Dec. 1951).

Repertorium der diplomatischen Vertreter aller Länder seit dem Westfälischen Frieden (1648). Internationaler Ausschuss für Geschichtswissenschaften, 1936–65.

Simon, Matthias. *Ansbachisches Pfarrerbuch. Die Evangelisch-Lutherische Geistlichkeit des Fürstentum Brandenburg-Ansbach 1528–1806.* Einzelarbeiten aus der Kirchengeschichte Bayerns, 28. Nuremberg: Selbstverlag des Vereins für bayerische Kirchengeschichte, 1955.

Zechmeister, Gustav. *Die Wiener Theater nächst der Burg und nächst dem Kärntnerthor von 1747 bis 1776.* Österreichische Akademie der Wissens-chaften, Kommission für Theatergeschichte Österreichs, III:2. Graz-Vienna-Cologne: Hermann Böhlaus Nachf., 1971.

APPENDIX B

PASTEL PROFILES

by Mary Macaulay Allodi

The small pastel profile portraits found in many Canadian collections, which have generally been attributed to William Berczy in recent years, have not been included in the present exhibition for reasons explained in this appendix.

The pastel profiles under discussion are physically homogeneous: that is, they are half-length profiles, inscribed in a feigned oval of approximately 18 × 12.5 cm. They are drawn on white or cream-coloured sheets of paper measuring about 23 × 19 cm. The profiles are outlined in black chalk and fully coloured in pastel; the background is shaded to contrast with the image. The flesh tones are quite thickly applied and blended – almost burnished – to a smooth surface; facial details are then picked out in umber or red-brown. They are "formula portraits," all very similar in technique and most probably by the same hand. They depict prominent residents of Montreal and Quebec City; all date to approximately 1808–11, judging from the ages of the subjects, the style of clothing worn, and the fact that several of the subjects had died by 1812. None of the forty Canadian pastel profiles examined are signed by the artist.

The Canadian profiles were not always assigned to Berczy. When a few of them were exhibited in 1887 and 1892 in Montreal,[1] they were not attributed to any specific artist. In 1908, the catalogue of

Laval University's collection cited one "G. de Berg" as the author of a pastel profile of Louis Dulongpré.[2] This attribution seems to have been made through typographical association, because the pastel followed a catalogue entry describing an oil painting, *La Liseuse,* as being signed by G. de Berg.[3] The two works had no relationship to each other in style. In 1935, Gérard Morisset re-attributed the pastel profile to William Berczy.[4] Both the oil and the pastel had come from H.-A. Verreau, who acquired much of his collection from Berczy's friend Jacques Viger. Three other works from this same provenance were in fact by Berczy. However, *La Liseuse* does not resemble Berczy's known works, and neither does the pastel profile.

The 1935 attribution was the beginning of the process of assigning all pastel profiles of this format to William Berczy. It was a gradual process: the Château Ramezay 1957 catalogue lists its pastel profiles as the work of Louis Dulongpré. In 1962, Russell Harper described the pastel profiles in the McCord as being by Berczy,[5] and after that time most pastel profiles were considered to be by him.

The attribution of the profiles to Dulongpré would have been based on the fact that he worked in this medium. However, Dulongpré's pastel portraits are much looser in technique than Berczy's known works, and more varied in colouring. His subjects

are often full face; and even the few profiles attributed to him show a less precise style of draughtmanship. In addition, Dulongpré's 35.5 × 29 cm sheets of paper are often backed with linen and mounted onto a wooden stretcher, which is not the case with the smaller profiles.

William Berczy's name was most probably associated with these profiles because of their classical format and precision of outline. A survey of Berczy's portraits that are either documented in his correspondence or by provenance from the Berczy family reveals that he drew some early academic sketches in black and white chalks, and that he sometimes doodled a profile in pen and ink. However, no pastel profile has come down among his documented works. In addition, Berczy never mentions using pastel crayons in his correspondence. He does make two mentions of profile portraits, but on both occasions he describes them as being carefully finished in India ink.[6] Berczy's technique is never as rigid and formula-bound as the pastel profiles.

An artist's complaint in an 1810 newspaper provides us with the name of the probable author of the pastel profiles: Gerrit Schipper (c. 1775–c. 1825), an itinerant pastel profiler. In an advertisement of 16 April 1810 in the *Quebec Gazette,* Schipper accused a Montreal print publisher of plagiarizing his portrait of Governor-General Sir James Henry Craig. The publisher, Mr. Turnbull, had advertised that he was about to issue a print of Craig after a portrait by Schipper. Schipper's ad maintained, "…I believe the likeness above alluded to, to be a Copy of a Copy sold by me, and by no means sufficiently finished to serve as a model for an Engraving … As I have the honour to be the Painter of the original Portrait, I propose to publish as follows: A Likeness of His Excellency Sir James Henry Craig, to be Engraved in Colours by one of the first Mezzotinto engravers in London, from a Likeness which I painted for that purpose, and which is now in my possession…" He added that the engraving

would be executed under his own supervision, and he launched a subscription campaign. The cost of the print would be £1.12, including the frame.

Three pastel profiles of Craig have survived in Canadian collections (see fig. 40), and two of these were at one time catalogued as being the work of

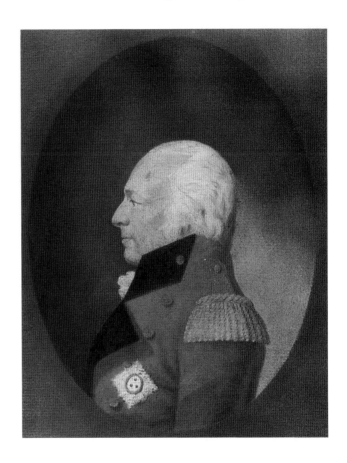

"Schipper."[7] On 4 July 1811, the *Quebec Gazette* announced the arrival from London of "…striking LIKENESSES of Sir James Henry Craig, and of Monseigr. Joseph Octave Plessis, printed in colours, according to the present stile…." These fine aquatints printed in subtle colours, although unsigned by either artist or engraver, correspond to Schipper's style of composition, and the Craig print reproduces the known pastel profiles. (The pastel of Plessis has not been found.)

So who was this enterprising artist, Gerrit Schipper? Records of his early life exist in memoirs written by his son, Nicholas Lockwood Shipper [*sic*],[8] his grandaughter Serena Shipper Wallace, and his great grandson Richard Hyer.[9] Schipper was born about 1775 in the village of Krommenie, near Amsterdam, in the Netherlands. The son of a wealthy sailmaker, he was sent to Brussels for his education. He later continued his studies in Paris, according to tradition at a "French School of Design." He was in Paris during the French Revolution, and his son remembered him saying that he could not get an exit passport until after the death of Robespierre, which would bring us to the year 1794. After this date he travelled in Russia, where he is said to have supported himself as a miniature painter.

The first notice of his arrival in America is his advertisement as an artist who would take likenesses in crayon, in New York City's *Mercantile Advertiser,* 18 May 1802. During the following six years his advertisements as an artist in pastel and miniature trace his travels to Charleston, Boston, and Worcester. A recent study adds to knowledge of his activities in the United States, and reproduces an unusual conversation piece portrait of the Knickerbacker family by him.[10] Apart from this conversation piece, all his known American portrait commissions (at least fifty in number, recorded in the Frick Art Reference Library, New York City) are profiles that follow the basic formula of the Canadian pastel profiles. These profiles are sharply defined, placed against a dark background, and with a shaft of light to set off the deeper tone of the costume. Some of the portraits are in the feigned oval, and others are given an octagonal setting which is similar to the borders in the prints of Craig and Plessis. A comparison of the Canadian pastels with the best documented of the American subjects, including one profile of Harriet Warner (fig. 41) which is signed and dated,[11] shows such a close similarity in style and format that one must judge them to be by the same hand.

During this period in the United States there were other artists who painted or drew profile portraits, but they have been eliminated as candidates for authorship of the Canadian profiles for stylistic reasons, and for the even simpler reason that they are not known to have visited this country.

Gerrit Schipper arrived in Montreal in the autumn of 1808, and on 31 October advertised in the *Montreal Gazette* that he would take likenesses in miniature on ivory, in coloured crayon [which is translated as "Pastel" in the French-language advertisement], in watercolours suitable for lockets and breast pins, and in black crayon. From 28 November 1808 through 9 January 1809, Schipper's Montreal advertisements make it clear that he was specializing in pastel portraits, as in this *Montreal Gazette* notice of 28 November 1808:

New Method of Painting in Crayons

G. SCHIPPER, Miniature Painter, who lately arrived in this city, has by a new experiment adopted to take likenesses in Crayons, in a small size; which he warrants not to fade or change their colours, so he has prepared the Crayons himself, avoiding each ingredient, which by experience will not stand. The price is Six Dollars, (an elegant gold frame with glass, included;) and if not approved of, no payment will be requested....

The "new experiment" may refer to the "Physiognotrace" – a method of drawing profiles by tracing the outline of a shadow cast onto transparent paper; with this image then being reduced in size by means of a "Pantograph" or hinged device, which reproduced an exact replica of the profile in a smaller size by going over the original drawing. This method of reproducing profiles was much used by silhouette artists from the 1790s onwards. The method of preparing his own crayons was most probably learned in Paris, where Schipper would have been exposed to this French fashion in painting and where he could also have read the 1788 publication on pastel painting[12] which, among other instructions, explained how to make pastel crayons so that they would hold their colour.

In a 15 May 1809 notice in the *Montreal Gazette*, Schipper advised his customers that he intended leaving for Quebec City in five days. There were no further advertisements by Schipper for almost eleven months, and then the Craig portrait controversy appeared in Quebec City papers. Schipper continued to advertise in Quebec until the end of May 1810, when he stated he would leave the city on 15 June – most probably for England, where he proposed publishing the Craig portrait.[13] Further commissions delayed his departure until late in the summer; in the interval he copied two oil portraits in the pastel medium for the Séminaire de Québec.[14] These were the portraits of Bishop François de Montmorency Laval (1623–1708) and Bishop Jean-Olivier Briand (1715–1794)[15]; here Schipper departs from his profile format, as he is copying paintings in the seminary's collection. However, he continued using his feigned oval format and his background shading in various tones of brown, which fades to light grey near the figure. The portrait of Briand shows Schipper's awkwardness in drawing hands, a trait also seen in his portrait of Beniah Gibb Jr. (collection: McCord Museum, M983.228.2), and in the signed Knickerbacker conversation piece portrait.

Schipper presumably sailed for England in August or September of 1810. In December of that year his son, Nicholas, was born in London. The family lived in Camden Town, and Schipper set up a studio at the "Sign of the Three Beggars." He is said to have continued as an itinerant artist, travelling throughout the British Isles, but no record of his work in that country has been found, with the exception of an 1824 sketch of his son,[16] and an etching after his profile portrait of Joseph Turner, Dean of Norwich.[17] Gerrit Schipper died about 1825–26, and his widow and children returned to the United States in 1826, settling in Rochester, N.Y.

NOTES

1. The 1887 and 1892 Montreal exhibitions of Canadian historical portraits, held under the auspices of the Montreal Numismatic and Antiquarian Society.
2. Laval/Carter 1908, p. 39, no. 239.
3. Laval/Carter 1908, p. 39, no. 251.
4. Morisset 1935; G. Morisset, "Un beau portrait: Louis Dulongpré par Berczy," in *Peintres et tableaux* (Quebec, 1936), pp. 99–104.
5. J. Russell Harper, *Everyman's Canada. Paintings and Drawings from the McCord Museum of McGill University* (Ottawa, 1962).
6. SAUM, U/1433: Berczy to Charlotte, Quebec, 6 Feb. 1799 (LW 71, 72); and U/1522: Berczy to Charlotte, Middlebury, Vt., June 1812 (LW 102, 103).
7. The work in the McCord Museum collection, M389, was registered as a Schipper by D.R. McCord in his manuscript "Catalogue of Original Paintings and Drawings, vol. IIII [*sic*]." Another pastel profile portrait of Craig was inscribed on the frame verso as "Taken by Schipper" when it belonged to the collection of the Literary and Historical Society of Quebec; it was sold at Christie's, Montreal, 16 April 1969, lot 81.
8. "The Life of Nicholas L. Shipper, written by himself, embracing a period of sixteen years, until his arrival in America in the year 1826," typescript in Frick Art Reference Library, New York City.
9. Richard Hyer, "Gerrit Schipper, Miniaturist and Crayon Portraitist," in *New York Genealogical and Biographical Record,* vol. 83 (April 1952), pp. 70–72; see also frontispiece, reproducing a self-portrait of Schipper.
10. Jeanne Riger, "New Light on Gerrit Schipper, the Painter," in *The Clarion,* vol. 15, no. 1 (winter 1990), Museum of American Folk Art, New York City, pp. 65–70.
11. *Catalogue of American Portraits in The New York Historical Society,* vol. 2 (New Haven: Yale University Press, 1974), p. 856, no. 2168, portrait of Mrs. George Warner, inscribed below likeness "G. Schipper, Pine Street No.6 – 1806".
12. *Traité de la peinture au pastel, du Secret d'en composer les crayons, & des moyens de le fixer; avec l'indication d'un grand nombre de nouvelles substances propres à la Peinture à l'huile. & les moyens de prévenir l'alteration des couleurs.* Par M.P.R. de C...C. a P. de L., (Paris: Defer de Maisonneuve, Libraire), 1788.
13. *Quebec Gazette,* 31 May 1809.
14. ASQ, file 121, no. 238. G. Schipper's receipted invoice for £4.9 for two pastel copies of portraits, including frames and glass, Quebec, 3 August 1810; and ASQ, Brouillard (dépenses) C27, expenses for copies of portraits of bishops Laval and Briand, £4.9.
15. MSQ, Album 159G, p. 78 (Laval), and p. 72 (Briand).
16. Photo in Frick Art Reference Library, New York City.
17. O'Donoghue 1910, vol. 4, p. 313, no. 2, etching by Mrs. D. Turner after Schipper.

MATERIALS AND TECHNIQUES OF WILLIAM BERCZY:
The Woolsey Family, 1809

by Anne Ruggles

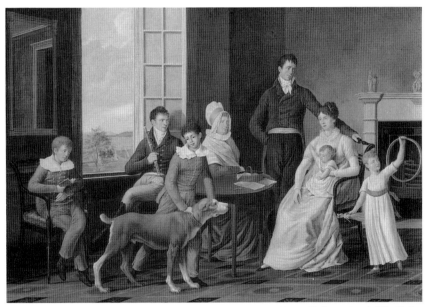

42. Overall front in visible light.

The paintings of William Berczy are generally characterized by careful attention to detail and thoughtful planning. *The Woolsey Family,* 1809 (cat. 84; oil on canvas, 59.9 × 86.5 cm), considered today to be a masterpiece of early Canadian art, is an excellent illustration of these qualities (see fig. 42 and pl. XI). The opportunity to technically examine this family portrait, to compare it with other paintings by the artist, and to refer to the artist's written comments about it, provides rare insight into the materials and techniques employed by this German-Canadian painter.

William Berczy was in all likelihood a painstaking technician, who spent many hours preparing for and

Detail from *The Woolsey Family,* showing straight graphite lines for architectural setting, and freehand graphite underdrawing in the collar and cap of Mrs Woolsey Senior.

effecting this important commission of his late career. A first-hand account of how he proceeded with his work survives in a series of letters written to his wife Charlotte. The artist arrived in Quebec City in July of 1808 and by 19 August, he and the merchant John William Woolsey had agreed on the type of painting to be done.[1] By 31 August, Berczy records that he had a rough sketch in hand when he went to visit the Woolseys to "examine the group closely." He also reports that another person, Mrs Woolsey Senior, is to be included in the family group.[2] On 4 September, Berczy relates that he has begun tracing his family painting onto canvas. He further explains:

> *To get on quickly, I have already done correct outlines of all the figures on paper in their relative proportions, which I will shade in for studies after tracing them onto canvas. Many parts, especially the clothing, I will try to finish first; for having completed studies in front of me, they will come all the more spirited and luminous.*[3]

On 16 November, Berczy mentions that he is working on a sketch of a dog.[4] On 7 December, he announces his intention to repaint the heads of the sitters in the Woolsey family portrait.[5] In May of 1809, Berczy comments that he has completely finished four figures in the Woolsey painting.[6] By 24 June, the artist describes himself as painting the delicate throat of a little four-year-old girl (likely Eleonora Woolsey).[7] On 28 June, he mentions his intention to have the final sitting for the Woolsey painting.[8]

In the earliest preparatory stages, Berczy must have decided on the dimensions of the painting and prepared a stretcher and canvas for it.[9] Although the original stretcher has not survived, the original plain weave linen canvas has. It is likely that a starch size was applied onto the linen fabric. The ground was added onto the sized canvas. This ground has two layers: the one next to the canvas consists of lead white, calcium carbonate, and oil; overlying this is a

lead white, calcium carbonate oil ground, with some red pigmentation from an iron earth pigment. These white and pink ground layers were commonly used by Berczy and are visible in others of his oil paintings on canvas such as *Maria Sutherland Hallowell* (cat. 70), *Joseph Brant* (cat. 77), and *The Archangel St. Michael* (cat. 88). The ground layers proceed generally from a white underlayer to a pinker overlying material.

Apparently the artist next took pencil and ruler to hand and drew, on the grounded canvas, the architectural elements of the room where the family members were to be posed. Careful observation of the painting, or an infrared photograph of it (fig. 43), reveals many areas of exposed straight graphite lines. These lines are especially apparent where the overlying paint is dilute and has been thinly applied. It was into this architectural drawing that Berczy introduced portraits of the individual family members. The use of graphite underdrawing for architectural forms is visible in other Berczy paintings. In the large altar painting, *The Death of St. Joseph* (cat. 94), graphite underdrawing lines are quite clearly visible in the foreground floor pattern. In the painting on vellum of the grand-ducal

44.
Detail from *Study for "The Woolsey Family"*:
Eleonora Woolsey, 1808,
by William Berczy (cat. 83).
National Gallery of Canada, Ottawa.
In raking light, showing incised lines.

family of Tuscany (cat. 12), Berczy scored the lines of the architectural forms, but graphite deposits are lacking.

Despite the fact that no overall drawing on paper has survived, it is known from Berzcy's own description that he began this commission with a sketch of the whole composition.[10] This sketch was amended very early on to include the figure of Josephette Rottot Woolsey, the grandmother.[11] His preparations continued in a conventional way, by making more detailed graphite drawings of each of the individual sitters. The only known surviving, preparatory graphite drawing on paper is that of Eleonora Woolsey (cat. 83). Examination of this drawing in oblique light reveals some incised lines that lack colouring matter of any sort (fig. 44). These lines included contour lines and lines depicting the folds of the dress. Notably, the drawing and the painted image of Eleonora are exactly the same size and

almost exactly the same configuration. It is likely that this drawing was traced onto the prepared ground of *The Woolsey Family* canvas. The fact that no graphite drawing lines are visible in the figure of Eleonora in the Woolsey family painting itself is consistent with a tracing technique in which the drawing on paper was held against the dry, prepared canvas, and a pointed tool was used to incise lines into the ground. In this method of transfer, pressure alone is employed. Recalling that the grounded canvas of this painting consists of a pink-coloured layer overlying a whiter material, scoring into the ground quite likely resulted in the appearance of faint white lines in the pink-coloured ground surface.

Berczy himself, when commenting on his sketching and transferring methods to his wife, describes a slightly different method, in which only the outlines of figures are transferred to the canvas. He associates this slightly different technique with quick progress. The advantage of the tracing of pre-drawn silhouettes, as opposed to direct, freehand drawing, would be that the figures surely would be in correct proportion. Some figures in the Woolsey family portrait seem to bear the evidence of tracing, in that fairly deeply incised graphite crosses are detectable in the sitter's costume: one in the skirts of Julie Lemoine Woolsey (fig. 45), the mother holding the baby; one in the jacket of William Henry, the young boy holding the dog; and one in the bib of Josephette Rottot, the grandmother. These crosses may be registration marks used by Berczy when he was locating and tracing drawings onto the prepared canvas; they could have been useful in ensuring that the figures were correctly aligned in the horizontal and vertical planes. Figure details, such as jacket buttons, were then drawn in, directly on the canvas. This method of working is, in fact, still visible today in the figures of Julie Lemoine, William Henry, and Josephette Rottot, as freehand underdrawing graphite lines indicating facial and costume details (see fig. 43). Like the architectural graphite drawing lines, these

45.
Detail from *The Woolsey Family,* in normal light, of Julie
Lemoine Woolsey's dress, showing a registration mark.

freely drawn graphite sketching lines are visible
under quite paste-like paint. In this method, Berczy
explored the details of the figures directly on the
prepared canvas, after the silhouettes had been
placed in the composition by tracing.

Why Berczy used different tracing techniques in
The Woolsey Family can only be conjectured. Perhaps
the artist was particularly pleased with the drawing
of the four-year-old Woolsey girl, and so he trans-
ferred it virtually directly into paint. But, most like-
ly, he traced only the outlines of the other figures in
his eagerness to proceed. Sketching the costume
and facial details directly onto the prepared canvas
eliminated the absolute necessity of fully developing
the drawings on paper. (In his earlier family group
portrait of the de Muralt children [cat. 23], the in-
dividual sketches were developed into miniatures

[cat. 20–22] and have survived.) Subtly traced lines,
although perhaps difficult to see during the painting
process, have the advantage that they are not detect-
able and thus not distracting in the finished painting.

Having drawn the architectural setting and posi-
tioned the figures on the prepared ground, Berczy
then proceeded to paint the foreground. In so doing,
he took care to reserve spaces for the figures who
were to be placed on the floor. A close examination
of the skirt of the mother holding the baby shows
the floor-tile pattern continuing under her dress
slightly, then stopping. (A more clearly visible exam-
ple of a space reserved for a figure is seen in the
painting by William Bent Berczy of an *Indian En-
campment near Amherstburg* [WBB 4]. Here, the sixth
figure from the right is surrounded by unpainted
ground. In this example, the area reserved for this
figure was over generous, and because the artist did
not subsequently paint the background around the
figure, the reserve is left exposed.) Once the floor
tiles were complete, Berczy likely then painted in
the background walls and next, the figures. Follow-
ing his first painting of the figures, he probably
reworked the background to integrate it with the
individual portraits. This technique gives William
Berczy's paintings their characteristic crispness.

Paint cross-sections from the area of the painted
tiles at the lower right of *The Woolsey Family,* viewed
under magnification (fig. 46), reveal the artist's actu-
al painting sequence in the foreground. Overlying
the pink-coloured top layer of the grounded canvas,
which was marked with graphite lines, is green-
coloured paste-like paint, which consists of lead
white, calcium carbonate, and terre verte. Overlying
this greenish coloured layer is a bluish-pink col-
oured paint that contains madder lake.[12] This area,
which appears purple macroscopically, derives its
colour from the underlying pink-coloured ground,
the green-blue of terre verte, and the overlying red
of the madder lake colourant. Berczy applied a clear
coating on top of these paints, then he applied more

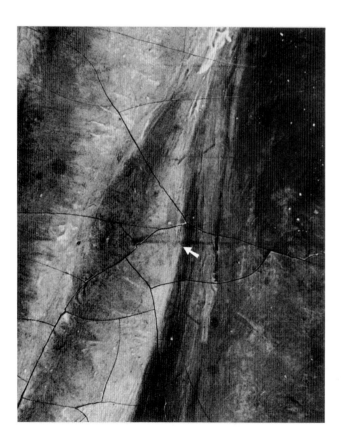

46.
Schematic cross-section of paint from purple
foreground area of *The Woolsey Family.*

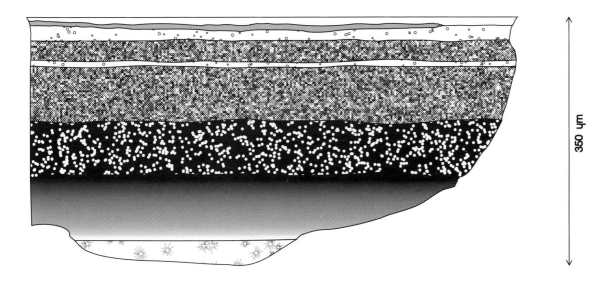

350 µm

varnish

paint/glaze

oiling out layer

paint containing madder lake

green paint/ground

pink to white ground

starch size

paint containing madder lake. The addition of more madder lake paint may have been intended to increase the depth of the colour of the floor tiles, but it may also be an example of reworking the background to integrate it with the painted figures.

"Oiling out" was a technique described in contemporary technical manuals for artists.[13] The purposes of this technique were described as twofold: to make the after-paintings unite with the first, and thus to create an appearance of having been done all at the same time; and to prepare the dry oil paint surface for a further application of paint. The most common material used for oiling out was poppyseed oil, but also recommended were linseed oil, mixtures of oil and varnish, turpentine alone, or petroleum.[14] An oiling-out layer could be applied locally or much more broadly. The clear layer visible over the first layer of paste-like paint on *The Woolsey Family* was likely broadly applied between painting sessions. The composition of this particular layer is

oil and lead white. The addition of the lead white pigment would cause the thin oil layer to dry more quickly. Expeditious drying would be of advantage in preparing the picture for further paint applications.

Although not specifically employed in the overall oiling-out layer in the Woolsey family portrait, Berczy did have a recipe for expeditiously drying oil colours: "Take of clear Gum Mastic three Ounces – Of sugar of lead one Ounce / grind them together in one ounce of the best Nutt or Poppy Oil, which Ingredients together form a paste that must be kept in a pot, constantly covered with water."[15] Note that the oiling-out layer from the Woolsey family portrait lacks the addition of the gum mastic resin.

In English artists' manuals of Berczy's time, the term "retouching" refers to the practice of painting over a previously painted passage, either with a complete layer of paint or with isolated brush strokes. Retouching could be carried out over an oiled-out layer, a varnish layer, a combination of both, or directly on the dried paint surface. The choice depended primarily on the state of the previously applied paint.[16] Berczy remarked in a letter of December 1808,[17] that he intended to "repaint" some of the heads of the sitters in *The Woolsey Family*. Technically, what Berczy meant by "repainting" is likely some variation on what has just been described as "retouching." In fact, nearly all of the methods applied by Berczy in his paintings can be found described in the practical manuals of European artists of his time.

In the small painting on copper of *Charlotte Berczy with Hat* (cat. 32), microscopic examination reveals that a brown-coloured, varnish-like material was employed over paste-like paint to enhance shadows in the frilly collar of the sitter, and opaque white paint was then used to re-create highlights in a conventional retouching technique of the day. Berczy, in a letter of 27 January 1809 to his wife, wrote:

Today I have done a little retouching of the portrait of William painted by our dear Amélie, and William will bring it back to her, as he will bring you his St. Francis … The work by Miss Panet has gained a little through my retouches but even more by the varnish which I applied to it. This effect tempted me to do the same operation with the St. Francis by William, but as I am not sure that I can trust the paper entirely, and that there are some delicate touches which I would not wish the painting to lose so that you can judge it, I have preferred to send it to you with less effect and softness. After you have seen it thus, he will bring it back to me and I will varnish it; if the [surface] details are then lost, I will retouch them with a fine oil colour which will certainly stand up to the varnish and will render it even more expressive and picturesque….[18]

Here he describes specifically the retouching of other paintings, apparently over layers of varnish and with the medium of oil paint. This technique is clearly visible in *Charlotte Berczy with Hat* (see fig. 47), a painting which was kept by the artist throughout his life, and which was probably retouched by him years after it was originally painted.

A different repainting or retouching technique is visible in the painting on wood of *Maria Therese, Archduchess of Tuscany* (cat. 13). In this painting, the iridescent appearance of the blue-green dress fabric is created through the application of a yellow pigmented glaze over more paste-like paint containing ultramarine blue. A cross-section of paint taken from this region reveals that the glaze lies directly over the paste-like paint, with no intermediary layer of a clear coating. In this same drapery, white paste-like paint highlights are seen to be added to the drapery, directly on top of glazes. These brushstrokes create the lightest highlights. Interestingly, this layering technique for drapery painting is very reminiscent of the method of drapery painting described by Berczy's contemporary, Thomas Bardwell.[19]

In the large altar painting of *The Archangel St. Michael* (cat. 88), a slightly different variation of repainting is exhibited. In a cross-section of paint taken from the flames of hell, at the bottom centre of the painting, a glaze-like layer of paint overlies a more paste-like paint, with a very slightly vermilion pigmented oiling-out layer separating the two. In the painting of *Maria Sutherland Hallowell* (cat. 78), the paint layer structure is even more complex. A paint sample from the upper-right background shows that paste-like paint is covered by a clear oil layer, which has then been painted with paste-like paint, oiled out again, and then glazed with a transparent paint. Today, overpainting by another hand masks Berczy's subtle glazing and layer technique.

Observing *The Woolsey Family,* we may assume that Berczy employed numerous variations of repainting or retouching techniques as he strove intermittently for almost a year to create precise effects in the background, foreground, draperies, and facial expressions. The paint cross-section from the lower-right foreground of the painting shows the application of a madder lake applied directly over a green terre verte and white (white lead and calcium carbonate) paste-like paint – in a "repainting" technique designed to create a purplish-coloured floor tile. This coloured area was then "oiled out," perhaps to dry the underlying paint or prepare it for further paint applications. The area was then repainted on top of the oiling-out layer, possibly to reintegrate the painted figures into the room setting, or to intensify the colour of the tiles. The clothing of the sitters likely is painted in the manner described by Thomas Bardwell: either with two layers of paint, one layer applied directly on top of the other to create a specific colour, or with a single layer of colour applied directly over the ground. Shadows in the drapery are usually exposed priming colour, while the highlights are stiff, lead white, rich touches. The presence of one or more oiling-out layers would be dependent upon the number of sittings required for the drapery to be completed. When Berczy mentioned the repainting of the heads of the sitters in the Woolsey family portrait, this likely entailed the laying down locally of an oiling-out material and the application of both paste-like paint and glazes. Close examination of the faces of sitters, such as the mother holding the child (fig. 48), reveals graphite lines that show changes in facial details, such as eyebrows, mouth, and nose. Importantly, these lines exist over paste-like paint. They were most likely drawn in preparation for subsequent repainting. Notably, the use of graphite

48.
Detail from *The Woolsey Family,* in normal light,
showing freehand graphite drawing lines on the face
of Julie Lemoine Woolsey.

Senior, John William Woolsey, his wife, and their
infant son appear to have a less refined finish than,
for instance, the face of William Henry (fig. 49), the
boy holding the dog by its collar. Further, as was
remarked upon before, graphite drawing lines are
visible on the face of the mother. Likely some of
these faces have suffered the ravages of time. Proba-
bly, when Berczy completed the painting, neither
the graphite underdrawing, nor the broad, crude
underpainting – seen for instance in the face of the
grandmother – was left visible.

A detailed technical look at this painting should
not omit some comment about the arrangement of
the group as a whole. An appreciation of the precise
hierarchical order, and the way in which the figures
are linked compositionally, is fundamental to an
appreciation of Berczy's skill and the significance of
the painting. An eloquent description of the com-
position is given by Jean Trudel:

> This composition consists of successive planes of height
> and depth that divide the painting into four distinct
> principal areas. First, in the lower foreground, is the dog.
> The second plane, a little further back, takes in John
> William Woolsey's four children. A third plane brings
> together his mother, his wife, and his brother-in-law.
> Finally, isolated in the background, but dominating his
> entire family, is John William Woolsey. It is the compo-
> sition, even more than the exchange of looks that unites
> the figures.[21]

A detailed technical examination of *The Woolsey
Family* reveals it as a testament to Berczy's patient
step-by-step building up of layers, and differential
redrawing, and repainting or retouching to develop
a fully polished final painting. Two layers of ground
exist, over which lie graphite drawing and incised
lines, which are then covered with one or two lay-
ers of paste-like paint. An overall oiling-out layer
likely exists over the first layer or layers of paste-like
paint. Over the general oiling-out layer, more paste-
like paint exists in some areas, in others there is more

underdrawing for repainting is not specifically
described in contemporary artists' method books.[20]
This specific repainting method may have been a
particular quirk of Berczy's. However, all of his
other retouching or repainting methods, as seen in
cross-sections from the Woolsey family portrait and
other paintings, are described in artists' technical
method books of the period.

When the viewer steps back and confronts the
painting of the Woolsey family as a whole, it be-
comes disconcertingly obvious that the degree of
finish varies widely from face to face, amongst the
family group. Specifically, the face of Mrs Woolsey

49.
Detail from *The Woolsey Family,* in normal light,
of the face of William Henry Woolsey.

graphite drawing. At one time, more oiling out, paste-like paint, and glazes may have covered the now exposed graphite lines on some of the sitters' faces. The varied, multi-layered structure of this painting reveals William Berczy as a conventional European-style painting technician of the late eighteenth, early nineteenth century.[22] Such artistic technical knowledge was likely rare in pre-confederation Canada. However, what perhaps engages the viewer most in *The Woolsey Family* is the meticulous rendering of details and the intricate nature of the composition.

Technical analysis undertaken on this painting has included radiography, infra-red photography, fluorescence photography, stereo microscopy, polarized light microscopy, fluorescence microscopy, Fourier transformer infrared spectroscopy (FTIR micro-spectroscopy and microFTIR), scanning electron microscopy, and X-ray energy spectroscopy. These methods of analysis have also been supplemented by some just plain, hard looking at the painting and at others of the artist's œuvre, in normal light.

Palette
lead white
calcium carbonate
calcium sulphate
terre verte
madder
prussian blue
ochre
ultramarine blue
vermilion

ACKNOWLEDGEMENTS

I would like to thank Scott Williams of the Canadian Conservation Institute for his instrumental analysis; Charles Hupé and Clive Cretney of the NGC Photographic Services Department for technical photography; and Louise LeBlanc of NGC Publications Division for computer graphics. I am also grateful to Leslie Carlyle for her technical advice on this appendix and for allowing me to reference her not yet published Ph.D. thesis.

NOTES

All excerpts from Berczy's letters to his wife have been translated from the original French.

1. SAUM, U/1465: Berczy to Charlotte, Quebec, 18 Aug. 1808.
2. SAUM, U/1468: Berczy to Charlotte, Quebec, 31 Aug. 1808.
3. SAUM, U/1471: Berczy to Charlotte, Quebec, 4 Sept. 1808.
4. IBC, William Berczy File, p. 09325: Berczy to Charlotte, Quebec, 16 Nov. 1808.
5. SAUM, U/1478: Berczy to Charlotte, Quebec, 7 Dec. 1808.
6. SAUM, U/1497: Berczy to Charlotte, Quebec, May 1809.
7. SAUM, U/1507: Berczy to Charlotte, Quebec, 24 June 1809. See also LW 96.
8. SAUM, U/1508: Berczy to Charlotte, Quebec, 28 June 1809.
9. Perhaps this preparatory work was actually carried out by William Bent Berczy, who is reported to have helped with this picture.
10. "As I have completed a sketch for the family painting, I shall send you a tracing of it as soon as William has a little more time." [SAUM, U/1468: Berczy to Charlotte, Quebec, 31 Aug. 1808.]
11. "After correcting the composition of my rough sketch, I spent the evening with William at their house." [SAUM, U/1468: Berczy to Charlotte, Quebec, 31 Aug. 1808.]
12. Likely this madder lake colourant has faded over time on exposure to light. Note that a similar coloured paint exists in the upper left of the painting of the grand-ducal family of Tuscany (cat. 12). Where this paint, which depicts a curtain, has been sheltered from direct light exposure by the frame rebate, it is much more brightly red coloured.
13. K.M. Talley and Karin Groen, "Thomas Bardwell and His Practice of Painting: A Comparative Investigation Between Described and Actual Painting Technique," in *Studies in Conservation*, no. 20 (London: International Institute for Conservation, 1975), p. 67; see also Thomas Bardwell, *The Practice of Painting Made Easy* (London, 1756).
14. Leslie Carlyle, "British Nineteenth-Century Oil Painting Instruction Books: A Survey of Their Recommendations for Vehicles, Varnishes and Methods of Paint Application," in *International Institute for Conservation Brussels Conference Preprints* (Sept. 1990), p. 78.
15. This excerpt was inserted in a notebook of London addresses [SAUM, boîte 11447]. This reference was brought to my attention by Mary Allodi. Further, Leslie Carlyle has pointed out that this is Julius Caesar Ibbetson's (1759–1817) recipe for "gumtion." See Leslie Carlyle, "A Critical Analysis of Artists' Handbooks, Manuals and Treatises on Oil Painting Published in Britain Between 1800–1900: with reference to selected eighteenth-century sources," Ph.D. thesis submitted to the Courtauld Institute of Art, University of London, 1991.
16. Leslie Carlyle 1991, p. 78.
17. SAUM, U/1478: Berczy to Charlotte, Quebec, 7 Dec. 1808.
18. SAUM, U/1486: Berczy to Charlotte, Quebec, 27 Jan. 1809. This reference was brought to my attention by Mary Allodi.
19. Thomas Bardwell, pp. 23–25; see also Talley and Groen, p. 83.
20. Bulkley (1821), however, described a comparable technique of using chalk for making the final additions of figures and animals in landscape painting [Leslie Carlyle 1991, p. 284].
21. Jean Trudel, *The Woolsey Family*, Masterpieces of the National Gallery of Canada series, no. 7 (Ottawa: NGC, 1976), p. 10.
22. The most unconventional technical aspect of Berczy's paintings is his choice of supports during his artistic career in North America. An example of an unconventional support is the book board (paper laid down on card) support used in his portrait of *John Mackenzie* (cat. 96).

WILLIAM BERCZY'S DESCRIPTION OF JOSEPH BRANT

Among the Berczy papers in the Service des archives de l'Université de Montréal collection [SAUM, série S, boîte 11446, pp. 581–83] is the following description of Joseph Brant from the pen of William Berczy:

Captain Brand, 1799

Captain Brand is now about the age of 55 Years; he is near 6 feet high in stance, of a stout and durable texture able to undergo all the inconvenience of the hardships connected with the difficulties to carry on war through immense woods and wildernesses – His intellectual qualities compared with the phisical construction of his bodily frame – He professes in an eminent degree a sound and profound judgement. He hears patiently and with great attention before he replies and answers in general in a precise an laconic stile. But as soon as it is the question of some topic of great moment, especially relative to the interest of his nation he speaks with a peculiar dignity – his speech is exalted energey and endowed with all the charms of complete Retorick. Without exception all the actions of his life he has without exception given proofs of the most unquestionable intrepidity, and of cool courage, which were never depressed by adversity – and unexpected events have never disconcerted the composure of his mind. These intellectual and bodily qualities, have acquired him the illimited confidence of his nations, which he has ever led and yet leads like a sovreign although he is not one of their constitutional Chiefs () [Berczy's asterisk]. That influence is not confined to the Six Iroquose Nation under the British Government alone but extends itself over many other Indian Nations which bear equal deference and Respect to his talents to govern mankind, and submit themselves in their national councils to his leading. A very striking instance of this influence happened in the year 1794 when a war betwixt Great Britain and the United States appeared inevitable. He succeeded at that time to unite near all the different tribes of Indians and to attach them to the British interest, even that part of the 6 Iroquese Nation who lieve in the United States in the Genesee Lands, along the Mohawk river an near Lake Oneidda.*

Besides a variety of Indian idioms he possesses the English tongue in great perfection which he reads and writes well. His hand writing is elegant and he possesses a good stile, in which so as in his public speeches it predominates a naivety peculiar to the Indians yet embelished by improvements of Learning. For the Information of his nation Brand has translated the Gospel in the Mohok Linguage, and for the same purpose he has composed a Mohock Gramar which was printed on the expences of Government. Himself and his Nation adher to the Lutheran Religion.

In the Settlement of the Six Nations along River Ouse (grand River) Brand has build himself a good and neat house in the fashion of those of the English settlers: there he lieves in a very decent stile and enjoys all the more rafined comforts of civilised nations. His menial servants are chiefly negroe: and though he enjoys a preponderant influence over all the individuals of his own nation, he observes with the utmost attention the rules [roles?] of truly perfect equality adopted betwixt them. In his house he receives strangers alwais with great hospitality, and Civility his friends and persons of some distinction he treats with all the attention of polished politeness and even with sumptuosity.

Note: See also cat. 75 for Berczy's 1794 description of Brant.

APPENDIX E

OUTLINE OF WILLIAM BERCZY'S PLANNED PUBLICATIONS

I

The collection of Berczy papers in the Service des archives de l'Université de Montréal contains the following draft outline for a book on Upper and Lower Canada. [SAUM, série S, boîte 11446, unbound manuscript, left-hand sheet, opposite p. 278.]

Plan for my Description of Upper and Lower Canada

1. *Annales of Canada – Historical Account from its first discovery.*

2. *Progress of the discoveries by Land in the Inner parts of Upper and Lower Canada, and the present state of the furr trade to the Northwest.*

3. *Commerce of Canada in General its successive progress from the beginning of the french establishment to this time.*

4. *Geographical Description of Lower Canada, with an analysis of what it is at present & what it was under the french government – shewing how much it has gained under the English, how much it could have gained and may gain in future by wise and just measures.*

5. *Geographical Description of Upper Canada.*

6. *Navigation inland.*

7. *Population, its progressive advance from the first french establishments, what it is at present, and what it can possibly become. Reflections upon the mode of accellerating that possible population.*

8. *Agriculture, to which it is inserted a new plan for the better use of the valuable sugar maple Tree on a plan for forming regular sugar Orchards with a Calculation of the advantages to be expected from that improvement.*

9. *Character and costumes of the different nations of white people habitating that extensive Country; and the same of the several Indian Nations living in both the provinces.*

10. *Reflexions upon the progressive Rise of the value of the land in both the Provinces.*

II

The following list was found on a loose note sheet inserted in a booklet containing articles for a publication on Lower Canada [SAUM, série S, boîte 11445]. The list probably refers to illustrations he had in mind for one of his intended publications.

1. *Map containing the Eastern part of the United States.*
2. *Special map for my Route to the Genesee*
3. *Plan of the Settlements I made*
4. *Plan of my Route from the Genesee to Toronto.*
5. *Loghouse exterior and interior- an mode of making worm fences.*
6. *Plan for a sugur Orchard and sugar house* [See cat. 43.]
7. *machinery for collecting the sap*
8. *Inner part of the sugar house.*
9. *machinery for transporting to sugar kettles.*
10. *plan of my Country seet.*

III

Loose sheets, evidently Berczy's drafts for letters sent to prospective publishers of his manuscripts [SAUM, série S, boîte 11445], contain the following notations regarding his "Statistical Account":

The Statistical account will contain each Vol. at least 350 pages equal to those contained in thes three sheets of manuscript Number 1, 2, 3, of which one sheet contain a part of the history of Canada and the other two part of the account of the Grants of Seigneries and Townships. Letter A is the title of the book and the table of contents of each Volume.

To this work will be joined several Topographical maps besid the General Geographical map.

After I shall have completed the three volumes annmounced in the title I have in contemplation to join to this work as an appendix a pictureske description of both the provinces which will contain a suite of coloured copper plates representing the most striking views of that extensive country intermixed with the costumes of the white inhabitants and Indians living in it. — the latter will contain: the following different tribes: 1st Hurons

2d. Abenaquis — Metis Monntenais, Iroquois, Missosaguis and Chipahways.

This appendix I intend to deliver to the public by parcels of 6 plates accompanied by their respective description and explanation.

The three Volumes of this work with the maps thereto belonging I would not like to give up under 1500 Dollars per Volume — and about the appendix I will not form any estimate befor the first parcel of Six plates is engraved and their explanation is finished. The plates I intend to engrave myself in the size of Great Quarto.

The first volume is almost entirely finished in a state as should dare to present it to the public — and the two latter I could deliver from Six to Ten months.

IV

The above outline is followed by part of another draft letter to a publisher regarding a proposed eight-volume publication on "The Letters of travellers through a great part of the principal countries of Europe and North America." The travellers' letters project would only be undertaken once the "Statistical Account" was completed.

SELECTED BIBLIOGRAPHY

Adair 1943. Adair, E.-R. "The Church of Saint-Michel de Vaudreuil." BRH, XLIX:2 (1943), pp. 38–49; XLIX:3 (1943), pp. 75–89.

Adams 1941. Adams, Frank Dawson. *A History of Christ Church Cathedral, Montreal*. Montreal: Burton's Limited, 1941.

AGO 1982. Boyanoski, Christine. *Sight and Insight*. Toronto: Art Gallery of Ontario, 1982.

Albany 1946. Albany Institute of History and Art. *Painting in Canada: A Selective Historical Survey*. Albany, N.Y., 1946.

Allodi 1974. Allodi, Mary. *Canadian Watercolours and Drawings in the Royal Ontario Museum*. 2 vols. Toronto: Royal Ontario Museum, 1974.

Allodi 1980. Allodi, Mary. *Printmaking in Canada: The Earliest Views and Portraits*. Toronto: Royal Ontario Museum, 1980.

Andre 1967. Andre, John. *William Berczy: Co-founder of Toronto*. Toronto: Borough of York, 1967.

Andre 1971. Andre, John. *Infant Toronto as Simcoe's Folly*. Toronto: Centennial Press, 1971.

Andre 1975. Andre, John. "William Bent Berczy (1791–1873)." In *German-Canadian Yearbook*, vol. 2, pp. 167–80. Toronto, 1975.

Andre and Harper. Andre, John, and J. Russell Harper. "William Bent Berczy." In DCB, vol. X.

Arthur and Otto 1986. Arthur, Eric, and Stephen A. Otto. *Toronto: No Mean City*. 3rd ed. Toronto: University of Toronto Press, 1986.

Bazin 1959. Bazin, Jules. "L'album de consolation de Jacques Viger." *Vie des Arts*, IV: 17 (1959), pp. 26–30.

Berczy, William. *Extract from the Minutes of Council*. Quebec City: New Printing Office, 1798.

Berczy, William, and F. von Diemar [trans. Benjamin Franklin]. *Auszug der Anmerkungen zum Unterricht derjenigen Europäer die sich in Amerika niederzulassen gesonnen sind*. Including a 16-page appendix stating terms for colonists offered by Genesee Associates, publisher unknown (copy in Staatsarchiv Hamburg).

Betcherman 1962. Betcherman, Lita-Rose. *William von Moll Berczy: His Career as an Artist in Lower Canada 1805–1812*. Master's thesis, Carleton University, 1962.

Betcherman 1965. Betcherman, Lita-Rose. "Genesis of an Early Canadian Painter: William von Moll Berczy." *Ontario History*, LVII:2 (1965), pp. 57–68.

Bibaud, Maximilien. "Une Dame Canadienne Peintre." In *Encyclopédie Canadienne*, pp. 74–75. Montreal, 1842–43.

Bibaud, Maximilien. *Dictionaire Historique des Hommes Illustres du Canada et de l'Amérique*, vol. 1. Montreal: P. Cérat, 1857.

Bibaud 1858. Bibaud, Maximilien. *Le panthéon canadien*. 2nd ed. (1st ed. 1858.) Eds. Adèle and Victoria Bibaud. Montreal: J.M. Valois, 1891.

Biermann, Georg. *Deutsches Barock und Rokoko herausgegeben im Anschluss an die Jahrhundert-Ausstellung Deutscher Kunst 1650–1800, Darmstadt 1914*. 2 vols. Leipzig: Verlag der weissen Bücher Erik-Ernst Schwabach, 1914.

Boisclair, Marie-Nicole. *Catalogue des œuvres peintes conservées au Monastère des Augustines de l'Hôtel-Dieu de Québec*. Publication no. 24, Quebec City: Direction générale du patrimoine, Ministère des Affaires culturelles, 1977.

Borroni Salvadori, Fabia. "Memoralisti e diaristi a Firenze nel periodo leopoldino, 1765–1790: Spigolature d'arte e costume." *Annali della Scuola Normale Superi-*

ore di Pisa. Classe di lettere e filosofia, III:9 (1979), pp. 1189–291.

Borroni Salvadori, Fabia. "Riprodurre in incisione per far conoscere dipinti e disegni: il Settecento a Firenze." In *Nouvelles de la République des Lettres,* vol. 1, pp. 7–69; vol. 2, pp. i–xix, 73–114. Naples: Editrice Politechnica, 1982.

Borroni Salvadori, Fabia. "A passo a passo dietro a Giuseppe Bencivenni Pelli al tempo della Galleria." *Rassegna Storica Toscana,* XXIX:1 (Jan.–June 1983), pp. 3–53; XXIX:2 (July–Dec. 1983), pp. 153–206.

Borroni Salvadori, Fabia. "Carlo Lasinio e gli autoritratti di Galleria." *Mitteilungen des Kunsthistorischen Institutes in Florenz,* XXVIII:1 (1984), pp. 109–32.

Borroni Salvadori, Fabia. "L'esportazione di opere d'arte nella Firenze della seconda metà del '700." *Amici dei Musei,* no. 31 (Dec. 1984), pp. 8–11.

Borroni Salvadori, Fabia. "Il coinvolgimento dell'Accademia del Disegno nella politica artistica-museale del granduca Pietro Leopoldo." *Rassegna Storica Toscana,* XXXI:1 (Jan.–June 1985), pp. 3–68.

Borroni Salvadori, Fabia. "Artisti e viaggiatori agli Uffizi nell Settecento." *Labyrinthos,* Studi e ricerche sulle arti nei secoli XVIII e XIX, IV:7/8 (1985), pp. 3–72; V:10 (1986), pp. 38–87.

Börsch-Supan, Helmut. *Die Deutsche Malerei von Anton Graff bis Hans von Marées 1760–1870.* Munich: C.H. Beck/Deutscher Kunstverlag, 1988.

Bovay, Émile-Henri. *Le Canada et les Suisses: 1604–1974.* Fribourg, Suisse: Éditions universitaires, 1976.

Boyanoski 1989. Boyanoski, Christine. *Staffage to Centre Stage: The Figure in Canadian Art.* Toronto: Art Gallery of Ontario, 1989.

BRH. *Bulletin des Recherches Historiques.* Quebec City: Société des études historiques/Archives de la province de Québec.

Burant 1991. Burant, Jim, et al. *A Place in History: Twenty Years of Acquiring Paintings, Drawings and Prints at the National Archives of Canada.* Ottawa: National Archives of Canada, 1991.

Château Ramezay 1931. *Catalogue du Château de Ramezay musée et galerie de portraits.* Montreal: Société d'archéologie et de numismatique de Montréal, 1931.

Château Ramezay 1932. *Catalogue of the Château de Ramezay Museum and Portrait Gallery: Exhibited by the Antiquarian and Numismatic Society of Montreal.* 19th ed. Montreal: Antiquarian and Numismatic Society of Montreal, 1932.

Château Ramezay 1939. *Catalogue du Château de Ramezay musée et galerie de portraits.* Montreal, 1939.

Château Ramezay 1957. *Catalogue of the Château de Ramezay Museum and Portrait Gallery. New Text by Louis Carrier.* Montreal: Antiquarian and Numismatic Society of Montreal, 1957.

Château Ramezay 1989. *Témoignages: 125 ans d'histoire et d'acquisitions.* Montreal: Château Ramezay exhibition catalogue in typescript, 1989.

Cooke 1983. Cooke, W. Martha E. *W. H. Coverdale Collection of Canadiana: Paintings, Water-colours and Drawings (Manoir Richelieu Collection).* Ottawa: Public Archives of Canada, 1983.

Cowan, Helen I. "Assisted Colonization on Two Frontiers: William Berczy, Agent." Typescript, *Helen Cowan Papers* (S194), Baldwin Room, Metropolitan Toronto Public Library.

Cowan, Helen I. "Venture in Colonization: William Berczy, Associate." Typescript, *Helen Cowan Papers* (S194), Baldwin Room, Metropolitan Toronto Public Library.

Cruikshank, Ernest A., ed. *The Correspondence of Lieut. Governor John Graves Simcoe, with allied documents relating to his administration of the government of Upper Canada,* vols. 1–5. Toronto: Ontario Historical Society, 1923–31.

Cruikshank, Ernest A., and A.F. Hunter, eds. *The Correspondence of the Honourable Peter Russell,* vols. 1–3. Toronto: Ontario Historical Society, 1932–36.

DCB. *Dictionary of Canadian Biography.* Toronto: University of Toronto Press, 1966–.

De Rainville 1892. De Rainville. "Amélie Panet." *La Kermesse,* no. 9/10 (25 Nov. 1892), pp. 129–35.

Derome 1982. Derome, Robert. "Le portrait de James McGill peint par Louis Dulongpré." *Vie des Arts,* XXVI:105 (winter 1981–82), pp. 44–46.

Derome, Robert, et al. *Dulongpré: A Closer Look.* Montreal: McCord Museum of Canadian History, 1988.

"Diary of John H. Summerfeldt." *Markham Economist and Sun,* 5 Oct. 1922.

Dippel, Horst. "German Emigration to the Genesee Country in 1792: An Episode in German-American Migration." In *Germany and America: Essays on Problems of International Relations and Immigration,* ed. H.L. Trefousse, pp. 161–69. New York: Brooklyn College Press, 1980.

Dunlap 1930. Dunlap, William. *Diary of William Dunlap (1766–1839)*. Ed. Dorothy C. Barck. New York: The New York Historical Society, 1930.

Einem, Herbert von. *Deutsche Malerei des Klassizismus und der Romantik, 1760–1840*. Munich: C.H. Beck/ Deutscher Kunstverlag, 1978.

Faribault-Beauregard 1987. *XVIIIth Century Life in the Illinois: The unpublished Memoirs of Marie-Anne Cerré. A Journey from Montreal to Kamouraska in 1840*. Annoted by Marthe Faribault-Beauregard. Montreal: Société de recherches historiques, 1987.

Feulner, Adolf. *Skulptur und Malerei des 18. Jahrhunderts in Deutschland*. Wildpark-Potsdam: Athenaion, 1929.

Firenze e l'Inghilterra, rapporti artistici e culturali dal XVI al XX secolo. Florence: Pitti Palace, 1971.

Forlani-Tempesti, Anna. "Le incisioni e i costumi." In *I contadini della Toscana in sessanta stampe a colori disegnate da Antonio Bicci e incise sotto la direzione di Carlo Lasinio*. Milan: Edizioni Il Polifilo, 1970.

Fryer 1989. Fryer, Mary Beacock. *Elizabeth Postuma Simcoe 1762–1850: A Biography.* Toronto/Oxford: Dundurn Press, 1989.

Gagnon 1895. Gagnon, Philéas. *Essai de bibliographie canadienne*. Quebec City: Private publication, 1895.

Graves, Algernon. *The Royal Academy of Arts: A Complete Dictionary of Contributors and Their Work from Its Foundation in 1769 to 1904*. 8 vols. London: Henry Graves and Co. Ltd. and George Bell and Sons, 1905.

Hamilton 1958. Hamilton, Milton W. "Joseph Brant – The Most Painted Indian." *New York History,* XXXIX:2 (April 1958), pp. 119–32.

Harper 1962. Harper, J. Russell. "Three Centuries of Canadian Painting." *Canadian Art,* XIX:6 (November/December 1962), pp. 405–53.

Harper and Hubbard 1965. Harper, J. Russell and Robert H. Hubbard. *Treasures from Quebec: An Exhibition of Paintings Assembled from Quebec and Its Environs.* Ottawa: National Gallery of Canada / Quebec City: Musée du Québec, 1965.

Harper 1966. Harper, J. Russell. *Painting in Canada: A History.* Toronto: University of Toronto Press, 1966. 2nd ed. 1977.

Harper 1967. Harper, J. Russell. "La galerie des portraits de la famille Hertel de Rouville." *Vie des Arts,* XII:47 (summer 1967), pp. 16–22.

Harper 1970. Harper, J. Russell. *Early Painters and Engravers in Canada.* Toronto: University of Toronto Press, 1970.

Historisch Biographisches Lexikon der Schweiz. Neuenburg: Administration des Historisch-Biographischen Lexikons der Schweiz, 1926.

Hould, Claudette. "Un tableau de Jacques Sablet au Musée des beaux-arts de Montréal." *RACAR,* VI:2 (1979/80) pp. 97–105.

Hubbard 1950. Hubbard, R.H. *Canadian Painting*. Washington, D.C.: National Gallery of Art, 1950.

Hubbard 1964. Hubbard, R.H. "The European Backgrounds of Early Canadian Art." *Art Quarterly,* XXVII:3 (1964), pp. 297–323.

Hubbard/NGC 1964. Hubbard, R.H. *The Development of Canadian Art.* Ottawa: National Gallery of Canada, 1964.

Hubbard and Ostiguy 1967. Hubbard, R.H. and Jean-René Ostiguy. *Three Hundred Years of Canadian Art.* Ottawa: National Gallery of Canada, 1967.

IBC. Inventaire des biens culturels, Fonds Gérard Morisset, Ministère des Affaires culturelles du Québec.

Jarvis, Eric. "Charles Albert Berczy." In DCB, vol. VIII.

Koschatzky, Walter. *Maria Theresia und ihre Zeit. Eine Darstellung der Epoche von 1740–1780 aus Anlass der 200. Wiederkehr des Todestages der Kaiserin.* Salzburg and Vienna: Residenz Verlag, 1979.

Laberge 1982. Laberge, André. *L'ancienne église Notre-Dame de Montréal: l'évolution et l'influence de son architecture (1672–1830).* Master's thesis, Université Laval, 1982.

Lafortune 1986. Lafortune, Hélène. *Le notaire et la vie quotidienne des origines à nos jours.* Montreal: Archives nationales du Québec, 1986.

Lanzi, Luigi. *La Real Galleria di Firenze accresciuta e riordinata per comando di S.A.R. l'archiduca Granduca di Toscana.* 1782. Reprint. Florence: Comune di Firenze, 1982.

La Rochefoucauld-Liancourt, duc de. *Travels through the United States of North America … and Upper Canada in the Years 1795, 1796 and 1797,* vol. I. 2nd ed. London: R. Phillips, 1800.

Laval 1905. *Laval University.* Quebec City: L'Événement, 1905.

Laval 1906. *Université Laval.* Quebec City: Éditions Marcotte, 1906.

Laval/Carter 1908. Carter, J. Purves. *Descriptive and Historical Catalogue of Paintings in the Gallery of Laval University.* Quebec City: L'Événement, 1908.

Laval 1913. *Université Laval.* Quebec City: L'Action sociale Limitée, 1913.

Laval 1923. *Laval University.* Quebec City: L'Action sociale Limitée, 1923.

Laval 1933. *Guide, comprenant Musée de peintures, et liste de tableaux qu'on ne peut exposer au public.* Quebec City: Université Laval, 1933.

Leisching, Eduard. *Die Bildnis-Miniatur in Österreich von 1750–1850; mit einer Einleitung über die allgemeinen Zustände der Kunstplege in Österreich bis 1850 und über die Miniatur in den anderen Ländern.* Vienna: Artaria and Co., 1907.

Lemberger, Ernst. *Die Bildnisminiatur in Deutschland von 1550 bis 1850.* Munich: F. Bruckmann A.G., 1910.

Lesser 1984. Lesser, Gloria. "William Berczy's Portraits of Joseph Brant." In *Annual Bulletin 6: National Gallery of Canada,* pp. 9–28. Ottawa: National Museums of Canada, 1984.

[Lincoln, Benjamin]. "General Lincoln's Journal." *Massachusetts Historical Society Collections,* vol. 5, series 3, 1836.

Lützow, Carl von. *Die Geschichte der K.K. Akademie der bildenden Künste.* Vienna: C. Gerold's Sohn, 1877.

MacLeod 1948. MacLeod, Margaret Arnett. "The Riddle of the Paintings." *The Beaver* (Dec. 1948), pp. 7–11.

Maheux 1939. Maheux, Arthur. "William Von Moll Berczy, colonisateur et peintre." *Le Canada français,* XXVI:9 (May 1939), pp. 872–85.

Market Gallery 1980. City of Toronto Archives, Market Gallery. *An Exhibition of Paintings, Drawings and Watercolours by William Berczy (1744–1813).* Toronto, 1980.

Massicotte 1941. Massicotte, E.-Z., "William Berczy et Amélie Panet." BRH, LXVII:5 (May 1941), pp. 132–35.

Massicotte 1943. Massicotte, E.-Z., "Le mariage Berczy-Panet." BRH, XLIX:5 (May 1943), pp. 141–42.

Maurault 1920. Maurault, Olivier. "Nôtre Dame de Montréal." *Revue Trimestrielle Canadienne,* vol. 6 (1920).

Maurault 1942. Maurault, Olivier. *Maison de Ville-Marie.* Montreal: Éditions Fides, 1942.

Maurault 1944. Maurault, Olivier, "Souvenirs canadiens: album de Jacques Viger." *Cahiers des Dix,* vol. 9 (1944), pp. 83–99.

Maurault 1957. Maurault, Olivier. *La paroisse, histoire de l'église Notre-Dame de Montréal.* 2nd. ed. (1st. ed. 1929.) Montreal: Thérien Frères Limitée, 1957.

Meloni Trkulja, Silvia. "Dalla reggenza al Granducato di Pietro Leopoldo." In *Saloni, Gallerie, Musei e loro influenza sullo sviluppo dell'arte dei secoli XIX e XX,* ed. F. Haskell. Atti del XXIV Congresso Internazionale di Storia dell' Arte, vol. 7. Bologna: Clueb, 1981.

MMFA 1967. Montreal Museum of Fine Arts. *The Painter and the New World.* Montreal: Montreal Museum of Fine Arts, 1967.

Moloney, Brian. *Florence and England, Essay on Cultural Relations in the Second Half of the Eighteenth Century.* Florence: Leo S. Olschki Editore, 1969.

Montreal 1887. Numismatic and Antiquarian Society of Montreal. *Catalogue Raisonné of a Loan Exhibition of Canadian Historical Portraits and other objects relating to Canadian Archaeology: held in the Natural History Society's Building.* Montreal: Gazette Printing Company, 1887.

Montreal 1892. MacDonald, A.C. de Lery. *A Record of Canadian Historical Portraits and Antiquities exhibited by the Numismatic and Antiquarian Society of Montreal, 15th September 1892, in Commemoration of the 250th Year of the Foundation of Montreal.* Montreal: Numismatic and Antiquarian Society of Montreal, 1892.

Morisset 1935. Morisset, Gérard. "Un beau portrait, Louis Dulongpré par Wilhelm Berczy." *La Renaissance,* 1:6 (27 July 1935), p. 5.

Morisset 1941. Morisset, Gérard. *Coup d'œil sur les arts en Nouvelle-France.* Quebec City: Charrier et Dugal, 1941.

Morisset 1957. Morisset, Gérard. "L'Album de Jacques Viger." *Vie des Arts,* II:8 (autumn 1957), pp. 15–18.

Morisset 1959. Morisset, Gérard. *The Arts of French Canada.* Vancouver: Vancouver Art Gallery, 1959.

Morisset 1960. Morisset, Gérard. *La peinture traditionelle au Canada français.* L'Encyclopédie du Canada français, no. 2. Ottawa: Le Cercle du Livre de France, 1960.

NGC 1945. National Gallery of Canada. *The Development of Painting in Canada, 1665–1945.* Ottawa: National Gallery of Canada, 1945.

NGC 1960. Hubbard, R.H. *The National Gallery of Canada: Catalogue of Paintings and Sculpture,* vol. 3, *Canadian School.* Ottawa: National Gallery of Canada, 1960.

NGC 1988. *Canadian Art. Catalogue of the National Gallery of Canada, Ottawa,* vol. 1 / A–F. Eds. Charles C. Hill and Pierre B. Landry. Ottawa: National Gallery of Canada, 1988.

Noppen 1977. Noppen, Luc. *Les églises du Québec (1600–1850)*. Quebec City and Montreal: Éditeur officiel & Fides, 1977.

O'Donoghue, Freeman. *Catalogue of Engraved British Portraits Preserved in the Department of Prints and Drawings in the British Museum*. London: Trustees of the British Museum, 1910.

Österreich zur Zeit Kaiser Josephs II. Mitregent Kaiserin Maria Theresias, Kaiser und Landesfürst. Niederösterreichische Landesregierung, 1980.

Ouellet 1955. Ouellet, Fernand. "Inventaire de la Saberdache de Jacques Viger." In *Rapport de l'archiviste de la province de Québec pour 1955–1956 et 1956–1957*, pp. 33–176. Quebec City: Archives de la province de Québec, 1955–57.

Paikowsky 1985. Paikowsky, Sandra, ed. "Selected Catalogue of Works in the Permanent Collection of the Château de Ramezay, Montreal." Typescript catalogue prepared by students in the Master of Fine Arts Programme in Canadian Art History, Concordia University, Montreal, 1985.

Pevsner, Nikolaus. *Academies of Art: Past and Present*. New York: Da Capo Press, 1973.

Pinto, Sandra. "La promozione delle arti negli Stati italiani." In *Storia dell'arte italiana: Dal Cinquecento all'Ottocento – 2. Settecento e Ottocento*, pp. 848–54. Turin: Giulio Einaudi, 1982.

Pitti 1979. *Curiosità di una reggia. Viande della Guardaroba di Palazzo Pitti*. Florence: Centro Di, 1979.

Porter 1983. Porter, John R. "L'abbé Jean-Antoine Aide-Créquy (1749–1780) et l'essor de la peinture religieuse après la Conquête." *Journal of Canadian Art History*, VII:1 (1983), pp. 55–72.

Prinz, Wolfram. "Geschichte der Sammlung mit Regesten zur Tätigkeit der Agenten und Dokumentenanhang." *Die Sammlungen der Selbstbildnisse den Uffizien*, vol. 1. Italienische Forschungen, Kunsthistorisches Institut in Florenz, 3rd series. Berlin: Gebr. Mann Verlag, 1971.

Prinz, Wolfram. "La collezione degli autoritratti di artisti." In Ufizzi 1979.

Quebec City 1952. *The Arts in French Canada*. Quebec City: Museum of the Province of Quebec, 1952.

Quebec City 1991. *Nouveaux regards, nouvelles perspectives : la peinture au Québec, 1820–1850*. Quebec City: Musée du Québec, 1991 [forthcoming].

Quervain, Th. de. *Lebensbilder aus der Geschichte des Geschlechtes von Muralt in Bern 1520–1950*. Bern: Private publication, 1954.

RAPQ 1940–41. Roy, Antoine, ed. "William von Moll Berczy: Lettres." In *Rapport de l'archiviste de la province de Québec pour 1940–1941*, pp. 1–93. Quebec City: Archives de la province de Québec, 1940–41.

Reid 1973. Reid, Dennis. *A Concise History of Canadian Painting*. Toronto: Oxford University Press, 1973.

Reid and Vastokas 1984. Reid, Dennis, and Joan Vastokas. *From the Four Quarters: Native and European Art in Ontario, 5000 BC to 1867 AD*. Toronto: Art Gallery of Ontario, 1984.

Repertorium der diplomatischen Vertreter aller Länder seit dem Westfälischen Frieden (1648). Internationaler Ausschuss für Geschichtswissenschaften, 1936–65.

RHS. *Publication Series*, 20 (1942). Publication of the Rochester Historical Society, New York.

Rögl, Fred. "L. von Fichtel und J.P.C. von Moll und ihre wissenschaftliche Bedeutung." *Annalen Naturhistorisches Museum Wien* (Vienna), 84/A (1982), pp. 63–67.

Rosenfeld, Roslyn Margaret. *Miniatures and Silhouettes in Montreal, 1760–1860*. Master's thesis, Concordia University, 1981.

Roy, Pierre-Georges. "Le Peintre Berczy." BRH, I:1 (November 1895), p. 173.

"S.R." [Jacques Viger]. "William Berczy." In *La Bibliothèque Canadienne*, ed. Maximilien Bibaud, vol. 2 (February 1926), pp. 90–91.

Stagg, Ronald J. "William Berczy." In DCB, vol. V.

Stettler. *Michael Stettler zum 70. Geburtstag: Von Angesicht zu Angesicht, Porträtstudien*, eds. F. Deuchler, M. Flury-Lemberg, and K. Otavsky. Bern: Verlag Stämpfli and Cie, 1983.

Stock, Beate. "William Berczy in Italy and Switzerland, 1780–1787." *RACAR*, X:2 (1983).

Stock, Beate. "William Berczy als 'Seelenverkäufer'." In *German-Canadian Studies: Interrelations and Interactions*, eds. Karin R. Gürttler and Edward Mornin, Annals 6 (1987), pp. 109–27.

Thibault 1973. Thibault, Claude. *Trésors des communautés religieuses de la ville de Québec*. Quebec City: Musée du Québec, 1973.

Thompson 1969. Thompson, J.R. Fawcett. "Thayendanega the Mohawk and His Several Portraits." *The Connoisseur*, vol. 170, no. 683 (Jan. 1969), pp. 49–53.

Toker 1970. Toker, Franklin. *The Church of Notre-Dame in Montreal: An Architectural History*. Montreal: McGill-Queen's University Press, 1970.

Toronto 1852. *Catalogue of Paintings, Water-Colours and Engravings, exhibited in the Assembly Chamber, Parliament Buildings, Front Street, in aid of the Bazaar for the liquidation of the debt due on St. George's Church, Toronto, September 1852*. Toronto: Henry Rowsell, 1852.

Toronto 1899. Women's Art Association of Canada (Inc.). *Loan Portrait Exhibition*. Toronto: The Women's Art Association of Canada, 1899.

Trudel 1976. Trudel, Jean. *The Woolsey Family*. Masterpieces of the National Gallery of Canada, no. 7. Ottawa: National Gallery of Canada, 1976.

Uffizi 1979. *Gli Uffizi, Catalogo Generale*. Florence: Centro Di, 1979.

Viger 1850. Viger, Jacques. *Archéologie religieuse du diocèse de Montréal*. Montreal: Lovell and Gibson, 1850.

Walpole, Horace. *Horace Walpole's Correspondence with Sir Horace Mann*, vols. 17–25, eds. W.S. Lewis, Warren Hunting Smith, and George L. Lam. New Haven: Yale University Press, 1954–71.

Wandruszka, Adam. *Leopold II., Erzherzog von Österreich, Grossherzog von Toskana, König von Ungarn und Böhmen, Römischer Kaiser*. 2 vols. Vienna and Munich: Verlag Herold, 1965.

PHOTOGRAPH CREDITS

Photographs have been provided by the owners or custodians of the works reproduced, except for the following:

Figures:
A.C. Cooper Ltd., London, 3
Foto Hirsch, Nördlingen, 1
National Gallery of Canada, 13, 15, 16, 17, 18, 19, 20, 22, 24, 31, 32, 39
Royal Ontario Museum, 35

Catalogue:
Patrick Altman, Musée du Québec, Quebec City, 79, 80
John Andre, Toronto, 10, 34, 35, WBB 13, WBB 14
Archives du Québec, Quebec City, 91
Burgerbibliothek Bern, 20, 21, 22, 24, 25
McCord Museum of Canadian History, Montreal, 62
Brian Merrett, Montreal, for the National Gallery of Canada, WBB 11
Thomas Moore Photography, Toronto, for the National Gallery of Canada, 28, 76
Thomas Moore Photography, Toronto, for the Hudson's Bay Company, 73, 74
National Gallery of Canada, 13, 16, 23, 26, 30, 32, 40, 45, 46, 49, 51, 52, 59, 64, 69, 78, 80A, 81, 82, 85, 86, 88, 89, 92, 93, 94, 95, 96, 97, WBB 1, WBB 2, WBB 3, WBB 4, WBB 7, WBB 8, WBB 10
Royal Ontario Museum, Toronto, 60
Sotheby's, Toronto, 33